LOVE, JOE

LOVE, JOE

The Selected Letters

of Joe Brainard

EDITED BY DANIEL KANE

Columbia University Press

New York

Columbia University Press
Publishers Since 1893
New York Chichester, West Sussex
cup.columbia.edu

Copyright © 2024 The Estate of Joe Brainard
Introduction, notes © 2024 Daniel Kane
All rights reserved

Library of Congress Cataloging-in-Publication Data
Names: Brainard, Joe, 1942–1994, author. | Kane, Daniel, 1968– editor.
Title: Love, Joe : the selected letters of Joe Brainard / edited by Daniel Kane.
Description: New York : Columbia University Press, [2024] | Includes index.
Identifiers: LCCN 2024020693 | ISBN 9780231203425 (hardback) |
ISBN 9780231555043 (ebook)
Subjects: LCSH: Brainard, Joe, 1942–1994—Correspondence. | Authors, American—
20th century—Correspondence. | Artists—United States—Correspondence.
Classification: LCC PS3552.R275 Z48 2024 | DDC 811/.54 [B]—dc23/eng/20240626
LC record available at https://lccn.loc.gov/2024020693

Printed in the United States of America

Cover design: Noah Arlow
Cover image: © Gerard Malanga

CONTENTS

ACKNOWLEDGMENTS

L ove, Joe: The Selected Letters of Joe Brainard would not exist without Brainard's friends, correspondents, and admirers who contributed their letters, advice, insights, and own voices to this book. The help I have received since 2020 from the poet Ron Padgett, Brainard's literary executor, was immeasurable. Padgett was Brainard's friend from the days when they were both students at Central High School in Tulsa, Oklahoma. I turned to Ron for information about Brainard, including the apartments Brainard lived in, the people he knew and loved, the galleries he showed in, and much more. I was in the privileged position of being able to email Ron, at times on a daily basis, with questions like, "Who's this 'Susan'?" or "When do you think Joe wrote this letter to Fairfield Porter?" Ron's patience with my inquiries and his affection for and belief in the project were crucial as I set out to shape Love, Joe.

A great pleasure in editing Love, Joe was getting to meet several of Brainard's friends in their homes to gather letters, reminisce, and gossip. Such activity is a different game entirely from the always satisfying but much more private process of research in library archives. I will never forget, for example, visiting the literary agent and former Paris Review editor Maxine Groffsky in her Greenwich Village apartment. Walking into her home filled with original works by Brainard, Larry Rivers, and other figures from that era was, well, breathtaking. Visiting Brainard's beloved Keith McDermott in his East Village apartment—similarly covered in artwork by Brainard and others—and seeing Keith pulling out a beautiful old, beat-up brown valise filled with Brainard's letters was also wonderful. I am forever grateful to them both.

I also extend thanks to Sandy Berrigan, Joan Brix Banks, Brad Gooch, Nathan Kernan, Michael Lally, and E. G. Schempf, all of whom, like Groffsky

and McDermott, shared letters from Brainard that are in their private archives. Thank you, too, to Vincent Katz for sending me letters Brainard sent to him and his mom and dad, Alex and Ada Katz, and for connecting me to the lovely staff at Colby College who maintain Alex's archive. To dear friend Lewis Warsh, who, from his home in COVID-era Manhattan just months before he died, mailed me scores of letters Brainard had sent him over the years—thank you.

Nick Sturm's grace and generosity in answering my questions about the histories of the writers and artists in Brainard's life; his sharing letters with me, including the ones Brainard sent to Ted Berrigan; his scans of Brainard's magazine covers and of hard-to-find pages from fugitive mimeograph and offset magazines were invaluable. Many thanks, too, to Michael Davis, who emailed me transcriptions he made of dozens of letters Brainard sent to James Schuyler, allowing me to include them here as I saw fit. A number of those transcriptions made it into *Love, Joe*, and Michael's annotations of those letters informed my own.

I am grateful to librarians and staff at the following special collections archives who enabled me to access well over a thousand of Brainard's letters: Matthew Gray and Patrick Seymour at the Andy Warhol Museum Archives; Sierra Hyte, Jacqueline Terrassa, and Levi Prombaum at Colby College Museum of Art; Melissa Watterworth Batt, Jonathan Trinque, and staff at the Archives and Special Collections, University of Connecticut Library; Danielle Nista and the team at Fales Library and Special Collections, New York University; Mary Haegert at Houghton Library, Harvard University; Bonnie Whitehouse, Anthony Huberman, Elizabeth Dee, and Julia Curl of the Giorno Poetry Systems and the Giorno Poetry Systems Archive; Lynda Claasen, Jennifer Donovan, Heather Smedberg, and Nina Mamikunian at the Special Collections & Archives, University of California, San Diego; Juli Cloon at the Special Collections Research Center, University of Michigan Library; and Paul Civitelli at the Beinecke Library, Yale University. Staff at the Jeff Bailey Gallery, the Kasmin Gallery, the Redfern Gallery, and the Tibor de Nagy Gallery were also extremely helpful in answering my queries and pointing me in the right direction when it came to questions about artists in Brainard's circle.

I have received a great deal of material help and benefited from many conversations about Brainard over the four years I've worked on *Love, Joe*. Thanks are owed to Tim Atkins, David Berrigan, James Birmingham, Olivier Brossard, Cody Carvel, Gavin Butt, Natalia Cecire, Miles Champion, C. Ondine Chavoya, Rebecca Chung, Angelica Clark, Steve Clay, Beverley Corbett, Rona Cran, Jake Dalton, Michael Davidson, Jordan Davis, Donna Dennis, Joel Duncan, Andrew Epstein, Thomas Evans, Andy Fitch, Mark Griffin, Duncan Hannah, Griffin Hansbury, Mark Simon Haydn, Diarmuid Hester, David Hobbs, Justin

Jamail, Daniel Katz, David Kermani, Sam Ladkin, Abigail Lang, Jeffrey Lependorf, Chip Livingston, Jenny Lund, Pejk Malinovski, Ken Mikolowski, Daniel Moynihan, Elinor Nauen, Alice Notley, Val Raworth, Alice Robinson, Karin Roffman, Yasmine Shamma, Stephen Shapiro, Jonathan Skinner, Tony Towle, Anne Waldman, Rachel Guynn Wilson, John Yau, and Sylvie Zannier. My apologies to anyone whose name I have inadvertently omitted.

I want to thank peer reviewers Brian Glavey and Ellen Levy—their encyclopedic knowledge of the subject, their meticulous attention to detail, and excellent suggestions for redrafting were unerring and much appreciated. Similarly, the help and advice from my editor at Columbia University Press, Philip Leventhal, are deeply valued.

Additional thanks to the English Department at Uppsala University, Sweden, for its financial support of an extended research trip to the United States that allowed me to access many of the letters included here.

I presented talks on editing *Love, Joe* and benefited greatly from feedback received at the Network for New York School Studies Inaugural Conference, Université Gustave Eiffel, Paris; the Department of American Studies, Konstanz University, Germany; the Department of Culture and Communication, Linköpings Universitet, Sweden; Radboud Institute for Culture and History, the Netherlands; the Department of Literature, Stockholm University, Sweden; and the Department of Literature, History of Ideas, and Religion, University of Gothenburg, Sweden. Thanks to Rona Cran, Yasmine Shamma, Joel Duncan, Timo Müller, Anna Watz, Michael Boyden, and Magnus Ullén for your invitations and making these events possible.

LOVE, JOE

INTRODUCTION

"One thing that I've always wanted to do with somebody (which doesn't involve art)," Joe Brainard wrote to the poet Anne Waldman, "is to plan a correspondence over a certain period of time knowing that it would be a book."[1] Brainard contacted other literary friends, including Joanne Kyger, Donald Allen, and James Schuyler, about the possibility of turning their correspondence into a book, but these projects were never realized. *Love, Joe: The Selected Letters of Joe Brainard* will go some way toward fulfilling Brainard's wish. Stretching from 1959 to 1993, the letters in *Love, Joe* provide intimate details about his creative process; the pleasures, passions, and agonies of his personal life; and reflections on his friends' lives and works. He writes to poets such as John Ashbery, Alice Notley, Ron Padgett, and Bernadette Mayer; artists including Alex Katz, Andy Warhol, Jane Freilicher, and Fairfield Porter; patrons; high-school friends; and fans. The letters reveal Brainard as an important writer and artist during a time when New York City was the place where literary and visual arts intersected with terrific parties, gallery openings, uptown soirees, Happenings, proto-punk and psychedelic rock concerts, and experimental music and dance performances.

Brainard's letters, full of unusual and sensitive insights into the processes of creating avant-garde art, also feature literary and art world gossip that offer street- and bedroom-level views of New York City's interlinked cultural scenes. *Love, Joe* fits well alongside Patti Smith's *Just Kids*; James Schuyler's *Just the Thing: Selected Letters of James Schuyler*; Richard Hell's *I Dreamed I Was a Very Clean Tramp*; Bill Berkson and Bernadette Mayer's *What's Your Idea of a Good Time? Interviews & Letters, 1977–1985*; and Andy Warhol's *The Andy Warhol Diaries* as an invaluable account of the richness of New York City's artistic life.[2]

Distinct from the memoir, diary, and letter projects just mentioned, however, is something only Joe Brainard could provide: a winsome and humble sensibility so at odds with the cliché of the artist-as-ego as to be in an aesthetic category of its own. "I do like those letters of yours—not like anyone else's as you are aware!" the poet and editor Rudy Kikel wrote to Brainard, and it's not hard to understand his enthusiasm.[3] Brainard's sentences do not show the debonair camp cosmopolitanism that we find in the letters of his poet friends Schuyler, Ashbery, and Frank O'Hara. Brainard, as W. C. Bamberger points out, "demands a suspension of 'sophistication.' "[4] Instead of reference-rich Francophile verbal fireworks, what we get is a tour de force of Brainard's mind moving from topic to topic with little care paid to logical transitions. Ellipses, exclamation marks, parentheses, double parentheses, colons, and single, double, triple, and quadruple underscores serve to pace and embody Brainard's exuberance, afterthoughts, hemming and hawing, asides, and clarifications.[5] As Keith McDermott, an actor and writer with whom Brainard had one of his most important relationships, explains, Brainard wrote his letters "in clear grammar-school caps generously spaced across lined paper and peppered with underlinings, exclamation marks, *SIGH*!s and *GULP!*s. . . . Joe misspelled words, drew hearts or rays around the word *you* and shaky letters to indicate turning into jelly."[6]

Even without our having the benefit of reading Brainard's original handwriting, the liveliness of his script shines through thanks to his iconoclastic punctuation, syntax, and grammar.[7] Take, for example, the following from a 1979 letter to McDermott: "And/but what a funny bunny you are to take my kidding serious! (Of course I was kidding!) I assure you, you can't get too sexual for me: and raunchier the better. (Slurp!) That—(you)—turns me on enormously! So please don't let me intimidate you. But, rather, give me more! More! More!" These kinds of graphic gestures, combined with Brainard's goofy sweetness, are utterly charming.

On seeing those "hearts" and "rays" alongside shakily drawn individual words that McDermott describes, I am reminded of Marjorie Perloff's description of Brainard's experimental memoir, *I Remember*: "The technique of *I Remember* is, of course, to use repetition—the anaphoric opening of each strophe, the repetitive syntax and rhythm, the generally flat tone—to equalize highly unlike items: the metonymic or collage principle."[8] As Brainard's writing draws on collagist principles, so his collages draw on literary principles. In a 1961 letter written to his then patron, Sue Schempf, describing his experiments with collage, Brainard explains, "They are not exactly 'pleasant' but eye-catching, honest, & stimulating. I've created them to be observed, but also to be read like a book."[9] One can "read" collages for their latent narrative, and one can "look" at the letters as an

extension of Brainard's wide-ranging interdisciplinary project. Brainard wrote letters to share the news of the day, to show his readers sketches of artworks he was working on, to generate emotion through word and image and word as image. His letters, despite what he wrote to Waldman, *do* "involve art."

<p style="text-align:center">✳ ✳ ✳</p>

Joe Brainard was born in Salem, Arkansas, in 1942 and grew up in Tulsa, Oklahoma. As a high school student, he served as art editor for *The White Dove Review*, a poetry journal his friends Ron Padgett and Dick Gallup started in 1958. The magazine published work by Allen Ginsberg, Jack Kerouac, Paul Blackburn, Robert Creeley, and LeRoi Jones (Amiri Baraka), among other writers affiliated with Donald Allen's groundbreaking 1960 anthology, *The New American Poetry*.[10] Members of the editorial board also became close friends with the poet Ted Berrigan, who was studying for a master's degree in English literature at the University of Tulsa.

Following a brief stint at the Dayton Art Institute, Brainard moved to New York City in late 1960. Padgett was already in the city studying at Columbia University, and Berrigan and other Tulsa-based writers and artists joined them. Soon after arriving in New York, Brainard became a central figure in the city's vibrant cultural scenes as both a visual artist working in a range of media and the author of poems, journals, prose, and single-sentence "mini-essays." Much of Brainard's work beginning in this period reflected his sexuality, placing him in the advance guard of the gay liberation movement of the later 1960s and '70s.

Brainard wrote numerous letters to poets affiliated with the New York School, who proved to be an immediately sympathetic audience for his work. The New York School of poetry emerged in the mid-twentieth century, centered on John Ashbery, Barbara Guest, James Schuyler, Frank O'Hara, and Kenneth Koch. These poets were influenced by and connected through friendship with first- and second-generation New York School painters such as Willem de Kooning, Jackson Pollock, Larry Rivers, Red Grooms, Jane Freilicher, Grace Hartigan, and Alex Katz, many of whom in the 1950s and '60s showed their work at the Tibor de Nagy Gallery on East Fifty-Third Street and, later, on East Fifty-Seventh Street in Manhattan. The gallery's curator, John Bernard Myers, bestowed the moniker "New York School" on the poets in an overt effort to link the writers to the painters he was central in promoting.

Beginning in the early 1950s, Myers started publishing the poets in chapbooks, such as O'Hara's *A City Winter* (1951, which included drawings by Larry Rivers), Ashbery's *Turandot: And Other Poems*, (1953, with four drawings by Jane

Freilicher), Nell Blaine's and Koch's *Prints Nell Blaine / Poems Kenneth Koch* (1953), Guest's *The Location of Things* (1960, with a collage frontispiece by Robert Goodnough),[11] and the "poets' newsletter" *Semi-Colon* (1953–1956). Such publications were part of a larger small-press revolution that inspired younger poets like Ted Berrigan to publish their own art-poetry hybrids, including *C: A Journal of Poetry* and *C Comics*.

O'Hara (who worked as a curator at the Museum of Modern Art and possibly had an affair with Brainard around 1963) and the artists and writers who constellated around him were particularly important figures for Brainard. O'Hara and his peers often contributed reviews of the artists' works for journals such as *Art News* and *Kulchur* and produced visual-verbal collaborations throughout the 1950s and '60s, including O'Hara and Norman Bluhm's twenty-six *Poem-Paintings* (1960), Schuyler and Hartigan's *Salute* (1960), and Ashbery and Alex Katz's *Fragment* (1966).[12]

So faithfully did Brainard, Berrigan, Padgett, and their friends model their work on Myers's projects and their older New York School predecessors more generally that they ended up becoming known by critics and readers as "second generation New York School poets" (though Ashbery is reported to have referred to them jokingly as the "*soi disant* Tulsa School").

The artists and writers Myers promoted set the stage for a cultural environment in which poets and painters worked together, served as each other's audiences, and provided strong examples for Brainard's navigation through New York's art and literary scenes in the 1960s. A more personal influence for Brainard in terms of bridging the gap between visual art and poetry was the librettist, editor, performance artist, and writer Kenward Elmslie, an heir to the Pulitzer fortune whom Brainard first met in 1963. Elmslie remained a partner until Brainard's death in 1994.[13] Despite the often mercurial nature of their relationship, the two were a kind of mini–New York School of their own, producing countless visual-verbal collaborations and hosting a parade of writers, musicians, and artists in Elmslie's rural idyll in Calais, Vermont, and his homes in Greenwich Village. Brainard served as a kind of house artist for these first- and second-generation New York School figures, producing book covers for, among others, Koch, Alice Notley, Bill Berkson, Berrigan, and Bernadette Mayer and collaborating on cartoons, collages, and illustrated books such as *The Vermont Notebook* (with Ashbery) and *Bean Spasms* (with Berrigan and Padgett).

Much of the poets' work resonated with Brainard's own writing and visual art, one characterized by charm, whimsy, and niceness in clear opposition both to the heroic stance of abstract expressionism and the clinical cool associated with much Pop art.[14] "Like the poets he likes," John Perreault wrote, "Brainard

does what he does because he enjoys doing it."[15] The poets shared Brainard's complicated relationship to seriousness—the letters included in *Love, Joe* are great examples of Brainard's discomfort when dedication to one's work veers into public pompousness.[16] Note the following excerpt from a 1969 letter to Berkson in which Brainard responds to Berkson's earlier praise of the painter Barnett Newman:

> I felt a little stab in my heart when you said you liked the Newman. I admit he is good, but he is everything I don't believe in. I wish I could explain how much I hate him but I can't. It is not his work itself I detest, it is everything that he stands for. If I ever turn into a real painter I will be a total reaction from him. In the totally opposite direction. I cannot read a word he writes anymore as it makes me so mad. Art is <u>not</u> God. Art is <u>not</u> that serious. And art is <u>not</u> that boring. And snotty. And stupid, etc. (See what I mean?) I don't really think it is fair to judge a painter by what he says but____but really! He is to me a total pain in the ass. I am sorry I cannot explain exactly why. All I know is that, to me, if art has an enemy, it is Barnett Newman. He is like death.[17]

Atypically harsh, but funny, too. It is not difficult to imagine why Brainard judged Newman so severely. Newman was renowned for making pronouncements some might consider haughty. Newman's definition of "the present painter," one he distinguished negatively from the surrealist project ("a mundane expression . . . still concerned with the human world: it never becomes transcendental"), is a case in point: "Herein lies the difference between [the present painter] and the surrealists. At the same time, in his desire, in his will to set down the ordered truth that is the expression of his attitude toward the mystery of life and death, it can be said that the artist like a true creator is delving into chaos. It is precisely this that makes him an artist, for the Creator in creating the world began with the same material—for the artist tried to wrest truth from the void."[18]

Insisting on a model of the artist as visionary was anathema to Brainard and most of his poet friends, who continued to find value not only in surrealist art and literature but also in cartoons, Tareyton cigarettes, Pepsis, and rock 'n' roll. Brainard and his friends rejected academic or otherwise inflated, self-valorizing language. As Brainard's close friend the poet Lewis Warsh recalled, reminiscing about his own attitude in the sixties toward writing critical reviews, "I wrote a few reviews for *Poetry* Magazine, but to what purpose? I could only reiterate the ongoing decades-long argument between academic and experimental writing and try to draw attention to the work of my friends (though I didn't have much say about what books I could review). Writing poetry criticism during the

late sixties was to associate oneself with an academic world, and a tone of voice, which was considered inimical to the life of poetry itself."[19] Extending his antianalytical position, Warsh responded to a characterization of his work as "impenetrable" with the following conversation stopper: "I like impenetrability. Past a certain point, this book simply exists. What more can you say about it?"[20]

Brainard echoed Warsh's attitude throughout his own visual and literary work. "You know," he wrote, "there is not much you can do with a painting but see it."[21] That is art criticism Brainard style, a radical departure from the pronouncements typical of Newman. Perhaps it is not such a surprise, then, to discover that what little art criticism Brainard produced appeared not in art magazines but, rather, in his diaries, letters, poems, and other generically hard-to-define texts, such as "Andy Warhol: Andy Do It," a short prose piece written in the early 1960s whose second paragraph repeats the phrase "I like Andy Warhol" fourteen times and ends with "And that is why I like Andy Warhol."[22] Brainard's suspension of sophistication in pieces like "Andy Warhol" characterizes the letters in *Love, Joe*, though his was not a suspension of intelligence, wisdom, and insight. As Andrew Epstein and Andy Fitch point out, Brainard's "Andy Warhol" is "fascinating, prescient" and "seems to understand things about Warhol's aesthetic of *liking*, and his obsession with repetition, way ahead of the art historians and critics."[23]

Brainard's inclusion of the (until now unpublished) text "Art" in a 1969 letter to Bill Berkson goes further in manifesting what Fitch describes as "his Fluxus-like resistance to institutionalized discourses of cultural authority and canonization":[24]

I want to talk about Art. Or about anything else that comes into my head. Mainly I just want to talk (write) but I need something to start off with. Art is a good starter.

Actually, I don't think about art much anymore. I don't believe in it much anymore. I believe more in what I like and what I don't like. And I don't believe that this, what I like and don't like, has anything to do with art.

I <u>do</u> wish that art wouldn't take itself so seriously. It drives me up the wall.

Art, actually, isn't what I want to talk about. When I say "Art" I mean painting. What I would like to talk about is me.

Deceptively simple, "Art" reveals Brainard's commitment to what his friend Frank O'Hara called "Personism." In his mock manifesto of the same name, O'Hara writes, "I don't believe in god, so I don't have to make elaborately sounded structures. I hate Vachel Lindsay, always have; I don't even like rhythm, assonance, all that stuff. You just go on your nerve." O'Hara adds, "Personism . . .

was founded by me after lunch with LeRoi Jones on August 27, 1959, a day in which I was in love with someone (not Roi, by the way, a blond). I went back to work and wrote a poem for this person. While I was writing it I was realizing that if I wanted to I could use the telephone instead of writing the poem, and so Personism was born."[25]

O'Hara proposes the poem amusingly as a conduit for personal connection and communication, achieved in large part through an aggressive (if fun) demystification of the very genre "poetry" as synonymous with high culture. In the same spirit, Brainard begins "Art" by saying he wants to talk about Art only to let his desire to talk about himself take precedence over making profound pronouncements about Art, capital A. Interestingly, there is not much of a distinction between the style of Brainard's writing in a text like "Art" and in the very letter to Berkson into which he folded "Art." Perhaps the message here is that talk, which itself can somehow be writing, too, *should* be understood as Art, part of a wide-ranging process-oriented project in which the lines dividing letter from criticism from phone call from painting from sketch from cartoon from art from life are merrily redrawn.

<p style="text-align:center">✳ ✳ ✳</p>

Given Brainard's reticence when it came to writing "serious" art criticism, what might his letters tell us about his own artistic practice? Many of his missives describe, riff off, or anticipate some of his better-known works. Consider his outrageous "If Nancy was" series of images, produced from 1963 through 1978 and based on Ernie Bushmiller's nationally syndicated *Nancy* comic strip series. John Yau and Ann Lauterbach describe Brainard's Nancy drawings as "so perfect in their balance of humor and precision that categorizing them as major or minor art seems beside the point. 'Nancy' is a derogatory slang for a gay man, which, as Lauterbach astutely points out . . . became the source of 'repeated visual/verbal puns [that] were not motivated by shame, but by its reverse, candor.' Brainard also declared that his favorite flower was the 'pansy,' and made numerous works in which they appear."[26]

When Nancy shows up in Brainard's correspondence, she becomes even more a sign of his growing acceptance and embrace of his sexuality. In a 1965 letter that Brainard wrote to his friends Ron and Pat Padgett in Paris, he included a series of Nancy sketches with titles such as "This is what I would look if I were Nancy" and "This is how Nancy would look if she had a dick."

It's a sly and gentle queer conversation that Brainard is staging with his heterosexual friends. I'm a girl . . . I'm a Nancy . . . look at my dick . . . Nancy's me.

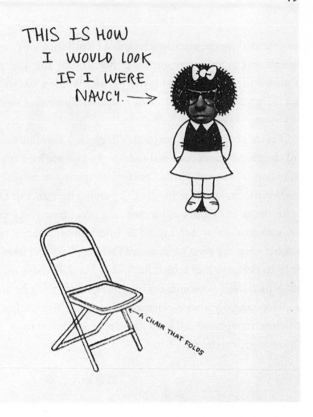

FIGURE 0.1 Image included in the letter of October 21, 1965, Brainard to Ron and Pat Padgett.

FIGURE 0.2 Image included in the letter of October 21, 1965, Brainard to Ron and Pat Padgett.

Making this even more fun are the details in the letter itself, like these following excerpts:

Dear Pat & Ron

Last night I went to the Russian Tea Room after a "Miss Julie" rehearsal and there sitting at a table was Tony Perkins with a producer friend of Kenward's. So—we said hello (and I really did shake hands with him), sat down, and had drinks. Tony was eating a vanilla ice cream sundae with blueberry sauce. When it had melted he said it looked like a Paul Jenkins. At any rate, he was nice, tho a bit dumb. I got his autograph, and he said he was going by the Alan Gallery to see my work . . .
 . . . Tonight will be my usual "night-out-alone." I go to Times Square and I have a Bloody Mary and ham and sweets at "Toffenetti's" and then I go to the movies. I do this at least once a week these days. There is something very comforting in doing the same thing over and over. It must be a bit like being married. I mean, the security of it all.[27]

What a delightful cultural moment when Brainard has a chance meeting at the Russian Tea Room with Tony Perkins, the actor best known for playing Norman Bates in Hitchcock's 1960 film *Psycho*! Perkins's homosexuality was a well-known "secret" among the cultural set in New York City, and the fact that he was headed over to Brainard's show at the Alan Gallery makes the detail especially delicious—people belonging to a gay Manhattan coterie bumping into each other, seeing each other's art and movies with little in the way of distinctions being made between Hollywood stars and hip new painters.

Brainard's letters also detail his efforts to move away from his assemblages and collages to start working more seriously on representational oil painting. This was a move inspired in part by his friendship with the figurative painter Fairfield Porter. Regarding a painting of Whippoorwill, the dog belonging to his long-term companion and lover, Kenward Elmslie, Brainard wrote to Porter,

Your letter spurred me into a spell of trying to do some larger paintings: actually, two, both of Whippoorwill on a putrid green velvet sofa downstairs, the putrid green of the sofa (so much of!) being one of my biggest problems. However, thanks to what light does to old velvet, one of them is O.K. Rather, thanks to exaggerating that a bit. But, aside from any real basic desire to paint big, my biggest problem probably concerns my preoccupation with an "even" surface, which becomes quite a chore on a large scale. Which probably has something

to do with what you were talking about as to oils being basically a bit "dirty" to Americans. But, actually, I don't mind being rough, or even sloppy, so long as I am totally, and evenly, so.[28]

His perceived failure to be consistently "even"—and how could someone who ranged across so many genres ever aspire to such a thing?—is very telling about Brainard's increasing self-doubt during this period. For all his resistance to seriousness, Brainard still clung to relatively old-fashioned values of craftsmanship as a marker of real value. As Padgett explains, Brainard's insecurity over his perceived lack of skill in oils probably played a big part in his decision in 1976 to stop showing new work in commercial galleries.[29] By 1979, Brainard had decided he simply couldn't work in oils anymore because he felt he wasn't good enough, even though the representational painting he did produce proves otherwise. For the remainder of his life, Brainard continued to work quietly and privately, though for all intents and purposes, he had retired from the art world.

* * *

It took me a while to figure out how to organize this book, as, with a few exceptions, Brainard never dated his letters. Making matters more difficult was the fact that many postmarked envelopes were missing from the archives and private collections where I gathered this selection. When I couldn't access postmarked envelopes, I did my best, using internal evidence, to provide readers with an accurate time stamp. This meant I could have presented the letters in a somewhat reliable chronological order, which would describe the contour of Brainard's life along the years and serve as a kind of epistolary biography. However, existing memoirs and biographical material such as Padgett's *Joe*, John Yau's chapters on Brainard's life and work in *Joe Brainard: The Art of the Personal*,[30] and a number of essays by Brainard's friends included in Yasmine Shamma's collection, *Joe Brainard's Art*, preempted the need for such a project. I was also concerned that arranging the letters in a strictly chronological fashion would mean that readers would lose out on gaining insights into the specifics of Brainard's friendships. For example, the way Brainard addressed Robert Butts (a fan of Brainard's who bought many of his artworks, manuscripts, and letters and donated them to the Special Collections & Archives, University of California, San Diego) was very different from the way he addressed, say, the writer and biographer Brad Gooch. Committed to highlighting the nuances in, uniqueness of, and distinctions

between Brainard's individual relationships, I arranged *Love, Joe* according to correspondent.

That said, there is a chronological feel to the book. I begin with the early letters Brainard wrote to high school friends Dick Gallup and Joan Brix; his patron, Sue Schempf; and his friends Pat Padgett and Ted Berrigan. This arrangement enables readers to track Brainard as he moves from Tulsa to art school in Dayton, Ohio, to New York City, to Boston, and then back to New York City and Calais, Vermont, where Brainard spent every summer with Elmslie. Following this quintet of correspondents, the letters in *Love, Joe* are arranged roughly according to the time the individual correspondence began. Brainard's letters to Sandy Berrigan, for example, stretch from the mid-1960s to 1983. These are followed by letters to Schuyler that also begin in the mid-1960s but end in 1971, and, after Schuyler, Brainard's letters to Elsmlie, which begin in the mid-1960s and end in the mid-1980s. This back-and-forth structure is maintained throughout *Love, Joe* to enable a medley of themes (i.e., Brainard's issues with oil painting, his sexuality, his work on *I Remember*), places (Boston, Calais, Bolinas, New York), and events (the deaths of his friends, his moves from one studio to the next) to echo across *Love, Joe*.

Combined with annotations throughout and brief notes preceding each section that provide basic facts about Brainard's connection to each addressee, *Love, Joe* stays true to the particularities of Brainard's relationships while also showing his development as an artist and writer across the years. The only time I veer away from this organization is at the end, where I include a selection of letters Brainard wrote to Berkson beginning in 1967 and ending in 1993. Given the expanse of time covered in Brainard's letters to Berkson and the way so many of the themes and events in the book reverberate in them, "Dear Bill" serves as a fitting finale to *Love, Joe*.

Brainard was a poor speller, and he knew it. For me to reproduce every spelling error faithfully, followed by "[*sic*]," would be annoying for readers. On the other hand, quite a few of his spelling errors have a charm that provides a fuller picture of Brainard. At times he makes a spelling error, recognizes it, and tries to correct it, often with another spelling error. For example, in a 1969 letter to Schuyler, Brainard writes, "But the clumbsy in me comes out. (I believe it is 'clumesy' Oh, well.")[31] In a 1970 letter to Larry Fagin, Brainard describes a series of green grass cutouts that are in "3 to 4 layers each (each picture) which will soon be put into plastic boxes so as to be 3-diminional [*sic*]. Now I know there is an 'e' in 'diminional' somewhere. Between the 'm' & the 'n' no doubt."[32] Moments like these show Brainard thinking as he writes, poking gentle fun

at himself, offering readers a moment where they can imagine him sounding out the words in real life. Similarly, Brainard often gets idiomatic expressions wrong—a 1980 letter to McDermott finds Brainard informing his lover that "I'm in fifth heaven over finding three Iris Murdoch novels I've yet to read." I like the way "seventh heaven" has been downgraded to "fifth," and I hope readers will too.

I am including correspondence Brainard sent to thirty-one people, the majority of whom all knew one another very well and were part of the "scene" Brainard was central to. This means that many of the names are repeated throughout. I have, with few exceptions, noted people's last names in brackets the first time they appear within each addressee's section so the reader can be aware of who that person is the next time his or her name is repeated in the same section. So, for example, in the first letter in the "Dear Kenward" section, where Brainard writes, "(Nor did you or Joe, of course)," he was referring to Joe LeSueur, so I include LeSueur's name in brackets in this first instance but not in subsequent references to LeSueur in the "Dear Kenward" section. I follow this pattern throughout the book, except for Ron and Pat Padgett and Kenward Elmslie, whose names are repeated so often that I expect readers will have no trouble recalling who they are based on their first names alone. At the end of the book, readers will find a glossary featuring thumbnail biographies of all the friends and acquaintances Brainard addresses or mentions in the letters.

Prefacing a number of sections, I have included a reproduction of a page from or image included in Brainard's letters to allow readers to get a sense of what it must have been like to receive a letter from Joe. While it isn't feasible to reproduce all the little sketches Brainard included in his letters, I do my best to describe most of what the reader is missing. If, for example, Brainard signed off a letter with a drawing of a heart (which he often did), I have simply written "[red ink drawing of a heart]" within brackets.

<p style="text-align:center">* * *</p>

Brainard tested HIV positive in 1989 (or perhaps earlier) and died of AIDS-induced pneumonia on May 25, 1994. One of the most upsetting aspects of the letters Brainard wrote during this period is how they reveal that he basically kept his diagnosis to himself. Up to almost the very end of his life, the only inkling most of his friends had that Brainard was ill were very brief, casual references to thrush, rashes on his neck, obdurate exhaustion, and the like. By late 1993, however, it seems that most of the people close to Brainard were aware of his illness. Alice Notley's letter to Brainard is particularly touching:

Dear Joe,

I received a letter from Anne [Waldman] yesterday telling "your news." Of
course I'm still digesting it and not doing so much else. . . . I'm very sorry
I can't see you or be of some service. Anne says you're in bed attached to
things. Perhaps you're not answering letters. I hardly know what to say. It's
cold here, but sunny. What we're supposed to do today is have lunch with
Allen Ginsberg and possibly Kenneth Koch. The students are demonstrat-
ing, everyone's driving and walking and smoking as usual, all bundled up.
 Everyone loves you. I love you.
 I was very affected by our lunch together last June. Your presence
lingered with me a long time; because you really had become so good. I sup-
pose you always were but it was something I hadn't known myself how to
think about or talk about before. Do you remember we talked about saintli-
ness. And you seemed to be trying for that, not to be a saint, but just not to
hurt anything. You certainly haven't hurt anything. You must be a saint.[33]

Everyone loved Joe, and as *Love, Joe* shows, Joe loved them back. The phrase
"Love, Joe" that Brainard used year after year in letter after letter is such a com-
mon two-syllable drumbeat. Isn't it true that so many of us write "Love," fol-
lowed by our names, without necessarily meaning it? And yet, "Love, Joe" in the
hands of Joe Brainard seems really and truly meant.

 This is not to say that we should simply nod our heads and refer to Brainard
as a saint, even as the letters selected here make clear why Notley and others saw
him as one. Readers will find that in terms of his personal friendships, Brain-
ard clearly was lavish with his affections. He also compartmentalized his sexual
relationships, suffered from periodic depression, and had recurring issues with
amphetamine pills. And, like many white people of his generation—particularly
those who, like Brainard, grew up in racially segregated environments—Brain-
ard was no exception in terms of his inherited attitudes toward Black people,
admiring their achievements but ultimately seeing them as exotic. The letters
show Brainard and his friends trading "Negro" (the respectful term of those
times) postcards, gossiping about a mutual friend's new "colored" boyfriend, and
delighting in "a new dirty Negro figurine." Yet Brainard was repelled by overt
racism, expressed solidarity with the civil rights movement of his time, and ulti-
mately discarded his collection of Black dolls, cards, and related images.

 All that said, Brainard's abundant generosity and honesty shine throughout
Love, Joe. What emerges from these letters is a portrait of an artist who was, put
simply, a hugely complicated person whose work across literature and visual art is
testament to that complexity and to his humanity.

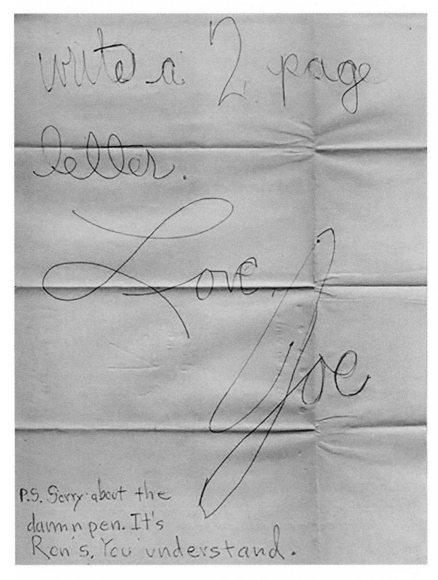

FIGURE 1.1 Page from the July 27, 1959, letter, Brainard to Dick Gallup.

1

DEAR DICK

Brainard wrote these two letters to Dick Gallup following Gallup's graduation from Tulsa Central High School, where he and Brainard first met and became friends. Gallup was on summer vacation with his family in their native Greenfield, Massachusetts. At the time, Brainard and his friend Michael Marsh served as art editors for *The White Dove Review*. These two letters are the only examples I found of Brainard's writing in script, apart from the words "NOT THAT KIND," which he capitalized in the original. All remaining letters in this book were written by Brainard entirely in all caps.[1]

July 21, 1959, Tulsa, Oklahoma

Dear Dick,

Can't find ink pen. Can't find address. Can't find stationery. Damn! Today just isn't my day. Not that it ever is.

Am babysitting now. Am going to sketch a model at the School tonight. It's a new deal. None of the artists in Tulsa can afford a model, so we all go in together ([John] Kennedy, Betty [Kennedy], Nylajo [Harvey], & others). It cost $1.00 each. Stud? I think so.

[Paul] England has moved to New York to live. Sob.

I have been doing a lot of good paintings. Can't wait for you to see them. Hurry home.

To make up for short letter am sending you 3 French post cards. (NOT THAT KIND.) Hope you like. Am hoping and praying you will get this before leaving.

Love,

Brainard

"The Starving Artist to Be"

July 27, 1959, Tulsa, Oklahoma

Dear Dick,

Am writing at Ron's house. That's my excuse for the newsprint.[2] We went uptown to see Mr. Stevens, the nice man who said would give money. He wants me to do a painting of oil well for him.[3] Money! Me need. [*sic*] Have not been painting much. Have been at cabin over weekend. Did one drawing. Mostly played around with 2 girls. Fun. Rained most of time; little swimming. Phil [Gulley] said "Hello." Said he would have written back didn't know address. Too bad. No letter. Have you heard from Mike [Marsh]. Haven't seen him in long time. Sob. Nothing to say but I'm determined to write a 2 page letter.

Love, Joe

P.S. Sorry about the damn pen. It's Ron's. You understand.

JOAN,
SO GREAT HEARING FROM YOU. FIRST I SHALL GIVE YOU
A SERMON. I HOPE TO GOD I'LL CHANGE. I HOPE
RON CHANGES, YOU CHANGE, & EVERYONE CHANGES.
JOAN, I CAN'T STAY 18 ALL MY LIFE, I'M BY NO MEANS
A PERFECT PERSON, I WANT TO GROW & LET MY PER-
SONALITY & ART IMPROVE. SO PLEASE DON'T DIE
WHEN I COME HOME CHRISTMAS, ▬ A CHANGED
& SOMEWHAT DIFFERENT PERSON. I'LL HOPE YOU'LL
LIKE ME JUST AS MUCH & EVEN BETTER. PLEASE
DON'T SLIT YOUR WRIST EITHER. GIRLS IN DAYTON
AREN'T EVEN ATTRACTIVE, MUCH LESS CULTURED.
YES YOU ARE SPOILED & SO AM I. I LIKE A
GIRL WITH A LITTLE BIT OF INDIVIDUAL CHARAC-
TER; ALL GIRLS HERE LOOK ALIKE (BLA!) HAVE
GOTTEN ONE LETTER FROM PAT. SHE LIKES
SCHOOL & RON I'M SURE. BUT SHE'S IN LOVE
(I GUESS) WITH SOME T.U. STUDENT, LIVING
IN TULSA. I LIKE CRY-BABIES! BE
CAREFUL OF ICEY LOOKING TENNIS
BALLS. I WANT YOU TO BE

Shepherd Piping
Woodcut by Aristide Maillol
for "Daphnis et Chloë," Paris, 1936
Department of Graphic Arts, Harvard College Library

FIGURE 2.1 October 26, 1960, postcard, Brainard to Joan Brix, courtesy of Joan Brix Banks.

2

DEAR JOAN

Joan Brix was a close high school friend of Brainard's. He wrote the first three letters to Brix from Ohio, where he was attending the Dayton Art Institute. The remainder were written when Brainard dropped out of art school to pursue an independent artist's life in New York City. His premonition that he was "A Starving Artist to Be," as he put it in a letter to Dick Gallup, was now a reality. Exuberance and joy shine through nevertheless.[1]

September 22, 1960, 221 West Riverview, Dayton, Ohio

Am in a small café drinking coffee. It's about 2:30 P.M. I can't sleep; I've tried, but I just can't sleep. All I seem to want to do is eat. Have been painting all night. Tonight's a great night for me. Have just started a large self-portrait and have done 6 drawings. Can't explain them to you, but will say this, I know they're the best I've ever done. They mean more to me than anything I've ever painted. The six drawings are all of me. They're nude sketches of me lying in bed. (This may not sound very exciting). I did them laying down, looking at myself. The perspective is very funny. I like them because they make my penis look enormous. Am glad I have at last found some subject which excites me enough that I can project it successfully. Wish I could express myself better verbally.

Love, Joe

September 20, 1960, 221 West Riverview, Dayton, Ohio

Joan,

Today was my 4th day of school, still haven't met anyone worth meeting. Everyone's so blah; very unserious about art or anything. Don't like my classes either; on a high-school level. However, I do like you, me, art & orange juice. Paintings are coming along greatly. Reading letters & books, and painting, is all I have to do. But am not at all board. ←(Sorry). Am enjoying & gaining much from it all. Love to get letters from Joan.
Love, Joe

October 21, 1960, 221 West Riverview, Dayton, Ohio

Joan,

So great hearing from you. First I shall give you a sermon. I hope to God I'll change. I hope Ron changes, you change, & everyone changes. Joan, I can't stay 18 all my life. I'm by no means a perfect person, I want to grow & let my personality & art improve so please don't die when I come home Christmas a changed & somewhat different person. I'll hope you'll like me just as much & even better. Please don't slit your wrist either. Girls in Dayton aren't even attractive, much less cultured. Yes you are spoiled & so am I. I like a girl with a little bit of individual character; all girls here look alike (blah!). Have gotten one letter from Pat [Brown]. She likes school & Ron I'm sure. But she's in love (I guess) with some T.U. student living in Tulsa.[2] I like cry-babies! Be careful of icy-looking tennis balls. I want you to be changed mentally, but not deformed physically. I had a jelly sandwich for lunch. I'll love you to death (almost) if you'll bake me something. I haven't had a decent, home-cooked, great, sweet thing to eat since I've been here. Am selling my books & records to pay rent. I love Joan & brownies or something. Let me hear from you soon like,
Love, Joe

February 6, 1961, 210 East 6th Street, New York City

Joan, too many things to tell you. I've got a job doing lettering for T.V. commercials (3 days a week) ($2 an hour). I live in a small 2 room store just east of the Village (no tub, shower, or hot water, but 1000s of bugs). It's a good

place anyway (210 E. 6th). I've enrolled in a life drawing class Wed. & Fri.
evenings / new model every week / very good. Am painting more realisti-
cally. See no other direction for me or my generation. Am seeing everything.
And am lowered by the sadness & greatness of such a big city. Am going to
Mexico during March & April I hope; will quit my job & rent my place out
for 2 months.[3] I'm happy. You have my address.
Love, Joe

August 12, 1961, 93 1st Avenue, New York City

Dear Fairy God Mothers,[4]

We love food. We love you. I guess Anne [Kepler's] told you, I've moved.[5]
Have a much better place, more room and a bathtub. Also 5 flights of stairs
to climb. I'm working a little (but making no money). Am helping an old
lady [Mrs. Sola] out; watching her shop a couple evenings a week. I just sit
& read. It's sort of a junk-antiques type place. In return I get merchandise.
Have gotten unbelievable things; tapestries, ancient Chinese brass vase,
frames, old shaving mugs, early American cookware, etc. It's kinda fun; I
don't sell much. Not much of a salesman I guess; no one can understand me
(I mean speech-wise).[6] It really is great to have good food. Ted [Berrigan's]
in Providence visiting his mother. Gave Dick [Gallup] lots of food, hope he
won't eat it up before Ted gets back. Anne, I've deceived you, I told them
where I got the food. Hope you don't mind. Thought they ought to know.
Had cereal for breakfast; unbelievable. (That's our new word; "UNBE-
LIEVABLE"). We're all using it every other word; terrible habit. Joan &
Leslie [Segner], you've got to move to N.Y. now. Everyone's going to be
here this fall;

Me
Ron
Dick
Ted
Pat
Anne
Bob Bartholic
Barbara Simon
Paul England
(All former Tulsans)

"UNBELIEVABLE"

Just kidding really; school is great (heh! heh!). Would like to know how both of you made out in school, & if you're returning to same places next year. (Almost here; summer has really gone fast) I keep doing new paintings & destroying old ones. Each new one (with some exceptions) seems so much better than the last (fortunately) I no longer like the old ones. My most recent (finished last night) is a large, basically realistic, self-portrait. It's the strongest & best painting I've done to date. But I am sure I'll do better soon; most of my paintings seem better right after completion than later. I guess I'm still involved too much in it. Can't stand back & look at it too critically. It's hard. Joan, let all your little group of fairies read this. It's always a lot of trouble (plus expense) to mail such a package, & want you all to know I appreciate it. Joan, tell Ron hello. Anne, tell Lauren [Owen] hello. Leslie, tell Tom (I think) hello.[7] You see, I'm still up on everything. Sorta. Am getting lots of good reading done. Thanks again.

Love, Joe

FIGURE 3.1 Image included in the May 31, 1961, letter, Brainard to Sue Schempf, courtesy of E. G. Schempf.

3

DEAR SUE

S ue Schempf was a Tulsa-based arts enthusiast, frame shop owner, and patron of Brainard's. She sent him money on a fairly regular basis, though sometimes their relationship could get a little touchy, especially when Schempf criticized Brainard's work or failed to send him much-needed cash. Written when Brainard was newly arrived in New York City (with a side trip to Mexico in early spring 1961), these letters are a revelation, as we find Brainard expressing his thoughts about artistic form, artistic integrity, the New York School of poetry, collage versus oil painting, and more.[1]

January 21, 1961, 210 East 6th Street, New York City

Dear Sue,

At last I have a place to live; a small shop in the lower east side. It's got good light, steam heat & a toilet, but no bathtub or hot water. However, it does have cold water & a sink. It's snowing. Hard. Cold. Wow! I got the place for $50 a month because it needed so much repair. So I'm busy cleaning & trying to be mechanical & do-it-yourselfish. Also am happy. Address is: 210 E. 6th, N.Y. New York
Love, Joe

February 14, 1961, 210 East 6th Street, New York City

Dear Sue,

This is a progress report (kinda), but not too much. Two nights a week I attend my life drawing class (excellent). Am approaching my drawing in a more realistic, or academic, way; studying light & shadows, etc. I want to get this foundation down so pat I can't miss (whatever I'm aiming for). Am sorta confused, per usual, about myself & my art. But I do have a new direction: realism. This came as a shock to me, for this is certainly a reverse direction from my most recent work, & what is popular today. But I think one of my main problems has been painting honestly. A more restrained style of painting seems much closer to my nature. I actually see no other direction for me, or my generation. This can't be the complete answer, but I know it's a damn good start. I'm happy & working. Am seeing everything & lowered by the greatness and sadness of such a big city.
Love, Joe

P.S. There was a mix up about my mail-box, so you may get a "returned" letter. If so, no sweat, you've got the right address & I'm still in N.Y.

March 10, 1961, 210 East 6th Street, New York City

Dear Sue,

Just a note to let you know how things are going, and believe me, they are. Time is flying.

Been going to lots of exhibitions, seeing some good shows, some bad. Saw a really good show of [John] Marin's watercolors. Am still working on figure studies, & have begun a large portrait of Ted Berrigan, young N.Y. poet. Last night I did an enormous collage on my wall, but unfortunately I can't preserve it unless I tear down the wall.

Spring is supposed to be here, but you can't tell it by going outside. It's drizzling a sorta ice-rain. I keep the oven going for heat. I'm work-ing up a deal with a gallery so I can bring some old etchings, drawings, & paintings back to Tulsa to sell.[2] But negotiations are indefinite right now.

Overall: New York keeps goading me on to do more kinds of paintings in different & better ways. I'm making progress.
Love, Joe

April 11, 1961, Mexico

Sue,

Loving Mexico; my new work; & life in general. Also, me.

July 1961, 93 1st Avenue, New York City

Dear Sue,

Things much the same only am tiring a little of collages, & anxious to start oil painting again. Unfortunately, I'm out of paint & canvas & short on brushes. This is one reason why I think perhaps I oughtn't to have a show in May as planned. I hope this will not mess up your plans too much; if so, I'll go on & have it. Money is, of course, the only problem. I just can't afford to invest any money in a show unless I'm sure of at least clearing. I'm afraid May is a bad gallery month; because of vacations and all. Also, I'd hate to have a show & not be able to do it right (have a few things framed as examples of complete-ness, invitations, etc). Hope you understand. Instead of a show I'd like to send some paintings & collages to you & Bob [Bartholic] to handle on the side; & to show to Faye & Dave Rich (patrons whom I owe about $80 to). Also, I owe you $60 in paintings. Would like other Tulsans to see my work, but just don't see how I can afford a show. If this is O.K. with you I thought I'd write short letters to some people who have collected, or show an interest in, my work and tell them that my new work can be seen at your frame shop & Bob's gallery. This would be good for business & wouldn't be as expensive for me. Wouldn't have to send back as many things as I would for a one-man show. Shipping is terribly expensive. In a couple of weeks, I ought to be able to send some small works. Then a week later a few larger ones. It seems silly to send any <u>gigantic</u> ones (4' × 6') & other sizes, all large, for Tulsans don't seem to go for large paintings & this shipping and packing is unbelievable. Hope you'll write me a word or two soon so I'll know what you think about it all. I got a letter from Nylajo [Harvey] yesterday; couldn't believe it. I didn't think she ever wrote letters. Made me feel very good. I do get lonesome here sometimes. Would like very much to come home for a visit & see everyone. There is a chance I might get a free ride to Tulsa with Ron Padgett's mother; a friend of mine from Tulsa who goes to Columbia University. Am hoping to God his mother will come & pick him up instead of flying back. Spent all day yesterday going around to galleries; saw John Nevin's show (good, but all tied up in a tight little world of his own). A really good artist shares his thoughts

& impressions more. I saw a new de Kooning show which was very fine. I think he's the greatest of the American Abstract Expressionists. The best show tho was a sculpture exhibition at the World House Gallery (a gigantic place; 2 whole floors; about 6 large rooms). Saw major & great pieces by Rodin, Max Ernst, Lipton, Arp, Calder, Hepworth, some very fine early Brancusis, Marino Marini, Picasso, Mascherini, fantastic Giacomettis, & 10 very beautiful young girls (10 separate pieces) by Manzù. I had never paid much attention to Manzù before; but I think he's great now. Also saw a one-man Dubuffet show (different from the one at the Museum of Modern Art), an Impressionist show (some very fine Renoirs), a Rouault print show, & a Chagall litho exhibition. So it was a full day & a very exciting and worthwhile day. I'm learning so much here in N.Y., it's just a great place for me. We've been having very spring-like weather & have taken many long walks in Central Park; plan to do some sketching there soon. Am seeing a free film series at the Museum of Modern Art by Roberto Rossellini; a very fine Italian director & producer who uses the medium as an art form, & not just entertainment. I think in the near future film making will become a major art. It's got many possibilities. The only thing that has held it back has been the expense of producing a film; art usually is a few steps ahead of public liking & appreciating and since the expense is so great, the film must make money. It's too bad; glad I'm a painter. Tho am not too sure the case is much different with me. A great majority of great painters have died starving. Doesn't really matter tho; the reward for painting is in the art of painting itself. I'm so happy when I'm working; no problems, peace of mind, & content. It's only when I'm not working that I wonder, worry about food & paying the rent, & am lonely. Life would be so much greater if say I had a steady $50 a month income. Would be able to pay rent, eat, & have art supplies, without digging around for money & wasting my time worrying & doing odd jobs. It's so funny when you consider that so many people just throw away so much more than that a month, yet would mean so much to me. That's the way the ball bounces tho. I'm not griping, just dreaming. Am probably happier than most people anyways. I think I told you I was using some poems by Ted Berrigan in some of my work. He's 24 years old, has a Master's degree at T.U., & a very good & truthful friend. His writing is very new, that is, of a new school here in N.Y of spontaneous thought (of which Frank O'Hara is the leader). O'Hara is now very well known & published widely, tho not completely accepted by critics. But then, critics are usually 10 years behind the times. Anyway, Ted sent some poems to O'Hara & got a more than favorable reply saying his poems were extra fine & he'd like to meet Ted, etc. Of course, that

made him feel great, & me too. I honestly think Ted is going to be a very important poet. (Moral of the story is: grab up all my collages using his poems, they may be worth a lot someday, if only for the sake of his poems). Really just kidding, that would be a terrible reason to buy one of my collages. Lots of New Yorkers buy paintings primarily on an investment basis. J. B. Thompson, who has the greatest private collection in America, never buys a painting unless he thinks it's a good investment.[3] From one viewpoint it is very false, & yet, the artist gets money to do more paintings with, & the buyer has works he can enjoy & at the same time, make money (if he has fine taste). I can't decide if it's a good or a bad thing. I do know tho, that if someone wanted to buy one of my paintings even purely from an investment stand-point, I would sell it. For as I said before, the beauty of painting for an artist is in painting, not in admiring his paintings once they are done (tho I do that sometimes too). I don't even know why I bother about thinking of such things. When I write I let my mind wander into all sorts of unimportant subjects. I don't mind, but I feel sorry for you who have to read it. I gave myself a haircut yesterday. [Figure 3.2] So went down into the subways and took 4 photos for 25 cents in one of those machines. Thought you might like to see me in short hair. Besides, I get a kick out of taking pictures of myself. I always look so different than I imagine myself. It's a funny thing. Can't think of a better way to waste money. And I do enjoy wasting & just throwing away money; wish I could do it more often. The past few days have slacked a little in my working; I'm obsessed with the idea of wanting to oil paint again & not overly interested in collages at present. I've done at least 50, & have explored this limited medium very thoroughly. Have some new great ideas for oils & experiments in color. This slack has given me a good chance to re-evaluate my work & direction. Tho it's still general, I feel strongly I'm getting someplace, & to some point of perfection & individuality. Feel as tho something really great is going to spring up soon; it's a great feeling. I feel myself acquiring a very fine sense & love of form through all my recent work & study of great paintings in museums & galleries. Am realizing the predominant role form plays in painting. And the understanding of this is of utmost importance. Many great painters, like Mondrian, Delaunay, etc., it's taken me a long time to like. Pure form is a funny thing, it takes a long time & constant contact with, to really understand. My work is becoming more pure & simplified. And tho subject matter does exist in my work, form does dominate, & a thorough sense of it needed to really appreciate it. Well, so much for my theories. I've grown to like you very much through our correspondence. Love, Joe

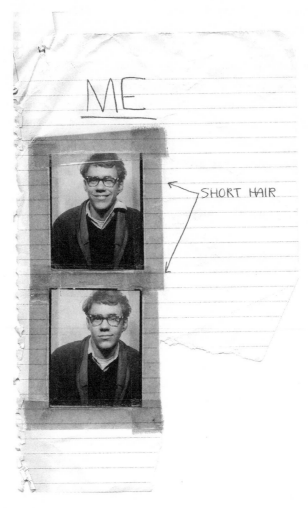

FIGURE 3.2 Photographs included in the July 1961 letter, Brainard to Sue Schempf, courtesy of E. G. Schempf.

August 21, 1961, 93 1st Avenue, New York City

Sue,

Thanks so much for the letter, & of course the money. Your new house sounds great (hope you have plenty of wall space). You're right about oil painting; in fact that's about all I've been doing lately. But oils are expensive & I was out of most of the colors when you came to my rescue. So I spent most of it on oil paints. Am definitely getting back in school. I've had several

offers to show my paintings for a scholarship; Pratt Institute etc. But have decided I must get in the best while I'm at it. Which in N.Y. seems to be the Art Students League. They don't give scholarships until you've attended at least 3 months of school (so they can really see how you work). I want to study under Robert Brackman (with a foremost reputation among American painters / has paintings in the Metropolitan, the Museum of Modern Art, & many others). Also has won hundreds of awards & grants & is supposed to be an excellent teacher. The class meets five days a week for 3 hours a day. The cost is $5 entrance fee + $38 per month (& God only knows how much supplies will cost). I figure if I can make it through the 1st 3 months, I'll stand a good chance for a scholarship. Therefore would really appreciate it if you could send my patron check for Sept. now. I have to pay my entrance & 1st month's fee immediately. Don't know quite what to say about my paintings, they're getting stronger & more realistic every day. Yet they still possess originality & character of their own; which is so often lost in realism. I'm learning to see things better & more closely; little highlights, shadows, & subtle anatomy. Also learning a lot about oils, their possibilities, etc. Am doing some very realistic drawings also; from paintings by old masters, & just things I see. Am so anxious to develop & know school will help so much. Am very excited. I have a feeling I'll be starving this winter, so will most likely send a painting similar (in style) to "White Lace"[4] for you to try & sell. Do appreciate your interest; however, more than just interest I'm sure. Thanks again. Love, Joe

September 25, 1961, 93 1st Avenue, New York City

Dear Sue,

Guess I haven't been too faithful this summer haven't really written you much & explained what I've been doing (partly because it's hard to explain). It's been an uneventful but very rewarding summer. I think I know what I'm working towards; an intellectual personal form of realism. Some new spark will have to enter art; it's now in a form of chaos, a transformation period between abstract expressionism & God only knows what. I think it's realism; but in a truer honest form encompassing the highly developed intellect. Abstract painting has deflowered art, made it true to life in a spiritual sense (deeper & rawer than it's been before; I mean free of sentiment & ornament). Realism of technique will aid in its honesty along with the large role of the intellect. The results are liable to be a little sterile; but we live in

a sterile scientific time. And a great artist <u>must</u> be a reflection of his own time. Actually I'm not so sure of myself, but I'm working in a wider scope & really beginning to understand art & not just painting a picture. Have just finished my 1st week at the Art Students League. Needless to say, it's great. I can really see myself advancing in just a week. I'm drawing more realistically than I thought myself possible of doing. Mr. Brackman is overly pleased with my work, which is encouraging. Am going to work hard & keep it up. N.Y. still fascinates me; <u>always</u> something new & great to see & do. It's so stimulating; I don't see how I could ever live in Tulsa again. It's a big evil depressing city at times too; especially in my area. I never knew people could be so lost & the world so cruel. Every day I see 2 year old kids using words I don't even use, and bloody drunken bums lying in the street half-nude. It's unbelievable. I can't walk two blocks anytime of the day without beggars (lots of 'em) grabbing your arm & pleading for 10 cents or a cigarette. Also queers & dope addicts all over the place. It really isn't so dangerous, just damn depressing. New York has so many sides. Am also still studying art history with great enthusiasm; I'm really understanding it & learning many things which are just good to know. Of course I see lots of art shows; too many to list. I feel at home here; I can really be myself. I'm happy.
Love, Joe

October or November 1961, 93 1st Avenue, New York City

Dear Sue,

New York is budding; the music and theatre season's beginning. Thousands of new art exhibitions are opening. It's cold and always raining; keeps you alert and on your toes. Recently have seen an exhibition of the last works of Matisse, the Art of Assemblage (history of collage), an American abstract expressionist show, and one on impressionism.[5] The Museum of Modern Art is showing a recent Yugoslavian film series which is fantastically fine. They show a new film every two days. So far I've seen them all; last till Nov. 4. Filmmaking is slowly working its way to the fine arts. I estimate that within five years it'll stand along with painting, music, and writing. It's a shame the finer experimental films don't come to the smaller cities. Painting wise, I'm very happy. Am working on a series of still lifes with abstract compositions but realistic objects. That is, I'm experimenting with new modern placements of the objects, but the objects themselves are realistic in approach and feel. The only obvious distortion is sometimes

in the color. Am working primarily larger and in oils. Like a kid, I save the worst till the last; I think it's time we reevaluate our patron plan. I say this because last month I didn't receive a single check, and the month before only two. My only income is the $25 I receive each month from you; my four patrons. My rent is now $30 instead of $24 because of a new heating system they installed. How I manage, I'm not sure. But I'm constantly having to sell books, clothes, and my blood. I've pawned everything pawnable, and sold everything sellable. When I do eat it's nothing to speak of. I'm usually forced to walk to school (52 blocks), to the museum, or wherever I go. However, "sob, sob" isn't in place. I'm very happy. In a way, I've chosen the way I live. I've given up certain things for my art, which is my life. Being free to paint, learn, and discover is more important to me than food and other comforts but rent is one thing I can't neglect, I have to have a place to work. This is where I must have a small steady income. I rely on your $25 for my rent. But I can't take your money if you're no longer interested in me and my art. I may live like a bum, but I'm still proud. What's in it for you? You're earning a little interest in credit each month; but that's really nothing since you have no guarantee you're going to like my paintings. Also perhaps you'll think I will ask too much for my work. My new paintings are far better aesthetically and technically; so I'm sure my prices will be a little higher. So in a way, you're just supporting an artist. Perhaps like many rich Europeans, you just like art and want to see it developed; and are not particularly interested in it from an investment standpoint. Business-wise you either lose completely (money wise) or you win enormously. If I should ever be considered great, all my early paintings would be worth small fortunes. Needless to say, the chances seem mighty slim. Knowing and being involved in myself as I am, I personally think the chances not so slim. This is not conceit, but confidence. I know I'm working in the right direction. I'm developing my intellect, technical abilities, and my senses. I'm constantly experimenting, and digging for new elements in art. I only bring all this up because since I haven't been receiving the checks, I wondered why. Maybe you just forgot; this is so easy to do. Or maybe you just doubt my intentions, or just don't care to send money anymore. In any case, I want to give you an easy out if you want one. But it is important I know how much to expect each month. I may get drafted any day. It's terrible having this over your head. It's not that I'm so unpatriotic, but I hate to give up two years of painting and study. Art school isn't the same as college, so school won't keep me from being drafted. I'm nineteen; hope they'll wait till I'm twenty.[6] They'll be asking me to give up so much. Anyway, while I'm in

the army I hope to save lots of money (something I'm not too good at) so I can live awhile on my savings. Also, when I'm released, the government will pay for my education. I sometimes think about the good chance that I might have to fight. I don't love my country and government as much as I love people in general. It'd be terrible to have to kill fathers, sons, artists, businessmen, bums, etc., just because they were under communist rule.
Love, Joe

December 22, 1961, 93 1st Avenue, New York City

Dear Sue,

Hope you had a good Christmas. I did; played in the snow all morning, completely broke my glasses, went down in the subways & took 8 pictures of myself in a "4 for 25¢ machine," worked on a self-portrait collage, went to a Chinese restaurant & had chow mein & 6 whisky sours, & then (as a result of this) wrote a 34 page story entitled "Self-Portrait on Christmas Night Age 19 Almost 20; Homage to George Washington" all night & until 7:00 the next morning. Also went to Mass Christmas Eve, tho I'm in no way, shape or form a Catholic. Thanks extra much for the money; believe me it was appreciated & was "just what I needed." Am working hard, and on complex "intellectual type" collages; collages with an obvious message & reason, as well as for the benefit of the eyes. I think they are very fine & definitely original. Tho they will be hard to accept, for they are different from what people expect & are used to. Also they are not particularly decorative; but not undecorative. They are not exactly "pleasant" but eye-catching, honest, & stimulating. I've created them to be observed, but also to be read like a book. Hope you will see them soon. Thanks again.
Love, Joe

P.S. reminder of $5.

March 1962, 93 1st Avenue, New York City

Sue,

I feel like I always say the same things in my letters; not much else to say tho. My life here is very simple & uninvolved, except for painting of

course. Sent 1 oil / 2 collages / 1 drawing to the Oklahoma Annual. Wish I could have sent more; had a terrible time deciding. Tried to pick a variety of my work; tho a variety of only my newest collages & oils, for they are the best. Will be anxious to hear your comments on them (the ones that are accepted; assuming that some will). They are all still lifes except one collage; it's a Self-Portrait in N.Y using two poems by Ted Berrigan. I also used a poem in the other collage. Am not illustrating the poems, but simply using them as I might use any other kind of paper; tho usually their moods are similar. So it's not as tho I was trying to combine two arts (for this is impossible since the "means" of creating are so different) but simply as a poem on a piece of paper in a still life or as an attempt (as in my self-portrait) at "intellectual" painting. You will see; feel sure both of these will be accepted. I have no faith in judges however, so you never can tell. Am anxious to see what happens; wish I could be there. Saw a fantastic large complete exhibition of Dubuffet at the Museum of Modern Art. It covers the years 1942–61; hung in that order. It was great to see his work develop, new ideas budding & then carried out. His organic & almost ugly world is totally unique & fascinating. Very fine show. Only criticism would perhaps be that he's very limited in both technique & purpose. He has developed & changed, but only within a very little area. An artist's life is basically spent in perfecting. This he has done, & if he had a little more to perfect he might even be really great. A very good & interesting show anyway. (How was that little piece of art criticism for a change?) Almost talked myself out of liking him. The 11th of this month is my birthday; I'll be 20. I realize this isn't actually so old, but it seems like such a big jump from 19. "Number wise" it seems like I jump from a boy to a man; too I realize there is no such distinction. In fact, I'll probably be a kid all my life; which suits me. I mean, I don't want to take on all the responsibilities of being "mature" (so just for the record, I'm still 19). Just kidding really; age doesn't mean anything. Not to be conceited, but I already feel I'm mature in the ways I want to be mature in; self-dependent, a purpose for living or a reason for not committing suicide, & faith in myself. An artist must spend his lifetime perfecting. This is what I must do, perfect, not grow older (I think). The only advantage to age is experience. And this I do need; experience in all kinds of ways. I really don't believe in this "look up to thy elders" bit tho; their world so often seems to be as poisoned as a child's world is rosy. Age becomes a person only when he has put faith in himself. Example: I know several older artists who put faith in art itself (as tho it just happens) or put faith in fame & success, and not having acquired it, have become a little bitter, stale, &

believe life to be a losing struggle. Paul England, tho I like him & think him
a good painter, told me once (about a year ago) about how evil the world
was, & how pointless. I never see him anymore, tho we live in basically the
same area of town, because it's so depressing, & so sad. So sad to see a good
person & artist "losing." I can see how this could happen so easily. A paint-
ing with spirit is just a picture. I'm building faith in myself, & my power to
paint, not in painting. The art world is very glamourous & inviting. And so
many artists are inspired by this, or by the romance of being an artist, and
not by life itself. Life is the only source for a great painting. I hope all this
is understandable; tonight I feel like I'm just about half here. Didn't go to
bed last night at all, & I'm dead tired, but too excited about the work I've
been doing the past few days to really be sleepy. I hate to tell you what I've
been working on because I'm so excited about it, & in words it'll sound
so dull. But (as simply as possible for right now) it's another direction my
still lifes are leading me; with a new sense of color & texture. I knew it,
I'm disappointed already. Don't know how to put it in words. No, what I
mean is, still lifes with added emphasis on color, actually 3-D texture, &
simplicity. Wow! Oh well! I've been concentrating on form primarily the
past few months, & now that I've got to some point of "form & order in
terms of myself" I'm adding to this extra concentration & experimentation
in color & texture. Needless to say, there's no end. And God only knows I
don't want one either. I shouldn't try to write about art when my mind is
incoherent; & it's a hard thing to do even then (at least for me) to translate
a process which in no way involves words into words is next to impossible.
Perhaps I'm just too involved in it to get a clear writeable outlook. Think
I'll try to go to sleep; tho sleeping has been hard for me lately. I just lie in
bed looking at the ceiling, a thousand thoughts on my mind; & no sleep.
Hope to hear from you about my idea for a show; tho am in no big hurry.
But am kinda anxious to hear what you think about it, if you'll be able to
have it or not, etc. Haven't been giving it much thought lately tho; been too
busy. There's just not enough hours in a day. It's a shame we have to waste 6
or 7 of them sleeping. Hope to hear from you soon.
Love, Joe

1962, 93 1st Avenue, New York City[7]

For you not to like my work is not really so bad; this is not the way I'd like it
to be.[8] But to tear down my intentions, this hurts. Do you really think
I regard my work as "child's play," or a "kick"? Certainly through our

correspondence you should know me better than this. To call my collages
trash is downright cruel. I have no intentions of shocking the world. I only
want to live in & with it, and to create from it. My intentions are of the fin-
est, and I deserve to be admired for this. You are right, I don't want to please
& delight the world, I only want to please myself. Through pleasing myself,
I can perhaps eventually please the world (I mean, I do want to please the
world, but naturally). I cannot be false in order to please. Conventionality
does not in the long run please the world, nor does pretention. This leaves
me only to paint naturally & spontaneously. This is what I shall continue
doing. At present I'm working on a series of 7UP labels in oils, and in col-
lages. Most important of all is to believe me when I say that I love art & must
fall to its command. My heart tells me I am right. You are very wrong in your
false accusations toward me. I <u>know</u> my work to be of superior & sincere
quality. I've always liked you because I've felt you were <u>real</u>. Obviously our
eyes are in different directions. I could criticize you for certain things; for me
they would be false & trivial. But they are a part of you & you are sincere. I
like you none the less than before I received your letter. I only feel sorry for
you in a way, as you must feel the same for me. It's so sad that we can only see
with our own eyes. We must both be missing out on so much. I feel terrible
now about not having the $11.50 I owe you for shipping. You will receive it
in a few days for sure. I'm sorry for the delay. This is not the way I'd like it.
Would also like to repay you the $54 you've given me. At the moment it's
impossible. I will do it in the future tho, but perhaps I'll have to wait until
I'm in the army. I realize this doesn't mean so much to you (probably) but to
me it does. I have an amazing amount of pride. Perhaps too much (if that's
possible).
Love, Joe

Late fall or winter 1962, 93 1st Avenue, New York City[9]

Lately I've been doing lots of oils. (Bob sold one of my paintings, so I
bought some canvas & oils). Have been having a heyday! With oils, I've
been doing still lifes, women, & self-portraits. Before that, working mostly
with collages, I got deeply into pure abstraction (for the 1st time in my life)
and per usual, many many sidetracks & branches. Color has been a big thing
with me lately: am doing some fantastic things with it. I have one large oil
which I'm sure you'll go crazy for. I mean for real. It's of Pat [Padgett, née
Mitchell] in a white chair surrounded by emerald green plants, Naples yel-
low / white / & light crimson red striped wallpaper, her blouse fading from

red to purple, shirt a very light off-beat orange, & with orangey watermelon colored hair. Face is very light & not too obvious. Not sure that it sounds so great in writing; but I'm really excited about it. Also intimate groupings of realistic apples. And people in large interiors simplified mostly to areas of color. Also large & small abstractions relying on lines which "do a lot." I developed my fascination for words & letters to a purely abstract form too. And some almost surrealistic, yet very modern, self-portraits. Could go on. Won't tho: it's frustrating not to be able to say as beautifully as to paint. So you'll have to wait & see. I'm pretty sure I'll have another show at Bob's sometime after Christmas, of all new work. Would like to have one now, or sooner. I certainly have enough good work. But can't afford it. Along with painting I'm doing my usual visiting museums & galleries, reading, and lots of writing (not letters). I'll enclose a few of my written poems & short (very short) stories. Wish I had a typewriter, I'd send more. And going to school too (a surprise). I got a scholarship to Pratt to study etching. I love etching, & I love the school. But I hate propositions, so to get it over with: I'm looking for 3 people to buy each etching I do for $2 each. That's really all there is to it. If you think I'd be a good deal for you, it'd make me happy. Etching is kinda expensive, & I figure that way each etching will pay for the next. My plans are to work in all different sizes, but in small editions of 6 to 10. Subject matter or style? God only knows. My 1st etching is of a woman in [a] chair. It turned out really good, tho I'm expecting to take much more advantage of the medium. I'm planning on working hard, so I hope to do one a week (will mail it out as soon as each is done) so if you're interested, let me know. Or if you know of anyone else who might be, would appreciate your effort in spreading the message. So far (been in school 2 weeks) it's been frustrating, because I haven't been able to do as much as I'd like (Am ahead of the class tho: heh! heh!). Big deal! Etc. The Museum of Modern Art is having a new <u>Old Swedish Film</u> series which I'm enjoying.[10] So far they've all been silent films from 1909–1917. Have seen too many really fine exhibitions to even consider even listing a few, for fear of leaving too many out. Also this summer I did stage sets for an off-Broadway modern version production of "La Boheme" (no money, but I really enjoyed it). Also I'm doing the cover design & illustrations of the new issue of the "Columbia Review."[11] Will send you a copy. Back to collages: examples: 3 Easter eggs, lots of 3-D cardboard reliefs, some almost humorous takeoffs on advertising & cartoons. Oils: still life with American flag on checkered table cloth with 6 oranges (fantastic overall pattern of checks, stripes, stars, & circles). Woman looking in mirror with 3 images. People seen more impersonally

as objects with a little hint of, or no, faces. A strictly (to the "t") realistic self-portrait in my apt. with oils/plants/paintings/books/etc. Have a new fascination for plants. Have been picking wild ones from Central Park & raising them. I really do have a very green thumb you know. I especially like ferns. Lots of paintings just of plants, & they pop up in interior paintings too. I take two vitamin pills every morning. Tell the Harveys [Nylajo Harvey and her husband] hello for me & thank them for the food & toilet paper they sent.

Love, Joe

P.S. Poem & 33 very short stories enclosed.

THAT WAS NOT ORIGINAL, AND I'M NOT EVEN SURE IF
ITS FUNNY. MORE BACK TO NORMAL:

(THINKING A HEAD)

(APPLE BUTTER)

EARRINGS
$2 A PAIR

(A BUCCANEER)

HAVE
GONE
HUNT-
ING

(REIGN CALLED ON ACCOUNT OF GAME)

AS FOR ART, I'M HAVING A BATTLE WITH SUTELTY. THAT
IS, DOING AWAY WITH ALL THAT ISN'T SUTEL, AND FINDING
A POINT WHERE SUTELTY IS FASCINATING AND NOT BOREING.
EXAMPLE: THE LONG RANGER MASH HAS BEEN REPLACED
BY LITTLE JETS IN THE SKY OVER MARY'S HEAD. NOT
A VERY GOOD EXAMPLES. I'VE COMPLETED ONE PART
OF THE GRAND COLLAGE, WHICH IS NO LONGER A PART

FIGURE 4.1 Page from the summer 1963 letter, Brainard to Pat Padgett

4

DEAR PAT

Patricia Mitchell, a former girlfriend of the poet Ted Berrigan and soon-to-be wife of Ron Padgett, maintained a lifelong friendship with Brainard. The tone of these intimate, loving, and very funny letters almost—but not quite—overshadows Brainard's very real poverty and hunger, a result of his decision to resist taking on regular employment in favor of dedicating himself entirely to his art. Mitchell and Brainard's correspondence included here covers his early period in New York City and, beginning in January 1963, Boston. Isolated from his New York community and committed to achieving a breakthrough in his practice, Brainard stayed in Boston through October 1963.[1]

August 1962, 93 1st Avenue, New York City

Dear Pat,

I'm actually not dying of anything : in fact I feel very very good. Maybe even too good. I've been painting tons & tons, and very goodly [*sic*]. Will try my damndest to discuss my new work later. Always later. But in this same letter. It's a very hard thing to do you know. I was overjoyed with your letter. Overjoyed with the money. I've been to Coney Island. Wow! The moment you get in N.Y. I've got to take you out to at least ride the rollercoaster : the most fantastic ride I've ever been on. The park itself is just greatly exciting too. Some of my new abstractions remind me of amusement parks. [Lorenz] Gude came by the other night & just offered to take me. I said sure. I got to ride it three times. Last night I had the greatest & most vivid dream of

my entire life : I married Marilyn Mounts.[2] (Girl friend of mine in high
school / you met her once / short / thin neck / short hair / large hips) I was
unbelievably happy for a few moments. It was really real. For me, it was an
amazingly "pure" dream. Based <u>completely</u> on love for her. Which I don't
even think is possible. Of lately [*sic*] I have to scan the trash cans constantly
in search of all newspapers. They're all running great illustrated stories on
Marilyn Monroe. N.Y. is really going all out. I'm fantastically interested,
tho I don't know why. Her death really kinda shook me, tho again I really
don't know why.[3] When I got your letter & money I immediately ran to
the Museum of Modern Art, buying a 15¢ pineapple pie on the way. Also
cigarettes. Took the long bus ride down 5th Ave. Enjoying the beautiful day.
And it really is a beautifully sunny day. (Lately weather, tho I hate to speak
of it, has been chilly & damp) Kinda yellowy too! Anyway, I roamed around
the permanent collection mainly (two new Matisses) (one new Juan Gris)
and slowly had coffee in the sculpture garden; which really gives me a buzz.
Then to the Howard Hawk's [*sic*] movie: <u>The Thing</u> (1951) with Kenneth
Tobey, Margaret Sheridan, & Robert Cornthwaite. It wasn't too good or
anything really, but I enjoyed it. Then on way to subway saw a sign in bank
window of an old model ship exhibition. It suddenly seemed like a good
thing to see, tho I've never really gone in for ships or models. It was amaz-
ingly fascinating to my surprise, as I guess all things can be if given the time
& thought. Still on my way to the subway, this funny little old man, old,
walked in front of me taking about 4 steps forward, then two steps back-
wards. I walked slow because I didn't want to pass him. He kept it up all the
way to the subway, where I went underground. I don't think he was trying
to be funny either. He may have been a little off, because he didn't seem to
notice everyone looking at him. I cut my hair again last night : am the angry
young man again. I know you won't really believe this, but some days ago
a tiger got loose from someplace & came into our apt. building. The super
wounded him with a broom (trying to get him out I guess) & he (the tiger)
got mad & ran up to the 5th floor to hide on the steps leading to the roof.
They just called the police when I got home from somewhere & the nice
old woman (the one that always says hello) said to be careful going up the
stairs because there was a tiger on the steps by my pad. I didn't believe her,
but she soon convinced me. So I nervously mounted the stairs & when ½ in
& ½ out of my door I glanced up to see for myself. It was dark, but I saw two
gigantic round eyes staring at me. So I naturally closed the door & locked
it. Later there was a lot of commotion out in the hall, but I was painting, so
I guess they got it. I still don't understand why they called the police tho.

Seems like they ought to have called the Humane League or something.
So things haven't really been dull. There was blood all over the steps too : 3
floors. "This is honest to God the truth"
Signed:

Joe Brainard

Almost forgot how to write my name. I always print. It's faster. Looks bet-
ter too : writing is too unorganized & uneven looking. I feel terrible saying
how starved I am & lacking in art supplies, & then name a list of thousands
of movies I've seen of lately. But I guess you understand how those things
work. I also usually manage to have cigarettes. Actually I really haven't
seen too many movies since last writing. (Tho I can't remember when that
was) The only one, of the 4 I think, that stands out was <u>Leda</u> directed by
Claude Chabrol with J. P. Belmondo & A. Lualdi. A beautiful use of color,
tho a little sickening at times. Too much. Also I saw <u>Hiroshima, Mon
Amour</u> again. Which was even greater this time. And I saw clearly how
<u>Last Year</u> stemmed from this : especially in small details & effects. Did I
tell you I saw 2 more Marx Brothers movies? In addition to the 2 I think
I told you about : <u>Go West</u> & <u>Night at the Opera</u>, I saw <u>Day at the Races</u>
& <u>Day at the Circus</u>. (Or something to that effect) At any rate, I can't
remember telling you about them. But I actually can't think of anything
to say about them. But of course they were funnily great. Kurosawa's new
movie <u>Yojimbo</u> is coming to the Carnegie mid-Sept. Also, another new
movie I want to see : <u>The Girl with the Golden Eyes</u> (Balzac). It's directed
by Albicocco, & is an updated version. (God only knows why). Am reading
this book on Groucho by his son. Just started it really. It's full of funny
quotes which really turn me on. Like: "One morning in Africa I shot an
elephant in my pajamas. How he got in my pajamas I'll never know." In
itself I guess it isn't so funny, but I always imagine Groucho as saying it : it
then becomes fantastically funny. Well, most of my new work is devoid of
subject matter, yet not really abstract. Purely that is. Such things appear as
stars, fantasy flowers, various commercial labels. (But with no connection
to reality) My newest collage I immediately thought to call "A Prize in
Every Box."[4] It resembles a game of some sort, divided into squares with
individual amazing "goings on" in each box. Also fantastic borders. This is
something else I've been doing a lot : including painted frames or borders
around my work. The large collage reminds me of a penny arcade game :
a deluxe penny arcade game. And tho there's a lot of variety (an amazing

amount still) I feel like I'm at last getting back into the full swing of things.
Recently also did a small series (kinda Klee-like) of watercolor abstraction/
very simple/more spiritual than my earthy flashiness/usually just a few
beautiful lines that do what beautiful lines should do. Mostly in blacks &
reds or golds & silvers. And some abstract forms (white) floating in black,
purely fantasy forms maybe similar to Arp, maybe similar to Matisse.
I don't know. Working a lot, so reading little. I think I told you I read
Thank You & Other Poems by [Kenneth] Koch. End of the Road by John
Barth too. And now Groucho. I'm enclosing a package of sugar from the
Museum of Modern Art. Also am enclosing my newest writings : all done
a couple nights ago. Also am enclosing a 6-page letter on light green note-
book paper written in pencil by Joe Brainard to Pat Mitchell. I told you I
felt good. I forgot to mention along with all my other reading that I've read
thousands of articles on Marilyn Monroe. In fact, I'm now an authority
on the matter. Any questions? Of very lately I've been working mostly in
black ink on white : mostly because of lack of supplies. This sharp contrast
is amazing, hard to work with, & the contrast itself so often dominates
what you're doing. But on several occasions I've been able to overcome this
& actually use the sharp contrast as a part of my work rather than just a
medium. Amazing things can happen in this case : as has. (An example of
the artist conquering)

 A new day—ugh! Damn! Terrible cold all of a sudden. Shit! Fuckadoo!
Another rainy day too. Ugh! Ugh! But am going to Metropolitan Museum
today rain or not. Will write about my daily adventures upon returning.
Have returned, an amazing day. I don't understand how I got done all I
got done. First at Met. Mainly to see new summer loan show from N.Y.
private collections: fantastic, honest to god like. An overabundance of bad
impressionism, but many really fine early Matisses, some never before seen
Van Goghs, & some of the best Gaugins I've ever seen : including Christ,
self-portrait, & many other earlier themes. Later too. Most impressive
perhaps: a fish by Soutine: thickly painted with Rembrandt richness, only
still expressionistically Soutine. A whole room of beautiful Degas : one por-
trait looking like you. Then around to the galleries: a summer international
show at the World House Gallery (one of our favorites with the fountain
& all the Manzùs) Fine drawings by Klee, landscapes by Morandi (though I
never knew he did them). A Delaunay (looking like some of my new work
/ wood cut & sculpture by Reder, and many, many, etc. etc.—etc.). Then to
Museum of Modern Art : a new show of color photos by Erni Haas. And
then to Hawks's movie : "The Big Sky" (1952) with Kirk Douglas, Dewey

Martin, Elizabeth Threatt. Really a good movie. Douglas was the same, only younger looking. Then home again. Home again. Jig-i-d-jig [*sic*]. Now am writing, coughing my head off, & sniffing like crazy. A good day except for cold. So now I'm tired, tho the night's just begun. Will read I guess. I've read two books on etching now : it's become a much more involved thing than I imagined. There's a hell of a lot of craft & patience behind it. Will be good for me. My throat is getting unbelievably sore. Must get over it soon : bugs the hell out of me. Kiss all the Kelly Girls for me, including yourself.[5] Save money!
Love, Joe

January 12, 1963, 231 West Newton Street, Boston[6]

Dear Pat,

Wrote you a long letter some time ago : first day I arrived, but it was just so typically a "Brainard" letter, I couldn't mail it. You know what I mean, my own little visual world, everything is hunky-dory, etc. I really do like Boston tho; everything is so articulate, sharp, and clear edged, orange rocks, red brick, black trees with white snow. Even the gray grass seems very rich. My room is too perfect : hope it'll continue being a wee bit comical. It's a dump (understatement of the year), at least as small as your room, red and green flowered plastic curtains, bright pink bedspread, dirty no-color walls, an old marble top dresser (good), one broken-down not sit-able chair, worn blue/yellow/orange rug, no heat, one window which faces a car & garbage dump, & worst of all, 5 railroad tracks not more than 2 feet from my wall. The sound is bad enough, but at night, dark, when my room starts shaking like crazy every 15 or 20 minutes, well, I can't help but laugh, as I said, it's too perfect, right out of Thomas Wolfe, or even Grace Metalious. All I do is read anymore, and time has never gone so slowly. Yet, I like it here, even my room. And the boredom isn't really bad. It just all feels kinda "distant." Have only been here 3 days and I've read four books, been to the Boston Museum, to public library to get my card, walked all around town, & actually feel I know the city very well. But not personally : it just doesn't strike me that way. My rent is $8 a week, & I'm paid up until Jan. 27th. That feels kinda good. And I've still got $3 in my pocket. I'm getting a nervous itch to do some small watercolors, more or less "representational" paintings of my room, me in my mirror, and outside my window. I see these

3 things in a way I've never seen anything before : sharp, distinctly clear, and "complete" impersonal, & at the same time <u>completely personal</u>. I can see absolutely no reason for my ever going to work again; so I don't plan to. So, all in all, I guess I'm a New Englander now. Joy! I'll tell you the books I've read: "Shoot the Piano Player," "Evolution in Action" (again), "The Tight White Collar," & "The Roman Way."[7] Now I'm reading Ellis's "On Life and Sex."[8] Boston has real newspapers, lots of old medieval-looking black churches, lots of small and large parks everywhere, and wide streets with lots of crisp air. It has a big downtown, or business area very much like New York, very cheap, and very exciting. Then it has very fine and conservative areas very much like one would expect Boston to have. Lots of antique shops : thousands : everywhere. And all the old architecture, as I guess you remember, is both obscene and beautiful. For some reason or another I was thinking last night and it suddenly hit that it was absolutely absurd to conceive of sin. I mean, there couldn't possibly be such a thing as sin in this world. And for some reason or another, Boston has the wrong idea about the holiday season : there are still Christmas trees, holly, balls, & ribbons everywhere. And I think I forgot to mention that my ceiling is going to fall down any minute & that I have no kitchen, so I either eat out, or potato chips & cupcakes. It's raining outside, & the sky is a weird color of purple. So, I must be running out of things to say. With time as is, it will seem like years before you write, even if you write as soon as you get my letter. So act accordingly. I hope you know your colors as well as I think you do, because I want to tell you <u>exactly</u> how I feel : orange. There is no way in words I could tell you this. And orange is, all in all, a basically good color (red & yellow), but then there's so much more to it. I guess you know what I mean. My latest kick is Mr. Goodbar ("quick energy"), and I have coffee at Bickford's every morning; their doughnuts are 10¢ instead of 5¢.[9] But the coffee's the same. I'm never asking anyone for money again, but I hope you're still planning on sending $10 the 1st of Feb. Believe me, I'm gonna need it. So, the story sounds basically the same: sorry. I guess there are some things I just won't be able to help. A letter from you will be a Godsend. So you send it.

Love, Joe

New Address:
231 W. Newton St.
Boston, Mass.

February 3, 1963, 231 West Newton Street, Boston

Dear Pat,

As always your letter excited me to tremendous heights. Honest. I don't
know why I get such a kick out of getting a letter from you, but I do. So if
you have no other reason for living you ought to continue anyway: just to do
your good deed of cheering me up. The dollar was more than nice too, so I
went out and had a good breakfast while I read your letter. I was going to get
some coffee and toast anyway, but when I saw the dollar I got orange juice
and corn flakes too. Bob [Bartholic] sold some drawings of mine so I had
$10, but I paid $8 for rent, and after living off the rest for several days I had
only 30¢ or 40¢. So it was more than welcomed. (The dollar) To say nothing
of the letter. The story is about the same : reading is all I do. Except today I
also went to the museum. I really like the Boston Museum. Everything is
displayed in such a way that you simply have to look at it. It makes you really
want to. And each object somehow looks like the very finest. The best. The
"select." They have a fantastic selection of American painters like Trumbull,
Sully, Bingham, Stuart, and the Peale family. At the Met. I never liked these
painters: they're all stacked on top of each other so closely and all. And their
selection of these painters is not nearly up to the Boston Museum's anyway.
(This is Fuck the Met. week.) Have you seen the smile yet? (Mona Lisa, in
case you're not in perceptive spirits.) Anyway, back to Boston : they have a
whole room and ½ of large Sargents which dismisses any previous feelings I
had of him as being just too "elegant." It's true, never-the-less, but there's so
much more to him than that. Also they have Gauguin's big mural, "Whence
Come We? What Are We? Whither Are We Going?" I imagine you saw this.
For me it's really the best thing I've seen by him: the yellow monumental
figures against all the blue rhythm really is unnerving in a good way. A
powerful way. Very quiet tho. All their Degas are "small and intimate and
perfect" in a way that you and I both go for. Today I like art again. Even art
history. It struck me what a funny thing it is : the way it works, the way it
flows, the way it's intellectual, then anti-intellectual. The way it picks an
element (all present), glorifies it, then drops it, color is predominant, then
form is, subject matter rises, then becomes a "means," then is simply gone. It
all works in a good way. It all makes sense even tho it doesn't seem to. So
today I like art. You know I have a weakness for cheap novels like I do for
movie magazines, and lately I've given in and read too many: "This Very

Earth"— Caldwell, "The Only Reason"— Torrés, "The Sins of Philip
Fleming"—Irving Stone, "Give Me Myself"— Sherman, & "Young Man
Willing"—Roy Dolinger. It's really too bad. I feel kinda guilty. (God only
knows what for) but I guess that's the way you grow. I mean, if you desire to
grow you have to become guilty first. But actually it's not as bad as it sounds:
I've been reading some good books too : "The Greek Spirit in Renaissance
Art"—Simpson, "Lolita," & "Sons and Lovers"—also, "Lady Chatterley's
Lover," and best of all, "Crime and Punishment." I really thought it was great,
so I've decided to read all his novels now.[10] Just started this morning [Dosto-
evsky's] "The Idiot." Also checked out from the library his "A Raw Youth."
About [D. H. Lawrence's] "Lady Chatterley's Lover," I sure do hope you have
read it, for I want you to know that you remind me tremendously of
Connie.[11] I'm just sure your mind must work similar to hers : mainly
concerning all the little things she did and thought, more than the result of
these things. I really thought it was good. I don't go to movies anymore. And
I still don't drink Pepsis. One of the things I like best in Boston is a clear sky
in the morning. And I've been having them. Maybe it is bad, I don't know,
but I feel myself more and more pulling directly back into myself. Being in
Boston by myself, maybe it's not by choice. I don't know. But I imagine I'd be
the same anywhere, no matter how many friends I had, or people I knew. At
any rate, that's the way it's going. Not that I care. I don't know. Have
something kinda strange to ask you : what does it mean if your piss is white
clear instead of yellow ? In other words, along with reading cheap dirty novels
and not drinking Pepsis, I'm pissing white now. By the time you see me again
you'll hardly know me. My face may be a little fatter too, since I'm suddenly
having a hell of a time with my wisdom teeth. I can feel them coming in with
my tongue, all side-ways and everything. Hurts too. I can't stop now. I've got
to go on : you see this knot on my right foot hurts so much I can hardly walk
very far. Honest. It comes from those black shoes the old man gave me. The
right one is too big. I stuff it with toilet paper, but it doesn't help. But on the
other hand, I hardly cough much at all anymore. I'm going to be a new
person : all new defects and deformities. And least it's a change. I was getting
kinda bored with coughing. Limping is actually much more fun. I know I'm
talking stupid. I'm sorry for you, but I feel like I've got to. And I've a feeling I
must go on for hours. All the people here are amazingly normal looking.
They don't really seem common tho, just normal. They don't look at me
much either : they don't seem to care that much. In a way that's bad I
suppose. But I hate to be stared at, so it's O.K. with me. There are no
beautiful women in Boston. Haven't seen a one. And thousands of

college-age boys; mostly all wear these terrible royal blue nylon quilted jackets. I see 'um [*sic*] everywhere. Must be a fad or something. I never did like royal blue : sickening like too many candy bars. Boston is really a very quiet town, but it seems noisy : since it's so quiet you can hear all the few noises too distinctly and clearly and loudly. I like the way it rains here : it's the kind that's good to walk in. The refreshing kind and not the messy kind. As for my big fight, I can't remember it too well. I only really remember exactly how I felt : like I had to kill the guy or else. The thing is foggy except for the red and black wool lumber jacket he wore. I remember that very clearly. I started the fight by grabbing hold of it : don't think I really did it in a defensive way but a pleading way. But he took it to be defensive. I always wanted a coat like that. This'll be easy to dramatize : I want to be careful not to do this. It'd be much easier to describe if I could work myself up to being mad again. I'll try. The guy is my super, but not my landlord. At any rate, when I moved in I paid him 3 weeks' rent ($24), and then just a few days later I was completely broke so I asked him to return one of the week's rent. I told him I didn't have a cent & would be getting some money later. He said casually he'd see what he could do : he didn't handle the money himself, he said. So I waited. I kept going back 4 or 5 times a day for 2 days trying to get some god damn money: I mean I didn't have a penny to my name & I was hungry. He just kept putting me off casually & didn't seem to give a shit if I was starving to death or not. The point is I was starving, I mean I was really weak, & dizzy from not eating for 2 days. (No cigarettes either) So I went back about 6:00 or so the second evening, that's when I grabbed his shirt & told him god damn it I had to have the money. That the whole thing was completely absurd. That it was my money. (You gotta know how mad I was; otherwise it's completely out of character) I was really mad. It just didn't make sense to me. People just couldn't be like that. So the guy pushed me back hitting my head against this big framed picture of Christ with the bloody heart. You know the one. (This all happened in the entrance hallway) I didn't break the glass. This really did it. Next thing I knew I was hitting the guy's head against the railings on the steps & I could hardly utter a word. I mean I was choked up all the way. It went on like this for I don't know how long : pushing, grabbing clothes, and knocking each other down. (Really in a clumsy way) It wasn't a fist fight at all. I kept trying to make my point all this time, calling him over and over a son-of-a-bitch. It was the only bad name I could think of. While he kept saying to take it easy. Anyway, his wife came up from downstairs. That kinda stopped things for a moment. Before he could say anything, I fumbled out the best I could the situation. So she made him

give me $8. I remember I told her thanks and I couldn't figure out why I said
that. Force of habit I guess. At any rate, I literally ran out. In a way I was
actually crying : like the way you get choked up when you have to say
good-bye to someone you don't want to say good-bye to. I ran into him 2
days later & he said he was sorry. And I was nice to him : force of habit again
I guess. I'm really a nice guy you know. But I hate him never-the-less. He has
those black beady eyes & pink lips. I really hate his guts. It all sounds stupid
to me now : like some farce that didn't really happen at all. So I went out and
had a big filet dinner which made my stomach hurt all evening. I think I've
only done one good watercolor-drawing since I last wrote. It's using this new
story I wrote : <u>1846</u>. I'll enclose it later. It's really good I think : especially the
way I used it in the painting. It's really the first successful thing I've done
using my own writing. Bob wrote and asked me if I wanted to have a show in
June while I'm in Tulsa. I don't know why in the fuck I'm going to bother,
but I know I am. In fact I'm kinda excited about it. I'm sure I'll want to use
most [of] the paintings in your collection. (Sounds impressive) But not for
sale of course : it's funny to think that anyone in Tulsa might buy them
anyway. Will you please explain to me why I'm having another show in
Tulsa? I always swear never again. But at least this time it's going to be a
<u>completely</u> good one. I promise myself this. And you too. Don't let me
forget. It's a very easy thing to do : easy money. You know, I gotta figure out
some way to exist. Same old problem. I wish I could trade it in for a new one.
My getting a job seems absolutely absurd. I did try tho. I applied for this job
two days ago at the "Book Clearing Store," stock work for the paperback
department. I might have gotten the job (only paid $60 a week) but the prick
said I'd have to cut my hair. But I just don't go in for kissing people's asses.
But it'll be the same anywhere I go, so I may as well forget about it. So instead
I wrote the Bartletts a letter pleading for temporary support.[12] (Pres. of 1st
National) I kissed the letter before I put it in the mailbox & I've got all my
fingers crossed. So if you pray for me too, how can I lose? I can't really expect
him to send very much, if any, since he hasn't seen any of my work in over 2
years. I did write him a <u>good</u> letter tho. Maybe he has faith. I'm sorry you
don't seem to be too happy with everything. I wish it weren't that way. I had a
very clear dream about you the other night. I hate to tell you about it, for it'll
show how childish & dramatic I am. But I'll give you a brief outline anyway :
I got TB & only had a little over a year to live. I wanted to <u>really</u> do some-
thing in that year or so & I realized that my painting would take many more
years to materialize into anything I would really like. So I decided to devote
myself to making all the money I could & then giving it to you when I died.

(I was still in N.Y.) So I suddenly became a high fashion illustrator for Vogue & you came over every Sat. & posed for paintings I sold out the art fair. At one point I had $4000. But I woke up in the middle, so it never ended. The whole thing made logical sense like a daydream more than like an actual dream. It was all very enjoyable. (I hate myself sometimes). I've nothing much else to say. But I have two new stories for you : January 13th 1963, & 1846.[13] My rent is due again the 30th of January so I hope you'll send the $10 as soon as you get it. Don't know where I'll get any other money unless

1846

THIS IS A JAR WHICH EVERYONE MISNAMES A BOX. THIS IS A HAT. (PINK) THIS IS A PINEAPPLE.... TO SERVE YOU AND YOUR NATION BETTER. THIS IS A CRIME." I JUST THOUGHT PERHAPS I COULD ADD ANOTHER ONE TO THE FAMILY RECORD BY BUTCHERING MY BROTHER JIM WITH AN AX IN HIS BATH, BUT IF YOU DON'T WANT ME TO I WILL I WON'T." I DON'T KNOW. BUT DID YOU KNOW THAT THE GREEKS BLAMED PANDORA FOR EVIL. THIS IS OBSURD. I DECIDED THERE WAS NO SUCH THING AS EVIL. AND THE JEWS STILL BLAME EVE. THIS COULD NEVER HAVE HAPPENED IN THE LEG-ENDARY DAYS. THEN IF A SUITOR WON HE WON. IF HE LOST HE LOST HIS LIFE. (I'M HUMING "SUMMER-TIME" TO MYSELF) IT'S BETTER THAT WAY. BUT THIS IS 1846. SO PERHAPS, INSTEAD, I SHALL ENDOW ALL OBJECTS IN NATURE WITH A SOUL. JUST IN CASE THEY DON'T ALREADY HAVE ONE. IT'S BEEN DONE; I KNOW. BUT I RATHER LIKE THE IDEA NEVER-THE-LESS. AND PEVER-THE-PESS. TO HELL WITH THE PRESS! "I WANT TO BE ALONE." (DEAR GOD MAKE ME T.V. KING FOR A DAY) AND FUCK NATUR-AL EVENTS LIKE RAIN! BUT PLEASE DO COME AGAIN ANOTHER DAY. LIKE YOU USED TO WHEN I WAS A KID. REMEMBER? SOFTLY. VERY SOFTLY.

FIGURE 4.2 Prose-poem entitled "1846" included in the letter of February 3, 1963, Brainard to Pat Padgett.

Bartlett pulls through in a hurry? At least I have two things to look forward to : Valentine's Day Feb. 14 & my birthday March 11th. I'll be of age : 21. (I'll get money for it too) My aunt always sends me $10 for a birthday, & my parents $5. Don't know why I'm talking about money so much. I don't even like it anymore. I want it, but it's never what I really want. Lately what I eat best are those cheese crackers with peanut butter. 4 for a nickel & I like them. I guess you know I want you [to] write soon. Do.

Love, Joe

April 1963, 231 West Newton Street, Boston

Dear Pat,

Just finished "The End of an Affair" by Graham Greene. Tore out my page 130. That's one of the secret things I do : the Boston Public Library now has 39 books all missing page 130. So, it isn't a secret anymore : I'm bored with all my secrets anyway. It's really not very nice you know. But I get some sort of buzz out of it. When feeling low all I've got to do is get down my collection of page 130's & I die laughing. I like to think of all the people I'm frustrating, & all that I will frustrate in the future. You'd think with the way I live and all I'd be able to cover up Sundays. That's what today is. But I can't. Aside from "that" feeling just hanging in the air, my neighbor next door always plays Polish music loud & clear on Sunday. So even in Boston I know when it's Sunday. Another secret: for the last two months I've been working on a novel about a 24-year-old man, Will, (you never know his last name) a candy salesman for Mars, and the people he knows but really doesn't know at all. And you read about him (Will) letter of February 3, 1963, the people he knows. I'm glad I don't feel the need to explain why I'm telling you some of my secrets. In the first place, I couldn't. Another secret : if I choose to be I'll be a great painter. (I know many things you don't know) If you think about this in its true light you will realize it has got to be true : that I will be a great painter if I choose to be. Another secret : I carry on a love letter correspondence with Pat Rosso (girl in Dayton, Ohio), with a "proposed" meeting in Dayton this July. We are unofficially engaged. And our first girl is to be named Selón, so she said. Of course it's all a joke, but not a cruel one really, for it's all a joke with her too, tho she doesn't <u>know</u> it yet. You'd have to know her to understand, but I am actually doing her a great favor. (Please believe me, for I don't want you to think

I'm going to hurt the girl) She's very romantic & enjoys this kind of thing.
I just finished two Snickers, my dinner, and the last of my money, but wow
has it ever been a great weekend. If you knew how much I enjoyed your
money you would be very glad you sent it. I spent only $2.15 on art supplies,
and all the rest on food. Up until I got your money order Fri. afternoon I
hadn't eaten anything but bread for 8 days. I even had to borrow a dime
from the guy next door to call you. He was drunk and very nice about it. So
as you can see, the $2.85 worth of food was needed as well as enjoyed. You
were wonderful to send it, tho I guess I didn't leave you much choice. I am
guilty. I can't seem to stop the urge, and pardon me if you think this is all
foolish, but here are some more secrets which only you and I now know:
 In the 3 months I've been here

(1) I've only washed my hair once & taken 2 showers.
(2) I've slept with a Northeastern student (male) who more or less picked me up
 at the Museum of Fine Arts (but don't get the wrong idea, because you will be
 wrong if you do). It's not really a matter of seeing how low I can stoop, but a
 sometimes "fascination" for the perverse. Do you understand? I don't.
(3) I've stolen lots of candy bars, but that's all.
(4) And I've begged off the streets, in one bookstore, and one used clothing store
 a total of $4.10.

 If you say "so what?" to all of this it will be a slap in the face, and if given,
one I deserve. But all this is one big game, so this would really be out of
place. Boston and me are not real at all, and all I want to do, here, are the
stupidest things I can. I suppose I spoil it all by telling you, but I'm so bored
with anything else I might have to say. Actually the truth is that I've a terrible
headache & my eyes are throbbing from so much reading. So I'm not feeling
my best. The weather is grand, spring-like, and I notice that green things are
coming up in accordance. I still have tons of stamps my aunt gave me. Am
anxious to see how the week will develop : I pray to God to begin working
by Mon. at the latest. You are extra swell, and really the only person I like :
which may or may not be a compliment. I've been reading a lot of Aldous
Huxley. I enclose an "M" I found and also a photo of Marguerite taken by
Elwin Neame, London, in 1910. For obvious reason [sic] I checked out "Some
Trees" and read it 4 times, once aloud, not understanding it, but liking it bet-
ter & better never-the-less.[14] Am going on Monday to Filene's[15] with the fash-
ion drawings I did over the weekend which, even to my surprise, turned out
fantastically good. But most of all I want the lay-out job. Did a few things for

them over the weekend too, but will wait until I get the collages to see them again. (Bresnick co. / 2nd largest adver. agy. [*sic*] in the U.S) The 3rd job for Lloyd Adver. Co. is pretty run-of-the-mill, & definitely my 3rd choice. Will also have to wait until I get the collages to see them. I admit that it doesn't make sense to torture oneself. But it's the logical thing to do when you can't make yourself be happy. At least you're still in control. I doubt that I'll be going to Tulsa in June. Mainly because, aside from my previous explanation, by the end of May I won't have enough money for bus fare back to N.Y. & enough to get an apartment. And this is all now I want. This is where it all begins again. Only in a different way. A much better way. And you will see. Love, Joe

P.S. Like always I'm hoping you are glad that everything is the way it is ; that is to say, happy. Do write, for it's really most important.
P.S. 2 collages, "7UP" & "Things Going On," are in the process now of being judged. I'm relying on Edward Hopper, hope he doesn't disappoint me.[16]
P.P.S. You know, I always talk about people in a kinda bad way: like Jane [Roper] or Jo Anne.[17] I guess you know me well enough to know, but in case not, I can't help but like those people too. I mean, I don't want to give you a wrong idea.

Circa June 3, 1963, 231 West Newton Street, Boston

Dear Pat,

This is another one of those really not a letter at all. I just can't seem to sit down & really write. I've been working <u>all</u> the time. Mainly I just wanta [*sic*] at last send my new poem for you & Ron to read. My newest collage is a fantastic, & still uncompleted, homage to M.M.[18] I shan't begin to describe it. Two new miniature landscapes. I'm working with things inside of things inside of things in side [*sic*] of things. Also I'm working with things being obviously the "wrong" color : ex: a pink airplane, a blue and orange Lucky Strike label, a purple bird. Other things I think I notice about my work:

(1) It is sorta "decadent," which I like : isn't Pop art, too, decadent kinda? (?)
(2) anti-sensitive : if a woman gets too sensitive looking, or the total effect of the painting, I can't help myself but add a "Kellogg's," etc.[19] I'm not referring to sentiment or romanticism, I'm referring to sensitivity which is supposedly a good quality.
(3) an abundant use of ugly pinks

(4) I've gone ape shit over birds : they are everywhere, in the collage, sitting on top of it, and flying completely over it way out onto the wall. (Which creates technical difficulties)

(5) Lots of borders, and within borders, and within that border

Let me thank you again for sending all that stuff. I've been using it up like crazy. If while junk shopping you see any frames, 3-D objects, etc. I might like please buy them & I will repay. I can use anything that I like. And what you like I usually like. I've cleaned out everyplace in Boston I know of. The best thing about working (job) is all the free stuff I pick up : film, negatives, all sorts of soiled photo papers, bouges, etc. and I steal things from photo magazines whenever I can. Also I steal brushes, Exacto knives & blades, etc. But the very best thing of all is that they've a dry mounting thing, which makes possible things I could never do before. I can now mount things giantly [*sic*] without a single wrinkle nor glue spots. And it doesn't curl nor buckle. But if I don't watch myself I'll be writing you a real letter. The other night, late, I heard a knock knock at the front door. I suddenly <u>knew</u> it was you and Ron, or Ted [Berrigan]. Got dressed, ran to the door to find Royla [Cochran].[20] She'd been to N.Y. looking for me, & had called my mother, not finding me at 93. I made it clear I didn't wanta see her, & she ate it up like love. Will say not more [*sic*]. Here is new poem.[21]

Love, Joe

More—this poem just kills me I love it so much. If you or Ron feel like typing it it would sure give me a buzz. I've still not mailed 4B, for I waited so long that I figure I might as well wait until 4C is ready too, and mail them together.[22] I [am]going to pick it up this afternoon. My frame bill this week is $19. And I've still to buy 4 12″ white plumes which will cost me a mint, for M.M. They sprout from her pink head.[23]

June 5, 1963, 231 West Newton Street, Boston

Dear Rosebud,

Terribly chilly for August isn't it? Actually, what I want to tell you is all about how wet it is outside, and how wonderfully orange. (How orange orange can be!)

Love,

Turkey

Dear Pat,

Actually, what I want to tell you is that I'm truly a genius. Will explain later. (And I'm not being just funny) It's raining hard outside and I've got to leave for work in a few moments. (I have a new ball point pen which writes in 3 colors) I dreamed of marrying Marilyn Mounts again last night for the hundredth time. It was great. How I hated waking up. But actually, I feel super-good. As of last weekend all I do anymore is dance around talking and laughing with myself. I'm so terribly happy and all over the work I did : 10 large (15 × 20) painting-collages. You might laugh if I say it, but for once you'll be wrong in doing so, they are without a doubt the greatest things ever seen. And considerably different from my other new work you saw. They totally destroy all normal sense of perspective, logic, art, realism, etc., by way of a new kind which is terrifyingly super-real by way of contrast. (A giant black hand emerging illogically into a pool of color) (Yellow nude men swimming in purple) (A little girl in pink swatting [*sic*] on top of a giant ink splash) I could go on, but I'm sure I'm giving you the wrong impression. They are more painterly than most of my recent work has been. They are much bolder and much simpler. They are much more demanding. And they are much more great. I'm seriously considering mailing them to you in a few weeks. It would be worth it for you to get to see them. However, I want to share them with you now. I know you'll have to see to believe. Of course, you'll have to return them. But I might let you keep one if I have seen them enough by then. And they are just enough "off" to make one wonder. Actually, I don't feel like writing. I need one of your letters to inspire me. And now that I think about it I see no reason to force myself. Love, Joe

P.S. My mother wrote that Michael Marsh told her you got married. True? Or false? In either case, "congratulations." And of course I will write more & better things later as I will always write more & better things later.

June 21, 1963, 231 West Newton Street, Boston

Dear Pat,

Since I can't seem to make myself sit down and really write you a letter like I want to do, I shall write a little each morning before going to work. Today is Tuesday and I am writing a little before going to work. I'll try to tell you all I've done since last writing many moons ago. (Why haven't you written?)

Remember the collage-painting of a little boy/girl in a chair with giant pink
roses on top? Well, I was never too content with it, but now it's wonderfully
great! I've not <u>abstracted</u> it by way of rectangles and squares, but I've imposed
and superimposed rectangles and squares rather illogically, which somehow
never-the-less seem "right" and perhaps even logical. It adds about 4 new
dimensions to the painting, both surface-wise and reaction-wise. I've a new
black-and-white collage-painting, mostly painting, which I hope to use as a
"C" cover.[24] It contains a white muscle man in a black bikini, logical dimen-
sions here and there of purple, film strips, and lettering plus a white "C" and
charcoal marks. The total effect is <u>the</u> action of all of this shifting into its
proper place. It's totally amazing that I did this, and this sort of shifting action
appears in the majority of my new work. I don't know exactly how it happens,
but it certainly does, and it kills me. It's as tho the painting(s) are/is not quite
finished yet. But everything is just on the verge of being in its proper place.
(But not quite)

Every time I change colors you will know it is a new day.[25] I bought for
you the most beautiful necklace ever seen, but I used it in a collage. Looks
like this: [pen sketch of a necklace]

The oval sets are smooth and orange, and they turn to purple from certain
angles. (Sterling) However, I've another surprise for you which I promise
not to use in a collage because I bought two: one for you and one for a
box collage I'm building & will try to tell you about later. At any rate, it's a
little English electric pop-up toaster (only one inch long) with real toast.
And I bought for myself a musical table which plays "Smoke Gets in Your
Eyes." Ted is coming to Boston this weekend you know. Actually I suppose
the point is whether or not everything being on the verge of being in its
proper place is a good thing or not. But actually there is no point to the
matter, for it just <u>looks</u> great. As for everything else I don't wish to speak
of it because I don't know what to say. So instead I will stick to facts : the
M.M collage changed entirely into primarily a painting, which actually <u>is</u>
great. It contains Marilyn Monroe, roses, wallpaper, sky, linoleum, the words
"you meet the nicest people!," a giant number 5, a 3-D white cross, and a
real white kitchen chair in miniature. Also white feathers and valentines.
This is all assimilated by way of gobs of splashing bursting white paint with
all undertones of ovals and rectangles and circles.[26] It is great. All together
(facts) I've 15 15" × 20" collage-paintings of which 2 are completely abstract,
3 muscle men collages of which 2 are very demandingly strong and "black
and whiteish," the other is somehow sorta feminine. It is very homosexual-

looking mostly in yellows with rear ends and dress shirts. I don't understand
it at all. Also it contains totally incongruous black "things." I have one with
a giant blue hand delicately holding a pink and yellow ice cream soda, and
an oval with a lady with black lips and a little black cross around her neck.
There is one large very geometric purple rectangle. It also has lemons in
it, and black stars, and a black seven. It says "Boom."[27] Another is basically
divided into two parts : pure yellow and black and gold Rip Torn posters
with yellow paint overtone. This area resembles earth/the pure yellow : sky.
In the very deepest part of the earth is a pink seven. On top of the earth is
a rectangle containing an orange post card view of Greece. Entering from
the top of the yellow sky is a same-size rectangle of a segment, appearing
abstract, of a torn poster in blue and orange and white. To the left of these 2
rectangles in a rather irritating spot is a giant black scribble which is terrible
[*sic*] ugly.

You are making me late for work. I don't think I will describe (try)
anymore of my collages for you because it is very disappointing for me.
However, now I am building a miniature kitchen inside a box. The box (so
far) is plain. Upon opening, the inside of the lid is the bluest of skies with
a giant black cross containing a silver metal Christ. The walls are ivory.
The floor black and white checks. It contains an ice box, a stove, a table, 2
chairs, a sink (all this in white) plus one black and white abstract painting
on the wall, and a toaster and electric mixer. Living in the black and white
kitchen with ivory walls and a sky ceiling with a black cross are a black and
white bride and groom. They only stand there of course. And since it is not
all put together it may change. One thing is that all my new collages have a
"7" in them, which is good because I hate to sign paintings, and this takes
the place very well. So until I do not want to put a 7 in my paintings this
means that it was done by me. I am doing fantastic things with color, tho
that is an impossible thing to put in words, so I have not mentioned it by
way of explanation. In other words, that is the reason. I won't ask of Tulsa.
However, I do have the urge to inquire as to Burney [Bernadean Mitchell],[28]
Tessie [Teresa Mitchell], your mother, and Bob B.

I'm rather excited about Ted coming. I don't see real people any more
because (people at work are not real) Jane left some time ago. I haven't seen
her since Ted & I woke her up to get my collage. And I've really treated
Royla like shit so she's stopped coming around; which is O.K. with me. I
think what finally did it was my saying sex was too personal. Which for
me I'm afraid is too true. I don't mean that in the way a girl would mean
that. I mean that in the way of "what right have you?" I dream of you often.

FIGURE 4.3 Sign-off to the letter of June 21, 1963, Brainard to Pat Padgett.

(When asleep) Also I've a new thing with flowers which says "God bless our home" that I bought in this junk shop which the guy said was over 200 years old. (It cost $1) Actually, it's sorta 1930ish. The guy is really nuts. He also told me these wax flowers I bought were <u>very</u> valuable. I mean, <u>I</u> like them, but, ah.......

Come to think of it, I rarely sign paintings anyway anymore. It's very nice outside. Ted will be here tonight. I'll probably be disappointed. Also I get paid which is good because I've no money and am hungry. I think I'll take a shower. It's hard to realize how good a shower makes you feel. But I just realized it. Actually I don't know why I said I'll probably be disappointed. That's not very true at all. I saw [director Frank Perry's 1962 film] "David and Lisa." It wasn't very good at all.

Love,

7

Summer 1963, 231 West Newton Street, Boston

Dear Pat,

I spent most of the entire 8 hours of work today pasting black rectangles over the important organs of women, men, and children from the Guatemala village of Rio Plátano. I had a time controlling myself. And strange as it might seem, it embarrassed the hell out of me. Thank God I finished them all today : much more of it I couldn't take. I knew that at any moment I'd crack up and die laughing of hysterical laughter, or else fuck everything in sight. At any rate, the other day I was eating lunch in this teenage kind of place by Magna. The juke box is always running, and I wanted to dance so

badly it hurt. (With you) I mean, it really hurt. Made me wanta cry. I won't forget that way I felt for a long time. I wish it was wordable. The food is terrible. Terry Southern disappoints me. Don't laugh, but Jo Anne, the secretary at Magna, has a crush on me. However, it hasn't helped my ego much, for she's slob and a half. "Arty." Reminds me of Elaine Warren. Her whole presence is so heavily obvious you have this feeling she's gonna eat you up alive any min [sic]. Suffocating. And she uses her every possible excuse for drowning me in her equally heavy words. She couldn't even begin to comprehend levitating. Strictly an earther [sic]. You wanta know the truth about Jane? It's stupid, and I rather hate to admit it; but, it just makes me feel good to have a "nice" looking girl around to take out places. She bores the hell out of me. Last weekend I took her out (Dutch, always Dutch) to see an old (1955) Antonioni movie: "Le Amiche." (The Girl Friends) It was supergrand. The women dominate per usual. But not per usual were the more real like outer spirits of the women he charactered [sic]. Next the "Eclipse" is coming. I missed it in N.Y. Can hardly wait. It is great to see movies again.

[Pen drawing of two rows of three identical-looking bearded bowler-hatted men. The first row features all three standing at the same height behind a desk. The row underneath shows the man on the left and the one on the right standing at the same spot, while we only see the hat of the man in the middle. A dialgue bubble containing the words "Will the real Toulouse-Lautrec please stand up" is placed between the two rows.]

That was not original, and I'm not even sure if it's funny. More back to normal :

[See figure 4.1]

As for art, I'm having a battle with subtlety. That is, doing away with all that isn't subtle, and finding a point where subtlety is fascinating and not boring. Example: the Long [sic] Ranger mask has been replaced by little jets in the sky over Mary's head. Not very good examples. I've completed one part of the grand collage, which is no longer a part of the grand collage, but is by itself. At the frame shop. ($15) You ended up in it rather than grand. The door which opens up to the bride & grooms is now a very black sky with a giant bird holding a crying human baby girl in its beak. It's fantastically horrifying! I found a deteriorating rubber doll leg in the street this morning. With red shoe. The Fogg has a new surrealism show which is small and kinda puny. But some wonderful Max Ernst drawings and 6 black and white photos by Man Ray. Also Duchamp's "Portfolio." (Under glass : damn) That doesn't mean that I wanted to steal it. It means that you couldn't see it very well; that little part that was seeable. Part B of surprise 4 is finally ready.

Will mail it Fri. When I've some money. In my work I'm trying to avoid
being clever, being surreal, and being absurd. <u>I want most of all to touch a
place of being quietly disturbing, that grows and grows in no direction</u>. The
library and I are through forever, for once when broke I sold their copy of
"Some Trees," which was too small to be stamped on the edges, to, of course,
a bookstore. I'm on the "watch out for this name" list. I've a new light yellow
dress shirt. And also, since my shoes had no heels & the nails were killing
my feet, I've a new pair of shoes (not cow boy boots : damn) which I don't
especially like. The black boots I wanted cost $20. I got these brown leather
shoes made kinda like desert boots for only $5, at a Boston place kinda like
Kline's, because they had a scratch on them. They are French! The shirt only
cost $2, and is really nice. And the weather here is simply great. Every day I
run home at lunch time to see if I got a letter from you. It hasn't come yet, if
it <u>is</u> yet. (?) At any rate, I've got to move soon. Probably weekend after next.
I'm looking very forward to seeing you. If I can help finance the trip will you
all come to Boston in a few weekends from now? Time is flying, just realized
that you'll be leaving for Tulsa by then. It's most important that you do come
to Boston. I've nothing else to say. Also, I have a new poem which is very
good, but terribly long for copying now. Anyway, I want a little while longer
for rewriting. Will send soon, and then, in final shape. Do write.
Love, Joe

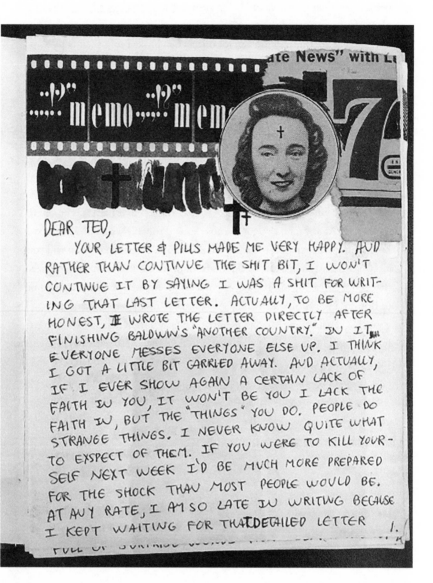



DEAR TED,

YOUR LETTER & PILLS MADE ME VERY HAPPY. AND RATHER THAN CONTINUE THE SHIT BIT, I WON'T CONTINUE IT BY SAYING I WAS A SHIT FOR WRITING THAT LAST LETTER. ACTUALLY, TO BE MORE HONEST, I WROTE THE LETTER DIRECTLY AFTER FINISHING BALDWIN'S "ANOTHER COUNTRY." IN IT EVERYONE MESSES EVERYONE ELSE UP. I THINK I GOT A LITTLE BIT CARRIED AWAY. AND ACTUALLY, IF I EVER SHOW AGAIN A CERTAIN LACK OF FAITH IN YOU, IT WON'T BE YOU I LACK THE FAITH IN, BUT THE "THINGS" YOU DO. PEOPLE DO STRANGE THINGS. I NEVER KNOW QUITE WHAT TO EXSPECT OF THEM. IF YOU WERE TO KILL YOURSELF NEXT WEEK I'D BE MUCH MORE PREPARED FOR THE SHOCK THAN MOST PEOPLE WOULD BE. AT ANY RATE, I AM SO LATE IN WRITING BECAUSE I KEPT WAITING FOR THAT DETAILED LETTER

1.

FIGURE 5.1 Page from letter of 1963, Brainard to Ted Berrigan, box 2, folder 5, Ted Berrigan and Alice Notley Collection, Stuart A. Rose Manuscript, Archives, and Rare Book Library, Emory University.

5

DEAR TED

B rainard met the poet Ted Berrigan when Berrigan was a senior attending the University of Tulsa on the G. I. Bill. Brainard was still in high school, and Berrigan—twenty-four years old at the time and just back from an army stint in Korea—proved a sort of mentor figure to Brainard and his friends on the board of *The White Dove Review*. Brainard and Berrigan ended up in New York City in late 1960 and early 1961, respectively. As Ron Padgett recalls, Berrigan "was sharing a storefront apartment with Joe Brainard at 210 East Sixth Street. They had a kind of Picasso-Max Jacob agreement. Ted slept during the day while Joe painted, and Joe slept at night while Ted read and wrote."[1] Brainard published texts and produced a number of covers for Berrigan's *C: A Journal of Poetry*. He also created two issues of *C Comics*, a magazine of collaborations, with Brainard drawing the cartoons and poetry friends such as Frank O'Hara, Kenneth Koch, and Bill Berkson writing the text.[2] Brainard and Berrigan collaborated often, creating works such as *Living with Chris* and, with Ron Padgett, *Bean Spasms*.[3] They were also, as these letters show, sympathetic and honest critics of each other's work and totally committed readers of literature.

1962, 93 1st Avenue, New York City[4]

Ted—brought by some collaborative works (for you). Moving to Boston or Phil. Or somewhere like that. Want to kind a begin afresh you know. Have more for you: will ring later (not leaving until Wednesday). Need money; so

in the worst way I need a couple pills so I can energetically do a few art fair paintings. Will be back again later like tonight. See you.
Love, Joe

PS—won't come by later after all: got pills from [Lorenz] Gude. See you tomorrow / <u>home all day</u> (I promise).

1963, 231 West Newton Street, Boston[5]

Dear Ted,

Ugh. Things are going terribly, so I won't write much. I really just have a favor to ask of you: to send me $8 by Mon. Hope like crazy this is possible, for they're kicking me out Mon. if I don't pay my rent. I don't know if you'll have any money or not, but could you borrow it for me on my honor to pay back as soon as I get a job? I've got to get a job you know, for a few weeks at least; I mean I've no longer got a choice. I never thought it'd come to that, but it has : no choice. Too bad. I'll write you a good letter once I'm able to write a good letter. It's not that I don't want to (that I haven't already). Sorry to put you in the position where I'm completely relying on just you. I am tho. I read tons, and that's about all. Lately mostly Dostoyevsky. "The Brothers Karamazov" & "Crime and Punishment" are my favorites to date. I'm playing a game with myself to read his complete works. Last night, going out for a walk, I returned to find my door wide open and the lights on. I know I locked my door and turned off the lights. But I have no money and nothing worth stealing. I kinda feel sorry for the guy who went to all the trouble. Am anxious to get my oils from Sandy [Berrigan], but most of all I just want to be able to exist. Sounds like such a simple thing. Damn it all. You see, I have nothing really to say except to ask for the loan (don't laugh at my calling it a loan). If it needn't be that's great, but since I've got to work it might as well be. I hope you'll write Monday too.
Love, Joe

1963, 231 West Newton Street, Boston[6]

Dear Ted,

Your letter & pills made me very happy. And rather than continue the shit bit, I won't continue it by saying I was a shit for writing that last letter. Actually, to be more honest, I wrote the letter directly after finishing Baldwin's "Another Country." In it everyone messes everyone else up. I think I got a little bit

carried away. And actually, if I ever show again a certain lack of faith in you, it won't be you I lack the faith in, but the "things" you do. People do strange things. I never know quite what to expect of them. If you were to kill yourself next week I'd be much more prepared for the shock than most people would be. At any rate, I am so late in writing because I kept waiting for that detailed letter which was to follow. But it hasn't yet. That you might come again to Boston is the greatest thing ever heard of. Don't let money stop you: I'll pay fare back to N.Y. (but warn me in advance). It would be totally great for you to get to see all my new work. And it would be totally great for me to get to show you all my new work. You've never seen Grand 2, 3, or 4 / The Madonna & Child after Raphael, or any of my pieces of sculpture. Plus tons more. I'm ape over the prospect, now, of you actually seeing all this. Please do this. You asked for more of what I think on "C." Yes. As for the cover, black and white is always great, & there are lots of things to look at. However, I can't get used to the fact that I didn't do it all. And you asked of "Building a House," yes, but "Some Feathers" is what killed me.[7] (Is that a bottle neck?). Those poems are all full of surprise words that seem amazingly natural nevertheless. Like:

> The true story of his arrival
> In Agawam.[8]

Actually, I suppose that is no brilliant deduction. And I've no, now, that I know of, brilliant deductions. It's funny but, reading your poems, it is very easy to accept the fact that you wrote them; but I find it impossible to believe that Richard [Gallup] actually wrote poems that I read. Maybe this is even to his advantage. I don't know. But, actually, I do think it is sometimes true. There are certain lines in your poems, that knowing you wrote them, I don't, or can't, like. Examples;

> And O, I am afraid![9]
> ------------------------------------
> Tell me now, (again,) who I am[10]
>
>
> ------------------------------------
> It is night. You are asleep. And beautiful tears
> Have blossomed in my eyes. Guillaume Apollinaire is dead.[11]
>
>
> ------------------------------------
>
>
> and Ron is writing poems and worrying about making it[12]

And actually, I'm sorry, I know this isn't fair. And the exact opposite is true just as often. That I extra like a line <u>because</u> I know you wrote it. Both are equally bad I suppose, but I <u>do</u> know you. And some lines are so far away that I don't think I realize if you wrote them or not:

> The big green day today is singing to itself
> A vast orange library of dreams, dreams
> Dressed in newspaper, wan as pale thighs
> Making vast apple strides towards "The Poems."[13]

I really like that. Ruth Krauss is great to read. And even greater when you read them to me. Ella [Rengers], in Dayton, says of "C"s:—"For me they will take some study. I read the incongruous words that make a line & I feel that somewhere they form some sort of pattern. I even read them aloud. But my concentration for them hasn't been strong enough a response. I can't judge. They may be too far from me in comprehension. Or they may be very simple & I'm looking for too much. But, write me when the next issue is to be printed, & I'll send you $20. Example:

[sketch of a twenty-dollar bill]

That is to say that Ella is sending $20 for the next issue. (To me). He! He! Another thing that you might want to know is that when you use words like fuck they somehow don't seem right to me. For me they fall flat. Henry Miller uses fuck always in a good way. Maybe, this is all my fault. Again, I really don't know. Is Warhol still doing next cover?[14] If not, I will: if so, I'll have it printed under my nose here in Boston. (Boston?). Or, if you want an illustration, or collage/drawing just totally by itself, I'm enthusiastically game. And, if so, how about letting me keep $5 of the $20 to help pay for it. I'm trying my darndest to be a cheap bastard these days. Or, when you come to Boston, if we can get in tune, we could do a black & white collaborative (still speaking in terms of "C" 4). At any rate, yes, I do still want the hand. But I can't afford it this week. Will send the money next week, & hope it is still there. Life is still somewhat like living in an isolation booth, what with not being able to see and all. Boston and its people are even more of one big blur, and it's just me me me. Margaret [Robbins] sounds good. But I've a vision of her being too heavy for me. To try and be more accurate, Grand No. 4 is built basically the same as Grand No. 1, only both indented areas are open, and flooding with activity. The main alcove is ½ circular with a silver Mary with a silver full-grown Jesus in lap. Her face, only, is white, framed with a gold oval. They are surrounded with black paint very dainty

on silver. The nipples of Jesus's breasts are black. And the red bird you sent
hovers over him. At their feet tons of black velvet drapes on over into the
lower opening, out onto the open door, and down down down on into the
air. Back to at their feet again: on the beginning of the black velvet are to
the left a stove and ice box behind which stands on his hind legs, arms in
the air, mouth open, ready for attack, a white polar bear. On the ice box
is sitting a baby white polar bear. Next to the stove is another white polar
bear. And another baby white polar bear is crawling up a fragment of an old
Greek marble column. Next to this is the main body of 3 marble columns
upon which a gold Jesus is hung, but crooked, as tho falling, following the
black velvet on into the lower alcove. To the left again: entering from the
lower alcove to the open door is a child saint all in black except for his/her
face and 2 hands which are flesh color. At his/her feet are a puddle of yellow
(bright) velvet flowers of a daisy sort. (Remember that all this is happening
in drapes and folds and tons of black velvet) And he/she is surrounded by a
black giraffe, a black moose, and a black kangaroo. On his/her black robe is
a small gold cross. And to the far right another white polar bear peeks her
head from behind a black fold of velvet. To the left, out on to the frame is a
giant black cross which extends all the way up & over the top of the entire
thing. A very small tarnished Jesus hand's normally there. Across the very
top of the frame is a sort of geometrical grouping containing red velvet
squares, a Nabisco triangle (cookies), a giant deep cherry red rose of which
its center is a rhinestone circular broach. From behind the rose comes a
fluorescent red "Merry Christmas," and a ruby red rosary which drapes on
down over the primary silver Mary & Christ, then up again to the right
side where it hooks over a red hook. Above the giant red rose lapped over a
large very deep Victorian type red rectangle are 4 fingers (minus thumb) of
a woman's hand (it looks real!) of a 3-D sort made of plastic: a mould of a
real hand. And her 4 fingernails are a true true red. Coming up from behind
this rectangle with the hand are a pair of red satin high heels, one going
to the left, one going to the right. From behind them spurt 3 black plume
feathers. It's all complete (and completely great!) except for the engineering
of the red satin slippers. It's really quite a problem seeing how it is that they
are practically suspended in mid-air. However, it shall be done. It is good
that you like the art article. I liked the "dear Japanese babies" ending, but
perhaps to other people they will not.[15] And it's great that you're going to
use it. And you are editor of "C," and that is why it's so great. So, if you don't
like the ending, it oughtn't to be there ("C" wise at least). And I don't think
it'll hurt what I've said any. Perhaps that's why you don't like it. At any rate,

that Ashbery sent 3 poems is great. And the cocktail party? In your next
letter please send the addresses of Warhol and O'Hara. And Grand No. 5
is becoming Grand No. 5. A hell of a lot can happen, but, now, basically
the central figure is St. Teresa, and it's of the people. Millions of people.
All kinds of people. And all shapes and sizes of people. Thomas Jefferson
is there. Two Japanese babies. A bride a groom. Snow White. Mary. Two
angels. A baby bullfighter. A highlander. A Confederate soldier. A midget
blowing a horn. Martha Washington. And others. The bottom portion is
isolated from the people, a different kind of place. A blue place; light blue.
With a light blue sky, giant light blue roses. And many many light blue
flamingo birds. They dance in and out of the roses. And they grow from
their giant petals. Today is Friday and tomorrow and the next are the days.
Thanks to you I'll make the very most of them. And love every moment
of it. Otherwise, I can be amazingly unamazing at times. And I've a new
brown clock. And a silver statue of liberty. Is Richard in Tulsa making Army
physicals? And what is to happen? I hope Pat & Ron get a car somehow
and bring Grands to N.Y. There is no more room in my closet even if that
was where they should be. It seems they ought to be in N.Y. Grand No. 1 has
a new face over the old one.[16] They are both there. Both look good together.
Yet each was obviously done at different times. Like the Miro. Write. It's
raining.
Love, Joe

July 28, 1966, Calais, Vermont[17]

Dear Ted____

All is well. I am working hard, and a bit fresher and brighter. The summer
is going too fast. I can hardly wait to see Pat and Ron. "Hello" to Sandy and
"hello" to David [Berrigan]. If you could spare a few pills I would L-O-V-E
to have them. I am really sorry about Frank. Not sure that I believe it yet.
Hope that you don't either.
Very much love,

Joe

1.

DEAR SANDY —

IT WAS GREAT TO
HEAR FROM YOU.

WHERE TO BEGIN?

I'LL BEGIN WITH TODAY.
TODAY I WORKED MOSTLY
ON MY "FRANK O'HARA" PIECE
FOR THE BOOK ABOUT FRANK.
IT'S VERY HARD AND NOT
MUCH FUN. I DON'T LIKE
HAVING TO SAY FRANK WAS
THIS OR FRANK WAS THAT.
IT'S ABOUT 5 O'CLOCK NOW
AND I'M VERY TIRED. SO
IF I DON'T MAKE MUCH
SENSE THAT IS WHY.
ALSO I'M JUST VERY MUCH
UP IN THE AIR THESE
DAYS. FOR PERSONAL REASONS.
AND BECAUSE I'M IN THE
MIDDLE OF MOVING. THE

FIGURE 6.1 Page from the letter of October 25–27, 1969, Brainard to Sandy Berrigan, courtesy of Sandy Berrigan.

6

DEAR SANDY

B rainard met Sandy Berrigan (née Alper) through Ted Berrigan, who was introduced to Sandy in New Orleans by Dick Gallup in February 1962. Ted and Sandy eloped just six days after meeting each other, much to the horror of Sandy's parents, who insisted she commit herself to a psychiatric institution in her home city of Miami. Florida police pressured Ted to back off, though two months after Sandy's admission, Ted returned to Miami and successfully helped his wife flee. Brainard and Sandy Berrigan ended up developing a decades-long friendship. The letters reproduced here are from the early 1960s through 1983, just after Ted's death on July 4 at the age of forty-eight.[1]

1963, 231 West Newton Street, Boston

Dear Sandy,

Was grand hearing from you. And that is the truth. It reminded me of you and Ted [Berrigan]. People are amazingly easy (too easy) to forget when you have no contact with them. Not that I could <u>really</u> forget, but just put aside momentarily, not think about, etc. Pat told me about the review: that sounds super great! Is it really going to happen? Hope so. Spring has been kinda behind the clouds the past few days. But this morning it's obviously here, and in the air. I mention it because it really makes me feel good. It's about 5:30 Friday morning. I go to bed about 8 & get up about 5 these days. I like it that way. No, I've not really a job yet, but have been doing some free-lance art work for 2 Boston agencies. However, I may have a job at

Magna Film Company setting type & running the hot printing press. Plus retouching photos, preparing slides, and doing some developing. I told them I knew how to do all this stuff, but actually I'm not sure I do. I worked yesterday, and will today, for them and so far I've done O.K. I've just been playing it kinda cool, saying I forgot this & that, having them show me, and saying "Ya, I remember now." I'm sure they like me and all that, but I think the pay will be too low. Will find out today (these two days are just a "trial"). Also, I've applied for this job at the Naval Museum in Newport, Rhode Island, travelling around the country drawing underwater things, arranging exhibitions, building ship models, and backdrops, etc. It sounds pretty good to me, as work goes, and I'll find out about it the end of next week. Have been reading mostly Gide (I don't know why) and now de Sade (I do know why). I hope I'll be in New York before you leave for Europe. Are you waiting until after the baby? I'm sure you know you're lucky. But want you to know that I agree, too. Did you like my poem? I did. I've discovered that I'm actually kinda lazy. And not only job-wise, but a little painting wise too. At first I decided to do something about it, and now I am doing something about it. Upon roaming around Cambridge I discovered Le Corbusier's new building. Being still unfinished inside I walked all around. It's fantastic. Like a complex jungle-gym with lots of hiding places. It's very colourful, yet very "quiet" in the same way a church is. A very special thing. The Fogg Museum has a completely abstract grid: first I've ever seen. And I really liked it.

Today is Saturday—the job only offers $60 a week. Ugh. However, I told them I'd take it unless something better turns up during the week (mainly Naval Museum job). I'm entering the Boston Fine Arts Festival which is for artists all over New England, and is judged by Edward Hopper, Robert Motherwell, [Henry] Varnum Poor, [Theodore] Roszak, & [William] Zorach. Entering a new outer space collage, and a woman. As for ideas I've too many. And no, I've done very little actual painting. My momentary conditions (little bitty room mostly) are just not made for painting. But I draw a lot, make collages, and small water colors. Most of my new work encompasses my own writing too. That is to say that my own words are part of it. At the moment I'm working on a series of ovals and squares which will fit together, creating, I think, a kinda complex world in itself. I don't really mean "complex"; I mean "complete." So, if I start working for Magna I may be in N.Y. soon. However, I really don't know what the hell I want. I broke plans for show in Tulsa: not planning to return this summer. Boston is fine and all, but I belong in N.Y. The Science Museum here is a farce: no fish. [Remainder of letter missing.]

Mid-1969, 74 Jane Street, New York City[2]

Dear Sandy___

I'm sorry that I haven't written sooner but I just finished my show the
morning before it opened and the day after it opened I came down with the
flu and have felt like shit all week. And I am especially sorry that you and
Ted have split. I still do not believe that it is a permanent split. Hope I'm
right. Being sick, I haven't seen Ted at all: except at the opening. I have the
usual after-show depression. I feel extremely empty inside. As tho it's me on
the walls. It sounds corny, I know, but—true. I can't say "yes" or "no" about
staying at Kenward's because it's his place (& other too complicated reasons).
Do write & ask him tho. He is now right in the big middle of the musical
(casting, getting money, etc.) and somewhat of a nervous wreck. It's a stupid
business. I hope that from this musical he learns his lesson. I loved the draw-
ings. Especially the pumpkin which is on my bulletin board along with your
Christmas card and your Valentine's Day card. Both of which (also) I loved.
I'm sorry that I haven't written you this year but I've been pretty much of a
nervous wreck myself: doing this show. I'm so glad it's over. I have learned
my lesson: don't fake a show. If you've got it, show, if you don't have it, wait
until next year. I do hope you can come to the city soon. Have a very happy
Easter and "hello" to David and Kate [Berrigan].
Love, Joe

October 25–27, 1969, 74 Jane Street, New York City[3]

Dear Sandy__

It was great to hear from you.
 Where to begin?
 I'll begin with today. Today I worked mostly on my "Frank O'Hara"
piece for the book about Frank. It's very hard and not much fun. I don't like
having to say Frank was this or Frank was that. It's about 5 o'clock now and
I'm very tired. So if I don't make much sense that is why. Also I'm just very
much up in the air these days. For personal reasons. And because I'm in the
middle of moving. The personal reasons have to do with life with Kenward
getting a bit stale. And with me. I'm tired of being such a bore in many ways.
And my painting. I don't know where I'm going with that. "Art" seems a
bit silly to me these days. Now I hope I'm not depressing you. These days

for me are very up and down. So I don't take down very seriously. Because I know that tomorrow I'll be up again. So_____

Mainly I am just marking time until I can move. Yes, I did find a loft. It's not as big as I wanted. But it was the only "livable" place I could find that I could afford. It's on 6th Ave. Right next door to a big orange church at 20th street (moving up). And it's the top floor. And I have a kitchen, a bathroom, and a special shower room, three air conditioners, and a sky-light. But I can't move in until November 1st. (So, as of Nov. 1st, my address will be 664 Sixth Ave). Jimmy Schuyler is in town and I'm having dinner with him & Kenward tonight.

News:

Got a haircut.
Do push-ups every day.
Eat a big breakfast out every morning.
Go to bars a lot and get drunk (on purpose).
It's fun (queer bars).

So you see I am not exactly the same Joe. As I am sure you are not exactly the same Sandy either. And that's what makes writing you somehow difficult (tho I'm having no difficulty at the moment). I do hope you realize tho that not writing has nothing to do with how I feel about you.

I'm going to stop now and get cleaned up for dinner. It's very cold outside. I'll write more on (in) this letter tomorrow.

"Tomorrow" was Sunday and now it is Monday already. I just didn't feel like writing yesterday. I finished my Frank piece and that, word-wise, wore me out. Today is going to be a practical day. I'm going to throw more stuff away. Pack up some more stuff. Pick up a package at the post office. And go to the bank. This is going to be a very quiet week. The only "event" (so far) is Jim Brodey's reading on Wednesday. It is going to be a quiet year in N.Y.C. (Ron & Pat gone). (Anne [Waldman] & Lewis [Warsh] split) etc. Did I tell you that I'm going to have a show in California next September? Also, I may come (go) out to California this spring for a month or so to work on doing a series of prints. Already this is page six and I feel as tho I haven't really "said" anything yet. I can't imagine how big David and Kate must be by now (?). I saw Ted last time he was here and he seemed in great shape. A bit lonely. But it suited him. I mean, somehow he was easier to talk to. Well, do write me again. And I will try to write you a better letter next time. Do

you have a boyfriend? And do you have any idea where you want to teach next year? Take care,

<u>Love you</u>,

Joe

Summer 1983, Calais, Vermont

Dear Sandy,

Just a note—(really, it's all I can do!)—to thank you for your sweet and odd words.

I think of you, and us, and "then" very fondly too.

Personally, I don't think death is as bad as pain, and so I can't feel as sorry for Ted as I do for us.[4] I am afraid it would have only gotten worse for him (physically) and it's almost as though he <u>chose</u> to die. Or so I would like to think. Not expressing myself very well, but perhaps you know what I mean (?).

And so I am sad, but not sorry.

Am having a healthy summer in Vermont, cozy and typical. Brown as a boot, and 15 pounds heavier.

Still can't paint or write, so I draw and read.

Just finished Proust, again! (In three weeks!!!).

And that's about it for "news."

Will <u>try</u> to be more available next time you come to the city.

Oh yes—the past is as present as ever, which includes my feelings for you.

Love, Joe

7

DEAR JIMMY

The poet James Schuyler, a central figure in the New York School of poets and painters, met Brainard in 1964. The two soon became close friends and confidants.[1] Brainard's letters to Schuyler included here span from the summer of 1964 through 1971 and were written while Brainard was moving from apartment to apartment in New York City and spending summers in Southampton, Long Island; Calais, Vermont; and Bolinas, California. We find Brainard complaining about crummy avant-garde plays and bad meals, describing his continuing efforts to paint, draw, and make his constructions; his delight in finally meeting John Ashbery; and a new writing experiment he was working on called *I Remember*, the book that, with its innovative fragmentary autobiographical style and poignant reflections on growing up queer in Oklahoma and New York, ended up establishing his reputation as a writer: "It is just a collection of things I remember," he writes modestly, adding, "Unfortunately, I don't have a very good memory, so it's a bit like pulling teeth." The selection ends with a short letter to Schuyler written when Brainard had just arrived in Bolinas, a small town north of San Francisco that poets including Joanne Kyger, Robert and Bobbie Creeley, and Bill Berkson called home. Brainard memorialized his stay in *The Bolinas Journal* (Bolinas, CA: Big Sky Books, 1971).

July 5, 1964, Mercer Street, New York City[2]

Dear Jimmy,

"C" comics is almost out, but not quite. At any rate, here is the last "C."[3] I don't think you've seen Ron's book.[4] So I've lots of room now, which I use well

in the daytime, but at night it just makes me want to walk around in it. But I never have known exactly what to do in the night time. It's terribly anti-climactic after a good day of work. The best thing to do is read. And that is what I do, usually, but to go out is best. And you? However, the address for the mail is still the same. I'm working on two giant (to me they are giant) canvases which build up to painted wood constructions, centered. What I like best about them is that you are not too certain if what you see is what you really see or not: because each thing sorta cancels out the next. A lot of what you see you only sense you see, but you don't really. Aside from all this they are quite beautiful. And I usually have a tendency to be a little indulgent, and now am not. So at least for the present that is good. I am not one to complain because it obviously gets you nowhere and I do like cats. But at night there is this horrible cat that climbs up the fire escape from I do not know where, always in uncontrollable heat, wakes me up purring, and hairy, and really quite frightening since, not being used to cats, I never know what is going on. And to shut the window is to be hot. At any rate, last night was the 4th and an awful lot of people had fire crackers. However, I did enjoy the noise. I don't remember it stopping until this morning waking up, there was none. I read "A Nest of Ninnies" yesterday again and really did like it again.[5] It is the kind of funny I enjoy the most because you get to give yourself a lot of credit, too, for finding it so funny. What I mean is that I could read it again I'm sure, assuring myself that it wasn't funny, and it wouldn't be funny at all. If that doesn't sound like a compliment it is anyway. Kenneth [Koch] and I have done an 18 page comic called "The Box" which is about this nurse who would really rather write novels, but who most of all wants to marry the emperor and rule the world. However, she does neither. Altho she almost does rule the earth. Also today I read "Big Sur" and cut my hair.[6] I didn't like "Big Sur" too much, but I didn't think I would. I thought it would be entertaining tho, and I wanted to read something entertaining. However, it wasn't. Yesterday Ron and Ron's wife Pat and I found some superoxide and decided we'd try it. But Pat chickened out. And once Ron and I had dabbed some on we both realized that we didn't want a blond streak of all things, so we washed it out. The next issue of "C" is going to be a play issue so we have been busy writing plays.[7] My play is about health, involving primarily Nurse Jane and Doctor Tom. It's quite good except that I couldn't end it so I ended it with the last act being a secret. Which, of course, is what I did do. So, somehow, I've still to write a final act. I am afraid that I am not so good of a writer except on some occasions. At any rate, I am working on illustrations and a cover for Ted's 88 sonnets which we are preparing to publish.[8] Not illustrations, of course, but I do hope to keep the same tone of voice as much as possible. And actually, there aren't 88 anymore.

Emilio—?,[9] this Spanish dealer, took 19 of my paintings—collages—col-
laborations on consignment to his gallery (Gallery Moos) in Toronto, and
I <u>do</u> enjoy money.[10] So this is good news. Also, there is some exhibition at
Finch College in Sept. where more well known painters pick younger ones to
exhibit with.[11] And I get to show in that with Larry Rivers. (I'm impressed.)
Actually, I think some of the people suspect me of "trying to get ahead." The
funny thing is, I am. At any rate, do you remember that beautiful long plant
of a vine sort that hung in the corner of the studio part, up high, of Robert
Dash's apartment. Well, it fell down with a giant noise. I put it in a new pan
and I tried my damnedest, but I'm afraid it looks quite dead. The cord broke.
Unfortunately, "C" will not fit in this envelope and so I will mail it to you
when I mail the "C" Comics. So write. I would like hearing from you.
Love, Joe

August 1968, Southampton, Long Island[12]

Dear Jimmy__

Wouldn't you know it? My rose petals didn't work out. Some of them were
not dried enough when I put them into those small Welch's grape juice bottles
and so they mildewed and turned green. So I had to throw them all away.
Now, however, I have begun sand bottles. (At night) I don't waste my time
with such stuff in the daytime. At any rate—I have many colors of sand now
(food coloring) all in many dishes all waiting for tonight (everyone is leaving
tonight) when I'm going to see if it works. I have seen beautiful ones with
very intricate designs but for my first one I will only do stripes. A nice size,
those Welch's bottles. I don't, however care for the juice. When Pat and Wayne
[Padgett] were here they would drink it for me (and loved it) but now I've
nobody. I had (just had) several days of bad painting (sloppy) but today was
very good. Today was (is) the most beautiful day I can ever remember: *very*
sunny and very cool. And very quiet: Sunday. Many Sundays seem somehow
odd to me, but today was just perfect. I do love it here. It just doesn't make
sense to go back to the city. Except for people. That's where so many of the
best people are, to me. The phone is ringing but I am in the studio. Kenward
is out watching the annual tennis tournaments. John and Scott are at the
beach. John and John Scott (I don't mean John and Scott, I mean John and
John) are driving back tonight to the city. John to visit his mother for her 75th
anniversary. I am talking of John Ashbery and John Scott, John's new colored
boy friend. I was afraid that perhaps you would get confused with John
Button and Scott Burton. John and Scott, you may not know, have broken

up. As I understand it tho, it was a mutual split. I am drinking a rosé wine. It's
about 5 o'clock. Once everyone gets back together we are going to an opening
around the corner of Leon . . . (can't remember) He is a very old romantic-re-
alist and slick with lots of birds and fish nets.[13] You know his work I am sure.
Very much like Bernard.[14] Morris Golde says that Fairfield [Porter's] paintings
looked terrific at the Biennale.[15] He was very impressed with the number of
them: said there were "lots." I did some yellow pansies this morning with Fair-
field's yellow-black for green. I think that I would have done it anyway (?) but
I always think of it as Fairfield's thing: yellow black for green. Actually, I have
seen it in very few paintings that I have seen it in : one being the one I have. I
hate to see today go. Will write more tomorrow, or soon—

Well—they didn't leave around six as planned but instead we all (except
Kenward) went to a queer beach party with Safronis [Sephronus Mundy]
and Jack (know them?) Safronis is from Sodus, like John A [Ashbery]. At any
rate, it got 40 degrees and so we didn't go to the beach but instead to some
terrible interior decorator's place. His name is Jack. I have never (no exagger-
ation) met anyone so disgusting in my entire life. Also there was a beautiful
Indian boy who has been after me for several years now. I must admit that he
turns me on terrifically. There is something fishy tho as he is so beautiful he
could do a lot better than me. He is the Gerard Malanga type but he really
has what it takes to be that type. He may know him he is quite notorious :
Tosh Carrillo. At any rate, I have come to regard him as somewhat of the
devil. Anyway, it was upsetting seeing him last night. (Temptation) I think
you know me well enough to know that I am rather liberal. I've had many
affairs since I started going with Kenward and I don't feel one ounce of guilt.
But this Tosh guy, there is really something dangerous about him. I hope you
don't mind my telling you this. It shook me up so much to see him again as,
of course, I'm very attracted to him too. I hope by telling you about it I can
forget for a while. So—today is another beautiful day : cool and hot. There
is (like yesterday) a bit of autumn in the air and yet the sun is shining very
brightly. It's really the best of both seasons and I love it. This morning I got
up at seven and picked 3 pansies and put them into 3 small bottles. One yel-
low pansy, one red-purple and yellow, and one solid blue-purple. I did three
paintings of them (all 3 in each) and I am sure that at least one of them will
look good in the morning. They are not so loose as before. More like summer
before last. When I finish writing you I am going to read "Le Petomane"
(about a French farter) And tonight I planned to do my first sand bottle.
Oh—the opening yesterday was paintings by Leonid.[16] They weren't very
good but I rather admired a very details [sic] : details painted with one or two

strokes of the brush. Like birds. Gore Vidal was there he looked quite young
(35–40). Today is the 12th. That means we have about two more weeks.
Right? Some of your house plants don't look too great. I think that at first
I watered them too much. They are not dead tho. So far there hasn't been
any serious damage done. A chunk of black linoleum in the laundry room
came up. Too much water was left at various times on the wooden tops in the
new kitchen part : a few black streaks in the wood. I am watching it carefully
now. I'm going to get this in the mail now. *Do* write soon. Summer is almost
over and winter will not write much. One thing I forgot to tell you is that
I use your bike. I love riding it and I knew that you would not mind. Did I
tell you that we are going to give a cocktail party for Jane [Freilicher] for her
opening? Not Sunday (the opening), but Saturday before.
Very much love,
Joe

P.S. Did you see our names in the Sunday Times? About painter poet collabo-
rations by Peter S.[17]

June 1969, Calais, Vermont[18]

Dear Jimmy__

Last night (how nice it is to be writing to you again) I made a real strawberry
short cake. I found the recipe in a "Family Circle." I must say it was awfully
good. And very easy. Egg, butter, milk, flour, baking powder, salt, and bake
for 15 minutes. Today is my second day in Vermont and I love being here. I
especially love being here because I know I will be here for ten weeks. What
to do? That's what I am thinking about now. Mainly I just want to paint but
also I want to get my manuscript together and do an issue of "C" Comics.
This is too much to do in 10 weeks but I imagine that I will try. If I had any
sense in my head I would just paint and forget everything else but I enjoy
"everything else" so much that I find this hard to do. So—as usual—I am
torn between this or that or both. And—also I will pick both. It is still a bit
cool up here. I continually (so far) wear a sweater. This morning (actually, it
is still morning) I wrote a bit on a new thing I am writing called "I Remem-
ber." It is just a collection of things I remember. Example:
 "I remember the first time I got a letter that said 'after five days return to'
on the envelope, and I thought that I was supposed to return the letter to
the sender after I had kept it for five days."

Stuff like that. Some funny, some (I hope) interesting, and, some down-
right boring. These, however, I will probably cut out. Unfortunately, I don't
have a very good memory, so it's a bit like pulling teeth. I've been eating lots.
I weighed in at 140 lbs. and I plan to arrive in N.Y.C. weighing at least 150. I
plan to do this by eating lots and:

- 2 glasses of milk with Ovaltine everyday
- 1 big spoon of honey everyday
- eat lots of nuts at night
- vitamin B-12 pill every morning

I might even cut down on my smoking, but I doubt it. I am afraid that
I don't really care that much. In Tulsa I picked up some old school photo-
graphs of me. Enclosed is one of me in 1951. I also got some old newspaper
photos and clippings of me which are very funny and very embarrassing.
I'll send them to you soon but I would like to have them back. Do keep
this photo tho, if you want it. I am tempted to draw a line and write more
tomorrow but actually I would enjoy this being your first summer letter so
I'm going to go ahead and mail it. Do write.
Love, Joe

July 4, 1969, Calais, Vermont[19]

Dear Jimmy__

You can't know how nice, really, it was to get your letter. You write such
nice letters even when you have nothing in particular to say. I am outside
sunbathing again, and so are Anne [Waldman] and Lewis [Warsh]. Kenward
is at the cabin he is writing, but surely nobody writes that much. Yesterday I
sorted out all my oils, lined them up according to colors and stretched two
canvases: 18" × 24". I thought I would start painting today but the sky is so
clear and the sun is so hot, and actually, I didn't (don't) especially feel like
it: painting. So—perhaps tomorrow. But I refuse to rush myself. No reason
to except nervous habit. And nervous habit only produces works like I've
done before. Which doesn't have much to do with "painting," as I see it. Or
as I think I see it. (I don't know what I'm talking about) Anne and Lewis
are terrific people to live with. Lewis (so far) remains just as mysterious,
but in a friendly sort of way. Anne is just as nervous as me, which makes me
feel not so nervous. We smoke a lot of "you know what." Talk a lot. Eat a

lot. Play cards some. (Pounce and Concentration) Did you ever play that?
Concentration. I like it. If you don't know how to play it, let me know, and
I will explain it in my next letter. It's very simple really. We read a bit every
night from a "Woman's Circle" or a "Woman's Household" which reminds
me: I want to send you some issues. Will soon. I don't know how much
I weigh now as we discovered that the scales are irregular. So—I am just
eating a lot, altho it is not as much fun without being able to see (read) my
gains. Next time we go into town, however, we are going to get a new pair.
This I have never understood. Why scales are called a "pair." Today is the
4th of July. Happy 4th ! We here aren't going to celebrate much, as far as I
know, except that for dinner we are having a Harrington's ham. There is a
4th of July parade today in East Calais, but I said "no thanks" to that, which
put a damper on going. Nothing is more frightening to me than "Elks and
Masons" and their children, etc. Besides, I don't enjoy being an outsider. Did
I tell you of a funny dream I had several nights ago? I don't think so. At any
rate—John Ashbery and I were chatting on my parent's front porch and John
said to me, "I think your Mondrian period was even better than Mondrian."
Actually, I never had a "Mondrian period" but in my dream I remember
recalling the paintings I had done. They were just like Mondrian except with
off-beat colors. Like slip [*sic*] peach and plum purple. Olive green. Etc. At
any rate, I was awfully flattered. Frank O'Hara and J. J. Mitchell were there
too, but I won't go into *that*. Other people's dreams are never as interest-
ing as it seems they ought to be : to other people. Your advice is good. I do
eat lots of nuts and I have been trying to eat as much as possible. Actually,
getting better looking will probably only get me into more trouble, and
make life more complicated. If I was wise I wouldn't even try—but—once
again—pardon the oil on this letter. It does help tho. And a warm shower
afterwards. I am enclosing for you some "Button Face" note cards I sent away
for from the "Woman's Circle." They're very funny I think. Kenward and I
have both been sending away for lots of stuff in order to get mail. Kenward
has got lots of seeds. I got a "forget-me-not" necklace ("like grandma used to
make") which is somewhat of a disappointment. Also I got some crocheted
butterflies which I gave to Kenward in celebration of the 1st day of July. They
will be sewn on to curtains. I also got some "music post cards." (Post cards
with music on them) And some stars you glue to the ceiling and they glow
in the dark. Like decals. I put them up in Anne and Lewis's room and they
like them. Someday it would be nice to do a whole ceiling. Also available is a
friendly moon. I just went in for a Pepsi. It is now one o'clock. This after-
noon I think I will get out my Polaroid and see what happens. Maybe we

can swap pictures. Like those clubs do. Of a less intimate nature of course.
In your next letter to me would you please sign your name (your autograph)
on a piece of white paper. I am beginning to put together my poet's scrap-
book and your autograph would be a big boom [*sic*] (Or a drawing?) I have
drawings already by Ron and Ted and Frank and Kenward. Also I have many
photos and clippings and wedding announcements, etc. It will be a nice book
that will never end. The sun is really *very* hot today. Now I am sunning my
back. This will be my first all-round tan since I was a kid. Kenward is doing
pretty well too, tho his skin doesn't tan as fast as mine. Obviously I am run-
ning out of talk. Will stop now. *Do* write again when you feel like it.
Love, Joe

P.S. Anne and Lewis city news:

John Giorno and Jasper Johns are back together again.[20]
Pat and Ron leave for Tulsa this Monday for one week. Then three weeks trav-
 eling around California.
John Wieners' parents had him committed but a plan is being worked out to
 get him out.[21]
Dial-A-Poem will be continued next year from the "St. Marks Church."[22]
Bill Berkson has moved. His new address is 107 E. 10th St.
D. D. Ryan has been promoted to assistant producer, and now, is actually in
 the movie.[23]
That's about it.
(again) Love, Joe

Mid-July 1969, Calais, Vermont[24]

Dear Jimmy:

Flowers not going too well. All the different greens (which seem to change
from moment to moment) are driving me up the wall. Also—there is a
red-purple I just can't get. Also my wild flowers are too curvy (Art-Nouveau)
and I can't seem to straighten them out. A line (stem) like this [draws a
smooth upward curve] always seems to end up like this [draws an upward
curve with kinks in it] and, when I try to straighten them out, they seem flat
(life-less) not that I have anything against curves. But my flowers are prac-
tically flying out of their bottles, off the canvas, to god only knows where. I
never have liked El Greco much. Except for one pope. So—I am not painting
today. A break. I am sunning. Today is a beautiful clear day, very blue, with

not a cloud in sight. The sun is hot. It is about one o'clock. Kenward is com-
ing back from the city around seven tonight. The whole back of me is peel-
ing, as one day it got too much sun. So—I will have to start all over, little by
little, as for several years it has been totally neglected. (Sun-wise) Not much
is new. Except that the day lilies are out. The orange ones. In full bloom.
All over. There are many more of them this year. And the milkweeds. They
are <u>everywhere</u>. Which is O.K. with me. I like them. I read somewhere the
other day that during the war they were used for lining coats. (Their fibers,
or something, make good insulation.) Army coats. For very cold weather. It
also said that their very small top leaves (the top two or three), when cooked
taste like asparagus. I would say they taste more like spinach. And not very
good spinach at that. Perhaps we didn't cook them right yesterday. After oil
painting all morning (I got up at 5:30!) I picked some grass and did lots of
green ink and brush drawings of it. I am now cutting the grass out (with an
X-Acto knife) and then I am going to put it all together, in layers, to make
a solid patch of grass. (11" × 14") So far I have cut out two layers. It is quite
delicate cutting and I have a big blister to prove it. (Delicate, but hard) It
will be very pretty I know. It can't miss. And it's a good thing to do (cutting
out grass) around 4 or 5 o'clock when your head is tired but you are still sort
of wound up. Just before a drink. I plan to do a fern one too. If we ever get
to Burlington (to get some more X-Acto blades). As it is rather intricate
cutting one blade will not cut very much so finely. I could always send to
the city for some. (Mail!) Now I am not sure what to do about my two oil
paintings of two wild flowers arrangements. The actual flowers are gone now
so I have a choice of "faking it" (which I am very good at) or forgetting them
and start some new ones. I think I will do this (start some new paintings) as,
if I'm going to fake it, I may as well wait until I get back to the city. Mean-
while, perhaps I can do some direct, here. I must keep reminding myself that
this is not my purpose, now, to "produce good paintings" (rather to learn)
about oils. About how things look. About color. Etc. Color *is* a real problem.
I don't know the tube colors so well as I know tempera jar colors. So I have to
think. And thinking isn't much good when it comes to color. From tempera
painting I remember the best "right" colors more or less just happen. Do you
know anything about toe nails? My right foot is bigger than my left foot and
cowboy boots are not very good for you, but I wore them a lot last year any-
way. The result is that my big toe nail is so squeezed together and it is very
thick and sort of yellow. My idea is to file the entire nail (the top half, actu-
ally) down to how thin it ought to be. Do you think this would hurt? (The
nail) That is to say, is a nail the same all the way through? I would hate to
file away the surface of the nail and find something different underneath it.

There are several health books here, all with toe nail sections, but you know
how health books are. (No real information) They are cutting down some
trees off to the left. (If one was entering the front door) So for days there has
been constant sawing. What we hear, I guess, is like an echo. Like a car trying
to start. One does get used to it tho. Mrs. [Louise Andrews] Kent's son owns
that land. Aside from getting lots of wood, it is supposed to be good for the
land. (Thinning it) So Kenward said. So Ralph [Weeks] told Kenward Mrs.
Kent is in the hospital. I don't know if you know her well enough that you
would want to send a card or not. I don't know exactly what is wrong with
her except that, really, she is very old. It is the Montpelier Hospital. The one
Ron was in. Pat and Ron are either in Tulsa, or on their way to California.
Or perhaps *in* California. It's hard to keep track of the date up here. And I
don't know their plans anyway. (Date-wise) Sometime in August they will
come up here next to visit some. Unless, by next year we are not very close.
Which is possible. Actually we weren't terribly close this year. Old friends
don't want you to change. And, of course, it works both ways. Or, perhaps it
is just harder, around old friends, to try to change. At any rate—sometimes,
around Pat and Ron (and especially Ted) I don't feel like myself. (1969-wise)
Of course, there are compensations. Like—I always feel very comfortable
around Pat and Ron. And that's **NICE**. I'm going to sign off before I find
myself with a whole new page to fill. There has been no mail for two days
as Kenward has been away. So—if I have received a letter from you and not
mentioned it, this is why I haven't received it. Do write.
Love, Joe

P.S. Actually, Ron is trying. Two times last year I got a kiss. And after seeing
the Royal Ballet he said that Nureyev has a rear end like mine. For some
reason I was very touched by that. (Wish it were true).

August 1, 1969, Calais, Vermont[25]

Dear Jimmy__

The sun is out but filtered through a totally gray sky. But thinly gray. So—
actually, quite a lot of sun is getting through. Bill and I tried collaborating
this morning, but no dice. It can be very frustrating, I find, except within
a cartoon form that, somehow makes it all make sense. Otherwise you
just end up with words on a picture. Unless you are Larry Rivers and your
paintings can really "use" words. (Visually) A new letter from you arrived

yesterday and, of course, I loved it. Congratulations on the red glass. Things have really been hopping since I last wrote. (Lots of visitors) Two nights ago the Katzes [Alex, Ada, and Vincent Katz] dropped by for dinner, to spend the night, and breakfast the next morning. Early. Then left. The night of their arrival we had a lot of fun playing charades. Then, the next afternoon, Ted and Donna [Dennis] came by. My heart sunk at first but then I adjusted to the idea of them being here, and we had a lot of fun. Got very high. We all did. On hash and pot. That night we played charades again. Then the next day we took some nude photos of each other. I took most of them. Some of Ted and Donna together and some of Bill and Kenward together. And a lot of Bill just by himself. Then Ted and Donna left (about 3) and I sunned for the rest of the day. So—actually—it was a very nice visit. Not much more than 24 hours all together. Ted was his usual self (talk-talk) but it was fun for such a short time. And being high helped. I like Donna. She seems to me both conceited and shy : a pleasant combination. I have started writing in my diary once again. Every other day I decide to stop. And every other day I decide not to stop. Well—if nothing else—it gives me something to do while sunbathing. Bill says I should be careful. He says it is really quite dangerous. Sunning so much. I suppose he is probably about half right, but I find it hard to care. Last time I wrote you I remember I was feeling sort of low. Well, I don't really feel low today. But I don't feel especially good either. Today is the first day of August. About the grass. No, I am not afraid to send it to you. I think tho, to play it safe, I will just send it in a plain (no return address) envelope wrapped in plain paper to feel like a letter. (Recently the post office here found pot inside a teddy bear) I don't know how they found it. Perhaps because it was addressed to "Goddard." I can't imagine anyone being suspicious of a letter addressed to Sunset, Maine. Speaking of grass, the word from New York City is that there is none. Perhaps an exaggeration. Kenward just walked in front of me with string in his hand over to the vegetable garden. Perhaps to tie up the peas or something. Tomatoes. So far, from the garden, we have eaten some lettuce and some radishes. The more I write the more cloudy today is getting. The thin light gray is not very heavy and dark and no sun is coming through. Write again soon.
Love, Joe

P.S. Your comic ideas sound great. Send them on up, ahead of yourself, if they are things I can do without your being present.

Love, Joe

Circa August 10–11, 1969, Calais, Vermont[26]

Dear Jimmy___

It does seem a long time since I have written. John and Pierre [Martory] just left to come and see you. (To go and see you). At any rate—it was nice to have them here. And it is nice, also, not to have them here. Right now I just feel very much like resting. I admire very much the way John can turn people on. (Me) (And Kenward) In the city I have noticed how John is around. Today is a beautiful sunny day and I am outside sunning and resting. Tho I feel a bit funny doing so. As the workmen are still here, working all around me. As today is their last day I thought I would wait until tomorrow to sun and relax but then if tomorrow is not sunny I would be awfully disappointed. So—here I am. Today, so far, they are finishing painting the fence and finishing painting the grape arbor. All of a sudden I am not sure that I told you that Mrs. Kent died. I know I told you in my head but I am not sure I got it on paper. I think I did. (?) And if not, there is nothing to tell really, except that she died. And that she wanted to die. (Ralf [*sic* Ralph Weeks] said she did). Yesterday was his birthday and Kenward is giving him a Harrington's ham and one of his two paintings by Mrs. Kent. (Ralf) I suspect that there is one more letter in "Ralf." Like a "u?" (?) At any rate—John, while he was here did a collage strip for me to do. Somewhat like you did the rain one only he collaged other spoken words over some of the real ones. (The ones that belong to the pictures) I showed him your rain one as I think it is so funny. Hope you don't mind. Your long poem is very mysterious altho I am sure I like it, I don't feel qualified right now to say that I do. I feel, rather, that it is a bit over my head. I don't like being (sounding) so modest, but in this area it really isn't modesty. I was thinking the other day that probably why most of my collaborative efforts work so well is that I admire poetry very much. Which has nothing to do with understanding it, as most people would assume I do. Words, other than the very basic ones, are so abstract for me. Let me tell you how I feel these days. Very nervous and anxious. About and for what I do not know. Perhaps I feel right now that I have no place to call my own as I plan to move as soon as I return to the city. (?) Or perhaps I am anxious about art, which is a very big part of my life and yet, right now, it isn't. I don't feel like very much of an artist these days, but I am not much of anything. It all seems a bit silly and hopeless to me (art) and yet I cannot imagine doing something which seems silly and hopeless to me. The whole thing, of course, is probably a passing phase, but I do wish it would hurry and pass. I am also anxious about Kenward. We get along fine and all that. Sex is good. And I will never have a better friend. But

there is something missing in the area of passion and adventure. Or something like that. And there is something in me right now that makes me want to drastically change my life. Breaking up with Kenward is the only way I could do this. I would be <u>forced</u> to live differently. I would be a fool to do this. I know. What worries me tho is that it is constantly on my mind. This is very much unlike me as all my life I have been so good to myself. What is perhaps even worse about this situation is that it does become to me a dare. That is to say, "Do I have the guts to do it?" (Totally break away and start life all over again) Like if I don't do it I will be a chicken. I am not asking for advice. I would, except that I don't think there is any. I shouldn't even be telling you this. (But, actually, I feel <u>right</u> telling you this, even if I shouldn't) So—from my point of view—I should. But perhaps for you it is awkward or embarrassing. The funny thing about it all is that actually, Kenward and I are very happy together. I cannot imagine a more perfect relationship. So—the problem is me—not our love. I do not trust words very much so now I am wondering how this is all going to sound to you. <u>Do</u> do me a favor and take it all with a grain of salt. (Is it <u>with</u> a grain or <u>as</u> a grain?) Kenward is at the cabin writing. (I assume) That, as he left the house, was his mission. You know, I hate to sound so goody-goody, but the truth of the matter is that I love Kenward so much I don't think I could possibly hurt him. This is another problem. And surely to my advantage. Perhaps just this will keep me from doing something stupid. And sometimes I have doubts about myself in the money area too. Which makes leaving Kenward even more of a self dare. I do hope that I am not making myself sound terrible. Because you know I am not. I feel very little in control. Which is to say that "life" is partly responsible for my confusion (I <u>do</u> believe that) corny as it may sound. I miss not liking myself as much as I used to. (I am going to change the subject) Did the you-know-what arrive? Kenward and I both agreed that it was somehow the most suspicious looking envelope we had ever seen.[27] With such neat writing (My attempt at forgery) and no return address. Also, through the envelope one could feel the lines of the paper inside but with no writing on them. (The lines) But I am sure it arrived O.K. Yes? Thank you for your last two post cards. I am enclosing a clipping about <u>you</u> from a Tulsa newspaper. Ron sent it to me. I imagine that he sent one to you too, but just in case. Also I am enclosing the two addresses you want. (D. D. [Ryan] and Bill) Bill's birthday, if you are interested, is August 30th. I am not doing so well in the weight dept. Altho I am holding my own (the 5 extra pounds) but I cannot seem to make it more. Partly, I think, because I have lost some interest, altho I try to pretend I have not (lost some interest in gaining weight). Pat and Ron and Wayne are to arrive (I think) next Monday or so. What I would really like right now is a big bottle of pills.[28] Not that I believe

in them after I take one. It's a bad habit, but you know how liberal I am in the bad habit area. At the same time, however, I believe in self-control. In all of my years of off and on pill taking I have never taken in one day more than one. And never over a long period of time. Knowing what they did to Ted cured me of any temptations in that (over doing it) area. So much for pill talk. You will be very surprised when you see the landscape around the house. That's all I'm going to say. It is very hot today. Do write soon.
Love, Joe

P.S. All this stuff about my wanting to change my life (totally) is probably just a fantasy running around in my head. So please don't take what I say too seriously. It is true. But I don't know how true. But I don't seem to know anything these days. Not that I ever did. But at least I used to think I knew something. Once again—

Love, Joe

Mid-August 1969, Calais, Vermont[29]

Dear Jimmy__

I only wrote you just yesterday but there is something I keep wanting to ask you but I keep forgetting to do so. And that is if you will please save anything you run across that has anything to do with bananas. I want very much to finish my manuscript before summer is over. One part of my manuscript is a banana book.[30] Like a scrapbook. (Banana jokes, "Believe It Or Not" banana things, clippings, pictures, etc.) I need more because "it's" [*sic*] being funny relies somewhat on there being a lot. So—if you happen across anything about bananas (even something not about bananas but with the word "banana" in it) please send it to me. Thank you. It doesn't have to be anything funny or inter-esting because I am "redoing" the stuff (and rewriting) in ink. I worked some this morning on a photo album-like cartoon that Kenward wants to do. I filled in some words on a fuck cartoon (also Kenward's) and I wrote a letter to Bill. It is about two o'clock now altho the sun is not exactly out I am in it anyway. (It comes and goes) Kenward is snacking in the kitchen. I'm tired. I don't know why. Rather than mail this little bit I will probably write more tomorrow. I just wanted to ask you for "banana" stuff before I forgot again. Until tomorrow—
Love, Joe

✳ ✳ ✳

Dear Jimmy—

I am afraid that several days have passed since I last wrote. Before I forget let
me tell you that every time we go into town we forget about your bus thing.
However, we have to pick up Pat and Ron and Wayne Monday at the bus
depot so we will surely not forget then (today is Saturday). This morning
I did the "Our New Age" strip. I love it. It is very much like a wet dream,
minus the juicy parts. But it is somehow very sexy anyway. I drew the strip
as "straight" and as accurately (to the originals) as I could. It has that boring
quality tho it is not so slick. I can never seem to get that kind of slick, tho
I do try. But the clumbsy [sic] in me comes out. (I believe it is "clumesy"
[sic])" Oh, well—as usual not much is new. Except that for the past 2 nights
I have won at Pounce. No new flowers. I guess that autumn is coming.
(Soon) How was John and Pierre's visit? Any sun? We've been having
nothing but sun. Katy [possibly Katherine Porter] sent me some nice black
rocks. Kenward wants to buy a boat. A canu. (I *know* that isn't how you spell
it.) But I don't know how you *do* spell it. For exercise (rowing) we looked at
some yesterday. Most are too big. The closest thing we found to what Ken-
ward wants is orange plastic ($98) and actually not a canu. It is a row boat.
Which I think would be better than a canu anyway. I imagine that Kenward
will get it. I don't want to start a whole new page—so will stop now. As
always write. And as always—
Love, Joe

July 4–5, 1970, Calais, Vermont[31]

Dear Jimmy__

It's July 4th. It's raining outside. It's *hot*. And heavy and sticky. And about
three o'clock.

I'm doing supper tonight with ham and carrots in maple syrup and butter
and raisins and fresh mint. Also fresh peas. Salad. And strawberry shortcake.

Cynthia [Elmslie] and Willie [Weir] are here and also "Little Vivy" (Cyn-
thia's daughter) and one of Cynthia's sons is coming in an hour or so. He and
another of Cynthia's sons bought a farm together not so far away. "Little Vivy"
(as they call her) I am sure you remember. (Very quiet with long blond hair)

Kenward is in the bathtub.

Last night Cynthia got "stoned" with us but Willie said he'd stick with
liquor, and that he did. (Actually I like him more than I thought) He is,

however, totally a bore. (I don't know if that makes it better or worse) Of course—nobody is *really* a bore. (He does come awfully close tho.)

Actually, I don't think that Cynthia really got "stoned" but she thinks she did. She said the green of the green glass lamp shade was greener than it was "before."

I think it's a bad habit I've gotten into using quote ("—") so much.

It *does* make writing easier tho. I seem to be under-lining a lot these days too.

Did I tell you that the pipe situation got fixed just before they arrived. And I do mean *just*.

This morning we went to the 4th of July parade in East Calais. Local events make me feel like I imagine Harold [Clough] would feel at a Gotham Bookmart party.

One "Float" was a white convertible with a sign on the door saying "Jane's Style-A-Way." (A Montpelier beauty parlor just across the street from "The Lobster Pot") Inside were riding three women and one little girl. All of whom had obviously just had their hair "styled."

There were lots of fire engines covered with Boy Scouts. One Boy Scout hanging on to the back of one engine gave Kenward the peace sign. [Little drawing of a hand giving a peace sign] But you know that. (Twice) (The parade came back the same it came [*sic*])*

*He was "cute," by the way.

One woman, driving a tractor, was pulling a platform with a tree on it with lots of little pieces of paper hanging from it. A sign said it was "The Calais Family Tree." I assume that there were names of people on the pieces of paper.

One float had two girls sitting at a card table on which was a green and white St. Patrick's day cake. It symbolized a local St. Patrick's day dinner given annually by some organization whose name I can't remember.

The rain has stopped.

There was a white bull wearing a purple ribbon he had won (I assume) at some fair. And a small bull-like looking animal with long brown hair. He, I must say, was quite beautiful. (Or she)

The hit of the parade was really very funny and cute, a little girl and a little boy of 4 or 5 years old dressed up like old people. ("Old" old people) (Of days gone by) Funny and a bit spooky. The little girl was wearing a bustle and a cane that I don't think I will ever forget. And, of course, granny glasses. (On such a very little nose)

The JR High band marched and played in maroon and gray uniforms following a majorette in a yellow uniform who was death herself. (Absolutely no face)

A clown who talked to people and passed out suckers and balloons to the kids just before the circus began [to make] a joke of Kenward reading the "N.Y. Times." (Kenward was reading the "N.Y. Times") At any rate—he made some joke (out loud to everyone) about reading "out-of-town" newspapers. It was a moment (flash) worth writing about, but impossible to do so. Perhaps in a movie. The same clown gave little Vivy a sucker because "It's better for you than your fingernails." (She was drying them)

As you can see—I didn't like the clown. (The whole clown thing has always given me the creeps)

And there was a recreation float full of people each doing a different sport. (Tennis, golf, etc.)

None of the floats were done with very much care. I am probably giving you the wrong impression of the parade. As awful as it now sounds to me as I tell you about it, actually, it was fun. After the parade we went to the booths. One sold food. One was a "rummage sale" booth. One had Boy Scout crafts. One had wood-work. Several were just general crafts and handy-work. (Terrible stuff) Very much on par with the stuff they tell you how to make in "Women's Household." Like bleach bottle swans.

Then we came home (around noon) and had some clam chowder. And then it started raining. I fixed the strawberry shortcake, took a shower, and then decided to write you.

Will write more soon.

Just as I finished writing the above I got up to pee and I broke my glasses. (The frames) Well—anything is news in the country.

I have a new side pain on my right side that occurs every now and then. (This is not a complaint) It's just "something to say." As you know so little "happens" up here. (Even tho a lot goes on) Writing to you yesterday about the parade made me write a very detailed (10 pages) account of it today. A prose work of some sort. Like a report, I guess. At any rate—it might be good. Well—everyone is gone. Willie tried to tell Kenward last night that he "liked me," in such a way that embarrassed them both, but it was an awfully sweet thing to try to do. Did I tell you that I broke (yes, I did) my glasses? Today is July 5th. The sun is not out. A letter for you is sitting right now on the pinball machine (wrote it Friday but can't mail it until Monday) so I will probably wait a few days before mailing this. Last time I looked out the window Kenward was again on his hands and knees raking up "mulch." More tomorrow or soon.

Made some more green grass today. The sun is out. I would say it is about 4 by now. Not much in a mood to write but I would like to get this in the mail. The little birds left their nest this morning.[32] It <u>was</u> getting awfully crowded. Yesterday we went to Burlington to get new glasses and just to shop in general. Got lots of "Harrington's" bacon and a big book all about the human body. It occurred to me the other day how <u>stupid</u> it is not to know about your own insides. So I'm going to read it and read it again and then read it again if I have to in order to really understand what is going on in there (inside) and probably it'll be interesting. A bulldozer has been here most of today and yesterday fixing up the big earth split, and the lake.[33] It really has been going down. Every now and then for three days you hear a funny noise and then the house shakes. (Like dynamite not <u>too</u> far away) Harold says it happens when planes get into some sort of an "air pocket." (Like from flying too low) (By the way, he says "hello" to me now) (Harold) But I doubt it. For one thing there seems to be no planes around when this happens. And for another thing it's never happened before (?) At any rate— maybe somebody <u>is</u> dynamiting. It's hard to believe that the summer is more than 1/3 over. From now on (until fall) "Harrington's" is going to mail bacon here every two weeks. I sure haven't been getting much mail.

Take care.

Do write.

Love, Joe

Early June 1971, Bolinas[34]

Dear Jimmy__

I think of you often as the flowers are so fantastic here.

Bolinas: very like I thought Jamaica would be, but wasn't.[35]

I have a house here for a month. (So much for "seeing" California)

But I'll be much happier here than traveling all around.

Hard to write as I'm not "down" yet. (Down to feeling I'm here) (And down to work) But—soon. Tomorrow I hope.

It's a long story, but my Lita book is now dedicated to Lita [Hornick].[36] (An old moment of enthusiasm I had forgotten about) but Lita didn't. I don't mind too much tho as I never felt too right about dedicating my book to 5 people anyway. (Like a joint letter)

I don't feel too great about it either tho.

A lesson here somewhere. (For me)

So—I love Bolinas. (Very "straight" tho) ((As opposed to queer))

I can't wait to start drawing flowers. (Giant roses) Whole hill-side of those bright yellow to orange flowers with round leaves. And many variations of begonias. (I think begonias) [small flower drawing] that hang down like vines (or vine like bushes) not sure which. Big white lilies like this [small flower drawing] Tons of forget-me-nots. Daisies I've never seen so big. And many wild flowers I've never seen at all.

The town is full of plain dogs that seem to have their own little Bolinas.

Beautiful blond naked babies everywhere.

Easy life. Lots of pot. Lots of "dropping in." Most talk about ecology, music, Eastern religions, and Bolinas problems.

Much deep talk about people in layers I never even think about (way down motivations, etc).

But I like it.

You can write me (Hope, hope).

Please do.

I'll be here for about 3 more weeks or maybe 4.

Take care.

Love, Joe

P.S. "Hello" to Bob [Jordan].

(THE RIGHTNESS OF ARCHITECTURE) TED 9.
LIKED THAT ONE BEST TOO. FOR SOME
REASON I FIND IT IMPOSSIBLE TO CUT
CAROLS' HAIR. EVERYTIME I SEE CAROL
SHE WANTS ME TO CUT HER HAIR AND
I ALWAYS SAY YES, AND THEN I NEVER
DO. THEIR BABY IS VERY FUNNY.

APRIL 17TH
"THE VELVET UNDERGROUND" WAS
ABSOLUTE GENIUS! I FEEL I HAVE TONS
TO TELL YOU BUT I FEEL VERY
IMPATIENT. RIGHT NOW SO MUCH IS
GOING ON I CAN'T TELL YOU ALL OF
IT AND PART OF IT IS NOT
ENOUGH, SO.....

← FINGER PRINT

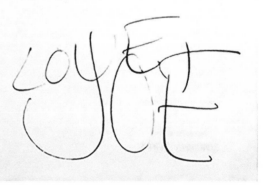

LOVE
JOE

FIGURE 8.1 Page from the letter of April 7–17, 1966, Brainard to Ron and Pat Padgett.

8

DEAR PAT AND RON

This selection of letters from Brainard to Pat and Ron Padgett was written in 1965 and 1966 while the Padgetts were living in Paris. Ron was awarded a Fulbright grant to research and translate twentieth-century French literature in Lille, but, finding affordable housing difficult and with very little in the way of research materials, he argued successfully to be transferred to Paris. Brainard takes care and time sending the Padgetts the latest poetry and art gossip (including a hilarious description of how, at a particularly wild party, Frank O'Hara "kept wanting me to go into the closet with him so we could 'straighten everything out.'"). Brainard also updated the Padgetts on police crackdowns in New York City's Times Square and downtown cultural institutions, protests against the Vietnam War, and other events he knew they would be interested in.

Though Brainard was hugely productive during this period, we nevertheless find him expressing profound doubt over his own talents, and as we know from his letters written in the 1970s and '80s, this doubt would eventually prove overwhelming. "I don't really feel that I am accomplishing anything," he writes in a February 1966 letter, adding, "I guess that that is one reason why I like Alex Katz so much. When I think of him I sometimes think I am just making a bunch of art, which is fine, but I am wondering if that is as good for me as if I was doing something else."[1]

October 1965, 40 Avenue B, New York City

Dear Pat & Ron___

In the mail department you all are not doing too well: except for a bunch of shit, only the new *Signal* [magazine] has arrived, with your translations,

which of course, I like. I especially like Arthur Cravan. He is a complete
mystery to me. I read a very funny art thing by him once, but didn't even
know he was a real poet. Speaking of poetry, I went to Tony Towle's reading
last night (with lots of drinks) which was good but not very exciting. There
is an under-current of sarcasm in his poetry that I hope he will get rid of.
What I mean is that they do not seem very sincere. I guess it is alright to
be insincere but it seems to me that you ought to be sincere first. (As tho I
know what I am talking about). At any rate—as long as I am putting down
the reading (which I did like), I may as well go all the way. His poetry is also
terribly smooth: no buzzes. I think what I mean is no ambition. Or perhaps
it is backbone. Etc. At any rate there is something in them that makes me
not quite trust them. But like I said—I enjoyed it. Ted and Aram [Saroyan]
are giving a reading Friday at some new "uptown" gallery. Also I (me) & Bar-
bara Guest & Kenward Elmslie are giving a reading there too in a few weeks.

Work-wise things are going extremely well: the best. At last! I knew it
was coming, but I feel much better now that it is here. I have one new Sky
Box. Which has three parts: sky, rhinestones, and miniature Pepsi bottles.
Also a new giant construction which has no center: no "meat." The basic
box is a cabinet with shelves & a glass door. The shelves are empty. All of
what is going on is on top. What is on top is like a little city. The city is
made up mostly of furniture, sky, & bottles. I am also working on a giant
totem pole. What is unique about it is that it is very "structural." It actu-
ally is not a construction, but a piece of sculpture. This is not so unique
I guess, but for me it is unique. I have written a very good article-review
of Man Ray's show at the Cordier & Ekstrom.[2] Am sending it to *Kulchur*
today along with photo of his iron: the iron is actually the main topic of the
review as it is my favorite of all times. Also a blue loaf of French bread. Well.
I must say that it was certainly a joy to hear from you. I have not gotten such
a long "straight" letter in years. You make me want to come to Paris. Thanks
for sending various works. I read them after reading your letter so they
didn't make much sense (which was just 5 minutes ago) and so will have to
read them again. I got a note from Tessie [Mitchell] saying she would be
here soon and would I meet her. I wrote back yes. And she's going to write
back exactly when. So—for now that is about it. The new "C" is out but I
am sure that Ted has sent it to you. Yes?
Love, Joe

P.S. Forgot: Lawrence McGaugh sent you his book.[3] It is enclosed with
Signal.[4] I am also enclosing a bonus surprise: a Nancy comic book. It is of the

first Nancy series (1945) under "Comics On Parade." Try not to throw it away because it is worth real money. Also I am enclosing a picture called "America Forever!" So you will not forget.

October 21, 1965, 40 Avenue B, New York City

Dear Pat & Ron__

I am taking pills to get normal: "Trophite" (Vitamin B, & Vitamin B12). What they do is make you hungry so you eat a lot and then you gain weight. Also I am drinking milk. Did you know that Zachary Scott died? I don't know why. I am enclosing some Nancy strips because I am sure that you must miss her, and also in hopes that it might all turn into another Ernie Padgett.[5] The one I have on my wall is not to be believed it is so funny. I am sorry to have misheard you in the felt pen department, but when I was in Paris I didn't see a felt pen anywhere. At any rate, I am glad for you. Are they as good as ours? Some time ago you wrote some things which I am using as a game page for "C" Comics. Example: "Substitute one letter in my name to spell a fruit." This is O.K., yes? Yes: Kulchur magazine is going to use the title page. There is a thing in N.Y called the Foundation For Contemporary Performance Arts, Inc. They sponsor John Cage concerts, the Judson Dance Theatre, Merce Cunningham, etc. At any rate, they are having a benefit exhibition in December at the Tibor de Nagy and Castelli, and three guesses who got invited to show?[6] So—at least I will get to be in three group shows this year, if nothing else. Actress Marie ("The Body") McDonald was found dead early today in her home (suicide). I have crapped out a bit concerning "C" Comics. Number one: someone told Tony Towle that I was doing a new issue and he asked me if he could do a comic too. I said yes. Also Barbara Guest is down in the dumps because she is not doing any writing, and you know me: I am a sucker for women I like. So I asked her if she would like to do a comic. She said yes-yes. So now the issue will include you, Ted, Kenward, Kenneth, Tony, Frank, Jimmy, and Barbara. I would also like to "do it" with Joe C. [Ceravolo], Tom [Veitch], and Ashbery, but they are not very available (and I am lazy). Actually, Barbara and Tony may do something quite surprising (I hope).

I thought you might be interested to know (keeping you informed) that Groucho [Marx] has a new book coming out called *Letters and Tomatoes*. It will be a book of some 300 letters, written and received from and to

T. S. Eliot, President Truman, Paul Goodman, William de Kooning, etc.
The Library of Congress and the University of Michigan are both bidding
on the manuscript. Says Groucho, "I must say that I am flattered."[7]

Last night I went to the Russian Tea Room after a "Miss Julie" rehearsal
and there sitting at a table was Tony Perkins with a producer friend of Ken-
ward's. So we said hello (and I really did shake hands with him), sat down,
and had drinks. Tony was eating a vanilla ice cream sundae with blueberry
sauce. When it had melted he said it looked like a Paul Jenkins. At any rate,
he was nice, tho a bit dumb. I got his autograph, and he said he was going
by the Alan Gallery to see my work.[8] Tony Towle's mother died. Actually I
guess it was a good thing because she has been almost dying for years. Won-
derful news: Lita is going to print the 6 Rose things in the next issue (no.
20) rather than no. 21. I am selling them to her very cheap because I think it
would be a good thing to do as she is doing so well with the magazine. So I
told her she could have them for $60 on the "side." So—will send you $30
as soon as she sends the check. Hope you don't mind my cutting you out
of more money, but I didn't want to ask her for lots of money just because
she is rich. Also: she has been very nice to me. I have new glasses. They are
tortoiseshell and rather round and very thin. They look very good except
that the world is suddenly terribly imposing. Everything is crystal clear and
so there is very little perspective. Is this right?

Ted's reading last night was absolute genius! I mean really unbelievable!
It made me feel good. And even Aram wasn't bad. His new prose pieces are
really very good and, and his poems, when best, have a wonderfully John
Cage off-beat sound. I really wish you could have been there. The gallery
where the reading was turns out to be on W. Broadway near N.Y.U. and is
a nice place to read.[9] They are going to have 2-man readings every Sunday
night. Kenward and I are going to read on November the 14th. Actually, I
was very impressed with Aram's reading. (I can't think of any reason). But I
was. His poems, of course, read better than they read. And he read well. Ted
had a sore throat, but he read well anyway, too. John [Bernard] Myers is put-
ting out a book of poems by Jimmy Schuyler.[10] I painted all day and tonight
am having dinner with Mr. Frank O'Hara. I painted two women. One of
the women is Sandy and the other woman is nobody. The nobody woman is
my favorite. She is not really a woman at all: she is like something to look at.
Her head is an egg with no face. And the background forms a form (white)
which is much more important than she is. She is really hardly there at all.
There is something extraordinary about it. It reminds me of a photograph
of my mother the year I was born: the way the hair is (all lumpy). *Tzarad*

magazine in London accepted that long poem I wrote called "People of the World: Relax." And also "May Dye" & "Live Better" (a new one).[11]

The painting of Sandy is all black except for the background which is all white. Glasses can be made out, but that is all. It is quite dramatic.

Tonight will be my usual "night-out-alone." I go to Times Square and I have a Bloody Mary and ham and sweets at "Toffenetti's" and then I go to the movies.[12] I do this at least once a week these days. There is something very comforting in doing the same thing over and over. It must be a bit like being married. I mean, the security of it all. I got your postcard today. Also a letter to you from the newly formed "Simon Fraser University" library in British Columbia (Burnaby). They would like to have a complete list of "C" Publications so they can order some. Will give the letter to Ted. I thought you would like to read Ted's reviews in this month's *Art News*.[13] [pen drawing of arrow pointing to a cut-out and pasted clipping of Berrigan's review]

Not much is new. I found out that Ruth [Landshoff Yorck] is 65 years old. When you come to the U.S.A you must have a sponsor. Her sponsor was Helen Hayes. She has had 4 novels printed in the U.S.A. She has painted her apartment a brilliant orange enamel. It looks terrible. She is going to give a party for Kenward and I after our reading on the 14th. Must get busy and write.

If it seems to you that yesterday was a very busy day, and that today has been a very busy day, and that I am going to have a very busy evening, it is because this letter was written over a 4 or 5 day period. I am going to the post office right now and so I cannot write anymore because I am going to the post office to mail this.
Love, Joe

November 10, 1965, 40 Avenue B, New York City

Dear Pat & Ron ____

It is absolutely winter here in New York and lots is new. I have new short hair. Some people like it and some people don't. My apartment got robbed, but it doesn't matter because they didn't take anything except for some change. Kulchur took 8 of the Rose Book Drawings.[14] They will be in number 21.[15] I have been working hard although I cannot say that I am happy with what I am doing. I have been doing Sky Boxes and sky objects. They look very nice but they are not much fun to do. Thinking about them is great, and the planning, but after that they are not much fun to do. And at the same time that I am working with sky I am also working on

two constructions both of which are driving me crazy. I do insane things
to them every day in hopes that something unbelievable will happen. And
every day what I do cancels out what I did the day before. And every day
what I end up with is a giant mess. But I refuse to give up on them. "Them"
I can think of nothing to compare them with except vomit. I had a very
fatherly dream about you, Pat, in which my only concern was to convince
you that you had nothing to worry about as to the ship ride. I told you over
and over again that I felt certain that you would not get sick or anything
like that. I have never loved you more. It is sort of funny tho, because I am
about as fatherly as a hole in the head. Actually, it was fun being that way.
Although, I certainly am not. Tomorrow I help Ted run off "C." We see
practically none of each other and that of course is too bad but there is not
much one can do about it. When we are together nothing clicks. There is a
little obligation left but that is all. I suppose this is depressing, but normal.
I am glad that you are away for a year because we will all be sort of different
then and it will be a little like starting all over and of course that is a good
thing. And also of course I am glad you are in Europe because it is good
to do things like that. I feel like doing something like that. You have lots
of mail. The University of Tulsa would like $56.86. I threw that one away.
The *Paris Review* sends you $12.60. This check is enclosed. The alumni
of Columbia College wants money. I threw that one away. The New York
Telephone Company says "thanks" for using their service. I threw that
one away. The Selective Service system has granted you permission to
leave the country. (Until June 15, 1966) You are also to send some sort of
letter or something. This form is enclosed. The state of New York sends
you two eight dollar checks. (I think from Buffalo College for "Time") I
gave these checks to Ted for "C," but I am enclosing the $15 cash. Also the
Grolier book shop in Cambridge sends you a $9.00 check which I also gave
to Ted.[16] Actually, I figured that you would have a hard time cashing U.S.
checks, and besides, Ted needed it, so—at any rate, I will send the other
$9 in my next letter as I am short. And that is all except for a few gallery
announcements of a boring sort. I have been sending out some writing.
Lines & Fuck You have accepted things.[17] "C" Comics is in full swing.
Ted and I did a 10 page comic called "PAT" which is all about Pat. Pat
will never be allowed to enter the U.S.A. again. Somehow it is quite good
although I do not know how. It was very forced and thrown together, but
I like it. The issue will include you & Ted & Kenneth [Koch] & Kenward
& Frank [O'Hara] & Jimmy [Schuyler] & I hope Tom [Veitch]. Also I
may break down and ask Barbara [Guest] because I like her & I like the

way she looks. And also I know that she would love to do it. I am afraid
that I am no editor. Kenward & I are putting out two new books. One is
a short story about a Negro lady and the other is "The Ten Most Wanted
Orchids" (ten short stories) with of course ten orchids by me. So—thanks
to me, Boke Press is becoming a real press.[18] It is a bit frightening the effect
I have over Kenward. A year ago he would not possibly have put out a book
of his own (although he did use to think about it). Also I have convinced
him that he ought to have paintings by all his good friends, (Alex [Katz],
Jane [Freilicher], etc.) just on principle I guess. And because he does like
their work. And because he does have tons of money. Two & two make
four, etc. I find myself with a certain talent that Frank O'Hara has, and
that is to say something quite simple so absolutely that one, without even
thinking, assumes that you are of course right. This is rather silly since no
one is ever right, but I suppose one has to impose oneself somehow. And
actually, when one thinks about it it is quite fun. And when one says it it
seems quite right. The small collages and collaboration which were shown
in Toronto last spring are still in Canada. I finally got a letter from Emilio
in which he said that the show did not sell a thing and that he was sending
the show to another gallery in Canada (I forgot where) for a November
showing. Evidently this was all worked out with Mr. [Charles] Alan but
I did not know anything about it. Mr. Alan is a very funny man, and very
stupid. My favourite sky object is a sky tie. It is a clean white new folded
white shirt (as one buys it) with a tie, tied as one ties it, except that the tie is
covered with sky. It looks very real. Like this:
 [ink drawing of shirt and tie that has the word "Sky" written on it three
times]
 It is in a white shadow box frame with glass. My Sky Boxes are boxes
filled with sky. Sometimes they have a strip of rhinestones. Printed sky is
very clean but unreal. Rhinestones are very cold and real. They work well
together. I am glad that you like Maxine [Groffsky]. She lets you know that
she likes you. This is something I find hard to do except to come right out
and say "I like you," and even this is hard to do. As "human" a type person as
she is, she still seems a bit unreal in that she is flawless, or so it seems. And
besides, she is beautiful. And in such a way that I can see her as queen of
Central High, which is a kind of beautiful I never knew.
 Time has passed. At last I have to get this letter off to you or—at any rate,
the 2 "problem" collages are finished and I am relatively happy with them
in that they are very good. A new "C" is out. I am going to see Paul Taylor
Dance tonight. Tomorrow night I am going to see "On a Clear Day You Can

See Forever."[19] The night after tomorrow night Tony is giving a reading at that lady's house who has all the Max Ernst's.[20] Busy-busy nights.

This always happens to me: I get to the end of the page & I have said all I want to say except that I have not said "goodbye" & so in order to say "goodbye" I have to start a whole new page.

"Goodbye"

Love, Joe

P.S. Sandy tells me that you got transferred to Paris! That is absolutely GREAT!

November 22, 1965, 40 Avenue B, New York City

Dear Pat & Ron____

It is raining outside and you know that I do not like rain. It's terribly gloomy and I have been working on a very gloomy homage (more or less) to Spain, which really is quite beautiful anyway. It is very black. And actually, it isn't gloomy at all. I have done one very big construction since I have last written which is my favorite construction of all time. It is very bright and glassy and it is not messy at all. It is constructed very logically and formally and geometrically. There is no real theme other than color. The objects in the construction remain crystal clear, but equally so. The objects become quite pure because they are robbed of everything except color and form. (Robbed of it through equality). This is getting messy. At any rate, it sparkles a lot.

Mr. Alan decided to have a 3-man show in January (I am one of the men) so I am madly trying to finish the Japanese City.[21] It is a lot of work to do in 5 weeks but I sort of enjoy deadlines, and otherwise I will never finish it. I do not know what will become of it after the show. It will never step foot in my house again and nobody can afford to buy it, I am sure. It will be terribly big. I promise to get it photographed during the show so you can see it.

I am also busy doing 20 drawings for "The Champ." Diane di Prima is printing the poem with my drawings in January (in color!). They have great new presses and the 3 books they've put out so far look very nice. However, I still do not trust them. Believe it when you see it.[22]

Pat—you are terrible for not telling me it was your birthday. "H-H-AP-.
. [*sic*]

Soon packages will start arriving because I want to be sure that they arrive by Christmas. Do me a favour, yes, and do not open them until Christmas

because Christmas is such a bore without presents. For all you know this may be your last Christmas in Paris so it really ought to be a good one.

I have written 4 new reviews (art) for *Kulchur*: [Roy] Lichtenstein's new absolutely great show, Alex Katz, Robert Mangold (Walls and Areas) and Jane Freilicher.[23] All of them are "raves" except Jane's, and actually it is a good review too (although I think she may hate me).

Andy Warhol gave me a *Paris Review* poster, in a roundabout way.

I saw Martha Graham & her company dance last night and tho they were good it was really rather sad. I kept thinking about how exciting she must have been 20 years ago, and now it is just old hat. It was fun tho, seeing how strongly she influenced [Paul] Taylor and [Merce] Cunningham—and even (I think) [George] Balanchine. So, I guess she must be very "important."

This is a big party week. There is a party for Alex Katz after his show. There is a party for Jane Freilicher after her show. There is a party for Steven Spender. And there is a party for Edwin Denby (on the publication of his book).[24] Also on Thanksgiving Kenward and Ruth [Kligman] are giving the annual dinner. I do not know who all is coming except Paul Taylor and his deaf-mute friend (he writes notes).[25] I am terribly afraid that I am going to say "thank you," or "pass the salt," etc. Tonight I am going to the [Jean] Tinguely opening at the Jewish Museum and then to the Danish Ballet.[26]

"C" Comics is fine, and getting bigger and bigger (help!). If it is out by Christmas I will be lucky. However—I plan on being lucky.

The package from Spain arrived with my skull! The Negro drawings you sent me were absolutely great! Many thanks. I have a new dirty negro figurine which is not to be believed: it is of a little Negro boy being blown by a duck. The dolls sound great! When you need the money let me know.

I am doing cover designs for "The Sweet Bye and Bye," and "Lizzie Borden," for Boosey & Hawkes (they are big music publishers).[27] They will be big hard cover books of the complete scores: music & words.

Mother will be out any day with "The Physical Sciences"![28] Also that drawing by Ted that I did.[29]

Congratulations on being the first person I know to be in Granta.[30] The poems were good to read. I sent away for 2 copies.

I do not know why anyone would want to write an opera based on Strindberg and in fact I am not even sure that I know why anyone would want to write an opera at all. I liked the music to Miss Julie (it was very likeable and plain) and I liked the libretto. But the production was absolutely terrible. The sets, and the lighting, were all dark and gloomy and dramatic and very boring. And somehow the whole thing never did fit together. (It got absolutely panned

by everybody).[31] In fact, the critics were so nasty that it made me want to write a good review of it for *Kulchur*. I did try, but all I would think of tho to say was that I don't know why anyone would want to write an opera based on Strindberg.

I sold a construction the other day, which is nice. I forgot who I sold it to, but he is supposed to be a very important collector who donates a lot of stuff to the museum.

We had a great dinner and birthday party for Ted that was lots of fun.

I am sure that lots more is new, but I cannot think of what.

Love, Joe

P.S. The cover is too small because the printer goofed.[32]

January 10, 1966, 40 Avenue B, New York City

Dear Pat & Ron

It is unbelievably cold here in New York; colder than I can ever remember. This seems to be true every year. It is impossible to remember how cold cold really is. I still like it tho. The dolls arrived and they are beautiful. I took the Oriental doll apart and re-wired her so her head would stay on. They are both great tho I especially like the Oriental-dressed doll best. The best thing about the colored little girl is her gold shoes and her long long legs. It really makes me sick when I think that you did not receive my packages by Christmas, or that maybe you have not even yet received them. That is, I assume that you have not received them because you did not say anything about them in your last letter. Two boxes & three big envelopes should have arrived. Aside from the fact that I wanted you to have lots of packages at Christmas, it also makes me sick because there is something very special in one of the boxes and if it is lost I will die. When and if the packages do arrive do let me know. OK? Per usual not much of anything is new. Everything is all screwed up here in New York because of the strike.[33] Many small businesses are having to fold. It is impossible to get a cab. My show opened and there are very few people who can get to see it, including reviewers. I didn't (yet) get one review.[34] "C" Comics is actually at the printers—so watch out! (Do me a favor and do not be surprised if not all of the issue is up to par). It is 112 pages long and is costing $950 to print 600 copies (at $1.00 each). I am afraid that is a money-losing proposition. Ted has a new girlfriend. Her name is Martha Diamond. She reminds me a little of Sandy, the way she looks. Ted seems to be doing alright. He is depressed a lot I suppose but Ted is amazingly self-sufficient in that

he can make any situation into a drama that, if not enjoyable, seems at least
"necessary" (like real life). I do, of course, not mean this as a put-down. A
lot of things are enclosed. Also a new story of mine called <u>Brunswick Stew</u>.[35]
I die laughing every time I read it. And it is a good thing that I do because
nobody else thinks it is funny at all. It is so difficult being a real artist. The
hours are long and the rewards are few. Everybody hates you because you are
"different." And there is the rent to be paid, and the children to be fed. The
little wife needs a new dress but there is nothing you can do about it.

i ½ hours pass

Ted and Martha just came over and we went out for coffee at the Red
Lantern. Martha really takes to me. Usually the kind of girl that instantly
takes to me is terrible but Martha seems very nice. She works at the Museum
of Modern Art and is Jewish. I continue to do dirty drawings. I am also
enclosing Ted's new article on Nell Blaine. I do not mean Nell Blaine, I
mean Alice Neel.[36] I wish you could see my apartment right now. It looks
so beautiful. But I suppose that it will look even more beautiful by the time
you return. Yes, I do have the Rose drawings. So—they are in good hands
(gulp!). <u>Mother</u> is going to print a portfolio of 8 faceless women in the next
issue, so I am told.[37] One of them is obviously Pat (so I am told). I have 23
house plants! You are really getting <u>too</u> good at drawing! "People of our
Time" is great! Many thanks! Write soon!
Love, Joe ! ! ! ! ! !

February 1966, 40 Avenue B, New York City

Dear Pat & Ron__

You know, all the things that you keep sending are really great and I am
afraid that I do not get around to thanking you all for even half of them.
The little books are absolutely beautiful! As I said before: you all have really
just gotten <u>too</u> good; I just don't know what to do. I'm jealous. And I am
jealous of you all being in Paris and all the fun and excitement of it all I have
a picture in my mind of you two in Paris and I see you two running around
and everyone thinking you are wonderful and happy and the most exciting
people in the world. It is almost like history. Like Braque and Picasso work-
ing on Cubism. I am convinced that you are the hit of Paris and that you
will never return. I don't want to be morbid or anything, but Ruth died in
such a perfect way that it really makes it all alright.[38] I was not very upset but
you know how I am. At any rate, Ruth went to the mat. performance of De

Sade's (which is now a big hit on Broadway) play of which I can't remember
the title, with Ellen [Stewart] from La Mama. It is supposed to be a play full
of tricks like *The Connection*.[39] So just before the play begins Ruth doesn't
feel well and Ellen calls out for a doctor and everyone thinks that it is part
of the play. She died very fast so it didn't hurt. I guess you think I am in Ver-
mont but I am not. Vermont was totally blizzards. We kept getting stuck and
having to walk for miles. And then one night we smelled this terrible smell.
There are a lot of field mice in Vermont and they bring in lots of straw and
build nests in between floors. An electric wire was loose between the 1st and
the 2nd floors and the straw was burning. So we turned off all the power
and pulled out a fixture and began digging out black straw and splashing up
water (there is no hose). It all worked out all right. A few repairs will have
to be made but at least the house is still there. And then the next morning
the pipes froze and so there was no water and so we decided to leave. We
were there only 8 days but actually they were very good 8 days. I would paint
Kenward all morning and then draw or something in the afternoon and
then we would play Pounce (for stakes) at night. I won some really great
things: a Vermont rug (the one with the house & two trees) and that great
little cabinet with all the little drawers and the letter box that was up in your
room with the purple satin. Kenward won a painting that I did of myself and
those (sob!) photographs of you (please send more) and two nude ladies and
a velvet piano throw I had picked up on the way. We also won lots of little
things. Kenward has 2 dogs now. He is very hard to paint. When one <u>really</u>
looks at his features they disappear. The only hope is to glance at them and
pray the hand will follow. The big one I did not have time to finish but I did
a medium size one that is not only a "good painting" but it looks like him
too. You will see. Now that I am back I am beginning work on a screen. Also
(in the back of my mind) I am thinking about a table. And even further back
in my mind I am thinking about a chair. The only thing is that I want it to
be a chair that one can sit in and that is very hard. A table can have glass over
it but a chair cannot. "Cherry" is absolutely funny and wonderful and I love
it.[40] It is so easy to read. One gently slides all over the place, never stopping.
Size-wise is there any size I should do it in. I mean, for sending out. Some-
times for me it is easier to work if I know that once I am finished something
will happen to it. We could always, of course, print it as a little comic book
ourselves. Let me know. You know, although through my letters I am sure
that you imagine that work-wise all is very well with me and that I am doing
and have done tons this is not true. So much of everything that I have done
since you have left has not held up one bit. At this moment I have exactly 4

constructions that are good and that is all. And although I have done many
Sky things only one of them really stands up for me. I have done many book
covers and drawings etc. but somehow they do not seem to amount to much.
I am not trying to tell you that I am depressed or that I am "slipping." What I
am telling you is that I have reached a funny sort of point somewhere where
things are a little different. There are two things that I lack: patience and no
feet on the ground. I might mean "focus" except that I don't like that word.
There are really so many different ways that one can go about being an artist,
and perhaps one does not have total choice, but one does I know have a con-
siderable say in the matter. I am curious as to would I be better off if I were
to concentrate on something (say painting flowers) and really make myself
be able to do it so well that that would be where me and the pleasure was.
Saying it makes it sound very boring but I don't think this would be true. To
accomplish something is really quite wonderful. I don't really feel that I am
accomplishing anything. I guess that that is one reason why I like Alex Katz
so much. When I think of him I sometimes think I am just making a bunch
of art, which is fine, but I am wondering if that is as good for me as if I was
doing something else. At any rate, you probably know what I mean. By hands
I just mean any kind of hands: wooden hands, mannequin hands, doll hands,
old statue hands, etc. I guess that you ought not to pay more than $10 for a
hand unless it is terribly beautiful. I only have six hands. I got this new book
called "100 Hands." If you feel like writing anything about hands it would be
a wonderful source drawing-wise. Your Vermont letter and thank-you books
were certainly an event. I had never seen so much snow. It is so wonderful to
wake up to, especially when the sun is shining. It sparkles and reflects a won-
derfully white light. Snow does not get all brown and mushy in Vermont.
It stays white and dry. I don't know why. Kenward wrote 3 Vermont snow
poems. I think that a small snow book is in the making. Can you buy those
little books like the book you used for "Pretty Papers"?[41] I would love to have
some (hint). Did I tell you that Donald Droll and the Fischbach Gallery
are putting out little books now? The first is to be a book of plays by Jimmy
Schuyler.[42] I gave you a plug and Donald seemed to respond to the idea of
a book of poems by you. If you wish, why not send him a manuscript? Did
I tell you that I have a new painting by Alex Katz? Donald gave me a very
special price on it ($100 off!) And only $25 down. It was only $125 I think.
I figured that if I didn't do it now I never would (and $20 a month). I guess
that you know that Sandy is back. David [Berrigan] is getting quite wild.
He certainly is beautiful. Kate [Berrigan] looks kind of ugly still, but then I
never have gone in much for babies. You never say anything about Tessie (are

you still there Tessie?). Did you know that you are in <u>Long Hair: 1</u> (Noh)?[43]
Have a happy Valentine's day! The Starry Night is to hang on the window at
night if it is not starry and you want a starry night. <u>Write soon.</u>
Love, Joe

February 1966, 40 Avenue B, New York City

Dear Pat and Ron__

This is not a real letter. I just want to know if you are still smoking Kents
and if so if you would save me the butts and send them to me. Or, as a
matter of fact, as long as you are smoking any kind of filter cigarettes I'd like
you to send them to me.[44] I am on butts again and will be for some time.
I am using them as a solid mass to surround a single object. Example: that
teddy bear. But it is very slow. I smoke as much as I possibly can already, but
a day of smoking does not amount to much area-wise. I know it may seem
silly since you are way over in Paris but, although I know lots of people who
smoke, I don't know anyone that smokes a lot who would not consider it
a pain in the ass, and that's no fun. At any rate, since your butts will be dif-
ferent from mine do not bother to send just a few: wait until you have lots.
Hope you had a happy V. Day! Many thanks. Write soon.
Love, Joe

February 23, 1966, 40 Avenue B, New York City

Dear Pat & Ron__

Actually, what I said about my only new collection since you left New York
being hands is not really true: I also have been collecting eggs. I have 31 eggs.
Today the Pepsi-Cola strike was settled. It was the longest strike in New York
history: 250 some days! I find it a little bit depressing that Ted doesn't like
"C" comics again. Of course, what he doesn't like about it is probably true.
But I don't see why I should have to put out an absolutely great issue if I
don't want to. I mean, I'm no dumbbell. At any rate, they seem to be getting
along well. Sandy goes to school 3 days a week at Hunter. I told Ted he could
sell some of my constructions cheap as a donation to "C." So Barbara Guest
is going to buy one, and so is Panna Grady. So—watch out for new "C"

publications! Billy Rose died. And so did Sophie Tucker. We have been hav-
ing absolutely spring-like weather and it <u>really</u> is wonderful. Fairfield Porter's
show opens tonight and then there is a party at the Hazans [Joe Hazan and
Jane Freilicher]. I guess I have to go and take a shower. Somehow I just don't
feel up to getting all clean and dressed up. Of course, I don't have to, but
once I do it I'll feel much better. So—will write some more tomorrow.

Your letter arrived and there is no better way to begin a day. I have been
working for over a week now trying to <u>really</u> "do something" with "100,000
Fleeing Hilda" and I almost have. It is not quite finished. What I have been
working with (for) is a sort of boring detachment between words and pic-
tures: eliminating both contrast & any possible relationship. That is to say
that the pictures neither belong or not belong to the words. Also I have been
working with a certain "off"-ness: an almost boring off-ness. That is to say
that a shopping bag is not where it ought to be, but it is not where it ought
not to be either. Example:

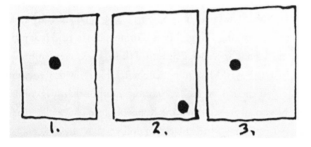

1. This dot seems properly on the paper.
2. This dot is too obviously (or dramatically) not where it ought to be. This is
 modern.
3. There is not much to say about where this dot is. It doesn't make one even care
 where it is.

At any rate, I think that you will be quite happy with it. I will send you
a photostat copy soon. Objects are used. It is very nice how Chinese food
makes you (Ron) feel. It makes me feel <u>exactly</u> the same way. I never eat it
anymore (weak knees, waves through my head and body, etc.). As you can
see, I have been reading Kenward's mail. Fairfield's show was really beautiful
and so well painted that it hurts. The simple way he paints reminds me of
Manet. It is as tho brass tacks have been reached. But it's really not so boring
as one would think of getting down to brass tacks as being. Actually, one

can sort of take a deep breath. I got lots of "C" comics letters full of praise:
Example:

"......very good indeed......" Joe LeSueur
"......marvellous......genius......" Maxine Groffsky
"......fabulous......" Alex Katz
"......loved it......" Paul Taylor

It's all going to my head. Kenward gave me a chair for Valentine's Day.
It's a folding chair with a tobacco advertisement on it. I am enclosing a new
story. Actually, it is not all new, as you will see by the title. I just re-wrote
it and added some stuff. John Ashbery's book is out, but only one copy.[45]
I saw it. As soon as it is buyable I will air-mail you a copy. There is talk of
Westhampton and Vermont and if or if not you all will be back in time for
a retreat. I hope so (?). Are you going to have to go to Tulsa to pick up stuff
or can it be shipped? Also, is there any possibility that you will stay in Paris
all summer? (Sob). The cover of 100,000 Fleeing Hilda is really great. It is
all simple block lettering 1″ high but it is impossible to read it at a glance:
because of the layout. It is such a beautiful title. Do you remember Hyman
Goldberg in The Post ("Man in the Kitchen"). He is my other reason for
buying The Post these days. He's very funny. Don Bachardy is coming into
town. I hope you all are still smoking Kents because I have plans for white
Kent butts surrounding a little black rag doll you have never seen. I hope
you like "Saturday, Dec. the 11th, 1965" because I love it. There is one line in
it that absolutely kills me every time I read it:
 "Sometimes very early in the morning it seems to me that everyone else
in the world is still asleep."[46]
 The thought of us all being in Vermont again playing Pounce absolutely
sends chills up my spine. Hope it can work out. Or Westhampton. I guess
that I have a lot more I could say but I get very irritated with letter writing
because it seems to slip over everything so lightly. Write soon . . .
Love, Joe

March 7–13, 1966, 40 Avenue B, New York City[47]

Dear Pat & Ron__

Your newest letter count (number of letters you have sent to me) is 19!!!
Your newest post card count is 18!!! Only 4 more days until my birthday,

and that is about all that is new except that Andy [Warhol] finally made
the cover of T.V. Guide (it is enclosed). There is only The Saturday Evening
Post left. Also, did I tell you that Kenneth Koch is a genius: he somehow
got Channel 13 to pay me $50 just for using "The First Bunny" on T.V.[48] I
guess you know this, but—just in case not—the Paris Review is going to
use that cartoon. As for my novel with Ashbery it is not exactly true. He
has plans for a full-length cartoon which, so far, I am forcing myself to do
(12 pages) ← (so far) it is really terribly hard because he just writes and then
I have to make up the drawings. I didn't say anything about it because first
I wanted to see if it is going to work and even if it does work, it will take
years. I am not really a real cartoonist, and suddenly that is the position I
have put myself in. I'm doing my best to cut the cake, but I don't know.

March 8, 1966
 There's a man going round buying manuscripts. He is young, with lots
of money, and not too much taste. (He got through buying Paul Bowles's
manuscripts, and a correspondence between Ginsberg & Cassidy). He seems
mainly interested in Duncan, Olson, etc., although he did say that he would
like to become more familiar with New York poets. He told me to give his
name to anyone who might have something to sell. His name is Andreas
Brown/ 337 W. 22nd St. / Apt. 3A. His phone number is CH3-3372. His
main interest seems to be letters (?) and buying lots: sewing up the market, so
to speak. Pepsis are here! I am drinking one right this minute. I already have
one home-coming present for you (but I'm not going to tell you what it is!!).
Tomorrow afternoon at 1:00 I am posing for Alex Katz. I am to be a cut-out.[49]
Needless to say, I'm flattered. I have a vision of my tragic death in a couple of
years, and the exhibition of paintings by various painters and poets of ME ME
ME ME ["ME" written numerous times in various sizes on the letter page]
 Work is going well, but as I never take pills anymore, a bit slower than
usual. I'm not against pills or anything, but they are not available very often,
and the on & off is no good. Big constructions are few between, but I do
tons of drawing. I just draw all the time. I've just become a regular little
drawer, that's me. Draw draw draw. I just draw all the time. (Help!)

March 9th, 1966
 Your packages arrived today and they are really unbelievably great! My
very favorite things are: the painting of the room, the pencil self-portrait,
the two photo-portrait boxes, and the black cigarette box. Pat, you are
getting even better than Grandma Moses! (Get the money!) (←Seriously!).

I'll see what I can do about getting you a one-woman show this fall, if.

At any rate, so far it is certainly a wonderful birthday: and it hasn't even started yet. Many thanks! Today is the day I go pose for Alex Katz in about 10 minutes.

March 10, 1966

Yesterday was the day I posed for Alex Katz in about 10 minutes. Today has been a wonderful day mostly because your other package arrived, and it was so inspiring and beautiful to look through. The books and the labels are really beautiful, and the comic books will come in handy. So—once again—thanks for a terribly lot. Posing for Alex was fun. He is doing a cut out of me 6 times in various positions (head on!). I have spent most of today (still) dyeing and re-dyeing that Homage to Spain. It is getting quite red and quite expensive. Went to Mike Goldberg's opening last night but it was so full that I didn't even walk in the door. Also went to Robert Good-nough's opening and there was absolutely no one there.[50] He really is a good painter, but as corny as it may sound, he just doesn't "give" enough. Tonight I am going to go see "An Evening with Pearl Bailey" (live). My Aunt Ruby sent me $10 for b.day, and my parents are sending candy & cookies, and a small doll. (So

March 11!!!

Had a very good work day! Working again (today) with "plain" objects: nothing beautiful, nothing not beautiful. Ted & Sandy & I went out to dinner last night, and to hear The Fugs.[51] I guess we like each other again. Hyman Goldberg (Man in the Kitchen) said today (March the 11th) that Johnny Appleseed died today in 1845. His real name was John Chapman. Ted gave me "Some Trees," and a book he made. Sandy gave me this thing that I don't know what it is. It may have been part of a dentist machine, or something medical, or chemical, I don't know. Sandy also baked an angel-food cake with chocolate icing, and a painting. Tonight there is a big cocktail party at Donald Droll's house for some rich lady who used to run around with poets in the '30s. The story is that she wants to meet some young poets and give them money (so they say). I say "big" because everyone I know is invited. It was really nice getting another letter from you this morning. Only thing is that I have a feeling that you were not really happy with 100,000 Fleeing Hilda. Shall we change a lot of things around & everything. Also, do you think the drawings dominate too much? Good

idea to drop "Bill" Page. I knew it wouldn't go, but I liked the way it looked. When we have finished it I will send it to Donald Droll. Might as well. I never do know about him. You have been writing so many letters lately that it's really wonderful (thank you!). I also think it's wonderful that you are writing something about my work. Can't wait to see it. I don't see how the article can possibly be out in the April issue, as new photos have to be taken. Do not worry: will save you many "C" comics. <u>Did</u> send to all the people you wanted to, except Kay Boyle. Must get her address from Ted. Gotta go get dressed now. Will write more tomorrow. That big blank book you sent me started me off on a new diary!!!

March 12

I've been a zombie all day from too much drink last night, which was a wonderful night. It turned into a surprise dinner party, and then into a surprise party. I got <u>unbelievable</u> amounts of presents. All in the world I want to do is to make a list of them. Here goes:

1. 2 more books (1 Boke) from Ted
2. A few pills from Ted
3. A lion water gun from Alex & Ada
4. A Dean Martin button from Dick [Gallup]
5. Beautifully wrapped soap from the Hazans
6. "The official guidebook to the New York World's Fair of 1939" from John Ashbery
7. Jimmy Schuyler's new book "May 24th or So" from Jimmy Schuyler (limited edition: no. 6)
8. An ornament book from the Gruens [John Gruen and Jane Wilson]
9. An autographed copy of "Bertha (& Other Plays)" from Kenneth, plus a big portrait of Pluto on golden file material with a poem written on it:

> "Gosh, it's nice to have a pal
> Who's just as nice as you!
> And it will always be the same
> No matter what you do!
> > Happy birthday to Joe
> > from Pluto"

10. Vincent Katz gave me marbles
11. Johnny [Stanton] & Johanna [Stanton] gave me a paisley shirt & a paisley scarf

(My cut-out, by the way, is finished! I posed for 8 hours today (or 7) and
it is really weird, and nice.)

12. Kenward gave me some absolutely beautiful tiny-tiny bronze negroes doing all
 sorts of things, painted, from Vienna (19th century) and a dye cabinet, and a
 lady shoe, and a Coca-Cola tray, and a Tiffany bug tie-pin, and a white lady
 vase with two faces, and two eggs, and a tin kitchen.

13. Ned Rorem gave me his latest record: something about "rain songs" (?)[52]

That's all I can remember. At any rate, I really feel awful, and also very
good, because it is almost Sunday (10:30 Sat. night) and I will feel much
better (tomorrow). That party, by the way, (for the poet lady) turned out to
be Caresse Crosby. Actually, I don't know who Caresse Crosby is, I didn't
even say "hello" to her, but evidently she is famous for something. Also,
my Aunt Ruby sent me $10, and my parents are sending candy & stuff,
and a doll. So—I really got a lot of stuff! Jimmy is going to send you his
book. Kenneth's book is not really out yet (you can not buy it), but when
it is buyable I will rush you a copy just in case Kenneth doesn't. People ask
about you all the time. I always say that you are having a wonderful time. It
certainly will be nice to see you. "The Group" (the movie version is coming!
I can't wait! (Wednesday!) I am going to do the cover for Aram's new book
called "Works," although I haven't started it yet.[53] Aram has an answering
service now! I am absolutely dead. Must drop into bed. Will write more
tomorrow.

March 13th

Also I got one of those pieta altars with a door from Peter [Schjeldahl] &
Linda [O'Brien]. There is [sic] only 8 more days until Spring! Does Spring
start in Paris the same day as Spring starts in the USA? It seems to me that
all that I have been writing is very silly & "off the top of the head": however,
I've no excuse. Will try to write something half-way intelligent soon, but—

March 22–27, 1966, 40 Avenue B, New York City

Dear Pat & Ron__

I got my first and only "Japanese City" review today. (Arts Magazine) It
goes as follows: "A motley but inventive show with no apparent theme to
link the 3 sculptors and a pair of painters . . . and the gallery was dominated
by Brainard's wall-sized, glittering 'Japanese City', a compulsive pile-up of
hundreds of carefully arranged Tokyo tourist-trade souvenirs. Its impact

was immediate and visceral, and one's revulsion was out of proportion to the simple comment of the piece, which amounted to something like 'isn't the Americanization of Japan awful.' Then one was impressed by Brainard's patience in amassing the 'kitsch.' Finally, though, the sculpture boiled down to shock-value sociology . . . within five different by [*sic*] equally 'acceptable' modes, the artists managed to show their technical finesse and individuality."[54]

March 24th

Posed for Alex again the other day. What I like about posing is that you can just let your mind wonder [*sic*], and I rarely give it that chance. The only thing is that last time all I could think about was you. I had to face looking out the window at the Flat Iron [*sic*] building which said in big letters "FLAT IRON BUILDING." [*sic*] All I could think of was crossing out the "I" in Iron and leaving it as "Flat Ron Building." At first it was funny, but then it was sort of infuriating because I could think of nothing else. As more or less of a farewell to constructions I am doing an all green construction sort of compiling the best things I have done, but all green. My plan from then on is to paint objects. I don't know why, or where it will get me, but for some time I have been thinking about it, and I've decided that it is one of those things I simply must make myself do. Also I will finish the cigarette butt things I have planned—so—don't throw them away. Tom Clark asked me to do a cover for his magazine, which I'm doing this week. I thought I might have to pull a little weight to get Aram to like the cover I did for him, but as it turned out, he loved it. The 8th Street book shop has sold 55 "C" Comics. The Cornelia St. place has sold 20.[55] I guess that N.Y. has changed some, in little ways at least, since you left. For one thing, Batman & Robin have absolutely taken over. There is a new "Batman" serial on T.V. And there are thousands of Batman stuff everywhere: buttons, rings, costumes, posters, books, kites, puzzles, put-together kits, radios, glasses, etc., etc. Also—a wonderful movie store has moved in on Kenward's street that you will go ape shit over. It has all books by & about movie stars. Movie star buttons, post cards, posters, stills, dishes, etc. (Another great Batman item is Batman paper-dolls.) Also new antique stores are popping up all over, prices go up-up-up, and everyone, I am sure, is going crazy. Everything from the 20's & 30's is now worth a fortune! Buttons (the kind you pin on) are having a boom too. Several art galleries are having buttons made now for all exhibitions. Lots of people all over wear buttons. ("Let's legalize pot" / "Withdraw from Vietnam"/etc.) A new store on MacDougal Street has opened up selling nothing but buttons: a button store. Kenward has a button collection

and so does Ted and so do I. And so does practically everybody. Buttons are now in bubble-gum machines. Underground cinema is not too underground anymore because there are two totally underground cinema places that show nothing but underground stuff: Warhol, etc. They even advertise in the "Times."[56] The Fugs have their own theatre now too: 2 shows every night.[57] They have a new record out. I guess you know about the new lower east side newspaper.[58] It isn't very good. April 27th (I think) is Kenward's birthday.

March 25th

Saw "A Band of Outlaws": absolutely great! Also [Phil Karlson's] "The Silencers," (Dean Martin): also absolutely great! Not much is new. Or "A Band of Outsiders," I can't remember which. (Godard) Tonight going to see a new musical (live) called "Superman." I know it is going to be terrible, but. . . . Green construction coming along well.

March 27th

One thing that I really like about "100,000 F.H." [*100,000 Fleeing Hilda*] is that it is sort of like a scrap book, especially in the way it looks. One thing (the only thing) that bothers me is that as a book it's terribly short. Also, pictorially, it could use a jolt or two. So—I am enclosing 6 new pages to see what you think about adding a bit to it. If you want to you could either write on them or I will print what you say to print. Also, if it's alright with you I would like to print the book not like the originals, but like the Xerox copies. Let me know. Hope you like the idea because I think it'd be beautiful to have some realistic pages pop up. And although they may look a bit heavy, by the time they are Xeroxed down they will fit well, to me. At any rate, yesterday I got the orange book and I don't know how you did it but you certainly did. I absolutely love that pig! It really reads good & looks good and fits together good. "Superman" was terrible. Bye the bye [*sic*]—did you know that it is almost Easter! The policemen are putting people in jail like crazy. There is a giant new crackdown going on. It's really spooky.[59] This morning did a beautiful cover for "Frice" with an egg beater on it.[60] The green construction is coming along as expected. The top is like a store: shelves of green "Prell." I am sorry that I have been so terrible about writing, & I am also sorry that what I have been writing is not much. Every once-in-a-while I go through a period of not being able to connect with words when I write them and that is how I have been lately. So—at any rate, I'll be glad to see you all soon—

Love, Joe

April 7–17, 1966, 40 Avenue B, New York City

Dear Pat & Ron__

Pat, are you really pregnant? I told Sandy & Kenward that you might be
pregnant and they both seemed very happy about it. I'll be glad if you aren't.
But then, I'll be glad if you are too. So let me know so I'll know what to be
glad about. Niki [de Saint Phalle] said that Tessie was her best helper. The
address of Art News is:

 4 East 53rd St. /10022

I never did get your collected comments on my work. (?) Is it really true
that Arthur Cohen loathed "C" Comics from front to back? I don't believe
it. I liked Nell Blaine's show. In fact, I wrote 3 pages about it in my book.
She is really a good painter, but that's about it. I decided, for the moment,
that that was enough. The funny thing about Nell Blaine is that Opal
Thorpe would like her paintings, too. (Help!) I have a feeling that you may
have been putting me on about you, Pat, being pregnant and about Arthur
shit-face "loathing" "C" Comics. On the other hand, tho, I don't know. (?)
Of course, babies are really great from about one to seven or eight. Also it
would keep you Ron out of the army. It would certainly make the relatives
happy. And it is a very natural thing to do. I mean, it might not be as bad as
it sounds. And actually, it doesn't sound bad at all. At any rate, things like
that always work out. Lorenz Gude (they have a whole house in the Bronx
now) took some pictures of Kenward for his record cover. Kenward gave me
a few to send to you. They are enclosed.

April 9th
 Posed for Alex yesterday morning. I am a full-figure now in the same
pose as St. John by Rodin in the Museum of Modern Art sculpture garden.
He gave me a small rose painting, for all my modelling, time, talent,
beauty, etc. Yesterday afternoon went to the Brooklyn Museum for the
first time with Jimmy Schuyler. They seem to specialize in the very worst
paintings they can find by the very best artists they can find. Last night
had dinner with J. A. [John Ashbery] & Jimmy & Kenward, to a party
at the Katzs', and dyed Easter eggs. Kenward is giving a big Easter party
tomorrow night. I am still working on the green piece.[61] It is unbelievably
green, all-green and totally jewelled: green-jewelled. I am going to finish
it tomorrow I hope: Easter Sunday. I hope my package arrived in time for
your Easter, but I doubt that it did. Lee Harwood wrote that you were

going to England to read. That's great! He also wrote that he was coming
to New York City in May. I hope you will follow suit. New York City
needs you. A woman (girl) by the name of Jane Jordan has contacted me.
She says that she is now a New Yorker. She is a copy-writer. And she is from
Tulsa. In her letter she assumed that I knew who she was. She says "hello"
to you, and she says "Do you ever hear from Royla Cochrane?" (Help!)
Who is this person?????

April 11th

Well, exactly one month from today was my birthday: in the other
direction. The Easter party was a smash, and that is exactly how I feel right
now: smashed. Tried to do some drawing this morning, but absolutely no
contact. Was up until 3 o'clock, and with lots of drink. I feel exactly like a
blob. I don't even feel bad. Frank O'Hara got so drunk he was making no
sense at all. Kept wanting me to go into the closet with him so we could
"straighten everything out." What he wouldn't say. He did say, tho, that I
was "King of the Mountain," but that I ought to be meaner. He also had a
long list of compliments and insults for everyone else. The incredible thing
is that everyone puts up with it all, included [sic] me. One minute he was
telling someone they were a shit, and then the next minute he was crying
and hugging them. It certainly is a different way to live than the way I know.
Somehow, tho, he avoids making himself appear like a fool. It takes talent.
And I guess you have to "give in" a lot. At any rate, it was a good Easter. I
got some Agee eggs (small) from Kenward, and a Negro porter from Sandy,
and a bunny from Ted. The babies are due in two weeks, or less, now and
Whippoorwill is really wonderful. He follows her around every minute.[62]
If anyone so much as touches her he barks like crazy. He is taking his new
role quite seriously. Easter afternoon I finished the green construction and
I guess I love it. It really is quite beautiful. Ted said he got a letter from you
and that you were a bit depressed. I hope you still aren't. More tomorrow—

April 12th

[Two cut-out sentences from newspaper articles pasted onto page. The
first reads " 'He got idealistic, I guess,' said the father of a New York College
student who tried to set himself afire outside the White House to protest
the Viet Nam war." The second reads, "A hearing was ordered today for
operators of a Lower Manhattan theater where child actors allegedly burned
the American flag and shouted obscenities against the President, the coun-
try and motherhood—in two languages."]

April 13th

Went to Bob Dashes [Robert Dash's] opening last night. It was so bad I couldn't believe it. It took me hours to decide what I could get by with saying without grinning. Finally decided on a hand-shake & "I wish it weren't so crowded, so I could see better." Ada Katz had a good one: "Congratulations!" Next Tuesday Jane Wilson and Wynn Chamberlain open. The "East Village Other" wants a full page of cartoons. Since you aren't here I think I will take the liberty of re-doing your "Nancy" strip that was in "Lines." I can't think of any reason why you would mind. I hope I am right. Worked today on the cover of "Vice."[63] It is quite plain, an orchid, but I like it. I am sending you "The Best of Bat Man [sic]": a book. Posed yesterday afternoon for Don Bachardy again. He did 4 drawings 2 of which are terribly accurate, pretty good. He does keep getting better & better. He did some of John Ashbery as the devil. Tonight Ted & Sandy & Kenward & I are going to Andy Warhol's "Velvet Underground."[64] It is like an environmental disco-tech [sic], so I understand, with movies. I have been working with a poem of Ted's called "Living With Chris." I am on the third version, and I think, the right track. You will see. I am working again on the big circular cigarette butt work I believe I told you of with the egg. Yesterday I received your comments on my work, and of course, I ate it up. The one I liked best was about architecture. (The rightness of architecture) Ted liked that one best too. For some reason I find it impossible to cut Carol [Gallup's] hair. Every time I see Carol she wants me to cut her hair and I always say yes, and then I never do. Their baby is very funny.

April 17th

"The Velvet Undergound" was absolute genius! I feel I have tons to tell you but I feel very impatient right now so much is going on I can't tell you all of it and part of it is not enough, so
Love, Joe

November 11, 1966, 40 Avenue B, New York City

Dear Put & Run [sic]—

John Ashbery gave a beautiful reading at N.Y.U. last Sunday. I wish you had been here. He read from Turandot & Some Trees & The Tennis Court Oath & Rivers & Mountains.[65] There was a full house, and more than a full house. They had to go get more chairs. The Hazans gave a party afterwards

that was also a full house. Harry Mathews is here. I hear that he is not going
to travel across country as planned, but I don't know. He is very busy so
I won't see him until next week. Yesterday I spent the day cleaning up &
clearing out my work room. You would not believe it. There is nothing
there anymore. Today I am going to paint over paint splashes on the walls.
The floor is mopped and the closet is packed. The windows are nailed over
with white boards so as to keep dirt out. I can hardly wait to start painting.
I don't know if it makes sense to you or not: paintings [*sic*] the way things
look. But for me, now, it is wonderful. It leaves you wide open. Also, it is
like "beginning again," which has always appealed to me. Also it is very
hard, and also allows me to be surprised at myself now & then. I have not
been surprised at my collage ability for quite some time now. I had better
answer your questions before I forget. I think reducing 100,000 FLEEING
HILDA is a perfect idea. I have always had the feeling about it that it was
a bit too big for its britches. I will send it back to you once it is adjusted,
at which point the most logical thing to do is to have it printed. Also, yes,
will send you Voices.[66] You as art critic: I don't know. I am not sure that
you have ever written any art criticism except possible [*sic*] that piece on
Man Ray, which, at the time, I did not say I liked. Perhaps I will like it more
in Art News. What I didn't like about it at the time was its tone of voice:
that of someone superior telling something to someone inferior. Also, you
didn't tell me anything about Man Ray that I didn't already know. It did,
tho, have a lot of style. I would have known that you had written it. Also
(gulp) I didn't like your position as the defender, altho I don't know exactly
why. I feel quite silly criticizing you, which by the way, I am not doing. For
one thing, I am not in the habit of it. If I read a poem of yours that does not
register much, it is a mark off my score, not yours. This is not a wishy-washy
position on my part. It is a matter of faith, mostly "there," and partly, I imag-
ine, because I want to feel that way about you. Pat: some tie decorations, or
what have you, are enclosed. Did I tell you that Fairfield Porter gave me a
beautiful painting of wild flowers? (Yellow) I say "gave" because it is quite
large & good in comparison to his tiny tempera Brainard. (Blush) My only
new object is a round paper wait [*sic*] with an onion on it. I've been doing
lots of Christmas shopping, tho, which helps satisfy my thirst for spend-
ing. Have you seen the Japanese City in "The Grand Eccentrics" Art News
Annual XXXII? It says of me:

> "Joe Brainard's Japanese City rejoices in similar polyphiloprogenitive ener-
> gies. The gimcrack parts (artificial flowers that would make an undertaker

weep: beads that Sadie Thompson would consider outré), as they are repeated
and multiplied, take on a severe gothic radiance."[67]

It doesn't mean much, but there are four words I like: energies, repeated,
multiplied, and radiance. I think that pretty well sums up the Japanese
City. There is quite a big picture of it on page 17. Alex Katz is doing a big
painting of Linda and Peter Shit. A new Angel Hair is out: nothing in it
except excerpt from "Clearing the Range."[68] John A. [Ashbery] & Barbara
Guest are reading at the Guggenheim soon. John is one of George Plimp-
ton's people who (government) decides what small magazines & poets to
give money to!!!(That's what the N.Y. Times said.) So—not much is new. I
am inbetween those collages and my new paintings and so there is nothing
to say about either one. My mother writes that if anyone is going to give Pat
a shower she would like to be invited. Take care & keep the letters coming—
Love, Joe

December 2, 1966, 40 Avenue B, New York City

Dear Pat & Ron__

Your letter written on Thanksgiving Day arrived today. I can't figure out
why it took so long to arrive to me. At any rate—it was great to receive it. I
mailed you a giant letter just yesterday, but I feel like writing you all again:
mainly because your letter inspires me to do so. News: I saw Rudy Burck-
hardt last night at a party following the Guest-Ashbery reading. He said
that the movie to go with my article about smoking was all finished except
for the sound-track, which he wants me to do. He said that lots of people
have tried, but that no one knows how to read it. More news: Arthur Cohen
is very very mean. I don't mean to be mysterious, but I will tell you why after
a few months have passed. More news: Tzarad-N.Y. is out. I am very embar-
rassed by that letter to a plant.[69] I must have been out of my mind. I'm going
to go hide in the closet for a few days. More news: Ted is going to go visit
Jack Kerouac this week-end.[70] The reading last night was not, for me, a good
one. Barbara embarrassed me, and John looked so mean I could hardly hear
a word he said.[71] Barbara's poems seem to have given in to herself, and she
read them in her lady-like-way, rather than her superior-way. It occurred to
me that what was "there" last night has always been there, but that her sav-
ing-grace was that she never completely gave in to it. Now, it seems, she has,
at least for the moment. At any rate—it made me terribly uncomfortable

because, to be blunt about it, she made a fool of herself. Also—I found it very spooky because I saw that it was a thing that could happen so easily to me, if I let it. It's a funny thing, tho, because some people seem to get by with it: like Frank O'Hara. He fell into a place quite personal and yet it doesn't seem boring at all. I guess if you are really extraordinary you can get by with it, and if you are not, you must constantly be one step ahead of yourself. John read a lot of Jimmy's poems, which were wonderful to hear out loud. The only thing is that with direct lighting he looked so mean & ugly that it was really very scary. And also, altho he read Jimmy's poems very well, he read his own poems as tho it were a chore. Spooky as it was tho, the poems separated as they were from John, became quite <u>definite</u>. That is to say, fact. And tho not as enjoyable, unforgettable. So—the whole reading was somewhat like a night-mare, and like a night-mare, not half so bad as it would have been in real life. Kenneth Koch has a new hair-do. He got it at one of those new beauty-parlours for men that are opening up all over town. I think one would call it an English-cut. I am told that it cost $25. Don Bachardy is in town. Out of the blue I got a letter from my brother Jim. It's very strange, especially as we have never really liked each other. He says:

"I've enjoyed your contributions to "The East Village Other." (In St. Louis?)

"I think now I should like to talk to you very much."

"I'm pretty much a different person than I was 2 years ago, and the changes have been sometimes painful."

He also says that he is going to begin analysis in January. He also says that he is tired of commercial art and that he plans to teach art to Negro children traveling around to underprivileged areas. It is true that I have been rather depressed lately, but as I tend to take advantage of most situations, it is not all that bad. I don't think most people say to themselves "Yes, I am depressed." I do. That is to say, I don't float around. Yes, Kenward did get the Toulouse-Lautrec cookbook, but I don't think he has had much time to enjoy it yet.[72] Also, yes, I will send you the Alice B. Toklas book.[73] So—what is Wayne [Padgett] doing? As a new plan to live by, but not necessarily to believe in, I have chosen to follow the stars in the Post. I am Pisces. For today: "using new mechanism to get all operating more efficiently is wise during morning and then get busy putting surroundings in better order. Shop wisely." Unfortunately, I didn't get up until 12:30. It is now 2:30. But I plan to get busy in a few minutes putting my surroundings in better order. And as for shop wisely, that is what I must do, want to not want to [sic]. I haven't been so broke in years. Actually, it is no problem tho, as I plan to sell

several more collections and also, I can always tap Mr. Alan. Also, before
long I think I'll get some more stock money. It comes every quarter. I am
enclosing today's Nancy just in case you missed it. Please write again soon.
Hope all is well—
Love, Joe

P.S.

[As his P.S., Brainard cut and pasted an excerpt from a newspaper that reads
as follows: "*EARL'S PEARLS: Morty Gunty went to see 'Don't Drink the
Water,' and was disappointed—he thought it was the life of Dean Martin.*"][74]

December 29, 1966, Providence, Rhode Island

Dear Pat & Ron__

"The Grass Harp" is a hit![75] The audience loved it. Me too. It is too long
and some of the stars aren't right. The costumes need a bit more, or less,
work. But—I <u>loved</u> it. It's absolutely lively and gay and happy and moving.
So—I am sure you will be seeing it before long on good ol' Broadway. It's
a natural. Last night was a preview opening (a social opening) for charity.
Truman [Capote] was there. He loved it too. Barbara Baxley is still kinda
sick & didn't give (I hope) her "all." Carol Brice was the hit of the show.
The sets were great. Carol Brice (Babylove) was drunk and everyone knew
it, but somehow she carried it off O.K. Anyway. The Providence critic
gave it a pan, but evidently that is customary. (Power) Also, it's obviously a
N.Y.C. show. It was a totally bitchy review and made it sound like a flop. I
really can't believe it. I would like so much to really kill him. Little people
like that make me so mad I really can't stand it. I've been thinking about
it all day and it's driving me nuts. So—Kenward and Claibe [Richardson]
are cutting today. Tonight is the real opening, but the Boston & N.Y.
critics don't come until tomorrow. I can't wait to see it again. Ted & I are
supposed to go to the museum today but already it is 3 o'clock, & no Ted.
They were going to come up here early, but actually only arrived Christmas
day. So—haven't seen much of them yet except at the opening last night.
Evidently his grandmother is worse than ever. Kenward's book didn't get
finished because the Folklore machine broke down. I was reading this ad in
<u>The New Yorker</u> for Denmark and I practically vomited. I suddenly had a
vision [of] Denmark which is unbelievably hideous. I don't think I'll ever

be able to forget it. One thing for sure, I am never going to Denmark. The slogan was:

"Denmark___
Little land of good living."

Can't you imagine the "little ol' wine maker, me" living there? (On T.V.) What I saw was a kind of nightmare Walt Disney place: terribly crystal clear and colourful. So much so that one could not possibly walk out of doors. Also cottages with bright green ivy, peasants with white aprons, and lots of cheese & grapes. I wish I could tell you how hideous this place I imagined really was. It was so bright that it made me spin. (Dizzy) My work the past few days has been going pretty well. Would like to tell you about it, but I don't really feel like writing. And when I don't feel like writing I can't seem to get anything across. I'll tell you what I got for Christmas. Kenward wore your tie you made last night with a tuxedo and it certainly was a conversation piece. (He wore it for good luck) From Ted & Sandy I got a Mickey Mouse figurine and a mirror with a bathing beauty on it, and that issue of "Life" with Marilyn Monroe all dressed up as various stars: Harlow, etc. From Kenward I got a patchwork pillow cover, a deck of Buster Brown cards, a cashmere V-neck, and 3 paper weights. 12th Night is coming up soon & we're going to celebrate that too.

The show is having lots and lots of problems. Babylove is being sued by Ecrity (?spell)-(Eck-ra-ty) for being drunk all the time during performances. She just staggers around all over the stage & can't sing. Dollyheart is still sick & can't be heard. And everyone is upset over the cuts. The critics have been held back until tomorrow night. (Thur.) Sandy is having a terrible time with her thing, and Ted called this morning & said he fell on the ice and spranged [*sic*] his ankle. So—they are both in bed. With me everything has been going very well. Working every day and very hard, and liking, I think, what I am doing a little more than before. One small tempera of a solid mass of flowers of every possible kind and color I especially like. It borders on being too elegant (fashionable) and too "Walt Disney" like, but somehow it survives. That is to say; rises above it all. At any rate—how is Wayne? I had better get this letter off because I know you will be wondering about the musical. Enclosed is the program. See if you can find my name in it two times. Lots and lots and lots of love,

Joe

HOWEVER, I FIND HIM SEXY NOT
ONE BIT, AND SO I COULDN'T
EVEN GET' IT UP. HOWEVER, WE
DID A BIT OF TIBETIAN MEDITATION
(2-2-2) THE POSITION OF WHICH
IS WHERE (FROM) I (FROM WHICH)

ME NO SPEAK ENGLISH
TODAY !

WHAT I MEAN IS THAT I FEEL
THAT IS WHERE MY ~~SEX~~ SORE
NECK CAME FROM, EXCEPT THAT
I KNOW BETTER.

AT ANY RATE _____

SO MANY LITTLE THINGS
TO DO RIGHT NOW I'M FLIPPING
OUT (BUT NOT REALLY): CONTACT
CON-ED, TELEPHONE, MOVERS, ETC.
ETC. EACH SOMEHOW A MAJOR
PROJECT, IN MY HEAD.

I'M READING "WASHINGTON
SQUARE" AND AM ESPECIALLY

FIGURE 9.1 Page from the letter of October 20, 1974, Brainard to Kenward Elmslie.

DEAR KENWARD

"I remember when I told Kenward Elmslie that I could play tennis. He was looking for someone to play with and I wanted to get to know him better. I couldn't even hit the ball but I did get to know him better."[1] Brainard did get to know Elmslie better, forming a lifelong bond sustained over the course of thirty years until Brainard's death of AIDS-related pneumonia in 1994. Not all was connubial bliss between them, as these letters reveal. Nevertheless, their commitment to each other as lovers and friends was remarkable and a model for anyone seeking to explore the boundaries of an open relationship. Brainard was uncompromising about his right to have other lovers and sexual partners, and Elmslie—while not nearly as dedicated to variegated carnal pleasures as Brainard proved to be—also had relationships outside the one he shaped with Brainard. That said, the two men consistently returned to each other, spending practically every summer from 1964 onward at "Poet's Corner," Elmslie's house in Calais, Vermont, and staying in constant communication throughout the years.

This selection of letters begins with one written at the beginning of their relationship, when Brainard was already acknowledging his affairs with other people. Following that, the letters focus on the 1970s through the mid-1980s, a period in which Brainard enjoyed the sexual freedom characteristic of New York's gay communities. We also find Brainard confessing his crush on Keith McDermott, a young actor who was to prove a major love of Brainard's life.

Circa 1964[2]

Dear Kenward__

Hi. I just received your beautiful stamps and words, and loved them of
course. And the Max Ernst book is absolutely beautiful too. So—I thank
you. And even more than thank you. I do wish all was well. But thanks to
me it isn't—and so—
 At any rate, I guess it's no good anymore. I mean, it's pretty messy. And
so there is only one thing I can do and that is to stop. And so I am stopping.
Being a little lonely never hurt anyone. And jerking off in the shower is
relatively satisfying and so that is me, at least for a while. I wish I could say
I was sorry for the mess of it all, but actually I am not. I mean, I don't really
think I did anything wrong. (Nor did you or Joe [LeSueur], of course).[3] But
somehow it just didn't work out. And I am certainly sorry for that, as I do
love you both very much. What I hope is that you are not sorry either.
 I thank you for Philadelphia and wonderful food and surprises and for
being exactly the way you are.
Very much love,
Joe
P.S. (It's hard to stop.) I suppose I'm being a little mela-dramatic [sic]. (Arg.)
But—
At any rate, I have not broken off with Joe yet, as he is terribly depressed about
his relation with Frank [O'Hara], and so I am waiting until they are friends
again. I tell you this because I want to be sure you know that I am not stopping
seeing you, but I am stopping seeing everyone. There is a very big difference.
At any rate, I hope most of all that we will still be able to see each other some.
I mean, aside from loving you, or "also," I think very much of you as a friend and
I hope to God that will not be lost too. One doesn't just throw those things away
does one?
Very much love again, Joe

P.P.S. I love you.

Spring 1971, 664 6th Avenue, New York City[4]

Dear Kenward__

I'm having my morning coffee. And a cigarette. But I am cutting down.
(Only one pack a day) That's not so bad I think.

Well—I'm with the Fischbach Gallery. She [Marilyn Fischbach] came over yesterday (with Aladar [Marberger]) and loved my new cut-outs. So— will probably have a show this spring. It's a great relief, but it doesn't make me all that happy somehow. My two hour dentist appointment was hell but now I only have two more short ones to go. I <u>do</u> love getting things over with.

New York City is hot and dirty and noisy and scary and I wouldn't hurry back if I were you.

I <u>do</u> miss you but somehow I don't mind missing you.

I've been getting drunk or stoned every night and just passing out. It's a good way to sleep.

My cassette is broken, so, no music.

Saw Pat and Ron last night and they are in great shape. Ron has very long hair and looks terrific.

Saw Ted [Berrigan] for a moment and he looks terrible. (220 pounds)

Aladar is now with the Fischbach Gallery. More or less, I think, in Donald Droll's position. He seems a little more natural in the city. He has plans for poetry readings at the gallery.

Tonight I'm going to eat with Joe and Alan.[5]

You just wouldn't believe how hot and heavy it is. (In a sticky way)

I hope Vermont is pleasant (as tho it could possibly not be) and that you are working well.

I'm going to spend the day cutting out wild flowers.

Will be seeing you soon—

Love, Joe

September 1973, 664 6th Avenue, New York City[6]

Dear Kenward—

Few new developments other than sore ankles from wearing shoes and walking on cement again.

Extreme heat continues, on which I blame two boils on my feet I just this morning got out a needle and popped.

However, a thunder storm is predicted for any moment now, and hopefully that may cool things off a bit. Tho the two brief previous ones we've had had no lasting effects.

Just talked to Pat and Ron who spent two days with Jimmy [Schuyler], and they say he's in the best shape they've seen him in since his breakdown.[7] Also, that Maxine [Groffsky] and Harry [Mathews] are coming to your opera![8]

It really is too hot to do anything and so I haven't been doing anything except reading a totally great book ("Elective Affinities" by Goethe) and getting as drunk as possible at night, which has been working well (sleep-wise) up until last night of no sleep until around four.

And so today, good ol' Labor Day, I didn't get up til eleven. Then a fowl [*sic*] breakfast out. A bit of Goethe. And now, now.

Good news is that Johnny [Stanton] thinks pretty much for sure <u>lots</u> of pills will be available late in the week.

Bad news is that unless I get a check soon I'm going to be up shit creek. And tho I know how hard this "loan" thing is, if you could make me an "official" one for 2 or 3 hundred, just in case, I would really appreciate it.

Altho I am not one bit happy, I am glad to think that once the heat is gone, once I've pills, and once I'm set up again for painting, that it will all seem so wonderful by contrast.

So ____

Well, I <u>do</u> miss you now very much.

Am very glad tho, that you aren't here : it would drive you bonko [*sic*]. (Me, I am only just able to bear it because I am skinny, and because I have a real reason to go through it)

You won't believe the new might of N.Y.C. prices. For what I thought would last me a week of Dr. Peppers, cigarettes, eating out, laundry, booze, etc., was gone in three days, and so my Labor Day dinner (big deal) is going to be of a diner sort, unless I delve into my bottles and trunks full of change (coins) which, alas, is almost impossible because of what one must wear (not wear) in this heat : no pockets. Cigarettes and keys is really all a white cotton shirt pocket can bear.

Body-wise I am feeling <u>most</u> rubbery and "tentative," which would be <u>most</u>-<u>most</u> spooky if the heat was not here to put the blame on. But the strangeness of it all makes death seem not at all too unpleasant. (I mean this in not one bit a morbid way) But it does make me want to put down in writing, finally, the fact that everything I have is for you to keep and/or distribute as you think (among friends & family) I would so wish.

I realize that this is not a very official "will," but as I know my family would not contest it, it will (would) I'm sure, do.

So—(again with not a morbid thought in mind)—I hope you will keep this letter until I probably someday will do something more official.

(You stand up from where you are sitting and walk across the room and your head is swimming : that's how hot it is!)

Being without a thing that is clean except an instantly upon arrival dry-cleaning batch, which is no longer clean, that's one thing I must do tomorrow.

Tho I did hear a bit of far away thunder, I guess that storm just missed us.

Well—for so little to say I've not done so badly, yes?

Think, tomorrow, also, I'll get a real short hair cut.

If Anne [Waldman] and Michael [Brownstein] are still with you—my love.

And my love especially so to you.

Love, Joe

P.S. Don't forget to let me know exact details on opera. And most important to use my zip code, as, as I am to understand it, a letter could take weeks otherwise: 10010.

October 20, 1974, 664 6th Avenue, New York City[9]

Dear Kenward __

Terrific to hear from you this morning!

The Russians crapped out, so I'm still stuck with two rents.[10]

(Three more days!)

Very boring life right now. (Sniff)

Got bad sore neck, and up into ear.

I must say I'm quite shocked at Whippoorwill!

Speaking of shocking—would you believe that I "went to bed" with Allen Ginsberg the other night? He's been after me for years, and I was feeling really weird (in a "so what have I got to lose? sort of mood) ((etc.)) However, I find him sexy not one bit, and so I couldn't even get it up. However, we did a bit of Tibetan meditation (z-z-z) the position of which is where (from I (from which)

Me no speak English today!

What I mean is that I feel that is where my sore neck came from, except that I know better.

At any rate _____

So many little things to do right now I'm flipping out (but not really) : contact ConEd, telephone, movers, etc. etc. Each somehow a major project, in my head.

I'm reading "Washington Square" and am especially enjoying thinking of it as tho I was you making an opera out of it.

The most practical thing right now seems for me to come up early (<u>before</u> Thanksgiving) but staying for Thanksgiving too, of course. And at the rate things are going, that will be <u>soon</u>.

 Can't wait!

<u>My love to you,</u>

Joe

October 1975, 8 Greene Street, New York City[11]

My dear Kenward __

Do you know what I live for? Mail. From you. And so today I got it. But my last fantasy is gone. It was not a mistake, I guess. It is for real.

And so I guess you are happy with Steve [Hall].[12]

Well, I <u>am</u> glad you are happy.

There is nothing about my life to write because it is nothing.

I have written you <u>so</u> many letters in my head, and on paper I didn't mail, that I feel I deserve this one last luxury. (I would write you most every moment of every day except I don't want to depress you, hurt you, make you feel guilty, bad, or what have you.

And besides—I feel so silly—the total fool—my concern is over a love so deep I am bowled over by the knowledge that such a thing could possibly exist—whereas your concern is to hurt me as little as possible.

It is much too pointless, and painful, to go on, and on, with this letter : the only thing in the world I want to do right now tho.

I <u>do</u> want to tell you tho that I really don't know how I am going to make it without you. I really really don't.

For the first time in life I know what regret is. (Tho I still do not believe in guilt, as I think you do not either really. Which is why I can tell you exactly how I feel.)

But (again) I am feeling the fool : you want to save our friendship : mine is a passion. But, actually, I couldn't care less : feeling the fool. I am.

I just can not, <u>can not</u> believe that I was so dumb as to not recognize my love for you.

I cannot believe that recognition is that important towards fulfillment but (you can learn from this!)—I now know that it is.

I wish I could too (learn from this) but I am missing <u>the</u> most important thing of all, care. I just don't care anymore. About nothing.

NOTHING.

<u>You are everything.</u>

But God I sure do hope I am not so masochistic as to continue my care here. Here with you. I am responsible for myself (I, and I alone) and can you not see how much nicer to myself nothing would be than this total torture?

Please (<u>please</u>) ((<u>please</u>)) do not think I am trying to hold on to you with a threat of suicide. For one thing, I would not want you out of kindness or pity. And for another thing, I am much too chicken, I'm sure.

(Or could it be that to get you back out of kindness or pity <u>would</u> be better than nothing?)

God—must stop this letter.

Please—do not have Steve drop stuff off Saturday.

Please do not talk to anyone about me. (No one can do anything anyway because I am not talking to anyone.) Please do not let me down in this request.

And please do continue to write to me. As often as possible.

I thank you very much for being the only person in my entire life I have ever been able to relax with. For putting up with all my impossibilities. (Do you realize—you <u>must</u> realize—that it is not your rejection of me that has brought all this about. I was just beginning to realize how much I really loved you, how much more of myself I was ready to give, etc. <u>before</u> you lowered the boom.

<u>GOD!</u>

My love to you,

 Joe

P.S. I must tell you, for your own good only, how vivid in my memory is how many times I shaved and tried to look good for you without you not even noticing it : please let people know.

"Letting people know" so obviously now seems to be the key to everything that I insist upon drumming it into your head.

I want to be sure I've given you something worthwhile.

If only it was not too late—God how I would "let you know" now!

[red ink drawing of a heart]

P.S. Note new envelope pattern inside. Lady joker. And early V-Day (ouch!) card.

November 3, 1975, 8 Greene Street, New York City[13]

Dear Kenward __

Guess I've just got to give-in again, and write to you. (I do so always in my
head.) Only problem now tho is that all I have to say are just things that
hurt. Well, that hurt me, at least. I know it'd be better for you if we'd just
drop the whole thing (i.e., silence) for a while but you'll have to give me
a little time, I guess. (Really & truly, this is not a role I covet.) My newest
fantasy is that I'll receive a telegram from you saying that it was all a big
mistake. And the few moments of joy are sure worth the reality let-down:
it is beautiful! A lot, me and my head, we go thru this thing about like—
why, God, didn't I try harder! To branch out our sex life. To be more fun
to be with. To enjoy you more. I do think life is exceedingly cruel in mak-
ing us unable to appreciate what we have when we have it. Tho, actually,
I blame myself more than I do "it." I really can't believe I was so dumb.
Can't quite believe I am writing this letter either. The restrictions are not
much help.
 I just want to have my arms around you. . . .
Love, Joe
(. . . so bad I can't stand it)

P.S. and please—I am sorry. I do know you care about me. That expressing
my hurt hurts you in return. But please understand that—tho I have no
illusions—reality aside—this is my only hope!

1975, 8 Greene Street, New York City[14]

Dear Kenward__

Night time now makes me wonder if maybe I wasn't too brief in my reply to
your letter this morning. (?)
 And so it is that I am writing to you once again.
 I rather suppose (tho by no means do I suppose to know) that you
thought your letter of this morning would make me feel good. Well, it didn't.
 And, besides, I can never know now if what you say is just to make me
feel good, or for real.
 You see—I offer you everything, and you respond with a possibility of
seeing each other Christmas [sic].

Even the thought of Christmas, alas, makes me ill : Christmas without
you, I mean. Never-the-less—am afraid that you ask too much. (Boy it sure
is tempting tho.)

Do let me tell you how un-kind it would be to take Steve to Scotland just
because you promised!

(Or are you letting me play the fool again? : like when you "couldn't"
back out of taking Steve to Vermont because "you promised"?)

Either way, I know you mean me well. But really—the truth is so much
better in the long run, whatever that is.

Guess I'm just rambling on. My main reason for writing you again is just
to be sure you didn't mis-understand my letter as being snippy. It is simply
that there is so little to say that doesn't hurt.

I know that my years with you were, and will continue to be thought of
as, the best years of my life.

And, aside from your blank areas, you are without a doubt the most
generous and kind and human person I have ever met.

You also hold the distinction of being the only person in my 32 years of
life on earth that I have been able to totally relax with.

Without you I really don't think I could have made it.

All of which is to say "thank you" (again) ((and again)) and that (again) I
am sorry I didn't try harder.

I find myself fantasizing a lot about what our sex-life could have been.
One is of our warm piss on each other, as we do it on each other in the
shower. Another is of blowing your big hot cock, you against wall, neither of
us even undressed yet : a prelude to just about everything. (Which, by now,
I have pretty much done.) Never—alas—will I forgive myself for not forcing
you into wilder (sexier) sex.

I think now I have finally realized that you want Steve more than me.
Or (at least) that you don't want me very much. And so now would also
be the time to stop writing. But, please, don't go out of your way to avoid
me. It's my problem, not yours. And, at this point, I couldn't care less if I
hurt more—not really, I mean. It is all that now ties me to you : now, now,
I mean. And I think I could all too easily learn to enjoy it. At least, as some-
thing better than nothing.

(And if I thought it'd do me even an ounce of good, I probably would.)

And so I guess we'd better make this one it.

I'm awfully sorry for a lot.

And I'm awfully glad for a lot.

I love you so very much Kenward I do not understand it.

Love, Joe

P.S. and don't forget to somewhat read "Anna Karenina"! (For me) And also for me—please think seriously about what I say—when you feel down (or are down on things) remember that the only exciting forces are from within envolvement [sic]. That envolvement [sic] is a choice. (As is life itself.) So don't think so much about things—do them! You are never stuck.

(Unless your name happens to be Joe Brainard and you are madly in love with someone who isn't so with you.)

Just goes to show how useless advice is.

But maybe it helps show how much I care about you:

TOTALLY!

Love, Joe

P.S. Except do let me know just one thing: how much longer will you be in Vermont. Have some things to send you.

* Pills

Your silver guy

2 French books I thought you might like

& etc.

P.P.S. Oh—and one completely dumb stupid romantic masochistic, etc. last request—I want you to play "a very special love song" and think of me. Just once. [drawing of arrow pointing up to above paragraph with phrase "Can you believe it?" appended to it]

True.

September 12, 1977, 8 Greene Street, New York City[15]

Dear Kenward__

Sunday night: and I'm plain old tired. (To say nothing of a bit drunk): dinner and much wine with Bill and Willie.[16] And last night was Maxine. And needless (but nice) to say, all ask after you!

Let me tell you for sure that I miss you a lot already. From the very moment I exited the Toyota, in fact.[17] All of which is rather (more than "rather") encouraging. And / but weird too. Evidently at least a large certain side of me needs you a lot. (A word I don't use lightly (("need")) for sure.)

All of which (which is why I say it) boils down to a big compliment; regardless (I promise) of how oddly stated. I don't know. Sometimes I think

we just know each other (at this point) too well to be able to do without all
the assumptions we give each other. Or—at least—without which an almost
impossible void seems to loom. No?

Well—at any rate now—why am I being so "serious" is what I'm wonder-
ing now. (As tho I'd risen <u>before</u> the occasion, somewhat.)

At any rate—back (back?) to the factual—N.Y.C. is very hot and "close."
Difficult and impractical. People are hard to be with. And I'm too nervous
and uptight to make anything seem a reality, it seems. (A not very optimistic
thought, from this end of the line. I've thrown it up so many times I must
assume to believe in eventual acceptance. A point I'm not quite at tho. But
it sure does seem to be that things just go on and on.

At any rate—spent all day reading again. Terrific book tho. A Henry
James novel I never heard of before. About a little girl growing up between
separated parents.[18] <u>Very</u> convincing in terms of "gathered informations."
(The means by which one does it.) : only one aspect of the novel, tho, of
course. At any rate—it's good.

Saw John [Brainard]. He has a new job (my brother John, I mean)
with "Forbes" magazine 3 days a week. Isn't too excited about it tho, as
it's mostly paste-up and mechanical art work stuff. Only in passing tho,
I suspect : he seems to have quite a direct way of going after what he wants.
And seeing him wasn't all that awkward at all. They seem to make them
much older these days—kids. And certainly a lot more secure. (Lucky
bastards!) But how little satisfaction if you don't know the difference—it
would seem.

(A theory I no longer buy)

At any rate—I'm being silly—and I really have no news. And no particu-
lar notions to write about.

Really, I'm just sorta getting off on the idea of writing to you: seems a
long time since.

I hope you're O.K. up there alone. Days can be awfully long, can't they?

Again—I hope you know how much a good summer means—and so a
formal but real "thank you"—again.

You're real sweet, actually.

All of which is going to get pretty corny if I don't watch out. (Sign off fast.)

Tomorrow is haircut. And some practical phone calls. That much I hope
for sure. I might even clean my windows.

Miss me too.

Love, Joe

October 13, 1978, 8 Greene Street, New York City[19]

Dear Kenward___

Well—filled in as much as I knew how to, or what to, which is/was not a lot. But—

It's a good thing I'm writing to you today instead of yesterday. Yesterday, I was furious:

(The nerve of you to complain about our relationship, as you flit thru town! And to consent to dinner, so long as I don't expect anything afterwards! I think you must be living in somewhat of a fantasy world, which is too bad really. And "etc." & "etc." But I won't go on about it. Because that was yesterday.)

But today it all just seems rather fruitless. I'm tired of feeling resentment. And whatever the problem is doesn't seem to have anything to do with <u>me</u> really. And so what will be will be, is about the only attitude left for me.

I guess you want someone who'll live <u>your</u> life with you, keep your hours, follow you around wherever you go, etc. And, you know, you probably could find someone like that.

At any rate—I won't go on and on about it.

(But <u>please</u>, if I can't make you happy, just tell me, and let's get on with our lives—O.K.?)

Well—I <u>do</u> hope you are feeling better. That you are trying to enjoy being alone with yourself. And that you are getting some "Lola" work done.[20] Am still very excited by what I heard.

Just finished another Sherwood Anderson ("Windy McPherson's Son") which is <u>really</u> good!

Now reading Jane Austen's last, but unfinished, novel, which has been finished by another lady, and recently come out. Too soon to tell how successfully so tho.

Only social plans are tonight: dinner with Tim [Dlugos] and friend.

Got things worked out with Joel about lighting : he'll begin on Wednesday.

Had a drink (by accident : ran into them on street) with Aladar and Larry [DiCarlo] and they were so nice & secure about me that I just didn't have whatever it takes to tell them I want out. Pissed at myself about that. I guess I just hate (and will do anything to avoid) scenes. So—don't know what I'll do about it now. Hate being so wishy-washy tho. (Ugh!)

Well now, I really don't want to hold you to that date I drug out of you. I'll be anxious to see you, and if you're not anxious to see me, I'll just be disappointed and depressed and boring. But I'll certainly keep free for you. And so if you feel like seeing me, call me when you get in—O.K.?

I will optimistically be looking forward to that.

Now do try to make the best of where you're at now.

Love you as always,

Joe

April 2, 1979, 8 Greene Street, New York City[21]

Dear Kenward,

Just home from John [Brainard's] and, during the walk, I couldn't help but re-live our earlier talk : my expansive words of affection, and your nam-by-pamby responses. And then your cold "goodbye," filled with resentment because we won't be seeing each other for four days. And so guiltily walking home, it was that it occurred to me, that of Sat.-Sun.-Mon.-Tues., I am only busy one night, and that you are busy all four nights. All of this made it quite easy to deduce that you're just looking for trouble. Or a way "out." Or whatever. But—whatever—I've had enough of it.

Although I know I'm no great bargain, you've managed over the past few years to make me feel like a frumpy shit.

And for once again in my life right now, I feel at least a tiny bit flexible and available. And you are not there. And I really can't afford not to take advantage of it, if it's still with me tomorrow. I sure hope so.

Your lack of compassion staggers me.

As do all the wonderful things about you too sometimes.

But from you to me, so much is "reserved," that I'm at a total standstill. And, tonight, I've finally given up.

I really don't care.

Which is why I'm writing tonight, before tomorrow makes me wonder.

If I know me, I may "retire" for a few days, but, if so, you can reach me on Wednesday afternoon, just in case it should mean anything to you that I be there opening night.

Know that I'll never think less than fondly of you. Simply couldn't.

It's just that somebody's got to stop things, if they can't go forward.

I feel you have made me do it. And I'd feel a lot better about it if I thought it'd make you happy. But I don't.

I don't even know that much about you, really.

And as evidently that's the way you want it—

Love* to you,

Joe

*Adios!

September 27, 1979, 8 Greene Street, New York City[22]

Dearest Kenward,

Just got your book today—thank you—tho I've yet to find the right space in time to re-read it in. Well, tomorrow.

Aren't people funny? Everybody—(figuratively speaking)—says "what happened to your tan?" and "where are your 15 pounds?" You'd think they'd leave me a few illusions—just to be nice. Or something.

And so how was Anni [Lauterbach's] visit? And who's next?

I haven't done too well cleaning up the back room yet, but I did get new lizard boots and a real short hair-cut. (Today)

And tomorrow is laundry and dry cleaning, and dinner with Tim.

Had dinner with my brother John tonight—(who almost got married this summer)—and gave me a pretty pair of beige suede cowboy boots that were a bit too tight on him, and a bag of grass!

(And confessed with pride that he recently got the best blow job he's ever had—from a guy!)

Another meeting on Tuesday about going co-op.[23]

Am reading a good rather "plain" book called "The Assistant" by Bernard Malamud : about a generous and poor Jewish grocer with a beautiful daughter, and etc.

And am enjoying very much the summer pile up of "National Geographics" : every article is interesting!

And/but that's about it for news I'm afraid.

Except that I love you and miss you. But that ain't news.

And yet.....

Well—you know—considering how long we've been together, I think we do pretty good—don't you?

It still scares me when I think of the giant gap you would leave in my life if you were not "here." I would just fall in I think.

But of course we're stronger than we think.

(I knock on wood.)

With <u>love</u>, Joe

October 24, 1979, 8 Greene Street, New York City[24]

Dear Kenward,

Two days back from Key West, and I'm still not feeling very good. Too old for such sharp transitions, I guess. But boy it sure was pretty down there. We all three wrote a lot, and read to each other at night.[25] Chris [Cox's] novel (he's been working on for 3 years) is as tight as lace. And very funny, and very southern. Ed [White's] novel—well—I don't know what to make of it as a whole, though it has some really beautiful and expansive parts. And my own re-working on the first two parts of "Nothing to Write Home About"[26] I'm real proud of. It doesn't amount to much, but it's the best writing I've ever done. As God only knows it should be, after all I've put into it. They sleep in separate bedrooms. Each have [*sic*] two nights out alone. And yet act as tho they are "married." With three cats. And dinner was pretty much a matter of pushing everything aside, to plunk down a pasta dish (etc.) until I made it my duty to set a real table, with candle lights and frozen glasses, so dinner became more of an "event," which I think they appreciated very much, as did I my influence. We had four days of rain, and three of sun. Golden-brown blonds all but fell into my lap from time to time, but for some reason or another I just wasn't "there" enough, to care enough, to even bother. (!!?) Having wheels—(a bicycle)—was great, after two days of sore thighs. And one of the greatest pleasures of all was lounging out in the front porch swing each night, all alone. Except for a coconut—from time to time—falling to the ground with a hollow "clunk." And I thought a lot about you. And about our relationship, which in so many ways—you know—is quite idyllic. Regardless of what either of us—from time to time—might think. I think we try to make life smoother for each other, each in whatever way we can. Our ruts are really surprisingly few. And I <u>think</u> you still need me as much as I <u>know</u> I need you, whether together or apart.

But it's been a heavy day. Had breakfast out. A fan letter from Australia, informing me that I am somewhat of a cult figure in Sydney, amongst a small

group of poets who pine for a bit of "history," and apologize for the lack of
it. Read some of "Sappho" by Alphonse Daudet : (a 19th century novel of
a sweetly S&M nature, set in Paris). And a chat with Michael Lally, who's
down in the dumps over money. And so I gave him really more than I could
afford to—just to pay his rent, and momentarily tide him over. (A thing I
mention—partly—just in case you too might be in the mood or spirit of
things, to ease a load.) And then I bravely filled a big garbage bag full of stuff
to dump, on my way out to the deli for dinner "to go" tonight. The hour of
which is soon approaching. And will no doubt actually occur before I finish
this letter, which is going to be a long one. Because I did a lot of thinking in
Key West, about what I'm to do, or not to do. And though the conclusions
are still fuzzy, the issues are clear. And now is the time to tell you what I
think—how I feel—and to ask you for the advice I am badly in need of.

But first a break for dinner—though only six o'clock—then I'll be back.
With fingers crossed for my ability to be clear and honest and straight with
you. In hopes of just the same from you.

I changed my mind, however, and went to a local bar for a grilled cheese
and bacon sandwich, and two Planter's Punches. (Reminiscent of Key West,
and the chairs that swivel in the Motor Inn Lounge.) ((VT.))

At any rate—everyone I've talked to says that it's a great bargain—(the
co-op deal)—and that I'd be a fool to pass it up. And that at any time I
wanted to I could sell out and make money on the deal.

And so if you still can, and still want to, loan me the 16 to 20 thousand I'll
eventually need, your security would be the place itself (my floor plus co-
ownership of 2 other floors) which makes me feel a bit better about the thing.

But this—alas—is not the only issue that is bugging me.

I've always managed to avoid "red tape" somehow. (I don't have a credit
card. I didn't even have a checking account until 3 years ago!—and etc.
etc.—for example.) And do I want to start now?

And now for the—gulp!—hard part. I guess I'll be having an affair of
sorts with Keith McDermott, when he gets back to the city. No big deal. No
different from the many others I've had from time to time over the years.
I know he'll get bored with me fast, if not me with him. And—for me—it
has nothing to do with "us." And the love I have for you. But he is awfully
cute. And seems to think he has a crush on me. And—God—you have no
idea (I suspect) how much my ego needs that.

I know it has nothing to do with us. And yet I somehow can't even con-
sider asking such help from you without telling you about it. It would seem
sneaky somehow.

(Though of course, the last thing I need to get over my feelings of frumpiness is to put myself up against a raving beauty : but I know if I don't at least try, I'll regret it. And that would be worse.)

And so I hope I have put my cards on the table as accurately and as honestly as I know them to be.

I don't really give a fuck about the loft, or anything too much right now—(except you)—but what I do want to do, and do need to do (for my own self-esteem) is to do the brave thing.

But I really don't know which is which.

Can you help me? (By telling me exactly how you feel. And what you think I ought to do.)

I know this is a letter I ought to re-write a few times. But once is hard enough. And you know me pretty well. Or if you don't, it doesn't really matter much anyways.

Do let me hear back from you as soon as you can—O.K.? I really am terribly confused over what to do.

Please. And thank you.

And love you, Joe

P.S. I told Bill and Willie about our puff balls, and they said that another great way to "do" them is to cut them up like large French fries, and then deep fry them in a light batter. Sounds good—no?

Early 1980s, 8 Greene Street, New York City[27]

Dearest Kenward __

When I found out from Joanne [Kyger] this morning that we were all having dinner together—that I would not get to see you alone—I simply knew I had to write to you—"talk to you"—before I go bananas.

I need your love and your help desperately. And so down on my knees again, I beg. And I don't complain : you are worth it. And, besides, I have no choice.

I very well know—and want you to know too—that my love for you is the only consistent thing in my life. It is the only thing I am really proud of. Without you, I crumble.

I know this is a heavy thing to lay on you. But it's so true—I need you so—I simply must.

Because—you know—I even love the things about you that drive me up the wall!

Let me tell you that I really don't mind if you see other people—it makes me jealous, but that is simply natural—as natural as that you should be drawn towards other persons, at times. But please don't drop me, or shut me out. I (again) beg of you.

After Steven, and the way you've been treating me of late, I am so terribly insecure about your love for me. If you have any left at all, will you please help me by trying to show it a bit?

Or, if you don't, please tell me in advance. Please be honest with me. Please don't keep me in the dark.

I know I'm no great bargain these days—(I don't even like myself)—but for you I will try real hard to improve. Will you please give me this incentive. And let me know in what ways I can please you more. As I would like so much to do that.

(Don't you know by now that I can "flower" under affection and approval, and turn into a total frump under indifference?)

So please try to remember our best days together, and try to have faith in their return.

Or if you are truly in love with someone else, and bored with me, please tell me. As not knowing is worst of all.

Of course this is not the letter I really want to write to you. But the best I can do for now.

Please don't leave me!

I love you so very much!

["For Kenward" above a drawing of a red heart]

As always,

Love, Joe

October 13, 1982, 8 Greene Street, New York City[28]

Dear Kenward,

Just finished lunch. Some slices of deli ham with mustard. And a tall iced coffee. Hoping the rain will stop so I can go to Nautilus this afternoon. Slept most of the morning, totally exhausted from teaching yesterday. Spending a half hour each, with fourteen students.[29] Don't know when I've ever talked so much in one day. And so nerve wracking, just finding and getting on

the right train. (!) Made me apprehensive for you, in regard to your eastern travels.[30] I don't think I could possibly do it. Just <u>could not</u> do it.

Most fun I've had was at Martha Diamond's opening. Saw lots of old and mutual friends. Everyone said I've never looked better. And got real expansive on just two glasses of white wine.

Of course everyone wants to know about my work, and I have to lie. My current story is that—although I haven't anything yet that I like—I have been working on it, am on the right track, have faith in the future, etc. Partly because people don't have much patience with old sob stories, and partly because a part of me thinks that if you say something enough, you'll <u>have</u> to live up to it. (So please don't spill the beans on me.)

Recent dinners with Bill Katz, Bobbie Hawkins (exhausting!) and Chris Cox. Saw "My Dinner with Andre" again, and loved it again, even more. And "Celeste," a movie about Proust's maid : very heavy-handed (German) and s-l-o-w. Tonight is Ted and Ron at the Church. Dinner with Ed White tomorrow. And night after tomorrow, dinner with Anni and Brian [Wood], if indeed that is his name. I think so.

Every day produces endless little errans. (?) And I zip through money with nothing to show for it. (?) Such is city life, I suppose. Yet I <u>do</u> still like it.

The Milton Avery show was terribly exciting. The people in the streets are simply amazing. And I have a new author crush : Anne Tyler. Two down, and three to go.

Thanks for your nice letter. And for the Barbara Pym short story, which I seem to be saving for just the right moment. Something to look forward to on the coffee table.

Of course I love you, and miss you, and look forward to hopefully hearing from you again soon.

<u>Love</u>, Joe

Summer 1985, 8 Greene Street, New York City[31]

Dear Kenward:

Spent a real nice weekend all by myself alone. Saturday I read and finished "Auden in Love," which I loved. Then I went to a four o'clock showing of "Kiss of the Spider Woman" (as I told you over the telephone) and then I walked down along the West Pier and watched the sun set. Then chicken

piccata at "Duff's" then home to T.V.! (Did I tell you that my tenant left her T.V. here for three weeks?) Oddly enough, I don't watch it much though.

Sunday I had a big brunch out. And read "Real People" by Alison Lurie all day: a novel in journal form, about writers and artists on a rural retreat near Saratoga, obviously based on that place Anni goes : the McDowell colony? Then I went to the "Waverly" to see the new movie about Patsy Cline—"Sweet Dreams"—which I liked very much, thank you. Then I had a chicken burrito at my local Mexican place, with two margaritas to put me out like a light.

Today is Monday, and Columbus Day, and—real soon—gym. But no school until Wednesday—(only three days a week this year)—because of Columbus Day.

I hope you will consider it a compliment that I would never write such a boring letter to anyone but you.

<u>Love</u>, Joe

10

DEAR MAXINE

The editor and literary agent Maxine Groffsky first met Brainard at the Settimana della Poesia, Spoleto Festival of Two Worlds, Italy. The poetry festival, which took place from June 26 through July 2, 1965, included the writers Bill Berkson, Barbara Guest, Ezra Pound, and Charles Olson. Brainard and Kenward Elmslie were there as part of the audience and visited Groffsky in Paris after the festival.

Groffsky had left New York for Paris in 1962. Friends with the poets James Schuyler and Frank O'Hara and painters including Willem and Elaine de Kooning, Groffsky moved confidently through Paris and New York jazz clubs, poetry readings, and art salons. It is no wonder that Brainard found her irresistible as he became ever more part of that world in the mid- to late 1960s. ("There have been a lot of parties," Brainard wrote to Groffsky in 1966, adding, "and I am slowly but surely becoming a better talker.") During the period these letters were written, Groffsky was the Paris-based editor of *The Paris Review* (she worked there from 1965 to 1974). The first letter included here was written following Brainard and Elmslie's visit to Paris in the summer of 1965. The two returned to New York on "the good ship Rotterdam," as Brainard put it. He started writing to Groffsky from the ship and remained close to her for the remainder of his life.[1]

July 1965

Dear Maxine—I'm writing you this letter from the Rotterdam. It is Sunday and it is cloudy and the boat is rocking and I'm determined not to get seasick. Wish me luck. Urg! The Rotterdam is <u>not</u> to be believed!

"A large assortment of chocolates of different prices can be purchased in the library."

"At 12:00 midnight the 'Tropic Bar' is open for the night owls."

And etc. Also there is the usual : movies, teas, dancing, bingo, bridge, ping-pong, shuffleboard, and midget golf, if you are a midget.

The movies, so far, have been terrible. The food is terrible except for breakfast.

Breakfast is good because they have cornflakes and I'm a fiend for cornflakes.

The movie for today is "Mediterranean Holiday," a documentary narrated by Burl Ives.

The thought for today is—"I will do at least two things that I don't want to do, as William James suggests, just for exercise."

Help!

It is nice to have someone new to write a letter to. Actually, I never hardly write letters ever, but I do want to be sure that you know that I think a lot of you and that I thank you for Paris.

Actually, aside from the cornflakes, there is only one good thing about this ship. In the library among all the chocolates I found a copy of Edwin Denby's "Mediterranean Cities," my first reaction was to steal it, as I don't have a copy of it, but on second thought it was too good really, finding "Mediterranean Cities" on the Rotterdam, so on the Rotterdam it will stay.

Hours have passed. The boat is rocking more and more. Everyone is sick by now, I am sure, except the little old ladies who ride this boat every summer, and me. Just finished a terrible lunch of tasteless fish. Actually, I did not finish it. And vanilla ice cream. The vanilla ice cream was O.K.

I am trying my best to find good things to say about this ship the Rotterdam. I have thought of one more thing : the drinks are cheap.

Enclosed you will find a self-portrait I just made. [See figure 10.1] Another good thing about the Rotterdam is that they print a list of the passengers, and I am a sucker for seeing my name in print.

I wish you were here. At 11:15 in the Ritz Carlton room is a get-acquainted dance and novelty dance with prizes! We would certainly win, or my name isn't Peter Pan.

Today is another new day on ship. It is cloudy. Tonight there is another novelty dance. I wish you were here. We would certainly win, or my name isn't Peter Pan.

On the good ship Rotterdam there is a daily bulletin of activities. And a "thought for the day." Today's thought is : "Just for today I will be happy. Just for today I will try to adjust myself to what is and not try to adjust everything

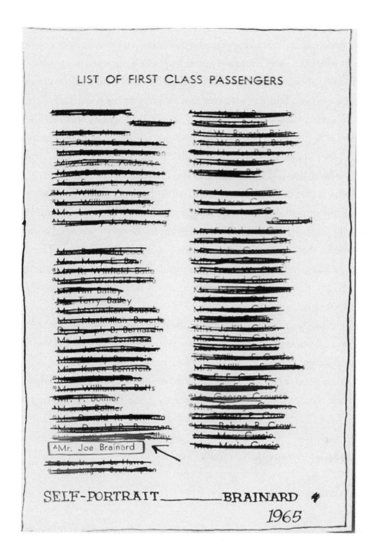

FIGURE 10.1 Image included in the July 1965 letter, Brainard to Maxine Groffsky, courtesy of Maxine Groffsky.

to my own desires. I will take my family, my business and my luck as they come and fit myself to them." If I allowed myself, I could find this quite frightening, fortunately, I prefer to find it amusing. Actually, I <u>do</u> find it amusing. But I am always curious as to how much choice one has. I vote for "a lot."

I have decided that the food on this ship Rotterdam can't be all that bad seeing how it is that one can't even taste it.

So—you appear to have a very good life going for you in Paris. I hope so.
Most people seem to find happiness is not being happy. This does not seem
true of you. Of course, I suppose either way is O.K., as long as it works.

Today is another new day. Today is Gala Day on board the Rotterdam.
At 7:00 is a Gala Dinner (whatever that may be), at 11:00 is Gala Entertain-
ment ("variety show by our talented crew members"), 11:45 is a Gala Show
Buffet (with floodlights for picture fans) and at 12:05 a Gala Hoot in the
Owl's Nest. There is no thought for today.

One more day and then a half and then N.Y.C.!!

Today is that one more day, then a half and then N.Y.C.!! There are peo-
ple on this ship who go around taking pictures of us. This picture enclosed
is one of them. I am the Mexican immigrant in the upper left hand corner.
Kenward is the diamond smuggler in the lower right hand corner. The
other people around us are fellow passengers. [Enclosed photo of passengers
including Brainard and Elmslie lined up on the ship's stairwell engaged in
what looks like an evacuation drill.]

You casually mentioned that you'd like me to do something for the Paris
Review and I casually said yes I'd like to. Actually—I'd love to. I like to do
lots of different things. And frankly, I love to see myself in print. So—

On the good ship Rotterdam Kenward and I play ping pong, read, and
sunbathe. That is about it. Not too interesting, but I am almost getting used
to it. Help! [Remainder of letter is missing]

Fall 1965, 40 Avenue B, New York City

Dear Maxine__

Pat & Ron tell me about you and about how absolutely great you have been.
(And how absolutely great you are!) I feel like saying "thank you," but that
would be rather silly. At any rate—Pat and Ron are really great too, aren't
they? Sometime soon let's have a party for "Really Great People" and not
invite anyone except us four. Went to Times Square last night and took
millions of pictures in those machines. I have new glasses, as you will see in a
few of those millions of pictures I took last night in those machines, which
I have enclosed. New York City is wonderful right now. There is a lot going
on and it is nice and cold. (I love cold weather.) Ted [Berrigan] gave an
absolutely great reading Sunday night at this new gallery which has weekly
readings. (Perhaps we could make it 5.) Kenward is going to read there soon.
(Perhaps we could make it 6.) And I am going to read there too. And Frank

[O'Hara]. (Perhaps we could make it 7.) And etc. Work-wise all is well. Did
a portrait of Sandy [Berrigan] I love. Also working on a large totem-pole-
type construction. "C" Comics No. 2 is almost finished—so watch out!
Love, Joe
P.S. New "C" enclosed.
P.P.S. Kenward's' opera going well.[2] Will open Nov. 4. The libretto is being
printed in booklet form. Will send you a copy.

P.P.P.S. "Hello" to Pat & Ron

Late 1965, 40 Avenue B, New York City

Dear Maxine __

Your good news certainly was good news![3] I assume that you are over your
hangover, and feeling much better by now. I hope so. I forgot where it was
that you've been, but I hope it was fun wherever it was. Well—now that all
of that is over with, I can think of nothing else to say. I am really a do-do
writer these days, a do-do letter writer, that is. Channel 13 is doing lots of
T.V. shows encompassing everybody from John [Ashbery] to Frank to Ken-
neth [Koch] to Kenward to me, etc. Actually, they don't like me very much:
the only way I am included is through a collaboration I did with Kenneth
called "The First Bunny." (But I get $50 just for letting them use it!) I'm
impressed. Have been keeping pretty busy working with cigarette butts,
a full length novel-cartoon with John Ashbery, and lots of cover designs.
Next I am doing a cover for Kenward's opera "Lizzie Borden," soon to be
published by Boosey & Hawkes. So—, when are you coming to N.Y.C?
Tomorrow I, too, am going to become an Alex Katz cut-out-figure![4] I am
enclosing two dirty drawings for you. I will be very hurt if when I come
to Paris again they are not up on your wall. (And with a cleaner wall area
behind them!) But actually, feel free to tuck them away in a drawer, or give
them away to friends, etc. I wish I had some "straight" dirty drawings to
send you—but that's the way the ball bounces. At any rate, I love the idea
of soon being in The Paris [Review]: many thanks for the pull that it must
have taken. I can think of no one I'd rather have pull for me than YOU!!!
 I guess I'd better stop now because when I have nothing to say I get
pretty silly, and besides, I have to go take a shower.
Love, Joe

January 1966, 40 Avenue B, New York City

Dear Maxine__

Of course, the woman was absolutely great and very much of a surprise![5] I love it! Many thanks! Etc! I've been working night & day finishing up the Japanese City and now it is (at last) up at the gallery under spot lights, and I must say it looks pretty impressive. However—it is a bit of a monster (much too big) and I never want to see it again. Kulchur magazine has folded (Help!) If I am not in print every once in a while I find it hard to wake up in the morning. So— how was Athens? "C" Comics is <u>actually</u> at the printers right this minute. The subways and the buses are on strike which is O.K. with me because I refuse to use them anyway. The only thing is that it's terribly hard to get a cab now. So I walk because I don't like to wait for cabs. Needless to say I have been doing a lot of walking. John Ashbery found an apartment in the neighborhood he wanted: around 5th Ave. & 12th St. So—he moves in Feb. 4th. I'm glad because I am sure that that will make all the difference in the world. Everyone needs a home. I had a really wonderful Christmas. I hope you did too. However, I must admit that I cannot imagine Christmas in Athens. For me to feel Christmasy I need cold, to say nothing of snow. We had rain. But somehow it worked out all right. Actually, it wasn't even very cold. John says he does nothing but go to the movies; but I guess that is pretty normal. I also must admit that I have not blown up the lady yet. She is so beautiful flat and I am afraid she may turn into something terrible. So I am saving her for a rainy day when I am bored. Meanwhile she hangs flat, and seems to be doing well. There have been a lot of parties and I am slowly but surely becoming a better talker. Altho, it is not easy. Words just do not flow from my mouth. As soon as "C" Comics is out I'm hightailing it to Vermont for a couple weeks to totally concentrate on Sky Boxes, and painting. I guess I will get a lot of reading done, too, as the nights are very dark and there is not much to do. Enclosed you will find a cartoon Kenward & I are submitting to *The Paris Review*. Do not worry if you can not get it printed (assuming that you like it) because if *The Paris Review* doesn't print it <u>we</u> will print it. However—it would be nice to have it in a <u>real magazine</u>. You said that your next stop was New York. Is that soon or is that someday? I did some dirty drawings for special editions of Auden's "The Platonic Blow."[6] (Pirated edition) It was so much fun that I have kept on doing them. Some of them are quite beautiful. I am tempted to send you one, but it may not be your cup of tea, as John Meyers would say. I have seen Dee-Dee [Ryan] several times since Europe and your name always pops up. She seems

to like you quite a lot. Or else I am a dope. Say "Hello" to Pat and Ron for me every time you see them. There is nobody in the world I love anymore [*sic*] than them. It's terribly spooky how easily one can do without your very best friends. I really don't miss them at all. (Tho I wish I did) At any rate—many thanks once again. Will hear from you soon I hope. Be good —
Love, Joe

July 1967, Southampton, Long Island

Dear Maxine __

Here are a few tee shirt ads.[7] I hope I'm not too late. I kept waiting for a shirt to arrive, but it never did. So—I guessed at what they'd look like. (I hope the emblem is on the front) Only 3 more days here. I'm going to miss Southampton, Jimmy [Schuyler], and Fairfield [Porter's] studio. Then—to Vermont. The address in Vermont is only c/o Elmslie, Calais, Vermont. Just finished, at last, my drawing for Frank's poem "Blocks" that Bill Berkson is doing for the Museum of M. Art.[8] And, I love it. I deserve to love it. I worked terribly hard on it. Mostly boiling down possibilities. And balancing : (poem / drawing) I don't know exactly how they balance, but they do. I mean, in every way. Mainly, I think, in a way that wouldn't make you even think about it. I mean, it's not "art." Nor is it "a Brainard." At any rate—if you know what I am talking about, please tell. I'm not nuts about these ads, but I figured I can't wait any longer. So—I hope one [of] them rings a bell for you. It is always good to hear from you.
　　Take care—
Love, Joe

P.S. Saw Ted last weekend he was out for a reading. Said that he was almost finished typing the tape.[9] I hope—I hope you have it by now. (?) Write and tell me about B. B.'s [Brigitte Bardot's] anniversary party!

January 1970, 664 6th Avenue, New York City

Dear Maxine __

Your postcards are great to receive. I wish you a happy new year too. And I hope you had fun in Spain. I take it that your mother is O.K. if she can go to Spain. (?) I hope so.

Charles Olson died.[10] Of cancer. Just a few days ago.

I am listening to The Rolling Stones on my new stereo cassette. Their new album "Let it Bleed." Beautiful.

I'm painting portraits now. In oils. In a few minutes Bill Berkson will arrive for a sitting. People are hard. (Painting people) But I love it. And it's a great way to talk to people. I find the situation very comfortable. (The situation of <u>really</u> looking at someone) My portraits (so far) are very Manet-like. And very personal. Straight. Not too "interesting." But good.

John Ashbery's new book is out.[11] John and Kenward and Kenneth [Koch] and Barbara [Guest] and Bill are reading tomorrow night at the Metropolitan Museum. Michael Brownstein reads Sunday at "N.Y.U." Michael and Anne [Waldman] got a house in the country so they are not (sniff) around much these days.

I am O.K. Altho there is still something a bit desperate about how I feel. Perhaps "that" is just being 27. But I suspect there is more to it than that. Now, more than ever before, I am out to make life more exciting. And that's not easy. So—these days, for me, are very "up" and very "down." (No inbetween) I even got a telephone. (My first)

Bill just got back from California and loved it.

Tonight I am giving a small acid dinner party. (Another first) I've never "entertained" before on my own. I get tired of big dinners so I am just serving lots of bread and lots of cheese and lots of apples. And wine. (And acid)

Let me know how you are.

Anne is printing as an Angel Hair this book I wrote called "I Remember." So—will be sending it to you soon.

The Hazans [Joe Hazan and Jane Freilicher] are in the Bahamas.

Jimmy is in Southampton visiting Pat & Ron. Pat makes her own bread now. Jimmy, this year, is in the city a lot.

Tony Towle has been getting drunk a lot at parties and insulting people. So much for gossip.

Are you coming in the spring? (I hope)

Love to Harry [Mathews].

I miss you.

Love you, Joe

P.S. My gallery folded![12]

11

DEAR FAIRFIELD

In a letter to James Schuyler, the painter Fairfield Porter wrote, "I am having a rather extensive correspondence with Joe Brainard, who asks me a lot of questions, which I do not answer all of, not out of censorship so much because I forget to, or I only answer questions that interest me. It is all part of my new role as mentor of the young, which I didn't seek, but has been growing anyway."[1] Brainard's letters to Fairfield Porter here, spanning from around 1967 through Porter's death in 1975, are a rare example of Brainard directing his attention and questions to a painter rather than a poet. We find Brainard learning from Porter how "to back up, to be more direct, and to let more happen," as Brainard put it in a 1967 letter. The letters also show Brainard feeling vindicated in moving toward a more personal and "realist" style thanks to Porter's example. That said, doubts about his own talents continue to linger. An ongoing concern for Brainard was his perceived lack of ability in working with oils—as he wrote to Porter in 1972, he was having difficulty "living up to the authority oils carry for me." Similarly, Brainard's perception of himself as a minor artist is expressed in one particularly melancholy sentence written to Porter in 1967 that raises what he calls Porter's "brightness" hierarchically over his own "lightness": "Your kind of brightness is terribly real and valuable. Perhaps you are confusing this with my lightness. (A thing about my work I don't regard too highly)."[2]

January 1967, Providence, Rhode Island

Dear Fairfield _____

Many thanks for your thank you letter. It embarrassed me a little, and
pleased me a lot. I wanted to write sooner, but it is a hard letter to follow.
It seems to me that I am not modest at all, but maybe I am. Your paintings
are incredibly "bright" for me. Your kind of brightness is terribly real and
valuable. Perhaps you are confusing this with my lightness. (A thing about
my work I don't regard too highly) I suppose that is normal : to not trust
what comes too easily. At any rate, I'm glad that you liked the imitations,
and I am especially glad if they were inspiring. I have been painting small
paintings of wild flowers from photographs from a wild flower book.
Several have turned out as fake Fairfield Porters without my even trying.
And almost all of them have bits of you in them. I don't know if other
people can tell or not, but I can tell. Kenward's musical is packed full of
everything good about musicals.[3] Only thing is, two of the star ladies are
terrible and somehow they leave a big hole in the show. Also, it was way
too long, but now it is cut down and very crisp. Opening night was a
disaster and most of the critics panned it. But since then it has gotten two
good reviews and Truman Capote loves it. Also, the audience loves it. So,
I think it may turn into a "hit" if everyone is lucky. I hope so. Providence,
what I have seen of it, is a beautiful city. I haven't seen much of it though,
because I've been working very hard and then at night I go see the show.
I have seen it so many times I am totally brain-washed. I just sit down
in my seat and then it happens and then it's over. I do enjoy it, but I just
can't remember enjoying it. It is almost a sin the way it sucks you in. I am
not a theater fan, though. I like to go to the theater before I go, but once
I am there I am usually disappointed. I do like "stars" though. I am more
of a movie fan. Jimmy and John [Ashbery] and Jane [Freilicher] and Joe
[Hazan] are arriving here at 5:30. (It's now 4:10). I haven't seen any people
I feel normal with in so long that I'm dying to see them. Your painting
is already framed and when I get back to N.Y.C. I will take it up to the
gallery. Will be back somewhere between the 10th & 15th (of January).
I hadn't planned on staying up here so long but it is very easy up here and
that's nice for a change. I hope 1967 is a very good year for you. Thanks
again for the letter. And "hello" to Anne and Lizzy and "happy new year"
to them too. See you soon I hope _____
Love, Joe

Probably February 1967, 40 Avenue B, New York City

Dear Fairfield ____

I am glad that, now, I can tell you how much I liked your big new painting
of Lizzy [Elizabeth Porter] and yourself.[4] At the opening I was not able to
somehow pull it all together. Nor was I able, totally, to accept Lizzy. She
seemed a bit too easy. At any rate, Jimmy [Schuyler] and I went up and saw
your show again yesterday and, as I suspected, it is a beautiful painting.
The room and the mirror and Lizzy each held their own very well. And,
as should be, Lizzy became the most important thing. How you managed
to hold everything in the mirror on a mirror level is beyond me. I was also
very thrilled with how, like in real life, a single color or object will totally,
for a moment catch your interest. "Moment-wise" I especially remember the
orange sweater and the yellow pillow and the bottle in the mirror and the
out-side of the window in the mirror and you and the white legs of the chair
against the black. There were so many other things too though, like the red
shoes and the print on the couch. And the way Lizzy was sitting, her size,
etc. At any rate—it is really an amazing painting. What amazes me the most
is how Lizzy and the room and the mirror were each such a different thing.
That's really amazing. If I say amazing once more I will kill myself. So—I just
wanted to let you know how much I liked it. And how much, once again,
I liked your show all over. Jimmy & I saw a really good show of drawings,
washes mostly, and prints by Goya. The drawings, and your show reminded
me once again to back up, to be more direct, and to let more happen. Also
to take advantage of what paint can do. (Direct) I read Jimmy's article about
me, and loved every minute of it.[5] Partly because it was about me, and partly
because it was so well written (good to read) and partly because he didn't try
to make too much out of what is not really "there" yet. Also, it was funny.
I guess you have read it too. My garden is coming very well and will proba-
bly be finished tomorrow. It looked very beautiful a week ago and it looks
beautiful today. I think I could continue to work on it for another week or
so and it would still be beautiful. It is quite tedious deciding when to stop. It
is mostly a matter of "how many flowers." This time it will not be as many as
possible. There are black areas. (Empty, but solid) So—I am running out of
things to ramble on about. Once again, thank you for your show. I can't wait
to get mine home. And I hope you are as happy and impressed with your
big painting of Lizzy as I am. I can hardly wait until my show is over. First
off I've drawings and a cover to do for a book by Ted and Ron that <u>Kulchur</u>

press is publishing, and then, I hope—I hope, I'll just work on drawing and painting whatever I feel like.[6] "Hello" to Anne and Lizzy—
Love, Joe

1968, 74 Jane Street, New York City

Dear Fairfield _____

It was good to hear from you, and thank you for all the information and advice. I think that for now (to keep things simple) I'm going to try stand oil.[7] From what you say it sounds very good. I hope I like the texture of it. (That it comes from the brush easy) That's what I like. That's what I hated so much about plastic paints: they didn't come from the brush very easy. And "yes" I would like to try a sample of your Flemish medium sometime. For the past week I had mostly just been walking around my new place doing little things trying to get comfortable here. Also stretching canvases. My new size for now is 24" × 36". It's a nice size I think. A little bit longer than usual, but not longer enough to seem "long." What I think I will be painting is my windows and plants. When the sun pours in, on, and through them, it's one of the most beautiful sights in the world. I am not exaggerating. I am still not very fond of teaching.[8] The truth is that I'm not very good at it. I tell people that my students are not very good, but actually, the reason I don't like teaching is that I'm not very good at it. I find myself saying "that's nice" a lot, when it isn't. (What they are doing) I guess that I really don't believe in it yet : teaching. Kenward and I are posing for a big cut-out cocktail party Alex [Katz] is doing.[9] As I understand it each person will be separate, so it will be very 3-dimentional. Alex got me very fast but Kenward I think is much harder. My apartment is painted now. Ron and I ended up doing it ourselves. Today I am (it is morning now) going to stretch 2 more canvases. I don't really like doing it so I want to get a lot stretched now. Also I'm going to put together a paint table and re-pot some plants. We are having beautiful weather: 70° & sunny. Thank you again for helping me out. Please say hello for me to Anne [Porter] and Jimmy. Will see you soon I hope.
Love, Joe

Fall 1972, 664 6th Avenue, New York City

Dear Fairfield _____

Good to hear from you.
 Yes, my healthy summer was terrific, but, here I am again.

Right now a bit low because I have a bad throat, and a green tongue, and I can guess what <u>that</u> means: strep throat, a thing I seem annually to get.

And also—my big toe nail is coming off! (Just hanging on). I practically ripped it off in the lake this summer, on a rock, and I sort of figured that if I just ignored it it would somehow re-attach itself, but— no such luck.

<u>And</u>, tomorrow I begin a series of seven dentist appointments. Eight caps, many fillings, and $1600!

Sorry to be a bore about this, but it <u>is</u> very much on my mind. I'm a baby when it comes to physical stuff. Which is to say that it scares me. And which is to say that I have no patience for it.

Pat and Ron are back.

I'm reading (very slowly) "Pack my Bag" by Henry Green. Such beautiful sentences.

I did O.K. with science this summer, but not as well as I had hoped. The simple truth of the matter is that I'm not as interested in science as I want to be, or think that I should be. (And my mind wanders) I got along best with a book about insects.

Spent the weekend working on a series of six McGovern flyers, to plaster the lower east side with.[10] A Maureen Owen and Allen Ginsberg project.

Right now I'm working on a few larger Nancy interior works, before I drop the whole thing.

Then, oils. Tho I sure don't look forward to the "setting up" and the "getting into" periods.

Here I lack patience too.

And living up to the authority oils carry for me.

A guy is coming by at one to buy some jewels. So I should stop and go through my stuff and decide what I don't want.

Ron wrote a terrific Dutch diary.

The Fagins [Larry and Joan Fagin] have split.

Kenward plans to stay in Vermont through October.

This cooler weather is nice.

That's about it for news.

I hear from Jimmy your small heads are really nice.

Love to Anne. And to Jimmy.

To <u>you</u>.

Love, Joe

Late summer 1973, Calais, Vermont

Dear Fairfield ____

It was as always good to hear from you, tho I was rather shocked and depressed over what you seem to think of your "official" and / or "commercial" status.

I can't believe that you could possibly take what museums think very seriously.

And that so many intelligent individuals think you to be the genius you are is certainly where it's at.

And, besides, I think you are in for a big surprise. (I have always been spookily accurate as to new wave predictions, if I do say so myself) and (pardon the term) "personal realism" is it. Both a matter of how good you are, and how "individual" you are. And you are very much both a lot.

And / but it pleases me that you seem, too, to care. (To be silly is really such a large and touching area)

Had a real disappointing week or so with birch trees. I love them so much I was "saving" them, expecting a sort of real music. But, alas, I cannot seem to find their source of warmth.

I'm leaving for the big city this Monday (today is Wednesday) (?) (or Thursday?) and so I've been capitalizing on the few signs of autumn with some grass ("etc.") works, which, in the frenzy in which they are done, are surprisingly good in that there is no room for any dilly-dallying.[11] And so it is a somewhat heavy and crude "speed," which is unusual for me.

Your large heads (large, I mean, in proportion to the canvas area) sound very exciting.[12] I am trying to visualize the "activity" of what must be almost a "border" surrounding the head. Is it a come and go (here and not here) sort of thing?

I still have my heart set on a small painting of yours one of these days soon. I think maybe you will like some of mine enough that a trade would be possible, if you, too, would like that.

I, too, liked "100 Years," especially so while reading it. But, again, intellectually, I shy away from such tightly knitted works.[13]

A bit hard for me to write now, as a part of me is already traveling. And also, that I cannot expect a reply (a reply to reply to, etc.) is not very inspiring.

So seems best to sign off, with hopes of seeing you this fall. Til then—
Love, Joe

July 1973, Calais, Vermont

Dear Fairfield ____ :

Your very intelligent and very stimulating letter was very good to receive, tho
it made me feel a bit silly, which is not to say that I am not. (Somewhat) but,
on the other hand, what we believe in, I assume (knowing that to "assume" is
in itself a bit silly: limited)—now—I forgot what I was going to say.

Well—I believe very much in "the individual," and so, what each of us
believes to be true, I believe is true, in one way. Not a very "grand" notion,
I admit. But, I think perhaps more than you do, I believe in the necessity
of faith in "experience." And in believing in what we find "practical" to our
sanity and person [*sic*] wellbeing. (Being able to "cope")

Also—I think I think more highly of "arrogance" than you do.[14]

All of which may make no sense to you as, as you said in your letter, you
forget what you write once you have written it. As do I. Perhaps for different
reasons tho. My excuse is that writing, to me, is rambling off the top of my
head which is why I say some pretty stupid things sometimes. Which is
one reason why I admire you so much: your words seem to have a "source"
beyond the moment.

Neil Welliver. Actually, it is not Neil's color that rubs me the wrong
way. It is "the formula" of form, all broken down so mechanically, and then
put back together in so puzzle-like a way. Was glad to hear, tho, that his
new paintings have an early Corot quality : they, the women, I have always
admired : soft, but strong. A matter, I suppose, of the often almost black-
brown shadows. And yet —

Contradictions. What I admire about Yvonne [Jacquette's] painting is
how "monumental" they are, and yet still remaining "personal" somehow.

Painting-wise I have been through so much since I last wrote I hardly
know where to begin.

For a while it was mostly a matter of doing very tight and accurate paint-
ing, alternated with deliberate attempts at minimal boldness.

Several of my new works are so good it is almost scary. But, alas, good in
such a way that they are first and foremost "good paintings," timeless, and by
nobody in particular.

However, the past three days have picked up a lot. The first of which
was two small paintings of Whippoorwill where I let myself "draw" a lot,
indulging quite heavily in "black and white." (And only one large brush and
turp [turpentine].)

Good day no. 2 was my first successful large painting, using lots of oil and lots of "dash," with much transparent overpainting, which worked beautifully for getting the pinks and blacks, partly seen and partly "felt," under Whippoorwill's thin white coat of hair. He is lounging on the olive green velvet sofa with two patterned pillows. Very focused in. (No eliminations) Very French. And also a bit, alas, Sargent. Never-the-less, primarily because of its size, I consider it a breakthrough.

Good day no. 3, today, was one small brush, no medium (not even turp.). A small painting again, of Whippoorwill again. Where I started out rough, focused in to very fine, and then did some very successful eliminating. The three stages of which I've felt was <u>the</u> process for me (now) but today, for the first time, I was able to bring the tightness back to something as hard-hitting as rough without its being rough. A bit, perhaps, like some Degas racetrack paintings I have seen, where details are somehow more "felt" than actually seen.

And so, right now, I am feeling nicely optimistic.

(I was wondering when reading your Sargent quotation if perhaps you meant that paint-talk is something you find not that interesting?)

What I meant by "Spanish" is an infuriating thing I do (generalization): "heavy" and black with the result of "dramatic" is what I meant.

What I meant by being surprised that the astronauts didn't return to Earth "ripped out of their minds" was <u>not</u> being surprised at being surprised. (Too)

Reading has been *A Cab at the Door* (a memoir) by V. S. Pritchett, which I was not too happy to have finished last night. Next on my list is *Les Liaisons Dangereuses* by Laclos.

Perhaps most rewarding these days has been learning (inch by inch) Whippoorwill's anatomy so totally un-scientifically. Although I could not carry on a two-minute conversation on the matter, I feel that were I to dissect him there would be no surprises. So much so that the temptation to regard this as "superior" knowledge is very much with me, if I didn't know better.

My first letter from Jimmy this summer said that Ellen Oppenheim's show was surprisingly good and that Ruth [Kligman] is not very fond of doing dishes.[15]

We had bad floods here but the past four days have been just beautiful: sunny and so clear, and just slightly cool.

Joe E. Brown and Veronica Lake both died this week. And, last week, Betty Grable. But I suppose you get newspapers where you are.

Two almost successful paintings of Kenward's organic garden: "almost" because of mulch: any definition carried too much weight, and no

definition carried not enough. And the slight variations of color in mulch was no help either way.

After one extremely tight day I set myself out to do <u>three</u> paintings (9" × 12") in one day, of the tooth brush rack in the bathroom, with four tooth brushes, with the idea in mind that time would not allow for being "fussy"; with O.K. results.[16]

Well—I'm about running out of words.

I certainly hope you don't think I have anything against Catholics. I only meant to say that it is mysterious to me. And "mysterious" is not something I have anything against. And, obviously, from past works of mine, I find it all very fascinating and beautiful.

Well—do you think we'll ever know each other better than we do in letters? Well <u>this</u> is very nice.

Again. Soon?

Love, Joe

P.S. Will you give Anne my "hello" and "love," and that I think of her surprisingly a lot, both as a finger [*sic*] and as, I suspect, an outrageously intelligent woman![17]

Summer 1973, Calais, Vermont

Dear Fairfield ____

Taking a day off from painting. Out in the sun. With oil on, which will explain any possible, and in fact, probable, letter stains. It's a beautiful day for sunning, but really almost too bright to see. So bright that I may end up with sore eyes halfway through this letter.

Sorry it's taken me so long to answer your, again, good letter. Once a few days ago I started a letter to you but after a day of work I was in a pretty scatterbrained frame of mind, and so, deciding that you deserved better, I stopped.

Which is not to say that I'll necessarily be much better today, however. Because, actually, I <u>am</u> pretty scatter-brained.

And I <u>am</u> sorry about my spelling.[18] I have an odd history with words tho, beginning with nobody being able to understand a word I said : bad pronunciation. Which made me not too fond of words (slow reader, bad speller, and bad stutterer) all of which is over now, except that such things <u>do</u> leave their marks, even if perversely so, as in my writing. And as for spelling, that's the one thing I haven't cared enough about to try and improve.

But, actually, I'm not as bad a speller as I appear in letters. To write fast is the only way I enjoy writing. And from experience I've learned that to re-read a letter usually means I don't send it. And so I compromise myself by not having to make the choice.

Words being what they are (pretty fuzzy) I suppose we could go on talking about "arrogance" til dooms day. And probably the whole thing (difference) lies in that I can only conceive of arrogance as a temporary state. Like being especially happy, or especially depressed. I cannot conceive on [sic] such a thing as an "arrogant person."

At any rate—your letter spurred me into a spell of trying to do some larger paintings : actually, two, both of Whippoorwill on a putrid green velvet sofa downstairs, the putrid green of the sofa (so much of!) being one of my biggest problems. However, thanks to what light does to old velvet, one of them is O.K. Rather, thanks to exaggerating that a bit. But, aside from any real basic desire to paint big, my biggest problem probably concerns my preoccupation with an "even" surface, which becomes quite a chore on a large scale. Which probably has something to do with what you were talking about as to oils being basically a bit "dirty" to Americans. But, actually, I don't mind being rough, or even sloppy, so long as I am totally, and evenly, so. This, however, is not something I'm willing to "except" [sic] yet.

Then I had several good days of doing some (four) (4 out of 6 that I like) slightly "cheap" paintings of cherries, somewhat in the vein of a Manet single stalk of asparagus: all 9" by 12": (which is my size this summer, unless I say "larger," which means, alas, 18" × 24"): I also have a mania for standard sizes.

Then there was a day of two zinnias paintings : each a single bright red in a yellow pottery vase. In both of which the zinnia turned out predictably red and predictably "painterly," but in the foliage and in the shadows I got away with murder, color-wise. Which is a pleasure. Tho I am sometimes a bit suspicious when I find too much variation of color in something, if, indeed, I really did "find" it. Or, if so, if it really matters.

(On the other hand, about half my mind is occupied with doing / having a good show for this January in the big room.)[19] I stick that in just in case I'm pulling your leg a bit about being so serious about painting: I am, but I'm pretty serious too about a lot of other things I wish I wasn't so much so about, I think.

The time it has taken for my new book to come out has pretty much destroyed it for me (it's very off the cuff, and should have been printed that way: minimally, and fast) but, never-the-less, a copy is on its way to you now.[20]

It seems to be a choice I have somehow made to let everything out and then apologize, when needed, later. As opposed, I mean, to being selective about

what one prints, or shows. Either that, or else by <u>not</u> making a choice. But, either way, this is where I always end up. This is somewhat exhausting, but I don't really disapprove. Which I suppose is what I want to know : do you?

(A big mystery to me is how strict you are on/with other people?). I have felt, from time to time, about you both ways : both that you somewhat are, and that you are not at all. Which is asking a lot, I realize, to expect anyone to be this way <u>or</u> that.

One nice feeling I've always had about Anne is that one could commit murder, and that she wouldn't hold it against you, not personally, I mean.

Not so much for the fact of it as for the possibilities of it, your repeating what de Kooning said about spaces in between chair slats is very inspiring.[21]

Hope this isn't too filled with questions. Tho I feel pretty sure you won't answer them if you don't want to.

Aside from wondering what you think about having a show of what you don't even know what it will be yet (pretty sneaky way of not asking another question, yes?) I <u>do</u> have a technical question which is not as vague as "medium" questions, I promise, and that is : are varnishes a sound way to get rid of uneven "spotty" (shiny & dull) surfaces?

About Alex's big paintings: I often have more faith in them, than that I actually like them. (But they make me try to)

And about Neil, I think he is good too, it's just that I, personally, like a bit more "room" : (loose ends), or what have you.

And I'm afraid that I don't quite get the "unavailability" of the "waste energy," re-reading your letter today, tho, funny, it all made <u>perfect</u> sense to me at first reading. But then, I don't imagine you'll remember. (?).

My "plan" for tomorrow is to try another large one: a "mixed" vase of flowers, as right now there is a good range of large ones (zinnias, tiger lilies, etc.) drawing carefully with a wash, and then "filling in" as flatly as possible. Which is not to say that, once in the painting I won't find myself doing something else, but it does seem to help me get started if I have a plan, especially so on for what is for a large (true to life) scale. One thing I can not <u>possibly</u> imagine doing is something larger than life, the "why?" of which for I haven't the faintest idea.

Well, running out of words.

Wish you would say more about what you are painting. But this is not to ask.

Hope all is well. And my love (big moment of decision : page 10?)[22]

And my love to Anne.

And <u>you</u>!

Love, Joe

ONE THOUSAND DOLLARS

REWARD

$1,000

DEAR ANDY___ SO, HOW COME I NEVER SEE YOU? (I'VE TRIED TO CALL BUT I DON'T HAVE YOUR STUDIO NUMBER, ETC.) AT ANY RATE, WHY NOT COME OVER SOME DAY OR NIGHT SOON? ASIDE FROM EVERYTHING ELSE I'VE TONS OF NEW WORK YOU'D ENJOY SEEING AND I'D ENJOY SHOWING YOU — SO — THAT'S ALOT OF JOY-JOY GOING TO WASTE. THE NUMBER IS CA8-6818. THE ADDRESS IS 302 ELIZABETH ST. SEEYOU ___ LOVE, JOE

WILL BE PAID FOR INFORMATION LEADING

P.S. AND I STILL VERY MUCH WOULD LOVE A BOX.

TO THE ARREST AND CONVICTION OF

FIGURE 12.1 Brainard, Note (from Joe Brainard to Andy Warhol), n.d. The Andy Warhol Museum, Pittsburgh; Founding Collection, Contribution The Andy Warhol Foundation for the Visual Arts, Inc. T1623. (Warhol promised to give Brainard one of his now-iconic "Brillo" boxes.)

12

DEAR ANDY

There is not much correspondence between Brainard and Andy Warhol, but what little there is tantalizes the reader with a sense of the exchanges between the not-yet-famous Warhol and the never-quite-famous Brainard. A short and tender letter Brainard sent to Warhol in the hospital just after Warhol was shot by Valerie Solanas in July 1968 reveals a depth of feeling and intimacy between the two artists that is otherwise belied by the breezy (if still compelling) tone of the other letters. The various gifts of artworks (either promised and never delivered or promised and received) show Brainard and Warhol taking part in an exchange economy that stands in stark contrast to the hyperinflated art market that Warhol would eventually capitalize on.

Summer 1964, 302 Elizabeth Street, New York City[1]

Dear Andy—Hope you were serious about giving me that Pan print. I <u>do</u> want it very much. I know how it is though, I'm like that too; it is so easy to say things and then sometimes so much trouble somehow to actually do it. Please <u>do</u> do it tho.[3] OK? Good. Thanks. And lots of <u>love</u>, Joe.
P.S. See you.

June 11, 1968, 74 Jane Street, New York City[4]

Dear Andy__

I just want to let you know that I have been thinking about you. I didn't realize until this thing happened how much I would miss you. Since we rarely see each other this seems funny, but true. I'm very fond of you, and I'm so glad that you are going to be O.K. Kenward and John Ashbery and myself are renting Fairfield Porter's house for the summer. (In Southampton) If ever during the summer you would like to come out and stay with us please call. (Fairfield's phone number is in Southampton's information) So—maybe I'll be seeing you this summer. And if not this summer, next fall. Once again—I'm sorry—but happy that you are better. <u>Do</u> take care. I'm sending you a copy of a new book Kenward and I did called "The Champ." Love, Joe

Late spring 1969, 74 Jane Street, New York City[5]

Dear Andy__

Just want to let you know that it was good to see you the other day. You know how much I like you. Have a great summer. See you more, I hope, in the fall.
Love, Joe

March 7, 1972, 664 6th Avenue, New York City[6]

Dear Andy__

If you want my Marilyn Monroe collection (books, calendars, playing cards, tin tray, & paper dolls) just give me a call* and they are yours.
 So—how are you?
Love, Joe

*243–1762

April 15, 1972, 664 6th Avenue, New York City[7]

Dear Andy___

Seeing you again was great, and I love the flower picture.

I thank you.

As I plan to boil my possessions down to what will fit into one suitcase it will be probably the only painting I can keep.

Do you like the portfolio? I wanted you to come over and pick out anything you wanted, but I knew how hard it would be to get you to come over, so—I picked for you. Hope I did so well. (?)

I love this cow, don't you?[8]

Hope it's not so long before I see you again.

Take care!

Love, Joe

13

DEAR ADA AND ALEX AND VINCENT

B rainard's letters to Ada and Alex Katz and their son, Vincent (who was seven years old when Brainard started including him in his salutations), are filled with details on his by then regular summers in Calais, Vermont, in the company of Kenward Elmslie. Like his letters to Fairfield Porter, these letters report on the development of Brainard's oil painting. "I am not especially happy with what I'm doing—but I'm happy with the possibilities," he writes in the summer of 1967, adding, "It's almost like starting all over again, and I like that. I've always had too much 'art' in me and I feel, now, as though I've dropped all that. (I hope)." Always wary of appearing too serious, Brainard found that oils posed a particular challenge to his sensibility, committed as he was to producing art and literature characterized by an almost willfully naive affect. What a wonder it would be, we see here, if Brainard managed to get "happy" with his experiments in oils.

One letter postmarked August 14, 1975, stands out for its prophesying what would become Brainard's retreat from the commercial art world. Referring to his show of fifteen hundred small works at the Fischbach Gallery (December 1975–January 1976), Brainard writes, "Doing a totally self-indulgent, un-self-critical, funny and spaced-out show (both rooms!) for December. But aside from everything negative, I think it will be an exciting show. (<u>Never</u> will I be able to give this much to a show again, this I know.) And, hopefully, I'll never even <u>want</u> to."[1]

Summer 1966, Calais, Vermont

Dear Ada & Alex & Vincent____

I had an absolutely <u>wonderful</u> time with you all in Lincolnville![2] (Many thanks.) I also had a wonderful time on the island, and I am having a wonderful time here in Vermont. It looks as though it is going to be a wonderful summer.

Don't know what I did to deserve all this, but I'm not complaining. I am very
proud of my new cut-out. Do not forget that this fall I want you to pick out
a flower painting, or something, that you like. I painted flowers on the island
too, with a bit of Fairfield-Maine atmosphere. (Pine trees, etc.) Fairfield [Por-
ter] and Jimmy [Schuyler] liked them very much, and I was happy about that. I
guess that I am going to make myself concentrate on flowers for the rest of the
summer at least, although I have several other things that I would like to do.
(Arg) I hope that on your way home, or before, that you will drop by Vermont.
It is really beautiful up here up on a big hill. Can't see anything but a lot of
trees and a few flowers and a dirt road and a lot of sky. So—at any rate—many
thanks again! I hope that you all have a good, what is left of it, summer.
Love, Joe

Summer 1967, 49 South Main Street, Southampton, New York[3]

Dear Ada & Alex & Vincent____

Hi. Guess what?—I may be teaching 3rd year painting at Cooper Union next
year—thanks to you. (Thank you) Thank you, also, for sending the magazine
with you and me in it. I love having it, and, of course, I think it's absolutely
great. It still shocks me, to see it. I have been working so much that I haven't
had much time to miss you all. ('Til now). Am oil painting. I am not especially
happy with what I'm doing—but I'm happy with the possibilities. It's almost
like starting all over again, and I like that. I've always had too much "art" in
me and I feel, now, as though I've dropped all that. (I hope) I mean, I don't
really feel like I'm painting "paintings." At any rate, by night time I am usually
a total zombie. I go to bed early and I get up early. I eat a lot but can't seem to
put on any weight. Pat and Ron and Wayne and Kenneth Koch are out here
for the weekend. Kenneth and Kenward have played tennis every day. Ron and
Pat and Wayne sleep most of the day and stay up most of the night. So—we
meet in passing now and then. Kenward's musical has found a producer! Will
let him tell you all about it. Well—not much is news to write about. I cut my
hair. We play bridge, a game I'm not terribly fond of, with the Hazans [Joe
Hazan and Jane Freilicher] quite often. John Ashbery was out a week ago and
has lost <u>tons</u> of weight. Jimmy and Kenward are trying to lose weight too,
but they aren't too serious about it. About as serious as I am serious about
gaining weight. It's really just too much trouble. The new Paris Review is out
with poems by Jimmy & John & Ted [Berrigan] & Kenward![4] I'm so glad
for Maxine. (Glad that she's around and does what she does.) Maxine's sister
refused to evacuate Israel, (foreign exchange student) but wanted to stay and

help. Evidently no one has heard a word from her, so Maxine is quite worried.
Maxine, who has been spending weekends in Rome, sent me Joanne Wood-
ward's autograph. And Paul Newman's. (She had dinner with them) Also, she
promises soon to send me B. B.'s [Brigitte Bardot's]. We had stew for dinner.

Today I painted a wild white rose in a mercury glass vase (which is even
more shiny than silver) (mercury glass) and some almost black cherries.
It's the best painting I've done so far. (The most direct) It's very much like
Manet. Although there are many colors it seems almost black and white.
So—I feel good about that. And it came so easy.

Jimmy and Kenward are in the city for a few days. So—I'm all alone in the
big house. Since the white rose and black cherry picture I've been able to do
nothing: painting wise. So—I've been drawing. Today drew mostly interiors.
Windows. Chairs. Etc. And sugar bowls and apples. I've discovered something
great to eat: shortbread from Scotland. I eat it all the time now. It's fattening
too. Being alone, I felt like doing something, so I went uptown (around the
corner) to buy something. But I couldn't find anything I wanted. So I bought
some sun tan lotion. Unfortunately, I can never seem to make myself lie around
in the sun. Have been reading a lot. This week have read 3 books about/on
Manet. Unfortunately, no one seems to know much about him (personally)
or else he was a terribly boring person. Don't know which. All the books seem
to say is that very little is known about him. At any rate—I would love to hear
from you! Did you know that Ron's Apollinaire ←? SPELL translation (The
Poet Assassinated) is going to be printed soon both here and in England with
drawings by Jim Dine![5] (Arthur Cohen! John A.'s publisher) So—I'm looking
forward to that. I think I'm going to bring the oils into the house tomorrow
and paint an interior. I keep waiting until I have something important to say
before I mail this letter, which is turning into a diary. I hope something hap-
pens soon. I am afraid (sob) that the summer is going too fast already.

Kenward is back, and Jimmy is arriving back tonight, with John A. (who is
going to spend the long weekend with us). Your packages arrived today! I espe-
cially like mine. Many thanks. Brought back fond memories of the rummage
sale last summer. It's been raining off and on all day. It's hot and heavy and
damp. Not much luck painting today. Drew more interiors tho. I got a letter
from Cooper Union saying I'm "in." I begin teaching Sept. 11th. Tonight we are
all going out to some fancy place to eat. It seems like years since I've had a tie
on. Well—sooner or later I've got to dump these words in the mailbox—I've
been waiting for real news—but—I miss seeing you all—take care—
Love, Joe

P.S Some post cards of me are enclosed for Vincent.

July 10, 1967, 49 South Main Street, Southampton, New York

Dear Ada and Alex and Vincent __

Ada—it was wonderful to receive your post card which, for some reason, made me feel absolutely great. We don't get mail around here until 4:00 or so. It was really good to hear from you. (Hint-hint) Today I painted four white roses speckled with red in a purple (almost black) goblet on a white table. I am especially proud of the greens. They are extremely accurate, which, at the moment, is what I am interested in. (Accuracy) I have finally decided what to do for Frank [O'Hara's] poem "Blocks." A volcano. A volcano is in the poem, and I know that he especially liked volcanos. And the tone of the poem that of excitement. So—it seems perfect. I've been busy collecting source material. Most volcanos, I've discovered, don't really look like volcanos. They look very abstract and "what is it?" At least, that's how they look in photographs. I've never seen one. Today is a beautiful day!

Today I painted red and white and yellow and pink roses in a wine glass with a pepper mill and a crystal salt dish and a vinegar bottle and six cherries. Today I tried to be "dashing," and indeed, I succeeded. Unfortunately, I don't like it. But like I said, I'm learning a lot. I would love to hear, Alex, what you are doing. Kenward is sunbathing. Jimmy is still asleep. He reads most all night some nights. So—we only have 12 more days here. I guess the summer will be over very fast. It's off to a good start. A fast start. Which, actually, is more than a start. So—I may be seeing you sooner than I think. And perhaps, really sooner, if you come (I hope) to Vermont. Pat and Ron and Wayne will be there too. So—see you soon—
Love, Joe

P.S. I went inside to pee and Jimmy is up and says "hello."

Summer, possibly 1967, 1968, or 1969, 49 South Main Street, Southampton, New York, or Calais, Vermont

Dear Ada & Vincent & Alex __

Painted roses most of the day. They are very good but, somehow, not very interesting. They are very much like Manet only, of course, he did it better. I am getting to like oils more and more though. It's a funny thing about realism : it isn't really there. (Or so it seems) I mean, you really have to make

it up. (So it seems) There are so many fine lines that you either cross or
don't cross. I've been half crossing too many. Like leaves. At the same time
that they are one green they are many greens. So—[three squiggly lines to
graphically illustrate Brainard's thoughts trailing off]

At any rate—I am enclosing some post cards for you all. Would like to
hear what you are doing, Alex. Am going to stop now—
Love, Joe

August 1967, Calais, Vermont

Dear Ada & Alex & Vincent ____

As usual, Ada, it was great to receive your card. (Ron gets most of the mail
up here) Absolutely nothing is new that I can tell you all about—except that
Rock Hudson bought a house only a few miles away from Calais.[6] I've yet to
see him, though. Everyone is downstairs reading The Sunday Times. Wayne
is practically walking by now. Mostly we eat corn, as it is in season now, and
very good, and sweet. The past two days, including today, have been rainy and
damp and cold. It feels like autumn, and, actually, it's a nice feeling. Mostly
I have just been goofing off, doing a small red garden (all anemones) and
a small yellow garden (all daffodils) and a small white garden. (All daisies)
Last night Pat and Kenward went to see "The Sound of Music," and cried.
Ron typed (I don't know what) and me, I read "Hard Rain Falling."[7] (A dirty
cheap novel) Actually, it wasn't very good, and it wasn't even very dirty. The
Museum of Modern Art asked me to do a Christmas card for 1968. That
made me happy. I hope that you all will be able to come by. We will be here
until the 3rd or 4th, I think, of September. Got a postcard from John Ashbery
from California. He and Pierre are there. I never took French, only Spanish.
Ada, I am working on a new prose piece of little known facts about people
and I was wondering if you would fill me in on the facts about your research
work?[8] I'd also like to know what both of you wanted to be when you were
kids. So—perhaps (I hope) we'll be seeing you very soon, and if not, it will be
very soon anyway, because Sept. is not very far away. I'm looking forward to
that, seeing you all —
Love, Joe

August or September 1967, Calais, Vermont[9]

Dear Ada & Alex __

I hate to be mean—but don't you think the King and Queen of Tonga look like John Myers (Queen) and Herbert [Machiz]. (King)? I do. I die laughing every time I look at these pictures, but nobody else around does. They refuse to acknowledge any resemblance. Except for Herbert. Kenward say, yes, that does look a little bit like Herbert. As for John, no. At any rate, I think the Queen and King of Tonga look exactly like John and Herbert. Tonga, by the way, looks like a wonderful place to visit. (From other photos I have seen) Beautiful simple white houses, and lots of green. Only thing is that they like people to be fat. I guess they would think I was very ugly, and I wouldn't, of course, especially enjoy that. I have been relaxing quite a bit here in Vermont and not doing much work-wise except a lot of drawing. Enclosed are some stamps, Ada, many of which, I'm sure you can't use, but—all together they make such an impressive lot. Wayne [Padgett] is beginning to do new things. He makes more noises, eats more solids, and crawls around more and more. Everything, of course, goes in his mouth. His eyes are getting bluer. And he is becoming more of a real person than just a baby. Pat is making a scrap book of old magazine ads. Ron is building a highchair out in the shed. Kenward is sunbathing and reading. The lake is even bigger this year. And all the green is even greener (many rains). Mostly the past few days I have been drawing jewels. Trying to make a drawing of a jewel really sparkle is very hard. I haven't been able to do it yet. Also it is very hard separating the geometry of the cut from the more irregular effect. One thing I have managed to eliminate is gray. Now I am down to black and white, but, still, I can't figure out exactly what is going on inside. At any rate—I hope you think that John and Herbert look like the King and Queen of Tonga. Drop a line—
Love, Joe

P.S. I'm sorry that we didn't stop by and see you all on our way to Vermont but somehow Kenward and I both just felt like getting to Vermont. Kenward, by the way, has bought a new apt. building on Greenwich St. which he will move to this fall.[10] It is possible that I may move to the top apt., tho I haven't seen it yet. Kenward thinks that I'll like it as it is on a corner and has lots of windows on two walls. Alex!!—I keep reading about you. The picture in the Times looked wonderful. And extremely powerful! Also I read something some where saying that you ought to have been in "The Museum of Modern

Shit"'s show of art in '66, or something like that. At any rate, I think so too.
Well—my P.S. is so long that I guess I have to sign off again—

Love, Joe

Probably late June 1969, Calais, Vermont

Dear Ada and Alex _____

I doubt that I've any "news" but just want you to know that I think (am
thinking) about you. I've been doing drawings all morning for the next
big issue of <u>"C" Comics</u>. I ought to be painting, but I think I will begin oil
painting again come Monday. I'm very curious as to what I will do. I've been
trying not to think about it. So as to begin again as openly as possible. Alex,
your cover for Kenneth's book was very beautiful, clean, and just "right." [11]
I like it. Right now I am outside sunning. Which will explain the oil stains
on this letter. (Sun tan oil) And the sloppy writing. (Writing in my lap with
a clip board). My big non-art project for the summer is to gain weight and
straighten up my back. So—I've been eating lots and exercising some. So far
so good. I weigh 140 pounds naked. (More than I've ever weighed before)
My goal for the summer is 150. So—you may not know me in the fall. Also,
I cut my hair way off. Kenward is fine and working on the Orchid Stories. [12]
The musical is still up in the air, but doubtful for fall. [13] Perhaps spring. The
bugs are thick this year. The sun is hot. The nights are cool. I love it here.
<u>Do</u> write if you feel like it. (Mail!).
Love, Joe [arrow pointing down to new page]
P.S. Vincent : In a separate envelope I am sending you some Cracker-Jack
prizes. I am afraid that they aren't what they used to be. Most every night,
before I go to bed, I eat a box, as I am sure they must be fattening.

P.P.S. Anne & Lewis Warsh are joining us for a week or so beginning July 4th.

July 27, 1970, Calais, Vermont [14]

Dear Alex—

It was good to hear from you. Didn't you get my letter of several weeks ago?
In your letter you said that Jimmy told you I gained weight but I am sure
than [*sic*] I wrote and told you so myself. (?)

Well—if I didn't write you a letter I certainly meant to. And I am just
sure that I did.

Vermont is very very dry this year and so the lake is all but gone.

I decided I shouldn't be so dumb in the area of science so I've been read-
ing various books and articles about various areas of science. This morning I
read an article about flies. (Pretty spooky.) I can't wait to use my new infor-
mation over dinner at the appearance of a fly. (A lot of them this year)

Most spooky, tho, is the human body. I really can't read too much about
it at one time without getting the creeps.

<u>We take ourselves so seriously</u>!

Really, I should just speak for myself.

I'm doing some cut-out "Wood Areas" that I like. (Areas of ferns, twigs,
dried grass, etc.) Solid areas, very "natural" looking, and almost 3-D.

I really want to have a show this year. I'm going to approach Marilyn
[Fischbach] about it when I get back. (September 1st) How long are you
staying? I remember your saying that when I was ready (to show) to tell you
and you would speak to Marilyn. If you think that would help, that would
be very nice of you. I think these cut-outs will make a beautiful and very
"sell-able" show.

Anne and Michael are here. (Waldman & Brownstein) They just arrived
last night.

Kenward is well. (Won $40 from him last night at Pounce).

A giant picture of Sonny [*sic*] would be great I'll bet.[15] Are you going to do it?

FIGURE 13.1 Promotional image for a Brainard show at the Benson Gallery, Bridgehampton,
Long Island, included in the July 27, 1970, letter, Brainard to Alex Katz.

I just finished correcting the proofs for "I Remember." It should be out during September. I can't wait. <u>My first book!</u>[16]

Give my love to Ada.

How was teaching?

And "Hello" Vincent.

Love, Joe

P.S. Having a Long Island show in August of old stuff. Ugly card, isn't it? [See figure 13.1].

Summer 1971, Calais, Vermont

Dear Alex & Ada ____

Good to hear from you.

Great post card.

Loved California.

(Note new minimal writing style)

Actually, I just don't feel very good today (tooth ache, sore throat, ear ache, and swollen gums <u>all</u> on right side) but I do want to answer your card before too much time passes, otherwise well—you know how a summer goes. And how this one, practically, has went [*sic*].

A funny summer for me (so far) to suddenly find myself more of a writer than a painter.

In Bolinas I did some small beach constructions and some drawings of people, and a few book covers, but mostly I just wrote a big fat "Bolinas Journal." (Which Bill Berkson is printing and should be out by fall) So about California—I'll just let you read about it.

And as for Vermont—it's been all book covers and more writing. A lot of short poems. And my "Bolinas Journal" being so self-indulgent and personal—I'm making myself keep a very factual "Vermont Journal."

However, I <u>do</u> have some birch tree cut-out plans. If September isn't here too much "before you know it."

Found out that the water here is polluted. (Perhaps from dead animals in well)

John A. arrives tomorrow night. Guess you'll be seeing him soon too.

Jimmy is fine. (Nothing to worry about so long as nothing terrible happens, I feel) Now if only life were <u>that</u> reliable.

Kenward's musical opens out of town around 1st of October.[17] Then— the big city. Will be glad for him to finally have that over with. (Not that

it isn't a good musical) But it's a bad business and for a dumb audience. Kenward knows that too, of course, but—well—I guess it's hard to give up. So, I'm glad he can give up by choice now.

(Of course, one thing I'm forgetting about is that he <u>does</u> enjoy it.)

Which is more than I can say about some of the things I do.

This letter is taking a turn I'm not "up" to today. Guess I'll go to a doctor tomorrow if not better.

Would like to know what you're doing, Alex. (Hint) Did I tell you how beautiful your print show was? Well, it really was. Beautiful. And very <u>fine</u>.

Plan to go back to the city a bit early this year. By the first of Sept., if not before. And—California did me in a bit in the area of traveling. And many things I want to do here, so I doubt if I'll be by. But it would be good, I know, and I thank you.

Seems to me I was writing to you all last summer saying how I hoped we'd see more of each other in the fall, well—ditto for this year.

("Hello" Vincent)

Signing off. With

Love, Joe

August 14, 1975, Calais, Vermont[18]

Dear Ada and Alex__

Just not to let a summer go by without a word—

Very little "news" other than work, which is not really news. Doing a totally self-indulgent, un-self-critical, funny and spaced-out show (both rooms!) for December.[19] But aside from everything negative, I think it will be an exciting show. (<u>Never</u> will I be able to give this much to a show again, this I know.) And, hopefully, I'll never even <u>want</u> to. Partly I see it as getting something out of my system but just how realistically so, I don't know.

One feature of the show will be 300 post cards, two of which I did yesterday of Kenward sunning in the grass, and remind me very much of you, Alex. (<u>Loved</u> your funny post card!)

One thing I'm not sure I like about growing older is how easy it becomes to admit your weak spots.

One thing I've pretty much come to terms with is that I'll never be able to seriously paint until I've more or less "made it" (assuming that it won't be too late). Not that I expect anything "from" it. But, again, another something out of the way.

(Can you buy it?)

Well, thanks for shoulder (shoulders) anyway.

Ada—I still have your drawing for you. (Tho it embarrasses me a bit in the area of "mushy" : I mean, in being so one-sidedly so.) But I hope to have another "crack at it" (if you'll pardon the expression) one of these days, yes?

Hope all is well with you both. And Mr. Stranger Vincent.

Returning to city Sept. 5th, or so, so—hope it won't be too long before we see one another.

(Think it'll be another spaced-out and "quiet" season?)

Hope not.

Love, Joe

P.S. Also for this show I'm bringing my prices way-way down—good idea?

March 1979, 8 Greene Street, New York City

Dear Alex__

Just a note this morning (first day of spring!) to let you know how much I loved (a lot!) your current cut-out show.[20] Really, it was, and is, quite mind-blowing in so many different ways! So—just wanted to remind you that I continue to admire you enormously, of course. And to thank you for the experience of that : thank you!

Not much news from Greene Street. I continue drawing : nudes mostly, portraits some. My biggest advancement being that I can now "handle" 24" × 36" as easily as 11" × 14". (Well, almost.) And am still taking things pretty easy : i.e., not pushing myself. Having determined that. no, let's not get into that!

I kept thinking of you a lot while recently reading Susan Sontag's "On Photography." Which makes me think that maybe you might like it. (?).

At Kenward's reading for your show—(wasn't Carter [Ratcliff] odd? Although what he read was rather extraordinary, it spooked me out some too)—upon telling Ada how beautiful she looked, I suddenly realized that every time I see her that's what I say! Which I was thinking—am thinking— must get pretty boring of me. At any rate—"hello" and "love" to her from me. (And besides, it's not my fault!)

Well—as this note turns into a letter—better get back to the point : which is that (gush) I think you're terrific, and thank you very much again for being so.

Love, Joe

OFF THE "UPS" (SNIFF) ————
NOT BY CHOICE. THO , ACTUALLY,
I SUPPOSE SO . HARD TO AJUST
TO SO LITTLE FROM A DAY.
AND SELF-CRITICISM IS A BORE.
NONE OF WHICH , HOWEVER , IS
A DIWNER. I FEEL GOOD. ⇸

MY LOVE TO MICHAEL.
ALAN.
YOU .!

Joe

⇸ (NOT TRUE)

FIGURE 14.1 Page from the August 14, 1975, letter, Brainard to Anne Waldman.

14

DEAR ANNE

Anne Waldman, poet, director of the Poetry Project at St. Mark's Church, cofounder with Allen Ginsberg of the Jack Kerouac School for Disembodied Poetics at Naropa University, and political activist, met Brainard around 1967. She proved to be one of his closest friends and most important early publishers. Angel Hair Press, cofounded by Waldman and then-husband, the poet Lewis Warsh, published Brainard's *I Remember*, *I Remember More*, and *More I Remember More*, along with other works of his in *Angel Hair* magazine.

The letters included here, most of them written while Brainard was summering in Calais, Vermont, begin in May 1969 and move right through 1990. Brainard's excitement about his 1975 solo show at the Fischbach Gallery is palpable: "A personal mind-blower, I promise," he assures Waldman. That said, his insecurity rears up in the very same letter, as he worries, "Will never be able to give so freely again, I know (and don't think I'll ever even <u>want</u> to again). So—." By 1979, we find an uncharacteristically candid Brainard acknowledging an obdurate depression; "Just between you and me—O.K.?—I'm having a real hard time hanging in there. So hard to explain though. And I really don't understand it either." In 1990, he writes to Waldman, "I've been sick all month (Feb.) and into March. Bad sore throat, then terrible case of shingles, all over the right side of my face, up into my ear, and on to the scalp." And yet, except for Ron and Pat Padgett, for a couple of years none of his friends—including Waldman and Elmslie—were aware that he had tested HIV-positive in 1989 (or possibly earlier).

May 1969, Calais, Vermont[1]

Dear Anne__

It's funny that you should mention Gertrude Stein. I am still reading her
on the toilet and I still find her very difficult and I was thinking how great
it would be to hear Gertrude Stein out loud. And I was thinking how great
it would be to have a Gertrude Stein reading where everyone read out loud
their favorite thing by her. I am finding it difficult to write. I've been out in
the sun all day. I hope I am making sense. I am inside now and I feel like I
am under/in a big shadow. And I cannot seem to think (write) in sentences,
but only in words. I feel like I am a stranger. Well—
 It was great to hear from you. Really and really. I am going to be seeing
you so soon that I don't really want to say anything. I just wanted (I'm pick-
ing up now) to tell you about how I think a Gertrude Stein reading would
be exciting. I just wanted to thank you for your letter. And I just want for
my presence to be felt once more before it actually is. I will be back either
the 6th or the 7th. You can be sure that there will be room for your flowers.
Certain flowers, now, are having a revival. I am way way up these days over
a piece I am still writing called "I Remember." I feel very much like God
writing the Bible. I mean, I feel like I am not really writing it but that it is
because of me that it is being written. I also feel that it is about everybody
else as much as it is about me. And that pleases me. I mean, I feel like I <u>am</u>
everybody. And it's a nice feeling. It won't last. But I am enjoying it while I
can. One thing that I realize is that losing a penny when you are one is just
as serious as "is there a God?" when you are twelve is just as serious as "what
am I going to do!" when you are twenty-seven.
 If only I was as smart as I really am.
 In the back of my mind I am a little bit afraid that [Remainder of this
letter is missing.]

January 9, 1970, 664 6th Avenue, New York City[2]

Dear Anne__

My head is heavy. It's snowing outside. And I'm listening to Janis Joplin.
I've always known that someday I would have music. And I'm glad I waited.
I need it now. Just to be <u>sure</u> I had fun at the party last night I took a pill,
drank a lot, and smoked a lot of hash. And—I <u>did</u> have fun. Until about two

o'clock. At two I totally conked out on the bed. All I remember after that is a lot of wet kisses from various people saying goodbye. As I couldn't open my eyes, it was fun guessing who it (they) was (were). Clarice [Rivers] I could tell. And J. J. [Mitchell]. And Scott.[3] The other people I don't know. It was fun, for a change, being on bottom. I mean, not on top. Under the weather. Or what have you. I guess I'm just a little bit in love with being able to make a fool of myself. Which, you understand, is different from being a fool. But as the possibility is there, I just don't like myself for covering it up. So—it was nice not to (cover it up). I didn't wake up until noon and my head was really in a mess. And it still is. Like I said, heavy. Altho the party was fun it was not fun too. Because you and Bill [Berkson] and Pat and Ron were not there. And because two people I have crushes on, but can't have, were there.

(SNIFF)

You are right: you have never typed me a letter before. I hope your fingers are alright (the burned ones). I, too, have a stuffed nose and a sore throat. I hope yours goes away faster than mine is (two weeks now). As for the jewelry, I will give you the other half of the one (two) I got. "My Piece." Which reminds me—I have a feeling in the back of my head that Michael [Brownstein] didn't really mean to give me that scarf. You know, high, you misunderstand what people say. Well, I have a feeling that I misunderstood what Michael said. Is this right? It's a beautiful scarf. But I suspect that it doesn't mean as much to me as it means to Michael. So if Michael would like to keep it would you tell him for me that he should tell me so? It's getting dark already (four now) and I am shaking (my body) ((inside)). I really just don't feel "here" today. I'm glad you like the scarf and the picture and the belt. The scarf, especially, seemed so right for you that I enjoyed finding it. In my head you have been wearing it for a long time (the scarf). This is a very "scarfy" letter. I'm afraid that I am sick (just now vomited a bit). It's good for you tho. Gets the poisons out of your system. Some people believe that you should vomit every week. Make yourself. By poking your finger way down your throat. It is four-thirty now. I had planned on doing the bars tonight, but—

But maybe I'll perk up. Maybe, now, I'll take a nap. A hard thing for me to do. I think I'll try some more aspirins first. And then if that doesn't work, nap. It was really good to see you again. And Michael too. People you don't know very well always start out being so predictable. And it's a pleasure to find out you are wrong (Michael). I'm anxious to read and see "3 American Tantrums."[4] I'm anxious, too, for "I Remember." I think that the best thing to do is to just send it out and not worry about the cost. I am sure I can manage it.

Party events:

Tony Towle got very drunk and started insulting everybody. He especially insulted Jimmy [Schuyler] (so I hear). So much so that he (Jimmy) left. To go to the baths. (Which he was going to go to anyway).

Irma [Hurley] found Tony (so I heard) on the top floor necking with Carol Gallup.

Kenward found Kenneth Koch necking (necking!) ((I don't know where I got that word)) with his (Kenward's) half-sister's girlfriend.

Kenward also found Tony necking with his half-sister. You probably never met her. She's very young. And crazy about horses. Sixteen or so.

So—you didn't miss too much. The food was good. D. D. arrived with (I assume) a new boyfriend. Joan Fagin curled her hair all up. It looked good. I got all dressed up but then I didn't feel like it so I got un-dressed in a navy-blue turtleneck and blue jeans (very interesting). I must be running out of things to say. John Ashbery got very drunk. Kenneth Koch was "on." A few dances with Clarice. And that was that. I wish _you_ had been there.

I wish _you_ were here.

<div align="center">NOW</div>

My bell just rang and although I usually don't answer it unless I am expecting somebody, I did answer it. But nobody came. Must have been a kid. Or somebody who wanted another floor. I guess I will take a nap. It's five o'clock now. And these aspirins aren't working.

It was really good to hear from you.

Write me again soon.

Take care.

Miss you.

Love you,

Joe

P.S. And need you.

P.P.S. Yes I did talk to Bill and I'm afraid that he liked California too much. He couldn't come to the party because of teaching but I'll see him Friday (dinner).

June 1970, Calais, Vermont[5]

Dear Anne __

Have you seen your cover yet? I like it. I hope you do. The skyline, now, is more realistic and more "New York City." The stars are smaller and "more"

and more realistic too. When the cover is printed in purple it will be a real
knock out, I promise.[6]

I am (you guessed it) out in the sun. The sun, however, is not out right at
this moment. I'm wearing the purple tie-dye bathing suit you gave me. Like
it a lot.

Well—I don't smoke anymore. Do you believe it? I don't. But it's true.
I don't smoke anymore. Coffee is not the same. And (hopefully) I am not
the same. For one thing—I eat more. And for another thing, I am continu-
ally horny.

Jimmy is here but he leaves Monday. John Ashbery and his new friend
Alamar [sic; Aladar Marberger] are coming (arriving) today. But only for
the weekend. After Monday nobody will be here (as far as I know) until
you and Michael arrive. I really look forward to your both being here. It is
so green here, so lush, and so "right." I mean : it makes "sense" is all so great.
But it's nice for a change. (Relaxing)

I haven't been working much yet but I've been reading a lot. Just finished
a biography of Whistler and now am reading Firbank.

I hear a snake in the grass.

I really like this bathing suit. If where you bought it they have more
would you buy me two or three more? Any color. Will pay you, of course.
That would be great. (To have more) So often good things disappear.
When you find something you like it's good to get a good supply of it.
I always think of Jughead when I think of clothes.[7] He had (has) the right
idea. (Easy)

Giving up smoking was not easy. There were three days of total hell :
hot and cold spells, fevers, etc. I don't know why I'm telling you this. I don't
want a pat on the back.

If you should get a chance to buy some acid would you buy some for me?
I would really like to take it this summer.

It seems that I am asking a lot of favors of you. Well _____
I am.

Writing to you makes me think about you and thinking about you makes
me miss you.

So hurry to Vermont.

Love, Joe

P.S. Have fun in New Jersey!

P.P.S. "Hello" Michael!

Love, Joe (again)

P.S. One more favor to ask of you—will you try sometime to find the 2nd
installment of "Little Known Facts About People I Know."[8] It was stupid of

me not to have made a copy of it, but I didn't. I gave it to you over a year ago (I think) for an issue of The World that got too big, so it wasn't used.[9] Or maybe it was less than a year ago. (?) At any rate—if you run across it please send it to me, O.K.? (As I don't have a copy of it and I may want to use it in my book) (Tho I doubt it) All I remember about it is that there was something about Lewis in it which Lewis wanted taken out. (About how the first time you met Lewis you thought he was queer, or something like that) But please don't feel bad if you can't find it. (I won't)

Love, Joe (again)

Spring or early summer 1971, 664 Sixth Avenue, New York City[10]

Dear Anne __

I can't believe it but, "I Remember" is finally finished. I've never worked so hard on a piece before (hope it doesn't show).
 Now—what to call it?
 "I Remember" No. 2
 or
 "I Remember More"
 or
 More "I Remember"
 or
 ?[11]
 I feel just terrible. When I woke up this morning my eyes wouldn't open. My eyelashes were glued together with yellow stuff. My nose full of snot. And my throat sore and swollen.
 So I took a pill and put on sun glasses and here I am: feeling better, but terrible.
 Partly bought a gold Chinese bracelet the other day because I couldn't get it off ("partly" because I probably would have bought it anyway) ((even if I could have gotten it off)).
 How about red words on the cover this time?
 How about dropping the "I" stuff for the cover and just have it say:
 [Simple drawing of face and torso, with the title JOE BRAINARD REMEMBERS MORE centered above the figure's head.]
 I don't know.
 Thank you for your great to receive letter. Always a "pick-up" to "hear" you.

To know you are there.

To know you care.

And to know that I care that you care.

(VERY MUCH)

Am going to try to leave for California with next to nothing behind.[12]
Selling some books and paintings and objects, and giving a lot of stuff
away.

Wish you were here to give to but I guess you need "stuff" right now
about as much as I do. (About as much as anybody does).

Still haven't gotten "Death" back from Harris [Schiff] to send you.[13]

Saw the circus last night and it made me want you and Michael to see it.
I guess that's impossible tho (2 more weeks). It really was great tho (3 hours
long) and <u>totally insane</u>.

Bought a copy of Michael's book at "The 8th Street" and then,
somehow, it disappeared. Will get another one night, tho (with better
luck, I hope).

Take care &

<u>Love</u>, Joe

July 29, 1971, Calais, Vermont[14]

Dear Anne __

Out in the sun for only the second Vermont time this year.

Just this moment got settled, and guess who wants out?[15]

Well, he'll have to wait.

Sometimes I think he enjoys it anyway : the wanting part of wanting
in or out.

Must be a pretty strange life.

Thanks for writing back so soon. Yes, mail is great. And especially (slurp)
your mail.

About the new "I. R."—Jimmy and Kenward, and now me too, think
that "More I Remember" is best.

I don't have the other photo with me and, actually, it relates to the first
"I. R." anyway. (Me in formal) That is the one you meant isn't it?

I <u>do</u> think it would be nice to have the cover words in red this time,
don't you?

As for how type is to fit on photo I would (off hand) suggest this:

[Simple drawing on the left hand side of the page of a face and torso, with the words MORE I REMEMBER BY JOE BRAINARD centered on the figure's shirt. On the right hand-side of the page Brainard writes RIGHT ACROSS MY SHIRT.]

Tho any way you like would be fine.

Funny, but with my own writing I prefer not having much to do with it visually. Don't know why.

Re-writing (would you believe it for the third time) my Bolinas Journal. So many layers of being honest I think I could keep on re-writing (pin-pointing) all summer. But no—this time around is it.

And then it's honest not to be honest sometimes too, if you aren't. And nobody always is. Even when you always try.

I mean—the hardest part about being honest is knowing when you're being honest and when you're not.

And more and more these days I just don't know.

Just finished Lewis's Canadian book "Part of My History" to do a cover for and title pages for.[16]

<p align="center">REALLY GREAT!</p>

Somehow made me understand Lewis's "place" in life now more. (Tho I still think he needs a good kick in the butt) But—I think I do too.

In fact—isn't that what we are all waiting for?

No. Not waiting for. But maybe secretly hoping for.

Well, I am.

I do it to myself often, in various ways, but it's not the same.

My favorite way is to dispose of everything and move. Which is what I'm seriously thinking about doing this fall.

A letter from Philip Whalen says you might go from Bolinas to Ethiopia! Really?

If I can muster up something I think you would enjoy writing on/for/ with (etc.) before you leave New Jersey, I will. But if not there's always fall in New York City.

We really should do something.

One thing that I've always wanted to do with somebody (which doesn't involve art) is to plan a correspondence over a certain period of time knowing that it would be a book. Curious to see if, and how, one's letter writing style would change. And back and forth is a nice format for a book. And everybody loves letters.

Jimmy is fine. Tho a bit nervous. And still on pills. Really O.K. tho.

I'm doing a lot of work but so scattered that I don't have that feeling that I'm accomplishing anything. But I guess it will all add up sooner or later.

<u>Do</u> keep the letters coming.

And, if after N.J. you know of an address you'll have for any length of time, let me know.

<div style="text-align:center">Love to Michael.</div>

<div style="text-align:center">And love to <u>you</u>.</div>

Love, Joe

P.S. "Lobster Pot" and a movie tonight. Got a giant big new dictionary. Kenward's musical (I really hate to say this) is <u>on</u> again. (For sure!) Opens out of town in October![17]

June 9, 1973, Calais, Vermont[18]

Dear Anne ____

It is such a pleasure just to look at your poems as they go their way across the page! [19]

And to read them is to be reminded of you.

And as always you restore my faith in daily living. And most of all in "us"!

Really, it is an extraordinary book!

And even if you do think "light" is a dirty word, it is <u>not</u> a word which applies in this case one iota.

It is no "neat package" of a book, and I don't think even "time" can do that to it.

And so "congratulations" and "love" and all the gush in the world I can't put into words right now!

Really, I love it.

Right now a lamb is in the oven. I'm drinking a Dr. Pepper. And it's raining like hell outside.

Today was all reading. Finished up [Flaubert's] "The Sentimental Education." <u>You</u>! And almost half of a Walter Winchell biography.

The lamb (leg of) is timed to coincide with the seven o'clock news, and that's what time it almost is now. Which means "setting the table time." And so_____

Til soon,

Love, Joe

P.S Did you know that Jane Bowles died? Lewis was by over the weekend with the Boston Bill [Corbett] who has a place very close by in Greensboro. Painting is "going," but still not too well yet. And thank you again for beautiful "Life Notes"! (And "hello" and "love" to Michael)

Late May 1973, Calais, Vermont[20]

Dear Anne ____

Terrific to hear from you back so soon! But, alas, so soon that I may have
a hard time thinking of much "news" to say. Drinking a cup of coffee.
Smoking a cigarette. The sun just came out, but not for long I'm sure. A bit
more work on "The Last I Remember," but on this one I'm in no hurry: it's
got to be the best, I feel, or nothing at all. And "The Best," at this stage in
my head, is going to take lots of digging. As for sending you a copy of "More
I Remember More," I haven't got one.[21] Just before I left the city I chopped
it down to the bone again, and had Trevor [Winkield] type it up for me.
Then I added a bit more new stuff, and sent it off to Bill, who said he would
have his printer do it (still as an Angel Hair book tho, of course) and so that
is where it is now. Which reminds me of your book, and that I am dying to
see it, to "have it," and read it again (soon?) I hope, I hope. Kenward is out
planting stuff, and I'm upstairs at the big round table, for some reason a bit
depressed. Mainly because I'm not oil-painting yet, and I don't really think
that the studio is not finished yet is a very good excuse. And then—I go
back and forth between thinking being so spread out as I am is good—and
between finding it all very discouraging : that this way I will never really
accomplish anything. Which is how I am feeling now (combined with the
knowledge that to live a life so totally for "accomplishment" is never going to
be very satisfying, to say nothing of unrealistic, and dumb) and that, as corny
as this may sound, I seem totally unable to, say, for example, go outside and
look at a flower with any basic sort of enjoyment anymore. Rather, I have no
patience. And rather, I instantly want to "use" it, somehow. And so—
 (And so as usual I am writing about it, instead of doing something
about it)
 But one thing I do feel I have accomplished since last writing was (is) to
get rid of that little wart on my face with daily drops that eat it up.
 Oh, and yesterday (rain) I read a cheap John O'Hara novel called "The
Big Laugh" which I'm delighted to say was very boring. (The one thing I
require of a bad novel is good sex).
 Your letter was very funny, probably because I feel I know you better (by
knowing myself) than I have the right to. What I mean is that I identify
very strongly with your "speed" of living (or something like that). All of
which was leading me into saying something more "accurate" (I felt) but
which has now left me.
 Do you ever have the fear, as I do, of getting "burnt out"?

(As everything I kept saying keeps falling flat of what I mean to say I'd better stop for now)

More tonight, tho, when (hopefully) words will be more with me.

I feel much better now after:

1. Cleaning out the big bedroom and putting together my easel for (tomorrow) painting! (Fuck "studio")
2. A much needed shower and shave.
3. A joint.
4. A lobster dinner.
5. And now T.V., and writing to you. During a show I'm not really watching, in between "All in the Family" and "The Mary Tyler Moore Show" with, really, not much to say. So—guess I'll sign off again.

Morning again (Sunday) and what a beautiful one! (Big blue sky and <u>sun</u>) and so I don't think I'll paint today: rather, I'd like one day of "nothing" and sun: a symbolic "in-between" gesture of sorts: to empty head out/to start "fresh": etc. And so unless the sky deceives me (clouds) that'll be my day.

And—happy Memorial Day! (tomorrow)

And—"love" to Michael.

And—write me back soon!

Til then—

Love, Joe

June 27, 1973, Calais, Vermont[22]

Dear Anne _____

Out in the sun (explanation for possible oil stains). After building up to a really good day of painting yesterday, I decided, today, to give myself this (a rest). Partly because I'm <u>exhausted</u>, which strikes me as being (summer-wise) a bit absurd. And so here we are!

Yesterday was <u>three</u> paintings! Two of the old stone wall out back. And one of a mostly already eaten up ham, on a white platter.

Awfully sorry, of course, to hear about Lee [Crabtree].[23]

But (everything aside) as to my feelings about suicide—I horrify even myself.

It just does seem to me to be a choice one should always have available with no bad feelings (guilt, etc.). A bit like life insurance, I suppose.

And so I feel bad that Lee wasn't happy. And that I'll never see him again. But—well, you know what I mean!

I just know that should that ever be my choice it would not be an ugly thing somehow.

Your book is both in Plainfield and Montpelier!

Rain instantly came. And then a few good days of work, which were totally exhausting. And so that is why a few days have lapsed since I last wrote. And now it's time to go into town shopping. And dinner "out," at the Lobster Pot. So—til later (or tomorrow) —

(Sunday) Two so-so small paintings of Whippoorwill in the grass. And now (soon) dinner no. 2 with the Cormans [sic] (the Boston Bill and Beverly) whose big autobiographical work (Bill) I am just beginning to read (good).[24]

Did I tell you that Farmer Martin died two or so days ago?[25]

And that no more T.V? (Basement). Good riddance!

Joanne [Kyger] said that Bill dove into water too shallow in Santa Fe and had to have stitches on his nose, but that it now looks normal again already.

This is the last time I'm going to write you in this fashion (random "notes") because it just don't work (no "build up"). And I haven't the faintest idea as to what I've written you about or haven't, and so —

I promise to do better next time, "honest Injun."

Til then,

Love, Joe

P.S. My Black Sparrow proofs came, and went, and boy are they thin![26] (Ugh). However, my one-liners are very good I think!

My love to Michael!

August 14, 1975, Calais, Vermont[27]

Dear Anne _____

Just to let you know in case you don't know that I miss you. Think of you often. Wish we were nearer. Loved seeing you in "People."[28] Glad you like Colorado. Sorry to hear you won't be N.Y.C-wise come fall (sniff) and will die if December (my show) is out of the question (?). A personal mind-blower, I promise. Will never be able to give so freely again, I know (and don't think I'll ever even want to again). So _____

PLEASE.

Off the "ups" (sniff)—not by choice. Tho, actually, I suppose so. Hard to adjust to so little from a day. And self-criticism is a bore. None of which, however, is a downer. I feel good.*

My love to Michael. Allen [Ginsberg]. You!!
Joe

*(not true)

July 1976, Calais, Vermont[29]

Dear Anne _____

Just a note (I think) to thank you for the belt buckle, and to let you know that
I think of you often too. And to try and get this new "italic" pen I got into a
regular "flow": no easy matter, it seems (which I got for doing a Victorian fan
design for the libretto cover of Kenward's "Washington Square" but (fucking
shit!) I'm about ready to throw it in the lake and do a nosegay of violets instead.
 Ah—this felt pen is much better.
 As you can well imagine—it's a strange summer. Kenward mopes around
a lot over Steven [Hall].[30] And I am Mr. Comforter, a role I would hardly
choose to play. And most especially so as I'm not in great shape myself:
drying out (dope).
 However, I am very grateful for the opportunity of a city-rest. No obliga-
tions. And no hassles.
 Am doing some work, as I have a big Paris show this fall.[31] But not a lot.
Tho, what I am doing, I am very pleased with. Going at a slower pace allows
for much more focus, of course, and so I am not relying so much upon "raw
energy." The works are quieter, more "spiritual" and incredibly subtle (and
sexy) color-wise. Several appear to be almost all-white until (ZAP!) one is sud-
denly aware of every color in the world in each its most subtle tone. The tran-
sition is very space-expanding. And so fragile as to be thrillingly "dangerous."
 ("Toot-Toot" goes my horn).
 Also doing some writing: primarily a note piece called "Summer Impres-
sions." Plus a lot of lying around in the sun just thinking (believe it or not).
And—as usual—adding on some summer weight to face the winter with
(8 lbs. so far).
 My winter plans (wish me luck) are to be as social and wild and ridic-
ulous as possible! (A big turn-on just to think about). Did I ever tell you
about that guy from Texas I see about twice a year as he passes thru (the one
we act out each other's fantasies with)? Well—it really is fun, and so—first
on my agenda is to find a few friends of (with) similar interests (living inside
a head is too prissy!)

One of my biggest current fantasies is to make out with Steven (will you tell him that for me?).[32] I hesitated to mention it in fear you might think that is why I am writing but—after all—you couldn't possibly not know that I love you—si?

(LUNCH) [The remainder of this letter is missing]

Circa 1976, Calais, Vermont[33]

Dear Anne ____

God only knows (a week or so ago) how long it's been since I wrote the enclosed letter part.

Long enough tho that it seems best to drop it and start fresh. For as much as that is possible, at least.

(What a "downer" I am!)

Actually—counting my blessings—

1. It is a beautiful sunny clear day and I'm out in it sunning, with not a single obligation to anyone or anything!

(Assuming, of course, that this is a blessing: à la "here I go again").

Well—only 4 more weeks of summer and then—big city winter again : a thing I would be looking even more forward to if only you were to be there (sniff).

(I would call you up a lot!)

Am beginning to realize that my big Kenward hang-on has a lot to do with the fear of being all alone.

Tho God only knows I have good friends running out of my ears—it's just not the same, as, of course, you know.

My vision of summer was, and is, a time for Kenward and I to help each other over our "humps" and to get used to our being "good friends" again.

Only problem is that Kenward, sweet as he can be, just is not very straight : so anything simple and direct gets all complicated and twisted up to the point of ("help!").

I do hope Steven hangs on because I simply can't take any more and I would fear for Kenward all alone.

(Is this all extremely boring to you? God—it must be! Especially so as I'm sure you're having your own problems. And one's own are tedious enough without someone else's being thrown in face).

I hope you'll excuse what seems to me a (my) very awkward use of language, but it is something I have yet to regain a handle on.

It is a bit like pulling teeth.

Jerking off up in the woods the other day (how do you like my new raunchy personality?) I started noticing the lace-like leaves, of which a few for you I am enclosing.

Plus (boy-oy-boy) some old hankies.

Plus an absolute promise to find you your Spanish soap-lady collage come fall. (A little reminder ((i.e., kick ass)) might not hurt tho).

Kenward just came up from walking to (& from) the co-op with an arm-load of trash gathered along the way. Plus 3 Indian horns:

[Simple drawing of an Indian Pipe flower on left-hand side of the page, with the words "All-white and membrane-like, remember?" written on the upper right-hand corner of the page.]

Now it is the morning of the day after. I have some things for you and also some things I'd like for you to pass out for me, if you wouldn't mind playing Santa (Michael, Steven, Allen). But in five more minutes it is co-op time (mail) and it just seems silly (stupid) to let one more day go by "with-out." So—another big envelope will follow soon. Till then—my love to the gang and most of all my love to you,

Love, Joe

1979, Calais, Vermont[34]

Dear Anne__

A real bright green day of steady rain. Mid-afternoon. Showered and shaved. Clean pants and shirt on. And drinking my—surely—50th cup of tea today. In accuracy to how it seems, in favor of fact.

Mail today was all you. Good to "hear" your voice. And what a beautiful card! I thank you for both.

Music now is Stephen Sondheim's score of "Stavisky," which, as a current favorite, I play over and over again now—today—and for days. I like its sophistication for not being at all "sterile."

Company is Bill Elliott, up for two weeks working with Kenward on musical version of "City Junket."[35]

And just to set your mind at rest, my works are on their way to Denver, if not already there.

I can't thank you enough for your health advice. Knowing so little about things, I needed some authority. And I can't think of anyone's I'd rather have than yours. To instill my confidence in. So—

No coffee. No white sugar. Tho I do allow myself cake and ice-cream (but no candy or cookies). Tho—of course—I can't see (feel) all that much difference yet. Except that I am forever falling asleep in the middle of books.

And then I exercise daily.

And then I meditate every morning. But only—(so far)—for half an hour, as at that point my back starts killing me. Looking forward to warmer weather and fewer bugs, so I can do it outside, I am wondering if keeping my eyes open would be O.K.? What do you think?

I still have this idea in my head that I would like to do a book of letters— (a summer correspondence)—with somebody someday. Joanne and I tried it, and did it, tho not quite to the point of seriously deciding it "was" a book. Tried it once with Michael Lally too, only we both petered out. But— why not us? If the spirit to communicate should find us doing so. I do think letters are a great form. And I do believe that people like reading them. If only for the voyeuristic involvement. And the fun of having to "fill in between the lines." Well—I save all your letters, and if you save mine, and if we write to each other a lot this summer, let's think about it—O.K.? I know for sure that either Robert Butts or Bill Katz would snap it up in a second, if a limited edition format doesn't turn you off at this point.

Well—(well?)—I'm short on news. Just wanted to keep in touch. Demonstrate—(reinforce)—my very strong feeling for you. That, after all these years, I am still drawn to you with curiosity is, I think, quite a feat— (you are not a neat predictable "package" in my pocket) as—a few years ago—I felt we were too much to each other. So I think we can give ourselves a pat on the back for that, assuming that I have held up my end for you too—I hope.

Anxious to be a part of "Naropa," to see Colorado, and be with you, come late summer.

With hopes of hearing from you before then tho—
Much love, Joe

June 1979, Calais, Vermont[36]

Dear Anne __

Figure I'd better get my shit together and write to you—in the mood or not—as I now "owe" you two letters. Always wonderful to hear from you, of course. And loved your account of London. But I got rather thrown by your letter before last, which included a list of all the various places you'll be

this summer. And so if it's alright with you, I'll just keep writing to you in
Colorado, regardless, as I really have no idea how long letters take, or don't
take, to reach foreign lands.

It's a hot muggy (buggy) gray dull Saturday morning (i.e., yuck!) and I'm
drinking tea, smoking a cigarette, and of course, writing to you. It is going to
be one of those very long days.

Last night I made a cheese soufflé that turned out perfect.

Just finished Diderot's "The Nun": a rather precious little book, plus
being outrageously erotic (a satisfying combo). Now am reading a collection
of Fairfield Porter's art criticism which Ron gave me in hopes that I might
review it for the newsletter. (I love it but I doubt it). I doubt—I mean—that
I'll be able to review it. It's simply too intelligent to be reviewed not intellec-
tually, which is out of my range "in words." That, at least, is how I feel right
now about it. I may very well give it a try tho.

Parts of "Nothing to Write Home About" have just appeared in the new
issue of "Ploughshares" and although I rarely read my own works once they
are in print, I did these, and was not too displeased. Though I do hope I
can eventually get rid of all my current dashes and parentheses, although I
do "understand" them (and underlining too). To say nothing of quotation
marks. I think what it is is that my "what I want or have to say" is more
refined—at this point—than my facilities to convey it. As my mind gushes,
rather than patiently "inquires." And then too, my vocabulary is certainly
not up to par. And so I find myself having to rely upon cheesy devices
instead (can you buy it?). I think I can.

At any rate—

I have given up meditating, as it slowly but surely became rather absurd,
due to my back. When, on so many days, as little as ten minutes became all
it would allow.

But I am still off coffee. And sugar: white sugar, soft drinks, and candy.
Tho—as I think I told you—I do from time to time allow myself cake and
ice-cream, tho with some moderation.

And although I am able to write from time to time, painting is still
beyond me in the area of even being able to approach it, although I do get
"buzzes" of desire to do so. But my lack of faith in my stamina deters me.
Regardless of totally knowing that involvement comes directly out of the act
of "doing it." One of those contradictions that the knowledge of is of not
much help, evidently.

Are we still seriously thinking of our summer correspondence as a book,
if the results should so warrant it?

(Takes two to tango).

Tho—knowing myself as well as I do—(which may well not be "a lot")—I don't think it will/would make much difference in what I say or don't say. As the only way I know how to write a letter is "to talk" to who I am talking to, off the top of my head, and therefore highly unedited.

At any rate _____

Pat and Ron and Wayne have arrived, and are settling into their unfinished house in a way towards finishing it. Wayne is shockingly at that stage in growth of extreme length, with large attachments: hands, feet, head. Awkward, but slightly endearing.

Oddly enough, Kenward has lost the 15 pounds that I have gained.

I'm sorry for selfish reasons to hear that life in N.Y.C this fall may not for you be.

Altho, having given up any illusions that city life is ever going to be less spasmodically reclusive for me, perhaps it won't make all that much difference.

Ron said that Bill Berkson was recently in town searching for a Long Island spot to live in come fall. A way perhaps of more gently easing into city life (?).

Travelling around so much—have you seen yet my "Time-Life" poster which—according to Ron—is all over the airports?[37] (It is a Mexican sun-dial-like "wheel," kaleidoscopically rotating around a Romanic sun with face). In yellow and turquoise, with some black and white for interior strength. All rather game-board-like in total effect.

As time does seem to be the way it is, so it is. The days—individually— are long, but the weeks and the months, they seem to fly by.

As for my Naropa lecture—I need to have some idea in advance of who I'll be talking to (mostly poets? Of about what age? And how seriously— and in what directions—are their minds implanted?). I hope you won't think giving an "open" lecture is a lazy way out, tho in fact to some degree I suppose it is.

Am so anxious to be in a new foreign climate, for a change. And too, just to be with you in the mythical place you are in (if not "at").

Forever thinking the world of you as a very particular and very special person, I remain—

Yours truly, Joe.

1979, 8 Greene Street, New York City[38]

Dear Anne__

Sure looks pretty, where you are. You're lucky in so many ways, don't you think? Am sorry to have missed your birthday. I guess my best excuse is that. . . . no head for dates. But that's no good. At any rate—I do wish you had a good year, of course. And I do want to send you something, and will, though it'll be late, of course. I do feel bad sometimes—like right now—for not being a better friend. I do love you very much though. See you and Reed [Bye] on my wall every day in the red mat, and I think all over again how beautiful you are. It's sorta late, and I'm tired, but I do at least want to get a few works off to you now, slim though they may be. Just between you and me—O.K.?—I'm having a real hard time hanging in there. So hard to explain though. And I really don't understand it either. So can't. Am really pretty scared and discouraged though. It's weird but, nobody seems to know! It's just as though everyone thinks I'm "eccentric," or work too hard, or something. At any rate—enough about this. (Too depressing!)
 Well—
 I guess I can't write anymore now.
 Know I still love you best,
Joe

March 1990, 8 Greene Street, New York City[39]

Dear Anne,

It's been a real pleasure, reading "Helping the Dreamer" at my leisure: thank you![40]
 Are you home? Ron is in Florida, teaching for a month. And Kenward is just back from Mexico, and a reading in San Francisco. And me, I've been sick all month (Feb.) and into March. Bad sore throat, then terrible case of shingles, all over the right side of my face, up into my ear, and on to the scalp. All pain gone now though, just a few remaining scars. Anni [Ann Lauterbach] took me to the opera last night, to see "Othello" with Placido Domingo. Jane Freilicher's new show is her very best ever. Jimmy is still in

love. And for my birthday Kenward gave me $48,000.00 (!) one for each
year. And that's about it for news.

I wish you (and Reed and Ambrose) all well, all best.

Love, Joe

September 1990, 8 Greene Street, New York City[41]

Dear Anne,

7:15 on a chilly Sunday morning. Now let me see if I can answer your
questions.

What was your first sexual encounter like? An out-of-body experience.
I was extremely naïve and modest and self-conscious, and so it was quite a
shock to find myself naked (no clothes on!) in bed with an older woman,
her hand manipulating my cock. Of course I had had hard-ons and wet
dreams before, but it had never occurred to me that you could make it
happen. So, like I said, I was too self-conscious to be much more than an
observer. A totally embarrassing experience. Though I felt very proud of
myself (cocky) after.

What was your relationship to your father like? Undemonstrative affec-
tion. And total embarrassment.

Did you have any "role models" as a child? Only Jesus.

What "character" (mythological, fictional, actual (such as in the movies)
do you remember identifying with at any particular point in your life? This
is hard because I find it extremely easy to identify with anybody. I have
always felt an enormous amount of empathy, and had an affinity for, homely
girls : perhaps (?) a result of identification. And then there's Katy Keene:
I thought she had the perfect life: beautiful clothes, two boyfriends, and a
little sister to treat like a doll.[42] And nobody has influenced my life more
than Ted Berrigan. But I think I am straying from the question.

I guess that's it for now!

Love, Joe

P.S. I AM ENCLOSING SOME POST CARDS
FOR YOU AND SOME TIN-TYPES
FOR PIERRE. I JUST KNOW I
AM NOT SPELLING "PIERRE" RIGHT.
YOU SHOULD SEE MY NEW GOLD
GYPSY COINS. I HAVE TWELVE
THAT ARE THIS BIG:

THEY ARE "GYPSY COINS"
ONLY BECAUSE THEY
WERE WORN BY
GYPSYS. ACTUALLY THEY
ARE FROM AUSTRALIA.
SOMEONE SHOULD WRITE A GOOD
BOOK ABOUT GYPSYS. AS FAR AS
I KNOW THERE ISN'T ONE.
BUT , ACTUALLY , THAT ISN'T VERY
FAR.

TAKE CARE.

ONCE AGAIN — LOVE,

JOE

FIGURE 15.1 Page from the letter of August 1, 1969, Brainard to John Ashbery.

15

DEAR JOHN [ASHBERY]

An "emphasis on joy, informality, and the embrace of the accidental," the Brainard scholar Rona Cran writes, "was . . . central to the work of Joe Brainard and his friend John Ashbery. . . . Brainard's desire to draw 'for' words and to avoid 'illustrating,' and Ashbery's approach to poetry as a combination of gestures, actions, perceptions, discussions, and audience reactions, made the two ideal collaborators for one another."[1] Brainard and Ashbery produced a number of works together, including poetry cartoons published in *C Comics* and *The Vermont Notebook* (published the same year as Ashbery's breakthrough book, *Self-Portrait in a Convex Mirror*).[2] Ashbery was also quick to notice Brainard's conflation of the anodyne with the perverse, describing his art as "humane smut" while affirming, "Joe Brainard was one of the nicest artists I have ever known. Nice as a person and nice as an artist. This may present a problem."[3]

October 1968, 74 Jane Street, New York City[4]

Dear John—

It sure was good to hear from you. And thank you, I love it, for the Negro card. I, too, wish I was there in Paris with you antiquing. But, of course, I want to be here too. It does sound good tho. I wish I had some big news items to tell you about but I don't. Small things are fun to read in a letter but not so much fun to write. I loved Jimmy [Schuyler's] piece on Kline.[5] The Kline show, tho, was almost "too much" to either like or dislike. I was impressed. A show that I really did love was Al Held's new show.[6] Black

208 DEAR JOHN [ASHBERY]

and white. More "jazzy" than usual. It made me and my work seem (to me) a bit mousey. If there is such a thing as big painters and little painters he is certainly a big one. It has always occurred to me, tho, that little painters may be luckier than they know. (Me me me) I'm talking stupid of course. I was (am) glad to hear that [you] were feeling nostalgic about our farewell dinner at the Waverly Inn. Me too. In fact, I was feeling nostalgic about it even as it was happening. It was just that kind of weather. Everything about that evening was so definite (visually) that I knew it was not to be forgotten. The red table. The green walls, the leaves, the terrible food, etc. Kenward's musical is off again.[7] Kermit Bloomgarden didn't like Kenward's final version so they split. Kenward is not depressed about it however. He's glad. And I'm glad. Kenward is going to Vermont for 4 or 5 days but I'm staying here. I just don't want to go anyplace for a long time. Unless I change my mind. My museum Christmas card is out but the colors are not as colorful as they should be. It looks like a real Christmas card tho. I'll send you one, at Christmas. Anne [Waldman] & Lewis [Warsh], and Bill Berkson, and Kenward, and I spent a whole weekend several weeks ago doing a book called "Weekend." It's very sloppy and silly and (I hope) will be fun for other people to read. (Look at) Jane [Freilicher] has her winter cold back. And a new beige sweater suit-dress (tweedy) that I was surprised to find out she got at "Macy's." It looks like a million. I'm going to buy a new suit myself, today or tomorrow. It will be brown again. Brown because I look best in brown. And because it's much easier to get dressed if everything you own matches. Clarice [Rivers] is well. We danced a lot the other night at a Morris Golde party. John Button's new boyfriend was there. He looks like Kim Novak. I think he does. I am working on what I have been working on for over a year now (off and on) : a giant garden. I don't know exactly how big "giant" will be except that I plan to make it as big as I can get by with, and perhaps a little bigger. I'm doing it for my show, as, actually, I would get just as much out of it not making it so big. Did I tell you that my show is set for March 22nd.[8] (My birthday is March 11th) It's going to be pretty much of a garden show as I am still not ready yet to have a "straight" show. The Katzes are going to move into Kenward's top floor for a few weeks until their loft is finished. I didn't get Donald [Droll's] place. Kynaston McShine got it. Wayne Padgett got his first hair cut. A beautiful kid. Jimmy was in town are [*sic*] several days last week. We saw the frescoes at the Met. Hard to look at. I found them hard to look at. Jimmy didn't. He loved them. I must stop before I start a new page. Do write. I love hearing from you. "Hello" & "love" to Pierre [Martory], Maxine [Groffsky], and Harry [Mathews].

I may as well start a new page as I just remembered Anne Dunn's show. She's here, and her show opened last Saturday. She seemed a bit depressed about it. (Collages) Once again—do write.

Love, Joe

August 1, 1969, Calais, Vermont[9]

Dear John__

Thank you for "Blimp Works."[10] I am assuming that it came from you. Are you coming up? It is 6:30 in the morning. Why am I up so early? That's what I'd like to know. Out the windows all you can see is white. Very heavy dew. Painting is not going at all well. Totally lost. No satisfaction. However, "C" Comics no. 3 is going great guns.[11] I hope you will want to be in it. (?) I think you will. Bill is here. Jimmy and I write a lot. I do hope you plan to come up. (?) Kenward goes to the cabin every morning and works on the Orchid Stories. One day he did ten pages. Wants to finish them by fall. The musical is off for at least until spring. No surprise. I've gained five pounds. Plan to gain five more. Will be here until Sept. 15th. Ada and Alex and Vincent [Katz] dropped by the other night. We played charades. More fun than I thought it was. Then they left very early the next morning. Which may explain why I am up so early. I am very much a person of habit. (Got up early to see them off) Well—I do miss you. You're a funny person. I suspect that I feel closer to you than I really am. But, if so, I like it.

Come up.

"Hello" Pierre!

Love, Joe

P.S. I am enclosing some post cards for you and some tin-types [sic] for Pierre. I just know I am not spelling "Pierre" right. You should see my new gold gypsy coins. I have twelve that are this big: [see figure 15.1] They are "gypsy coins" only because they were worn by gypsies. Actually they are from Australia. Someone should write a good book about gypsies. As far as I know there isn't one. But, actually, that isn't very far.

Take care.

Once again—Love,

Joe

P.P.S. No, I am not enclosing some tin-types for Pierre. I just looked at them and they are not very good. I am afraid that I sent all my good ones, already, to Jimmy.

Date unknown, Calais, Vermont[12]

Dear John___

September's evening autumn light falls softly over our cottage world and the scent of burning leaves drifts through the chilling air. The days flee swiftly now and concede their broad ways to autumn's longer nights.

As I worked with the cheese pumpkin today, steaming the cleaned and quartered pieces in the oven and scraping out the softened pulp to turn it through the food mill for freezing, I decided that I love autumn best.

We've been enjoying pumpkin bread, pumpkin pudding, pumpkin pie, pumpkin cookies, and pumpkin muffins, and will continue to do so.

We've tried our hand raising rabbits. In a year's time we ended up with five. So we gave up on that.

Everyone needs a hobby. Having a hobby—a favorite occupation that we do for pleasure and rarely for profit—gives a zest to our life that we don't always get in our everyday "jobs."

One day while cleaning pig's feet, I thought, what cute hooves! I could visualize them as containers for my miniature arrangements, so I saved them.

If you will use your eyes and your imagination, you can come up with plenty of containers designed by nature that cost nothing and are so much pleasure to look for.

I seldom use a store-bought container for any of my arrangements, whether large or miniature.

Sometimes you can just start a collection of a certain type, and make that a collectable item. After all—that's how it all started.

My beautiful Boston fern is dying. This is the third one I've tried. I vowed I would never buy one again, but this one was on sale and I just couldn't pass it up. Ferns are among the oldest plants in the world, and very set in their ways. I think they would just like to go back to the woods. Our modern heating systems and air conditioners don't suit them at all. I remember that my grandmother kept her ferns under the house.

Know anyone who might have some pink wisteria seeds to share? I've found the lavender ones in my area, but not the pink ones. In fact, when I mention the pink vine to most people, they look at me funny.

While we were on vacation this winter our furnace went out and I lost all my large violets.

Well I better say so long for now as I have to get ready to go to the garage sale.

Love, Joe

November 12, 1981, 8 Greene Street, New York City[13]

Dear John,

I'm very much in-doors and "at home" with the flu. Sitting at my desk, listening to ("Sentimentally Yours")—Patsy Cline, and drinking a glass of iced coffee, which I enjoy year-round.

Why I'm writing is to let you know how much (a lot) I liked (loved) your play "The Heroes."[14] Really, it's very funny and beautiful. (And just the right length.) And—as always—I am totally in awe of the scope beyond the surface of everything you write, even when it's totally over my head.

While I'm at it—"Hi!"

I miss not seeing you. And David [Kermani] too. And yet I don't call you up, and I don't know why. So easy to get into ruts, and except [*sic*] current cycles, I suppose.

Continue to know I think of you fondly though.

Until maybe soon, I hope, I send you my love,

Joe

September 3, 1984, Calais, Vermont[15]

Dear John,

Ugh: a dark dreary wet labor day Monday morning.

Just the other day I was saying to Kenward "Isn't John's birthday coming up soon?," but he said I was too late. Hope you had a happy one, whatever that means: (hope you didn't have a bad one!)

Then that same night I dreamed about you. You introduced me to Anthony Powell—(just read "Books Do Furnish a Room")—who seemed really nice. Then we all turned into large and brightly colored tropical fish, and swam around awhile. End of dream.

Then the very next morning "A Wave" arrived in the mail, which really tickled me pink : I am so flattered! [16] Of course I had already read it— (!?!)—but like a lot having my own autographed copy. Thank you.

I don't suppose for a minute that I get half of what there is to get, but it doesn't seem to matter. It's a pleasure just to wade around.

A deep bow from the waist.

A friendly pat on the ass.

<u>Love</u>, Joe

P.S. I return to the city Oct. 1st, so maybe. it sure would nice. hope so.

P.P.S. Kisses to David!

FIGURE 16.1 Image included in letter from Joe Brainard to John Giorno, Courtesy of the Giorno Poetry Systems Archive.

16

DEAR JOHN [GIORNO]

I n 1969, the poet and performance artist John Giorno wrote to Brainard with an unusual request: "make more drawings of dirty sex, piss drinking, shit eating, a hand up someone's ass, whips etc. Also, a series of drawings of sex in a moon-orbiting spaceship using Armstrong, Aldrin, & Collins."[1] Giorno was renowned as the bad boy of New York's literary scene. He created LSD-fueled performance works. He established a pirate radio station that was broadcast from the bell tower of St. Mark's Church in New York's Lower East Side. He played the central role in Andy Warhol's five-hour-long film *Sleep* (1963), composed of a series of three-minute takes of Giorno sleeping. Perhaps most famously, Giorno transmitted avant-garde poems (including Brainard's) through what he called "Giorno Poetry Systems," part of which was the renowned Dial-a-Poem telephone call-in service and related record label series.

As the letters between the two reveal, Giorno and Brainard had a special relationship founded on their embrace of guilt-free gay sexuality. Giorno's celebration of his "countless lovers of boundless / fabulous sex / in the golden age / of promiscuity"[2] found a visual and verbal corollary in Brainard's art and writing, even as Brainard at times tended to rein in some of Giorno's excesses. "About piss drinking, whips, shit eating, etc." Brainard wrote back to Giorno, "I don't find these things very sexy, which, for me, would take a lot of the fun out of it."[3]

July 10, 1969, Calais, Vermont

Dear John __

Anne [Waldman] & Lewis [Warsh] were just here and said that you were in North Carolina. How is it? I gave Anne a sort of basic idea for a cartoon strip

I hope you will want to do for the next issue of "C" Comics. It is of ladies (or
a lady) wearing various black garments. You never see her face. Black gloves.
Black nylons. Black garter belts. Etc. You may do with it whatever you wish.
Make the balloons and fill them in yourself. Or designate where the words and
balloons are to go and I will ink it in. If more pages are needed (more drawings)
just tell me what you want. There is one page with just an invisible woman
wearing black nylons and black gloves smoking a black cigarette in a black long
holder. I thought of this as the title page, but it doesn't matter. There are some
squares that have nothing in them. These squares can either be all words or you
can tell me what to draw in them and I'll do it. If you want me to neatly print
in the words and balloons be sure and tell me if they are "thought" balloons or
"spoken" balloons. [Simple pen drawing of two speech bubbles with arrows,
one pointing to the word "thought," the other pointing to the word "spoken."]

 Not much is new. Anne and Lewis were here for a week and we had a
great time. Took ½ a purple pill I had never taken before and I loved it.
(Methedrine I think) Vermont is so beautiful! Of course, it always has been.
Beautiful. Today, however, it is raining, which is O.K., but not great with
me. I feel sloppy, and horny, and nervous. But good. Rainy days always do
this to me. And driving in cars. If the drawings for the cartoon are alright
and you write something for them, when you finish, will you send them
here to me? Unless it is September. In which case I will probably be in the
city. Actually, I will be in the city. (September) I would like to finish up the
issue before then however. My other plans for the summer are to gain some
weight, and to get a great sun tan, and to get together my manuscript for
Lita Hornick. And, of course, to paint. Write if you feel like it.

 Love, Joe

August 8, 1969, Calais, Vermont

Dear John __

Sorry for long delay in writing. But Bill Berkson has been here and I didn't feel
much like writing letters while he was here. We had a great time tho. And did 4
cartoons. I like the poem and will try to do it. That is to say, I will do it, but will
try to make it work. There is one thing tho. (About piss drinking, whips, shit
eating, etc.) I don't find these things very sexy, which, for me, would take a lot
of the fun out of it. Also—they would be very hard to draw unless I had some
photos to go by. So—I don't know—let's wait until fall. So—how does it feel to
be back in the city? I am itching to get back myself. And to moving. I want to

move into a loft when I return. A living loft. Know of any? I can pay a goodly
sum for the loft, plus $200 a month. Vermont is very much the same. Beautiful.
And nothing much happens. The weather is very important. Yes—you can use
my camera (Polaroid) and timer when I get back. It doesn't take great pictures
but it's fun to be able to see the results instantly. Any luck with Dial-A-Poem? I
am not painting right now but just writing a lot (diaries) and doing "C" Com-
ics. That, for now, is about it. As always—it would be good to hear from you.
Love, Joe
P.S. Altho, like I said, I have doubts about shit eating, etc., I will go ahead with
the poem you enclosed in your last letter. One question. What about a title?

P.P.S. Also—what is a Garrison belt?[4]

July 18, 1969, Calais, Vermont

Dear John ___

It was good to hear from you. Painting not going so well so I've been
drawing a lot and reading a lot. Sunning. And taking lots of naked photos of
myself. I don't really think that I am such a narcissist, but, I do find it very
exciting, as you can see from some I have enclosed. Hope you like them. I
have taken literally hundreds and there is not much one can do with them.
I keep thinking that soon I will get bored, but, not yet. It's a very expensive
habit. But fun. As for the Black Gear comic, Anne is bringing it to you
when she comes to visit. As for a comic of 2 boys fucking and sucking, that
sounds great to me. I would rather, tho, do the drawings in a more serious
and realistic way (more beautiful) than the drawing for Anne and Ken-
ward's reading, which was a fake primitive style I couldn't keep up for very
long. Nor would I especially want to. But—I will send you some fuck-suck
drawings soon and I think you will like them. I have begun already and they
are, to me, very sexy, but not at all funny. Is this O.K.? Thank you for the
match book, which I love. It has gone, already, into my book (scrap-book)
about/of poets. (Clippings, manuscripts, photos, etc.) And announcements
and autographs. By the way, if you should write me again, will you sign your
name on a piece of paper? (Auto for the book) "Art Type" sounds fine for
Black Gear. Draw in the balloons, too, if you want to. Or just anything you
want to do. And if you need more drawings, or any drawing in particular,
let me know. (I sure am easy to work with.) Feel free, even, to draw over, or

add to my drawings, if you wish. Right now I am reading that new Marilyn
Monroe book. I love it. Today is not a terrific day. Cloudy, gray, and not sun.
And too buggy. So I am inside. I can't think of any "news." I'll be sending
you some fuck-suck drawings soon. In the mean-time, if you feel like it,
write. "Hello," "love," and "more" to Anne. (If she is there yet.)

 Take care,

Love, Joe

July 23, 1969, Calais, Vermont

Dear John __

Your Fuck & Suck drawings will be arriving in a few days.[5] I had a lot of fun
doing them. Someday we ought to do a really sexy book. I think that with
a little practice (getting into it a little deeper) I could do some really great
ones. These were rather hard as I had no models and only a few photos to
go from. Plus imagination, and plus memory. At any rate—do whatever you
wish with these. I may want (?) to touch up some of what you do. As I like
to draw out of the blue, with a brush, I do make mistakes. (Lines that don't
belong) Sometimes I like these extra lines, and sometimes I don't. Do keep
in mind that the writing in the balloons can overlap a drawing. (If I have not
left enough space) That is to say:

WHAT GOES INTO THE BALLON (BODY-WISE) CAN BE WHITED OUT, PASTED OVER, ETC.

There are some blank squares. These can either be all writing, or I can draw whatever you wish in them. I am, perhaps, sending too many pages. Don't use them all if they don't to you fit. We do need a title page. If you know what you would like on the title page besides the title & our names, let me know. Actually, one of the two full-page "fucks" could be a title page. I just keep wanting to tell you that "anything goes." You shouldn't ever feel restricted. Am anxious to hear from you. And to see what we can work out. Is Anne there yet? ("Hello" Anne) If she is, I'm going to write her a letter (love) tomorrow I think. Slurp. She's great! (Are you reading this, Anne?) "Veronica" has really stuck. (Anne named Kenward's lake Veronica when she was here) I assume you get it? (Veronica Lake) She also named Kenward's field "Edward." [6] In the drawings you find a sort of "black come" page which might, I thought be a good ending. Or title page. Or a very bad idea. At any rate—I'm enclosing it. (With the drawings) I'm afraid I have the wrong "come." Is it "cum"? (Cumm) At any rate __

 I'm tired.

Love, Joe

P.S. Write.

P.S. Tell Jasper Johns (we don't know each other) that I like his work very much. It just occurred to me that I do. It also just occurred to me how much I like it when someone says that to me. (That they like my work) So it would be a waste, not to say it. So, tell him for me. That I like his work.

P.P.S. I also plan (I think) to put some more black around the bodies, depending on what you do. What do you think about this?

DEAR LEWIS —

HOW GREAT! THE POEM
IS. AND GETTING THREE
LETTERS FROM YOU.

FIRST — THE POEM.
YES IT WILL CERTAINLY
WORK. I KNOW IT WILL.
BUT I AM SURE THAT IN
PUTTING IT TOGETHER I
WILL WANT TO NEW SOME
NEW DRAWINGS TOO. (WHICH
IS WHAT I HOPED FOR)
I MEAN, I WANT TO
BE INSPIRED BY THE POEM
LIKE YOU WERE INSPIRED
BY THE DRAWINGS. (I
ASSUME YOU WERE) WHAT
AN ASS I AM. (CONCIETED)
AT ANY RATE, IT WILL
BE GREAT. TWO PROBLEMS
WILL HAVE TO BE SOLVED.
ONE IS THE FORM OF
THE POEM. (LAY-OUT) I

FIGURE 17.1 Page from the letter of November 23, 1969, Brainard to Lewis Warsh.

17

DEAR LEWIS

◀◀◀ A rt' bothers me," Brainard wrote to the poet and fiction writer Lewis Warsh in November 1969, explaining, "All I really want to do is to get to know people better." This declaration sets the tone for many of Brainard's letters to Warsh written in the late 1960s and early 1970s.

Brainard reports on what a good drinker he is becoming, shares literary gossip, and makes several resolutions, the most essential being "More sex. And fewer hang-ups." Brainard also addresses topics specific to his art, describing, for example, his frustrations with portrait painting. "Tomorrow Bill sits for me. And it's a little bit like war. I am so aware of the fact that the person I am painting is 'there' and that I, painting, am 'here.' I wish I could say what I mean more clearly. All I really know is that painting somebody, for me, is like really confronting them in a very personal and naked way." Given Brainard's extensive work producing book covers and cartoons with his poet friends, it is perhaps not surprising to find him framing his practice as an act of sociability. What makes his descriptions of his painting so moving here is the way he maintains his playfulness while making clear his profound desire for intimacy with other people.

November 1969, 74 Jane Street and 664 6th Avenue, New York City[1]

Dear Lewis___

"Happy birthday." If I wasn't so up in the air right now I would send you a present. But—but I am. Right now I am sitting here at the table I'm leaving behind at Jane Street. Waiting for the movers to arrive. Only thing is that I

don't know when they are arriving. They may arrive any minute now or they may arrive tonight. So here I am not really "at" Jane Street or "in" 664 Sixth Avenue. How come you haven't written? (Stupid question) I suppose that you just haven't felt like writing. And that's understandable. And for some reason I am wearing a heavy turtle neck sweater and today is not that cold. But all my shirts are packed. And along with being "up in the air" and "hot" I am also very nervous. Nervous, perhaps, that being in a new place won't make that much difference. (Some birthday letter) Well—I'm excited too. And happy. These are funny days of everything. (Very up and very down) It just seems to be that kind of a year. (A year to me begins with September) Now, if I feel up in the air, you must really feel up in the air. Am I right or wrong? Or, if so, do you like feeling that way? I got a beautiful letter from Ted the other day that made me realize once again how close we are even if it doesn't show. (Didn't show) Actually, we have seen so little of each other the past few years that there was no chance for it to show. Now I don't like that word "show." At any rate—I am looking forward to his NYC return. Anne [Waldman] came by yesterday. She's terribly busy and very nervous and looking more beautiful than ever. She, too, seems (to me) very up in the air. Did you know that Jimmy Schuyler's birthday is the same day as yours? Lita Hornick (soon) is giving her annual party. The 7th of Nov. I think. (Very interesting) Did you see "Album"?[2] If not, let me know, and I will send you one. Are you going to be at Tom [Clark's] for awhile? Kenward is O.K., tho he, too, finds this a very funny (uncertain) year. I am not putting you on about "this year." It really is (for everybody I know except Ron & Pat) a very strange and "anything can happen" year. I'm glad you are in California. (If you are) If you are glad. Words like "glad" get so abstract if you use them more than once. I don't go to movies much these days. The newest thing I enjoy doing is going to queer bars and getting drunk. (Drunk in a good way) Warm. Warm and soft and generous inside. That's how getting drunk makes me feel these days. And I like it. That feeling. And need it. It used to be when I got drunk I either got sleepy or I got sick. Because, I suspect, I never "gave in" to being drunk. Now I can get drunk in a very relaxed way. And it's terrific. Right now it is ten o'clock in the morning. I think that Anne is going to use a drunk diary I wrote in the new "World." A very emotional and corny diary (six nights and one day) written only (except the one day) when drunk.[3] Being drunk is definitely a luxury. (To me) Of course, I'm not at all afraid of luxuries. (As opposed to Ron) Who, I am sure, is very smart for himself. His book is out and is beautiful.[4] Beautiful and easy to read. And, if I do say so myself, beautiful to look at. (Total stars) You will see. I'm very proud of it. And proud to

know Ron. The bell just rang. But it was not the movers. It was the postman
with two copies of <u>Ron's book</u>! I like it when things like that happen. (Tho,
actually, I would prefer the movers) Gotta get out of here. I can't tell you how
long October has been to me. Today is only November 1st so maybe I'll write
more before I send this letter off to arrive November 9th. I don't really have
much to do to my new place except paint some brown exposed beams white.
Paint one red wall white. And paint the red and black kitchen white. Also I
have to somehow unseal the windows. The people before me didn't like dirt.
I don't like dirt either, but I <u>do</u> like air. Did I tell you that my place has 3 air
conditioners. I don't know why. I mean, it's not <u>that</u> big. The place. In fact,
I'm afraid that it's not so big at all. I only saw the place for about 5 minutes
(someone else was looking at it the same time I was so I had to say "yes"
fast) and I haven't seen it since. (They just moved out yesterday) I'm getting
boring. Will stop now. Will add more words in a few days.
Love, Joe
P.S. <u>I miss you.</u>

P.P.S. A fire just broke out directly across the street! Under control now tho.
The firemen just carried out of the building a big black mattrice. (?) That's
not how you spell matrice. (?) But you know what I mean. (To sleep on)
Smoking in bed no doubt. Well, "goodbye" again. Until soon.

Dear Lewis __

Moving somehow became a big hassle. And now it is well into November.
And now your birthday is over. (Sniff) I'm not much for missing people.
But, now, writing you, I <u>do</u> miss you. <u>Do</u> let me know at all times where
you are. (O.K.?) And I will write. Are you still at Tom's? What about the
landscape poem or poems? And what about <u>you</u>?

Anne sat for me the other day. I did some drawings in preparation for an
oil portrait. People are so hard. I can't keep my distance. (Can't be detached)
Like Alex [Katz]. I can't "see" the whole. Lips and eyes, etc., change every
moment for me. Do you know what I mean? I don't think I'm expressing
myself very well. Well, I'm trying. I love my new place. It's very clean and
white and empty. My address is 664 Sixth Ave. (Hint) Ted arrives today.
Sunday is his birthday. The annual Hornick party was fun. Ron's book is out,
and beautiful. Michael's book is not out yet but I saw an advance copy.[5] I did
the cover at the same [time] I was doing those landscape drawings. And that's

what it is. It looks good, tho a bit conservative. (Conservative is not a bad word) (Necessarily) [Brainard blacks out some words in the letter, and writes the sentence "Sorry, but I just can't seem to write these days" with an arrow pointing up to the redacted words.] Too nervous. Nervous to get back "into" work. More sex. And fewer hang-ups. More fun. (How stupid <u>not</u> to have fun) Sometimes I really just don't understand people. And "people" is me.

I <u>do</u> miss you.

I <u>do</u> hope you are happy.

I <u>do</u> hope that luck is with you.

I <u>do</u> hope you will write.

I <u>do</u> love you,

Joe

November 23, 1969, 663 6th Avenue, New York City[6]

Dear Lewis __

How great! The poem is. And getting three letters from you.

First—the poem. Yes it will certainly work. I know it will. But I am sure that in putting it together I still want to do some new drawings too (which is what I hoped for). I mean, I want to be inspired by the poem like you were inspired by the drawings (I assume you were). What an ass I am (conceited). At any rate, it <u>will</u> be great. Two problems will have to be solved. One is the form of the poem (layout). I would like for the poem to move the same way it does on your page (it moves so nicely). So—chopping it up will be hard. (Any ideas?). Two is whether or not to really get involved in the poem or to keep my distance (like you inside a car and me the passing landscape). What do you think about that?[7]

The problem with your first letter was that I didn't have a key to my mail box and so, two days ago, I just took my hammer downstairs and broke it open. And there were your two letters.

You sound fine.

I'm not writing too well (too clearly) because my head and hands are still with Anne. She just left a moment ago. I've been painting her portrait. Very straight. With oils. "Art" bothers me. All I really want to do is to get to know people better. And to be able to let people get to know me better. I think that that is what my new portraits will be all about. It's so hard. Anne's face changes every moment, even when she isn't moving. And I cannot keep a distance (detachment) with people when I am painting them. So I guess

I don't want to. It would be easier, tho, if I did. If I could. Tomorrow Bill [Berkson] sits for me. And it's a little bit like war. I am so aware of the fact that the person I am painting is "there" and that I, painting, am "here." I wish I could say what I mean more clearly. All I really know is that painting somebody, for me, is like really confronting them in a very personal and naked way.

Soon I am going to paint a stranger and see what happens.

I will send you an "Album" tomorrow. Actually, probably not until Monday. I will send one to Tom too. Tell Tom I am sorry I haven't sent him one before, but Kenward said that Lita was going to send him one (?) but I guess not.

At last, this morning the telephone man came. But he couldn't find a certain very important wire (behind a wall) and so he couldn't hook me up. But he's coming back at four. I am very anxious to have my first telephone. I don't know what he is going to do at four. Perhaps put in a new one (wire).

Perhaps, this weekend, I will go out to Southampton and stay with Pat and Ron to draw some trees. Corinth Press is republishing *Some Trees* and I'm going to do the cover and anything but a tree, to me, doesn't seem right.[8] Anne is going to write the introduction. Of course, there are trees in Central Park.

I [am] really glad that you liked what I did for Ron's book so much.[9] I'm happy with it too.

It is not four o'clock yet (only two) but the telephone man just returned. He left a little gray machine buzzing and went up to the roof. I guess he is still looking for the wire. If the machine stops buzzing I'm supposed to hit it (that's what he said). Sometimes I am amazed that the world stays put together.

The first night of John Giorno's benefit is tonight.[10] I may go. Tomorrow Anne and Allen Ginsberg and Gary Snyder read. I am going tomorrow night for sure.

The machine is buzzing. Very fast now. And loud. It's a bit creepy. And the man is still on the roof. I was going to make my own coffee for the first time this morning but the electric stove didn't work.

Along with "Album" I will send you a drawing for your new place.

I wish you were here to sit with (for) me.

Soon I'm going to get a big mirror so I can paint myself. But I hate buying big things. So I keep putting it off. It's the carrying them home part that I don't like.

I do love my new place. It's not great, but it's very comfortable. Tho a bit chilly. The heat here is not enough. Which is the way I like it when I am

working. But for reading or something it can be downright cold (which is why I am painting Anne in a sweater).

I got so anxious about "I Remember" that I asked Anne if she would publish it. If I paid for it. She said yes. So I'm excited about that. My first book.

Ted was in town for a few days. Only got to see him once tho. I feel very close to him again. After several years of not.

The man is still (I guess) up on the roof. The machine is still buzzing. And I'm tired. I'll write more tomorrow.

[The remainder of this letter is missing.]

December 8, 1969, 664 6th Avenue, New York City[11]

Dear Lewis __

It was good to hear from you. It always is. Today is Sunday. At three Bill and Kenward read at NYU. Afterwards Kenward is giving a party. Monday I go to see Paul Taylor and Company. Also Monday is a party for John Myers's anthology.[12] Wednesday is a party for Ron's book. This is how NYC is this time of year, this year. And I like it (busy at night). I've been keeping very busy in the daytime too. Still working on Anne (four sittings already). Tessie [Mitchell]. And a self-portrait. Also a cover for *Some Trees* which Corinth is reissuing. And Christmas. There is a lot to do for Christmas if you expect Christmas to be as "special" as I do (expect it to be). Yes I am still in touch with Black Sparrow about "Landscape."[13] Will let you know soon. Christmas, however, is not going to be so easy this year without you and Ted and Bill and Pat and Ron. And Anne and Michael might not be here for Christmas either. (It wasn't that easy to learn to say "Anne and Michael" that easily).[14] As easily as, to tell you the truth, I can now. Time is so fast. I hope you got your drawings O.K. (?). The mails. I have no faith in the mails anymore. For reasons not worth going into (lost stuff). I'm happy here on 6th Avenue but already my floors are dirty and my white windowsills are covered with little black specks. And the garbage (trash) is piling up. I always think of garbage as food and most of my garbage / trash is paper and bottles. John Giorno had a crazy (and pleasant) birthday party. Lots of acid. I do love it. Acid. I wish I weren't so lazy about getting it (to take it more often). Sex-wise I am batting zero. And I really don't know why. And it's not too good for my ego. Partly it is because I won't play any games. But it is more than that. I wish I knew <u>exactly</u> what I looked like so I could know what to expect. That sounds cold.

If I am writing more to myself than I am to you it is because I don't really have any idea of what you where you are now are like [*sic*]. From your letters I try. But I still don't know. But—if I am not writing to you I am certainly writing <u>for</u> you. This paragraph doesn't exactly say what I meant to say. But maybe you know what I mean.

Henry just came over to sit for me and now he is gone (went O.K.).[15] Anne, by the way, is going great (the painting I am doing of her is). The flesh tones are good. And her strength is present. I mean, her own-ness. Two more sittings and I hope it will be finished. She is smack in the middle of the canvas wearing dark red velvet and a gold necklace (my choice). My portraits, I can already tell, are going to put people on pedestals. I mean like, in a spotlight.

Well—it's about time for the reading. I did something to my neck sleeping last night. If I move my head in certain directions it hurts.

Write me again soon, OK?

I don't want for us to get separated (lose ground) any more than naturally will have to happen.

Take care.

Love you.

And miss you.

Love, Joe

August 12, 1970, Calais, Vermont[16]

Dear Lewis __

Summer is so much over that I find it hard to write about it. Or about me in it. ("It" being summer) September! I really do look forward to September.

It was good to hear from you although your letters sometimes depress me a bit. As did your last one.

Are you really that much inside of yourself or do your letters just give that impression?

Now I don't feel myself to be in any position to give advice but it's really all I can do not to as <u>I do care.</u>

(For you)

And, actually, I don't know what advice I could give except "don't be so much inside yourself" and that's not very constructive advice.

So—no advice.

And maybe you <u>want</u> to be that much inside yourself. (?)

When I lived in Boston I was. (That much inside myself) But I was happy. (As I remember) And you don't sound so happy.

To simplify things perhaps it is best just to try for happiness.

(Please pay no attention to such simple minded statements as the one above) It's just not that simple, of course.

And actually—I wasn't so happy in Boston. I remember crying sometimes til I couldn't cry anymore. And I remember days that were as long as weeks. And I remember sitting through movies over and over again just so as not to be in my small head for a while.

And now I <u>miss</u> being so close to myself in Boston.

If I am trying to make a point I don't know what it is.

Dick Higgins wants me to illustrate "A Book About Love & War & Death." [17] (The complete version) It makes no real sense to me (who needs it?) but I may do it if I like him. (Dick) He's coming to visit Friday. It would be a weird thing to do and I sort of feel like doing something off in left field. Or is it <u>right</u> field? I never did like baseball. Tho, being queer, I hate to admit it. (So typical) Which is why I even bring it up at all. (Probably).

Anne and Michael left yesterday. Harry [Mathews] arrives Friday. No, Saturday. And then like 4 or 5 days later Maxine [Groffsky] arrives.

I've been doing a lot of ready-made writing. Which means buying lots of magazines and books and a lot of turning pages. I have a lot, but only 4 that I <u>really</u> like.

Here's one called "Short Story." It was a "preview paragraph" of a story to come "next month" in a confession magazine.

<div align="center">SHORT STORY</div>

Ten years ago I left home to go to the city and strike it big. But the only thing that was striking was the clock as it quickly ticked away my life.[18]

Well—I think I'll go out and sun a bit.

<u>Take care</u>!

Love, Joe

P.S. AND LOVE TO BILL!

P.P.S. (Lewis) Did I thank you for "In London"?[19] It's a very inspiring poem and beautifully done. Made me wish I could write poetry. And it made me try. (But no luck) At any rate—if you ever see Robert Creeley I hope you will tell him that I loved it. So thanks for doing it. And thanks for sending it.

Love, Joe (again)

July 26, 1971, Calais, Vermont[20]

Dear Lewis__

Your manuscript is really moving and beautiful and <u>everything</u>![21]
 And everything means great.
 I'm really glad I get to do the cover and the title pages. Will do my best. A letter from David [Rosenberg] says I have two weeks. (That's good)
 Wish I could have seen more of you in Bolinas but, to tell you the truth, I wasn't too happy with you there until towards the end. (Which was too late) And then—you weren't around much either.
 At any rate—I'm sorry. (For thinking you needed a swift kick in the ass) When actually I knew nothing from nothing.
 I mean—I think I'm very good about trying to always meet people with a clean slate.
 (Pat on the back)
 Reading your manuscript has inspired me to try once more to get "Bolinas Journal" into good shape. And I thank you for that.
 And for dedicating it to me—I really thank you for that.
 Jimmy is fine. Kenward is fine. And Whippoorwill too. (No more skin disease)
 Me, I'm a bit jumpy, and scattered, but somehow doing a lot anyway. Tho it seems to be taking a long time to add up.
 Really disappointed I haven't heard from Bill. He's O.K.? And Susan [Burke]?
 And <u>you</u>?
 Not much "news" right now.
 Will probably be here through the first two weeks of August—then N.Y.C. again.
 Seem to have a few big problems that I can't even figure out exactly what they are. And to write about anything else seems—well, not what I want to write about.
 So ____
Love, Joe
P.S. "Part of My History" is really one of the most extraordinary books I've ever read! (Just want to make <u>sure</u> you know how I feel)

<u>REALLY GREAT</u>!!

October 12, 1971, 664 6th Avenue, New York City[22]

Dear Lewis__

Hard for me to work these days as I feel like shit. (Recovering very slowly) But finally I did come up with something. (For "Dreaming as One")[23] It's rather plain and "tough" and abstract. The colors are bright blue and bright yellow.

I'm sorry if it's not as good as it should be. But, if printed well, it may be better than I think. (And it certainly is not bad)

As well as not feeling too well, I seem to be in some sort of a rut with covers. They never please me anymore. So I think I'm going to take a break for awhile.

Reading tons. Now all of E. M. Forster's novels. (2 down & 3 to go) I'm so glad not to have read him before. I'm really enjoying it.

Kenward seems to be having a thing with a model (a raving beauty) (male) and it's strange to feel jealous. Tho I suppose it would be even stranger not to. I, really, am outrageously demanding.

So—perhaps I only have one more week to go. (Before being well) But then, I thought that several weeks ago. And—I won't be able to drink for 3 to 6 months!

Sorry to be so gripey but I have little patience with sickness.

So much on my mind these days is how, all of a sudden, my life could totally go downhill. (Could explain further, but won't)

Also I'm still upset by "Bolinas Journal." It's really cheap in several ways I didn't realize. I suppose making a mistake isn't so bad, but hurting people is.[24]

But otherwise—I'm fine.

My Gotham show is framed now and I'm glad to have that out of my hands.

Johnny Stanton is going to publish my "Cigarette Book."[25]

Kenward isn't too happy with his musical but glad finally that it's going to be done, over and done with.[26] Opens in New York November 2nd, I think.

Still worried a bit about Jimmy. Just not the same. But then, maybe he should be different, having gone through what he's gone through.[27]

Anne looks great.

Lita's big party is soon.

I thank you for the cookbook, and, how are you?

Do write soon.

Love, Joe

DEAR LARRY

T he poet, editor, publisher, and teacher Larry Fagin got to know Brainard around 1967 when Fagin moved from San Francisco to New York City. Fagin, who edited and published the *Adventures in Poetry* magazine and book series (featuring the likes of Tom Veitch, John Ashbery, Anne Waldman, and Tom Clark), was living in the so-called Poets Building at 437 East Twelfth Street in Manhattan. His neighbors included the punk musician Richard Hell, the composer Arthur Russell, and the poets John Godfrey, Allen Ginsberg, and Peter Orlovsky.

This small but sweet selection of letters to Fagin, written in 1970, focuses on Brainard's efforts to produce a cover for Fagin's book *Brain Damage*. Note the *in media res* opening of the first letter featured here—"That's true! We've never written to each other." Brainard has a wonderful way of treating letter writing as a form of active conversation—you can almost feel him thinking and improvising as he makes his way down these pages.[1]

July 9, 1970, Calais, Vermont

Dear Larry __

That's true! We've never written to each other.

I've been working on some green grass all day and now it is about four o'clock. So—if this isn't much of a letter it's because my head is a bit tired.

The "Green Grass" is (are) cut-outs of areas of green grass. In 3 to 4 layers each (each picture) which will soon be put into plastic boxes so as to be 3-diminional [*sic*]. Now I know there is an "E" in "diminional" somewhere. Between the "m" & the "n" no doubt.

Would you believe that I have given up smoking? It's true. I don't smoke anymore.

<u>And</u>, I've gained 15 pounds. Pretty good, yes?

About "Brain Damage"—you didn't tell me where to send it.[2] <u>Do</u> write and tell me.

Mostly what I have been doing these days is reading. I am trying, now, to read all the books that everyone else has read but that I missed out on somehow. "Moby Dick." "Anna Karenina." "Madame Bovary." Etc. My favorite book so far this summer is "Anna Karenina." After 3 or 4 more big novels I plan to learn all I can about the human body.

It occurred to me the other day how <u>stupid</u> it is not to know how your own body that you live with all the time works.

I mean—I pay more attention to my hair than I do to all my inside parts all together.[3]

There have been some strange noises that shake the house every now and then for two days now (like dynamite). I think it is airplanes that get into some sort of an "air pocket" that they shouldn't be in. That's what Harold [Clough] said.

I do Air Force (Canadian) exercises every day.

Joan [Fagin]: I thought of you just yesterday when I saw on the cover of "Seventeen" a girl with a smile very much like yours! (With blond hair). "Hello." (Joan).

Larry: I think I will go ahead and sign with those German people. It seems like a good deal and if I don't sign now the book can't be out by spring. (As, if I sign now it can be). I am talking about the comics.

I have only written so far this summer one piece. A ten page "report" on a local 4th of July parade (funny / spooky / etc.)

Well—I'm not running out of things to say but I would like to get this to the co-op in time for the last pickup so I had better stop (mail pick-up). We get mail two times a day. 10 A.M. and 5 P.M (approximately).

I really <u>am</u> a better letter writer than this, but _____

Take care.

Have fun.

<u>Do</u> write. *

Love, Joe

* Especially so as to let me know where to send "Brain Damage" cover.

1970, 664 6th Avenue, New York City[4]

Dear Larry __

Good to hear from you. It is always fun (and impossible) to try and imagine what people's parents are like. <u>Your</u> parents I absolutely cannot visualize. London <u>does</u> sound great.[5] I always suspected that all backyards in England were full of roses. I've never been there, you know. I don't know why I am only writing on every other line (will stop). I seem to have some sort of a cover block. No cover designs I do please me. I am enclosing one that I think is too silly so if you want to have somebody else do one don't hesitate to do so.

(I'm not just being nice)

I don't know what's wrong with me right now, but something is. My eyes and head and hand don't get together as they should (for work).

(scattered)

What I seem to be able to do best these days is read. I'm doing tons of that.

Today started out very bland but is turning into somewhat of a number (beautiful and sunny).

I just can't seem to write a poem (<u>have</u> been trying).

I <u>have</u> been able to write some prose tho.

Have you <u>really</u> given up smoking? I <u>really</u> have (I think). Six weeks so far.

John Ashbery (I hear) is quite serious about someone named Aladar [Marberger]. Or Alamar. I forget which.

Dial-A-Poem is at "The Museum of Modern Art."

Let me tell you again to use this cover if you want to, but please don't hesitate not to (use it).[6] [see figure 18.1]

I just feel too "sloppy" right now to do anything good. Do you know what I mean?

(Sorry)

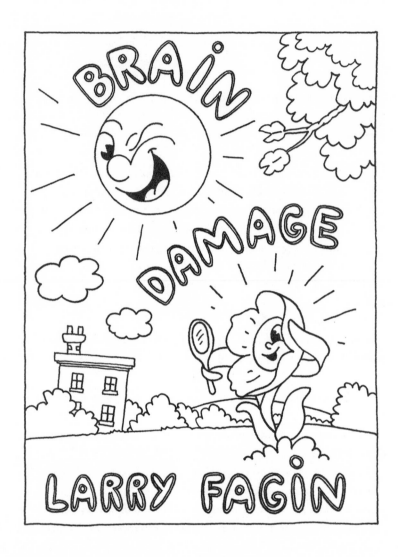

FIGURE 18.1 Draft of a book cover for Larry Fagin's *Brain Damage*, included in the letter of 1970. Brainard to Larry Fagin. Courtesy of the Estate of Larry Fagin.

The other night for supper we had as salad a salad made up of seven different kinds of lettuce all from Kenward's garden (organic).

This afternoon, unless I change my mind, I start a new book: "The Human Body" (info). But what I would really like to do is to get lost in another big novel. But I decided to alternate fact with fiction. So, probably, I will stick to my plan ("The Human Body"). I'm sure that once I get into it it will be very interesting. But it's a big book and as an object rather frightening. "To pick it up" will be a major step.

There are problems with the lake. It just keeps going down. However, there are plans to fix it. When Anne was here last summer she named the lake "Veronica" ("Veronica Lake"). The real problem is that the beavers (who made it) have left it.

Take care.

<u>Do</u> write.

Love, Joe

P.S. Sorry, again, about you know what, but—

But I don't know what.

P.P.S Love and "hello" Joan [Fagin]!

Dear Larry ___

I <u>really</u> don't think this cover is right. Hope you will either use the old one or dig up something else.

(?)

Love, Joe

19

DEAR BERNADETTE

T he poet, editor, and publisher Bernadette Mayer was a central figure
in the Lower East Side poetry scene in New York City from the late
1960s through the 1990s. She edited or coedited a number of maga-
zines, including *0–9* (with the performance artist Vito Acconci), *Unnatural Acts*,
and *United Artists* magazine and press (with her then-husband Lewis Warsh).
From 1971 through 1974, she led a series of poetry workshops at the Poetry Proj-
ect at St. Mark's Church that included students such as Charles Bernstein, Nick
Piombino, and Hannah Weiner. Mayer also served as director of the Poetry
Project from 1980 through 1984. This brief selection of letters from Brainard to
Mayer stretch from late 1972 through 1992 and show the pleasure Brainard took
in Mayer's writing as well as his often frustrated efforts to provide illustrations
and writing for *United Artists* magazine.

October 15, 1972, 664 6th Avenue, New York City[1]

Dear Bernadette___

I was sorry to miss your reading but I just was not up to a room full of peo-
ple and a room full of words that night.
 For a relatively well-adjusted person I am sometimes surprisingly not.
 Two reports (Ted Greenwald and David Rosenberg) said you were great,
as I bet you were.
 Til next time—
Love, Joe

August 17, 1978, 8 Greene Street, New York City²

Dear Bernadette__

Really nice to hear from you. And, now, to be writing to you again. Which is very much to "see" you again, only in my head : still, in particular. ("Hi!")

It's a beautiful hot day of total-sun, and so I'm out in it with coconut oil and black bathing suit on: a situation I often seem to be writing letters in, clip-board in lap.

I'd love (and thanks for asking) to do a cover for your next book.³ Just send me the manuscript, size and color stipulations, and—if you have any "visions," I'd like to know what they are. (If only as further "info" to work with or against.)

Altho I do do a lot of writing these days, it is pretty raw, and hard for me to go back into, and I don't really feel right trying to get by on "raw energy" these days, as I've done it so much already.

The one piece I do feel pretty good about—"Nothing to Write Home About"—is so close to being a book in itself that something makes me not want to "spill any beans" until I can spill them all at once, so to speak. Although—I admit—it doesn't sound very rational. Except that it is almost a document about writing itself, during a particular period of time, and, therefore, is very much held together by the uncertainties of high-contrast. I feel very good about it. But only as a mole. (I mean _whole_).

Nevertheless, I'd _love_ to be in your magazine and will try that—using that—to help me "get my shit together," as the saying goes.

As wet as a wet mop—(it's _very_ hot out today)—now seems to call for a dip in the lake. Or, at least, a good cover-up for "no news." Or, at least, as a relatively graceful way of signing off. Though I suppose my explanations have blown it.

Well—tho brief—surely a "yes" and "maybe" that borders on "probably" is better than last year—no?

I miss you.

And I miss Lewis.

Give my love to him for me, O.K.?

Anxious to read your book. And anxious to see what I can come up with for it. Will be here until the middle of Sept., or so.

Speaking of which—(school)—I know just how you feel. Fall always gives me butterflies too. Which, of course, I thrive on.

Til again soon—

<u>"OH BOY!"</u>

&

<u>"LOVE"</u>

Joe

November 25, 1978, Calais, Vermont[4]

Dear Bernadette

Thank you for your very "up" letter of several weeks ago, which made me feel good, a lot better about the cover, and glad to share in your feeling so "up." And too (thanks) for your most recent postcard about sending works for magazines. Though hardly the point, I feel very flattered.

But, really, you misunderstand me here : I need no inducement. I just need the work. Which, though I've been writing a lot, I just haven't got. The trouble being that I have trouble going back into things to "finish" them. And so I have lots of words on lots of paper, but not much "product" yet. (Which is rather driving <u>me</u> up to the wall too ((too?)) As. well, it's just rather frustrating, I guess).

I would say that <u>surely</u> I can send you a big batch for the next issue but, having said that before, I hesitate.

I guess what it all boils down to is that I'm much more demanding than I used to be. It seems to me I've already "tossed off" so much work—and so much of it seems to me bad—that I, now, ought to be more careful and certain and exacting and/or what have it [*sic*].

At any rate—am up in Vermont for Thanksgiving, which is today. Made a pumpkin pie. And am to "dress" the turkey every hour or so : or, no, I believe the word is "base." At any rate—though usually a great appreciator of the out-of-doors, I really find it rather dreary and depressing this time around: so <u>very</u> washed-out & naked! As though just waiting for some snow to fall.

Kenward works mostly on his new musical "Lola."

And I go back to what now seems "real life" on Saturday.

Well—hope you all are having a happy and thankful day.

My love to Lewis.

And my apologies (I would <u>love</u> to flood you with great works!) And <u>love to you</u>

Joe

P.S. Altho one good day could do it (give me enough to send) so—should it occur, will instantly send, in case of making this, or next issue.

May 20, 1989, 8 Greene Street, New York City[5]

Dear Bernadette,

Just want you to know that I loved reading the sonnets.[6] And that I <u>admire</u> you tremendously. A deep bow from the waist.
Love, Joe

March 1, 1991, 8 Greene Street, New York City[7]

Dear Bernadette,

<u>Loved</u> "The Formal Field of Kissing" : <u>thank you</u>![8]
Love, Joe

July 1992, Calais, Vermont[9]

Dear Bernadette,

Actually, I've already read "The Formal Field of Kissing"—(so easy to read!)—and I liked it a lot. And/so it's real nice to have a special copy. Thank you!

But I hope you don't think. just because I. that that means. anything.

What's <u>really</u> hard for me is Alice's new poems with all the quotation marks.[10] (Did you and her make up?) I'm so out of it.

What's new isn't much. Hardly seems like summer yet really, so few sunny days. (N.Y.C. too?)

7:00 in the morning. (!) Sunday. And that means eggs. A cheese omelet. Whole wheat toast. With scuppernong jelly. (You got me ((?)) but it tastes good.) And—always—a tall glass of fresh orange juice.

And now—soon—back to the latest Lawrence Block : The Continuing Saga of an X-Cop Who's Now in A.A.

<u>All best</u>!
<u>Love</u>, Joe

1.

DEAR JOANNE —

GOOD TO HEAR FROM YOU
BACK SO FAST. WHAT SORT OF
A BOOK IS IT YOU'RE DOING
WITH GORDON? THIS NO VERY
AMAZING POEM (ENCLOSED) I
FOUND IN THE STREET THIS
MORNING, WHICH, SOMEHOW, I
DO FIND AMAZING : TO FIND
A POEM IN THE STREET.
AT ANY RATE, IT WILL MAKE
THIS LETTER SEEM FATTER,
AS I REALLY HAVEN'T
MUCH TO SAY TODAY
(NO "NEWS") EXCEPT
THAT IT IS

FIGURE 20.1 Page from a 1975 letter, Brainard to Joanne Kyger.

DEAR JOANNE

"Everyone said I was going to love Joanne Kyger and I do, <u>I do</u>!," Brainard enthused in his book *Bolinas Journal*. The poet Joanne Kyger was immersed in the Beat Generation milieu of California. At the time of her correspondence with Brainard, she was living in Bolinas alongside other writers and editors, including Donald Allen, Robert and Bobbie Creeley, and Bill Berkson. Brainard first met Kyger in Bolinas in the summer of 1971, and the two ended up having something vaguely resembling a fling that grew into a long friendship and correspondence.[1] The letters included here are from the summer of 1973 through 1975. They are filled with funny gossip, requests for pep pills, and updates about Brainard's life in Vermont and New York City. They are also peppered with delightful sentences that read like aphorisms or Zen riddles. Take two terrific lines addressing Kyger's umbrage at Brainard's referring to her in an earlier letter as snake-like: "I suppose what I meant is that snakes are certainly as sweet as life itself, in terms of being a snake. But to us they must at times be regarded as an enemy of sorts."[2]

Summer 1973, Calais, Vermont

Dear Joanne __

I guess our letters have crossed in the mails.

Thank you for the beautiful drawings. And as always, for your words.

A letter received from you is always saved until last, with, often, a fresh cup of coffee. Of which I have just finished. Now how's that for a fast reply?

[Simple pen drawing of two trees by a stream.]

That / this drawing of two trees by a stream is, I fear, an indication that I really haven't much to say today. (Especially as I wrote you only two days again)

"Wrote you": sounds slightly obscene, don't you think?

The apple blossoms are gone. The lilacs: gone. Dandelions. And some tall yellow flowers. And in their place are, just beginning, buttercups and devil's paint brushes.

Speaking of which (paint brushes) I just this morning moved all my stuff down to the new studio from the big upstairs bedroom. And so tomorrow it gets sworn in!

And the colored T.V. set is now, as of last night, in the basement. I think it was beginning to do funny things to my eyes. And also, after a day of work, I haven't enough discipline left to resist watching it. And watching it, tho not a bore, is, I suspect, a bore when compared to what one might be doing if not watching it. And so I feel good that that temptation is now out of the way.

And yesterday I got a chinning bar!

Anne [Waldman's] new book "Life Notes" is out, as dashing and grand as Anne herself.

If you are considering a tattoo, how about considering letting me design one for you? (I assume you want a small one?) Any particulars?

As for what I meant by "sweet as a snake" I'm not sure. (You know, when I write, I really don't use my head much) ((off the top of)) However, now that I am thinking about it, I suppose what I meant is that snakes are certainly as sweet as life itself, in terms of being a snake. But to us they must at times be regarded as an enemy of sorts.

But, no, actually, I meant something a bit more "twisted" than that. (Can't seem to put my finger on it tho)

Perhaps simply that "no harm meant" is a bit beside the point. (Fact)

Oh well _____

(As we walk across a lawn, stepping on an ant, I would hope no not [sic] sweetness to be implied)

Or, to be a bit more brutal, eating a cow.

Glancing at your letter I note that I said "sweet as a nice snake," which seems to confuse the issue somewhat : somewhat to the point that I'd best drop the whole thing.

(I suspect it to be one of those statements which only make sense if instantly excepted [sic], as opposed to giving it a moment's thought : a way language has of being taken which I do believe in)

At any rate—I'm sure it made perfect sense to me as I wrote it or it wouldn't have happened.

(z -z -z -z)

NEW TOPIC PLEASE!

[Nine lines of indecipherable squiggles to indicate shift from discussion of the snake to the "new topic."]

Soon I am going to send you a "Christmas in July" package (for various people) partly because of the incredible rate at which (help!) I seem to accumulate things. And, unless the idea turns you off (or is "impractical") I would like to supply wine, and have it be a party.

("Impractical," I mean, if perhaps some people are not on good terms with each other) ((?)) Perhaps (?) My Bolinas vision is a bit romantic. (?)

But since I am not with you all there, I would love to do something as tho I was.

A postcard from Anne at Cherry Valley, "preparing" the place for a final move up soon.[3]

Kenward got a postcard from John Ashbery saying he'd been to Bolinas. You saw him?

Well, going to stop now as I want to try to finish up the 30 drawings from my Black Sparrow book today.[4] (To be "out" by the end of this month) So—I'll be sending you one soon, but without too much enthusiasm I'm afraid, as by now it is all such old stuff. But it is always a nice relief, I find, to have things printed, and no longer "mine."

So til soon, again, I hope __

Love, Joe

P.S. And my love to Peter [Warshall]!

1973, Calais, Vermont

Dear Joanne__

Your note-letter was nice to receive. Just to hear from you. Just to be reminded.

Hope your Peter problems are not more than problem-problems. (?)

Beautiful day. And I'm out in it for the first day in what seems like ages.

Working very hard, and very well, up until two days ago.

My downfall began with a large painting of milkweeds : those gray-mint green leaves of which can drive one crazy, especially when some have sun shining through them (where yellow comes in) and so my attentions all zeroed in on color, and ended up with mush.

Much the same went yesterday with a lobster. (On which I painted for eleven solid hours : a real "trip" I assure you.

But (oh, hum) I guess I learned a lot.

About lobsters.

About the many oranges in orange.

And as always, just about paint.

However, I have some real beauties of Whippoorwill, so good they are almost scary.

My book is out, and looks good, tho rather too "official" for most of the works, which are of a more jack-off nature.[5] The book covers the Vermont summer after Bolinas, and the following N.Y.C. fall, winter, and spring. (What I thought this information was going to "explain" I have now forgotten) At any rate—one will be in your post box soon.

Kenward just came over with his first tomato! A bite of which was very good. He has two gardens this year. And, upon finding out that I am writing to you, says "hello!"

Reading now "Queen of the Head Hunters" by Sylvia Brooke : the last Ranee of Sarawak. Not terribly good, really, but no autobiography (so far!) is bad to me.

The party package is taking so long to arrive because it hasn't even left yet. My tendency to get carried away is getting carried away. I suppose everything must end up having to be a compromise. Thank god for time, or nothing would ever get "done."

Well—this, too, just started out to be a "reminder of us" note—and so I haven't done too badly, yes?

Hope you'll feel like writing again soon.

Til then,

Love, Joe

P.S. I hesitate to ask you this, tho I don't know why I should, and so I I am—should you be in the position of knowing anyone who sells "ups" would you get some for me? (Price no issue) In my mind I rather seem to think you don't approve. (?) True, they certainly aren't good for you (?) but— well, of course, it's a matter of what you want and right now I just want to work as hard and "close" as possible, and I never overdo it for very long periods of time because, actually, I take rather good care of myself. Tho I seriously doubt that you know many pushers, just thought I'd give it a try (nothing to lose) and it certainly is making this letter a lot longer! (And only six or seven more weeks of being able to take advantage of being here!)

Well, to end on a less desperate note _____

The outside of the house is going to start getting painted tomorrow.
The button on my new Polaroid broke.
Basic words from Anne in Cherry Valley seems to be "too crowded." (People)
Hope your travels went well.
Wish you were here, and I really do.

Love, Joe

January 1975, 8 Greene Street, New York City

Dear Joanne__

It was such a very nice treat to receive your book, which I <u>love</u>.

After your terrific works in "Z Z Z"—plus new book to boot—I am definitely to be counted upon as one of your biggest fans.[6]

And I really do mean that.

Also the "Joe Toe" sign—I thank you for that too. It is leaning up against my bamboo suitcase right next to my bed. So, we encounter each other often.

As seems to be the general trend, these have been hard days. The strange part is "Why?" Don't know, how, in this area, is Bolinas holding up? And more importantly, <u>you</u>?

Well, I'm working a lot. (Painting) And that's about it. Cityscapes. Soho roof tops. Lots of skies. Mainly concerned (or so it seems) with color. Color in terms of weather, and time of day. (Architecturally-wise, Gordon [Baldwin] would cringe) As I too am beginning to do over the word "architecturally" : just doesn't seem quite right.

Been going to lots of rehearsals for a ballet being made from "I Remember" (composed by Juan Antonio of the Louis Falco Company) for which I'm afraid I didn't say "no" to doing sets and costumes for to. Basically, I see no reason for words with dance (another distraction) but—well, I'll give you a full report soon. (Opens Jan. 22nd)[7]

Also opening soon, this week, are two shows I'm in. One a group show of "Drawings for Books," and another group show of works based on the theme "The Condition of the Tie Today" (can you believe such desperation?)[8] For which I did a totally obscene collage of a giant dick hanging out of a T.V. set Nancy is innocently watching.

Most successful, of late, is a painting of a snowing night with a bright orange sky. Pollution-orange, but beautiful.

Christmas and New Year's were both extremely quiet.

I go baring [*sic*] every almost every night, almost every night unsuc-
cessfully. I aim too high. That must be the problem. And so I can't really
complain, not really.

Kenward is semi-fine, working on new libretto.

Maxine [Groffsky], happier as a literary agent.

Gray dribbly day.

Finally finished Gide's journals, which I hated. Or, rather, didn't espe-
cially find interesting, inspiring, or what have you.

And now—Balzac's "The Chouans." And I always love Balzac.

Again—reading you a total pleasure!—and so thank you again.

My love to Peter.

My love to you,

Joe

P.S. will you write soon?

1975, 8 Greene Street, New York City

Dear Joanne __

Good to hear from you (thank you) and thank you for beautiful Little Red
Riding Hood card. Not much news on this end except that Bill is here,
and Lynn [O'Hare], which is great, except that I haven't seen them much
yet. And work : I'm very much into oils now, at last. And rain: we've been
having tons of rain. Anne and Kenward have just closed in a drag show I
wish you could have seen.[9] And as always I think about you a lot. Except
for being a bit zapped today from a late party Marisol [Escobar] gave
after her opening last night I'm fine. And you? And Peter? And how was
Mexico? This summer will be Vermont again, and am looking forward to
that : to not being in the city, to being in Vermont, and to being (I hope) "a
landscape painter." And so—along with many little ups and downs—this
is where I stand now / how I am / etc. Only after a year of so many tiny
pointless "affairs" (hate that word) I feel—well, I feel older : which is a thing
I value not one iota. (Or is it "ioda"?) I am almost beginning to think that
"truth" is (in relation to living a life) a bit destructive. But, of course, these
are just words. Writing-wise I've been editing and shaping up my "New York
City Year" journal, which will end (finito) as of Vermont. And writing a
long prose piece called "I Believe," which is an attempt at finding out what
I believe in, which, unfortunately, boils down to not very much.[10] (Right

now what I believe in most in [*sic*] <u>you</u>) And, of course, I believe very much
in right now: eternal "right now." (This letter is getting pretty heavy, yes?
Well, it's all your fault. I began this letter feeling as bland as ping pong. But
now that suddenly you are "with" me—I hope that things are good with
you. And that you will write me and let me know soon. In fact, why not as
soon as you have finished reading this letter? Those times in between, they
are depressing to me right now. And so <u>please</u> do, O.K.? Very important)
My faith in "asking" needs a boosting. Well—running out of words.

 I love you and need you, regardless.

 <u>Please write to me right back</u>!

Love, Joe

Circa 1975, 8 Greene Street, New York City

Dear Joanne __

Good to hear from you back so fast. What sort of a book is it you're
doing with Gordon? This not very amazing poem (enclosed) I found in
the street this morning, which, somehow, I <u>do</u> find amazing : to find a
poem in the street. At any rate, it will make this letter seem fatter, as I
really haven't much to say today (no "news") except that it <u>is</u> a beautiful
(sun!) day. Most of which I've been spending on a "Penguin" anthology
cover, and tucking things away for summer, which is more work than you
might think, as I've become rather messy of late. Bill has given two terrific
readings of which one last night was especially terrific : clear. And not one
bit boring as, alas, so many readings, regardless of how good they are, are.
And so next time you write to me (let's write a lot, OK?) write to me in
Vermont: c/o Elmslie, Calais, VT. 05648. In fact (everyone loves letters)
I have always wanted to write a letter book with someone, and if the idea
appeals to you, maybe this summer could be "our" book? I can't think of a
more pleasant way to do a book (I'll stoop to anything for mail) and you
and I, let's face it, are so terrific, and so different too from each other, that,
well—we couldn't miss. (I suppose it's a "cheap" idea, but I have no qualms
with that if you don't). One last thing I have to finish before Vermont
is a mashed potato recipe and drawing for an "Artist's Cook Book" the
Museum of Modern Art is doing. Kenward has been wearing the shirt you
sent him around a lot. I wish I was the sort of person who could just jump
[on] a plane and all of a sudden see you, which is what writing to you
often makes me wish I was : that sort of person. Actually, I like to think

that I <u>am</u> that sort of person, but—(but "but" is more accurate, I fear, than "I like to think") and so—

LET'S DO A BOOK!

(Or would writing to me knowing that it would be for other people too make you nervous?) If so, I would suspect so only at first. Well—I guess that's about it. Just finished "The Eustace Diamonds," which I regret to have finished (Trollope) and so I hope to be hearing from you again soon, yes? Love, Joe

DEAR MICHAEL —

 REAL GOOD TO HEAR FROM YOU.

 HAPPY FOR YOU HAVING QUIT

YOUR JOB.

 AND — AS FOR BEWG AN ACTOR —

IT'S A VERY EXCITING IDEA. (THO I

DON'T ~~SHIT~~ ENVY YOU THE SHIT YOU'LL

PROBABLY HAVE TO PUT UP WITH.)

NEVER - THE -LESS , IT'S VERY BRAVE

OF YOU. YOU'LL BE THE ENVY

OF THE GANG , ENCLUDING ME.

SO — GOOD LUCK!

FIGURE 21.1 Page from the August 1978 letter, Brainard to Michael Lally, courtesy of Michael Lally.

21

DEAR MICHAEL

The actor and poet Michael Lally became a friend and lover of
Brainard's in the early 1970s. Much of the early correspondence
is practically pornographic in its details, though—this being
Brainard—the porn is (slurp) somehow always winsome. Covering a period
from early 1973 to 1993, the tone of Brainard's letters adapts with great sen-
sitivity to the changing circumstances of their relationship. The final short
postcard Brainard sent Lally in 1993, reporting on an AIDS-related stomach
condition without actually naming the cause of the illness, is heartbreaking in
its reticence.

The last word goes to Lally, who recalls, "Joe and I were lovers on and off over
a period of around a decade from earlier '70s to early '80s mostly in between var-
ious women I lived with and other men, but the main correspondence was when
I was still living in DC before I moved back to NYC in spring of '75. . . . We spent
a lot of time together just hanging at his place(s) and I look back on that now and
clearly see he was one of the loves of my life, and wish I had made that clearer to
him . . . although maybe I did."[1]

March 16, 1973, 664 6th Avenue, New York City

Dear Michael __

Sorry I haven't written sooner but I've been away. (Paris, Nice, and Sicily)
All of which was great but—I'm glad to be back too.
 Also sorry that you didn't drop by. Well—maybe next time?
 And thank you for your very full and (slurp) sexy letter.

Being, of course, always on the look-out for sex, and possibly more—and being somewhat of a romantic, I suppose—

Well, what I mean is—look me up in a book found most everywhere called "Mug Shots" (my picture) and see what you think.

And how about a snap of you? (Etc.)

Which is not to say that sex is everything, but—shore [*sic*] is nice!

And I've yet to meet anyone "through the mail," which is an idea that appeals to me, for some probably perverse reason. (<u>Wonderfully</u> perverse tho perhaps)

At any rate—your letter made me feel very good, as did your phone call, and I thank you.

Til soon, I hope—

Love, Joe

May 15, 1977, 8 Greene Street, New York City

Dear Michael:

Love my book! Thank you. (Kiss-Kiss) ((Suck-Suck))

But you know—aside from it all—there is a problem.

(Tho way out there. Existing on its own.)

That what we both really need—and therefore want—is our confidence (ego, or what have you) built up.

Which goes for making contact hard to get beyond bumping up against one another.

(Which is not at all bad ((slurp)) but somewhat limited)

Or so I feel.

(Assuming a lot, I admit.)

Wish I could right now spread my legs a fraction, just enough to still keep your head tightly held down in my thighs, your mouth all the way down tightly around the shaft of my dick, filling up the hollow of your throat. Letting it throb around. Til your lips slowly glide up to and around my hot red head : driving me bananas it's so "on end." And feeling it feel so big. And feeling you want it so bad. A hot load and a half I'm not about to give you just yet.

See what I mean?

I'm power mad!

(Still—it <u>is</u> what naturally came to mind.)

The living proof of which is poking its head out of a convenient hole I just happen to have in the crotch of my jeans I'm wearing.

Well—just wanted to thank you for the book, let you though [*sic*] what I thought about our current compatibility, and to write you a turn on.

I am left with the feeling that maybe one would have been enough.

But "which?"—which is what my dick is already deciding.

Too late tho.

Til next time.

<u>Love</u>, Joe

June 14, 1977, Calais, Vermont

Dear Michael __

Up above the house where the woods begin is where I'm at. Lounging on a nice mixture of grass and soft pine needles. Thinking of you. And so is my dick. (If you get my drift.) Would you believe that in 3 weeks I've only jacked-off 4 times? (What's <u>wrong</u> with me?) Once, however, was rather extraordinary. I came inside my bathing suit, with just a slight bit of exterior ficion frition fricshon (fuck!) fricion [*sic*].² And the stuff came pouring down my left leg onto my foot in one long stream: a bit like being 12 years old again somehow. Tho—why that seems good to me, I don't know: (them were <u>not</u> "the days.") At any rate—I can honestly say that "I wish you were here." Tho rather unlike me (for starters) I wish you were here messing around with my ass hole, with your fingers, until it gets real moist, and drive one in, and way up. And too, I'd like to see you leaning up against a tree with your pants around your legs, both hands on your meat, dying for me to get up and come over and suck it. Just licking and sucking on your head until you can't stand it anymore not to ram it in so we can both feel the whole hot length of it.

(Would you believe only 5 times in 3 weeks?)

Which, however, is not the real reason for such an abrupt ending to the above scene. It was an animal felt by my feet to be considerably larger than an insect as it scurried across them ("FLASH!") into some busy bushes.

Visually a large brown brown [*sic*] streak, I'd almost swear. So I casually got up, and ran into the house.

At any rate—reality aside—I hope you don't feel as tho I skipped town without saying "goodbye."

I always find them embarrassing. (Good-bye's) They lead nowhere. And September is always sooner than one thinks. (Yes?)

Well—I hope you are happy and well and not too hot.

Summer (so far) has been nothing but books: Virginia Woolf, Turgenev, Henry James, Muriel Spark, Thomas Hardy, etc.

"Hello" & love to Miles [Lally].

And to <u>you</u>

Joe

July 6, 1978, Calais, Vermont

Dear Michael __

Just came across this photo of—you know, the track star you remind me of—tho, alas, it's only a side view.[3] (Have you yet to see his cereal commercials on the boob-tube?)[4]—which reminded me of you—which reminded me that I've yet to wish you a (hope you <u>did</u> have a) "Happy Birthday!" Yes? Come September I'll give you a nice straight-on ass shot drawing, remembering your interest shown. I won't forget but—if slow in doing so—<u>do</u> remind me—O.K.? (I already know the one : the body in sepia, the sheets in gray.) Well—how <u>are</u> you? (I'm fishing for mail.) Me : I've got a tan already, more weight already, and am already feeling more "up" to fall : i.e., the Big Apple. And—so country-horny again! (Will resist the temptation to elaborate, however.) Tho I don't imagine Rain [Worthington] would care : she knows we like to flirt, doesn't she? ("Hello" Rain!) And Miles too. Last time I saw him he seemed very much on his way towards being a totally "different" person. God how well I remember being of that age : so "different" every day. (For some reason—as you may have noticed—I find it awfully hard to use that word "different" without quotes.) Not very "commital" [*sic*] of me, I guess. At any rate—as you may also have noticed—I've very little news. I make frequent attempts at painting and/or writing but, tho the desire is strong, the stamina is weak. (I.e., I peter out.) All of which, actually, has been going on for quite some time and IS DRIVING ME UP THE WALL! Otherwise, however, I feel fine—and perhaps even dandy.

If you happen upon any form or procedure in which to do a written summer collaboration via the United States post office—and if it appeals to your current state of mind—it does to mine, suddenly. (A play? A correspondence? A. . . . A. . . . A novel?)

I suppose I am rather selfishly thinking that perhaps the continuous "feedback" might help me sustain something.

Also, tho I already know it's going to sound rather dumb—I really do like you a lot. And that's a turn-on.

Well—it's been nice "talking" to you. And visa-versa [*sic*] would be real (hint-hint) nice.

Take care. And <u>love</u>, Joe

August 1978, Calais, Vermont

Dear Michael __

Real good to hear from you.

Happy for you having quit your job.

And—as for being an actor—it's a very exciting idea. (Tho I don't envy you the shit you'll probably have to put up with.)

Never-the-less, it's very brave of you. You'll be the envy of the gang, including me. So—<u>good luck</u>!

Me today—I'm all "oiled up," as letter stains will no doubt prove—out in the sun (tho already as brown as a dingle-berry, if you'll pardon the expression) : all very "as usual" except for a <u>blue</u> bathing suit, for a change. (Well . . . a mini-step in the right direction.) 10:30 in the morning. On my second glass of ice coffee. It's going to be a beautiful hot day today. Tho Vermont weather is often full of radical changes.

Speaking of which (changes) here's a weird one for you : my most realistic "radical-change" fantasy of late is to become a writer!

Of a sudden, you inspire me to grander heights however. Tho yet to be mentally materialized.

Which is certainly not to imply that I regard your desire to be an actor as "just a fantasy." (For starters—I would never regard a fantasy as a "just.")

What I wouldn't give for a few more of these days!

Am still writing quite a lot. Tho painting none.

Speaking of which (writing) it would be a big help to me in the general area of motivation plus fantasy if I could at this point think in terms of a manuscript, if perhaps small. But am so out of touch right now. But—do <u>you</u> know of any press that might be interested?

Thanks a lot, not by the way, for the encouraging tone towards me in your letter. Only thing tho is that—you see—my behavior of the past few years is really <u>not</u> the way I am, to me. Tho perhaps I'm only kidding myself. But—at any rate—it's very generous of you except [*sic*] it all, regardless.

A play I have always wanted to see is (curtain rises) the brick wall of an apartment house from the outside : I love the kind of focus seeing into a room thru a window carries with it—don't you) [*sic*] as much as I also like multiple stories going on at once. Perhaps interrelating, perhaps not. (Ring any bells?)

By the by—you could always get a month or two's rent out of that city-scape of mine you have—so if you ever need to sell it, don't hesitate : (I'll help you.) In fact, at most any time I'm good for a hundred or two, should the need arise. So—you can always count on an ounce of security from me. (Tho I'll warn you in advance that I'm rather selfish about loaning money: I won't. I only like to give it.) So <u>do</u> take advantage of me when and if you need to—O.K.?

(Boy Scout's honor?)

Well—for "no news"—five pages ain't bad, is it?

Thanks again for good letter.

Again soon would be nice but—if not—September in the flesh for sure!

<u>Love</u>, Joe

January 1982, 8 Greene Street, New York City

Dear Michael,

Bad news is that I simply can't do your cover. Really I have tried. But now I am afraid of not being able to come across, and of holding up (delaying) your book.

Needless to say, this is not the way I would have it.

But it's very hard for me to work at all these days. And to do anything that requires a readily available style has proved to be simply impossible. Out of reach. (Etc.)

But—gee—I really am sorry. As I would really like to do it, if but <u>for</u> you.

My only comfort—(thank you)—is that I trust you to understand.

What <u>I</u> think would make a great cover is that picture of you on "Little Caesar"—printed in blue instead of black) [*sic*] with type underneath.[5] Simple and glamourous. No?

That suggestion is the best I can do.

Sorry.

<u>Love</u>, Joe

P.S. Kisses for Penny [Milford].

September 21, 1993, Calais, Vermont

Dear Michael,

Nice surprise—and great treat—to hear from you. I think of you often too, and wonder how you are. <u>Not</u> up to a real letter right now : weird stomach condition, which hopefully a minor operation next week will fix. Til then, I'm pretty much horizontal. In Vermont until mid-October. And no real news. As always, <u>Love</u>, Joe
P.S. <u>All best!</u>

P.S. HOW'S ABOUT LETTING ME KNOW
THE SIZE OF THAT PANSY DRAWING
AND I'LL SEND YOU A FEW MORE:
SIMPLY A MATTER OF MY SENSE
OF ORDER ‖(THE SIZE PART) WHICH
I CAN FREELY DROP IF I DON'T
HEAR FROM YOU.

FIGURE 22.1 Page from the letter of March 12, 1975, Brainard to Robert Butts.

22

DEAR ROBERT

R obert Butts played an outsize role in Brainard's life in the 1970s and
'80s. With no connection to any art or literary scene, Butts "had
for years been an ardent collector of Brainardiana—manuscripts,
letters, magazines, books, drawings, collages, paintings—anything he could
afford."[1] In 1985, Butts donated almost his entire collection of "Brainardiana" to
the Mandeville Special Collections Library at the University of California, San
Diego, adding to and cataloguing the collection as the years went by.

Very little, however, is known about Butts. I asked librarians who worked with
him; I asked Ron Padgett; I asked a number of other people close to Brainard
about their knowledge of Butts's background. No one knew much about him
beyond the fact that he was a shy gay man living in the suburbs of Los Angeles
who, when pressed, would variously claim to be a liquor store owner, an aspiring
actor, a songwriter, and so forth. Even the internet came up blank on Butts. All
the more charming, then, to witness the affection and friendship Brainard offered
him. These letters find Brainard advising his superfan on gay dating etiquette, rec-
ommending good books to read, and reflecting on his own and others' art practice.
Generosity, playfulness, and intelligence shine brightly in this correspondence.

March 12, 1975, 8 Greene Street, New York City[2]

Dear Robert—

Welcome to your new home! Hope it's good to you.

Rain again today: my second day of being 33. Which has been consider-
ably improved by the arrival of your (<u>my</u>!) Japanese print designs. Both of
which (the fact and the effect) I thank you very much for.

And speaking of "thank you"—better hold on to your hat—only problem is where to begin......

The unfinished miniature is absolutely breathtaking and extremely precious (dear, afraid I'm going to use up my whole vocabulary too soon)—extremely precious, especially so in how accurately it appears to have "crystalized" a kind of moment very much forever gone. Which is not why I like it so much (the "gone" part), it is the "crystallized" part I like. Sweet, too, is that it remains unfinished : or, rather, that it is "finished" unfinished.

I am wondering if, like traveling portrait painters (early American semi-primitive) "you" picked a finished background and "you" when where filled in [sic]?

And—if it is American or English? (Feels American to me.) Tho nothing could surprise me less than to be wrong.

And Goya etching no. two I, of course, love very much too. What kills me so about Goya (passion aside) is a slightly crude (almost primitive) element to his extreme sophistication : a thing Alex Katz has too, yes?

The two books I (thank God!) can't say much about yet, as I've yet to read them.

Altho my taste in Japanese prints is probably underdeveloped—I am completely crazy about the ones you sent (to say nothing of a bit envious of such style and patience) : especially so I love the almost invisible bird with long gray beak and legs on tree branch. The two pigeons. The mouse eating a sort of melon fruit. The laughing Buddha (I assume) on big rock. And— my most favorite—the frog's head behind the giant stream of green water falling from the big rock over-hanging a stream.

(Is there any way you know of to frame Japanese prints without giving them too much "weight," other than a contemporary version of "nothing" : i.e. Kulicke slip frames?)

As these prints seem to me more heavily aware of style as style (as opposed to a spiritual "school" of thought / awakeness / etc.) I am assuming them to be fairly recent, yes?

And so—well—

THANK YOU VERY MUCH FOR ALL!!

You completely made my birthday.

(The price of which is that now you must tell me yours.)

Have gone completely bananas over trying to finish that self-portrait I've been working on for several years now. Working 12 to 15 hours a day solid now for two weeks, at least, primarily just on it. Much of which has been

doing very analytical drawing for. Which has resulted in 5 hours a night in sleep. Which has resulted in that I am hardly a human being any more. In fact—one more week of such focus and I honestly think I would go over the edge. However, knowing this, I won't.

Sex—(not to change the subject too abruptly, but—)—(God, I'm turning into a dash freak!—)—ought, it seems to me to be pretty much an activity of inspiration, relying heavily, of course, upon the "room" the given situation allows. Either that or, if one certain person totally infatuates you, you can try to set things up. Either that, or, if you're just plain horny, you can try to find another human being who is so too, and try to work it out/off with each other.

As you don't right now totally infatuate me sexually in my head and you not be just a body [sic], the only possibility would be the first.

Hesitate a bit to mention this at all (but only because I don't want to seem to be stringing you along, dangling a possibility) but then—probably I am.

Not much point pretending I don't enjoy being found sexy.

The (a) dis-like of "no."

And the whore/hustler in me is a bit more developed than hopefully in most people.

And that you are a virgin doesn't help matters any because there is no way then that it could be as casual as—whatever.

If you would want to tell me quite frankly what some of your sexual fantasies are I have a feeling that in one way or another that might be good.

As for me—am I [sic] practically <u>turning</u> into a virgin. Tho most every night I go baring [sic] before sleep it seems that I am rarely "up" enough to take the overwhelming odds of rejection. (And, alas, I never made out unless <u>I</u> take the initiative)

Turning into a pretty long letter, yes?

I visualize your "role" as the lonely surfer very similar to mine as the lonely diner. (Restaurants) It's all very silly (to say nothing of unfruitful) and yet it is somehow fun tho, yes? Or, if not fun, at least involving. And I suspect more necessary to contemporary survival than it might logically seem.

Got a few tricks up my sleeve to surprise you with soon.

One minor one of which is enclosed.*

To help fatten out a big
<div align="center"><u>THANK YOU!</u></div>

<div align="center">(again)</div>

With hopes that you are well, like new work, new home, and maybe somewhat new life? I remain

Yours truly,

Joe

*Original Ernie Bushmiller "Nancy" drawing

P.S. How's about letting me know the size of that pansy drawing and I'll send you a few more: simply a matter of my sense of order (the size part) which I can freely drop if I don't hear from you.

March 18–20, 1975, David's Pot Belly restaurant, 94 Christopher Street; 8 Greene Street, New York City[3]

Dear Robert __

Just ordered a cottage cheese omelet, orange juice, & coffee at the "Pot Belly." Tho 2 in the morning, this is supper. Working <u>so</u> hard (night & day) that it's almost impossible for me to sit down & write, & so—will take advantage of this pause to <u>thank you very much</u> for the muy bonito (bonita?) print, which I do especially love. And especially so too, the rainbow.

Dear Robert __

Two days and two nights later (around two or so) I'm rather completely zonked, but, I'm determined to finish this "letter," & get it off to you tomorrow morning.

Well now—you know it's all <u>your</u> fault—this mad work rush. It all started with those things I made for your birthday. Then, upon realizing how hard I am upon myself with oils ("realism") I decided to fuck it for awhile and <u>have fun</u>!

So—I am. Tho I'm working harder than ever. But, at least, am getting a lot of satisfaction out of it: ("it" being everything from postcards, to miniature food, to miniature mail, miniature rooms, crackers, cupcakes, T.V. sets (things inside T.V. sets) ((and things inside of what's inside . . . etc.)) So— get the picture? (And also more inside matchbook works. Favorite of which, so far is one I did today of a theatre inside M.B.C.): 3-D![4]

At any rate—so now I am up to about 16 hours a day of solid work. I'm a mess, my place is a mess, and I'm totally exhausted, but <u>am having a ball</u>!

All of which, I suppose, is in way of explaining why I am so late in writing to thank you very much for the beautiful print. Neither of which ("thank you" or "beautiful" seem tonight to carry enough weight) ((importance)) but—I guess—the best I can do for now.

Hope you are well.

Hope school is good. (I.e., involving.)

Hope you won't be dead by the time your pansies arrive.

Love, Joe

March 10, 1978, 8 Greene Street, New York City[5]

Dear Robert__

Thanks so much for the beautiful flowers! : (as in "wow!") They certainly perked up my day.

Am going out tonight for a change : dinner party at John Ashbery's with special guest star John-Boy [Richard Thomas] (of T.V. fame) who just happens to be a poet too (tho not too good, I gather) but a big fan of J. A.'s.

And tomorrow night Kenward is giving me a birthday party I wish you were here to attend.

(Long pause.)

Due to total lack of "news."

Tho I'm not painting again yet, I am finally drawing somewhat regularly from models: male & nude. So—a tiny step in the right direction.

And still reading a lot too. Right now "Shirley," by Charlotte Bronte. And, just recently, a terrific book on Zen painting, which was/is awfully inspiring.

I've got somewhat together various things to send you, but rather than wait until Monday (post office) for now I'll just enclose this thing from my Clinton show.[6]

Just recently received a French version of "I Remember" written by Georges Perec (of his remembers, not mine) dedicated to me, of course, tho, of course, I can't read a word of it. Very handsomely done tho.

Can't wait to hear about your new sex life. Good and fun, I hope? (Or what have you.) As for me—alas—I've none. My own fault tho, I suppose. (Since I don't go out, making myself "available.") At any rate—

Being neurotic is so new to me I really don't know how to handle it.

Life is certainly full of surprises : which ought to be an optimistic statement enough to be so, I suppose.

(At this point the phone rang & for some mysterious reason I decided to answer it & it was <u>you</u>!)

You sounded nice & "up": my instant fantasy is that the guy you were joking with is <u>the one</u>. (?)

At any rate—thanks again very much for the flowers. And—too—for the phone call. Tho my usual lack of anything to say always embarrasses me (phone-wise), I <u>do</u> appreciate being thought of, <u>always</u>. And so thanks too for that. You're an awfully good friend! Hope I deserve you. (Will try to.)

So til again soon—

Love, Joe

June 20, 1978, Calais, Vermont[7]

Dear Robert__

Out in the sun on another really hot day, covered over in oil as usual : my usual explanation for grease spots, sloppy handwriting, etc.

Well now—I <u>loved</u> your letter. Thanks really ever so much. I feel I know you a whole lot better now, and that's a pleasure.

And thank you especially also for the beautiful lyric : I love it too, and am not even remotely embarrassed, so you ought not to be either.[8] And, aside from just liking it for itself, it's a very generous compliment, and I thank you for that too. Really—you know—any feelings in the realm of the positive ought to be glorified in, and I can't think of a better way than in sharing them—can you? Well, that is how I feel.

And while thanking you, let me thank you also for the money and the little books. Money—well, you know money : i.e., "slurp!" And as for the little books—well, you know I like little books.

Best of everything, however, is your letter, which told me more about you than you've ever done before, and I really do appreciate that.

I think probably you expect too much of your encounters, however. Really, it seems to me that an encounter with another person is an exciting experience in itself, just for having "done" it. Of course some will be disappointing. Some will even probably be distasteful. But—obviously—the more chances you take, the better your chances are. (Of meeting really interesting people, and possibly falling in love, or, at least, having some fun : which is certainly not to be sneezed at—right?) But—of course—if you feel like cooling it for awhile—you ought to cool it for awhile. Just because

that's how you <u>feel</u>. Surely it is the most exciting and demanding way to live by—your feelings—and whenever and however you can "live up to" this, I'd shove all other considerations rapidly aside, and indulge for the pure sake of indulging, and of <u>learning</u> to indulge. Because, as I'm sure you know, it's not all that easy. And I can assure you that nobody needs this advice I'm giving you more than <u>I</u> do.

And—and this is rather important I think—from personal experience I can absolutely guarantee you that the only things one eventually regrets are the things one <u>didn't</u> do.

Sure—you risk fucking up a lot. Falling on your face, etc. Speaking here just for myself tho—it's not really all that bad. In fact, what <u>I</u> find with age is that the more I can allow myself to appear foolish, the more I can actually admire myself. (Which is certainly not to say that I am able to allow myself this "luxury" very often—alas.) But—hopefully—someday. It is a quality I admire very much in John Ashbery. (Tho—indeed—not all do.) And I also <u>appreciate</u> it of him, because it tends to lend you the same liberty. That of being quite frankly and openly "human"—a great relief!

All of which is just to say that I'm delighted with your efforts—and inspired by them too. And I <u>know</u> they are forever worth making, hard tho they may be, and usually are.

So—if you're not patting yourself on the back a bit, let me do so for you.

Your lyric might make me uncomfortable if I thought that your feelings for me made you unhappy, or what have you, but somehow I don't. Tho I don't know why, and then too—feelings are forever changing : I'm just glad and flattered that they are in the area of "strong." Speaking for myself again—I am always grateful for such feelings of my own, regardless of frustrations. And I hope you do too.

I also liked, and thank you for, the photocopies of you : one in particular is already in the process of becoming a "work" which, if goes well, I'll send to you.

The Z Press broadside you spoke of is a poem collaboration done many years ago with Anne Waldman, Lewis Warsh, Kenward, and me. And is on its way to you <u>now</u>.

I asked Ron about the flyer (1956, I think you said) and he said that it <u>was</u> a line from a poem around then, but neither of us can remember it as a flyer. Perhaps it was a collaboration. (?) To be sure tho maybe you ought to send me a Xerox to confirm. As for "style"—you know how flexible I am with that—and especially in terms of collaborating : that often being the point, to "use" in each to expand.

So—that it doesn't seem my "style" of the period wouldn't surprise me at all.

Well now—how I feel now is that I ought to "spill a few beans" for you. But the actual truth of the matter is that life right now for me is pretty "Z-Z-Z" and predictably obvious. My feelings about Kenward are always rather fuzzy and undefinable. That we are <u>very good friends</u> is obvious. Beyond that, I never know for sure myself. (Tho, of course, I love him very much, as <u>the</u> person I <u>know</u> best in the world : and that's a strong tie.) But, otherwise, one's sex life in the country is very much confined to a lot of jacking off, which, of course, is fun too, tho it doesn't leave one with much to "say" about it, other than echoes of "pant-pant" & "splat-splat."

And I can't help but feel that the "drama" in my life over work problems, and those of not liking myself very much right now, could be anything but plain boring, even if they were so "figureoutable" as to be able to write about them.

So I can offer but a small return for now, with lots of affection tho.

And very soon I'll be sending you a portfolio of "visuals" that appeared in a little California magazine called "Little Caesar" : just waiting for my copies to arrive.

Will be here until—say—the middle of Sept., so can I hope maybe to hear from you again in Vermont? Would be nice.

It was fun corresponding to your mother, and hope we'll find reason to keep it up.

(I <u>do</u> wish you wouldn't think of writing a letter as so serious a thing tho : you make me feel "sloppy" about mine, which are obviously never even corrected, much less re-written. But that, I guess, is <u>my</u> problem.)

Well now—(talked-out)—but with promises of a "fuller" letter soon as I'm up to it.

If there are any mysterious areas in my life to you—why not write me a letter of questions to answer. (And I'll do the same to you!)

Til then—

<u>Love you</u>, Joe

December 20, 1978, 8 Greene Street, New York City[9]

Dear Robert __

It was nice talking with you today except that now I'm worried : why are you so mysterious about your illness? And what's this about your <u>having</u> to work? (In which case you oughtn't to be sending me money!) And so I

am confused and too, like I said, worried. So do let me know what's going on, O.K.?

Am writing to you also just to wish you a "Merry Christmas" (and all that stuff) as I'm afraid your Christmas will arrive a bit late. Which won't surprise you by now, I suppose.

I'm feeling rather flustered about trying to do too many different things all at once again. And what with Christmas too, and all. But I just don't seem to have that much control over myself anymore, which is kinda scary. So I'm going to have to <u>try</u> and make some <u>serious</u> New Year's resolutions.

Did I tell you that "Houghton Mifflin" wants to do a book of mine? Excited about having "a real book" out, except that they want the manuscript by mid-January, and that's going to mean a lot of work. But—I'm trying to swing it.

I seem to be being picked up on by the gay world, as there's to be an article about me in "Christopher Street" soon.[10] And an interview in "Gay Sunshine." And I'm going to be in a movie too, about artists and "the gay sensibility," whatever <u>that</u> is. (?)

And too I keep drawing, which is going well up to a point. Up [to] the point of making something "finished." But then maybe—I'm beginning to wonder—a drawing doesn't <u>need</u> that. But still, it seems to me a possibility I would like to be able to carry off. But then I find myself off onto (into) something else, and then going back into an old drawing is hard. Simply what I need is more discipline and patience.

Was looking forward to drawing you, and seeing you, and will be real disappointed if your trip is off. Especially if it would make it easier and less exhausting to you, <u>do</u> plan on staying with me—O.K.?

Having dinner with my little brother tonight. Don't know if I've told you or not but he now lives just around the corner on Broome Street, and works for "Forbes" magazine in the art department. We look quite a bit alike (everyone says) and we get along well.

Right after Christmas I'll be sending you the old Madonna collage I spoke of, the Frank O'Hara collaboration, and the city-scape oil painting, but as for the jewels—I'm just not convinced you really want them—that it's simply be [sic] a favor to me—and tho I do indeed appreciate that—I just won't let you do it. (Sweet of you tho!)

Well now—do take care—and do try to come see me—O.K.?

But til then (I hope) "merry Christmas" (again) and "happy new year"!

Know I think the world of you,

With <u>love</u>, Joe

May 21, 1979, Calais, Vermont[11]

Dear Robert,

Real good to get your letters. Am only so late in responding because I'm up in Vermont already. Where my self-improvement projects are no sugar, no coffee, and daily exercises, and ½ hour meditation. Though too soon to feel much the results yet.

Am delighted with your having quit the liquor store business, especially if, as you say, it has helped you to feel "a sense of value" : though I'm not sure exactly what that means.

Am very excited about our book, which has grown considerably. Which I hope is O.K. with you. (?) As of now it will have 24 pages (still in portfolio form tho) and called "little pictures and some words" : as, in some cases, I have integrated the words into the pictures.[12] Many of which I feel to be the best things I've done in quite awhile—so hope you will too. As I only have 3 more to re-do, they'll be arriving soon. (One is—in keeping your press name—a "B.L.T.")

A word of advice tho—(I refer here to John Giorno)—as a press I think you only ought to do what you personally like—(irreguardless [*sic*] of "good" or "bad")—because a small press is nothing without an individual's taste behind it. So—trust your own taste—O.K.?

Also—(if I was you, which of course I'm not)—I'd beware of committing yourself to too many things too far in advance. Rather—concentrate on one thing at a time. If you get too booked up, it's likely to simply become a chore. And the stimulation of actually getting one thing out, will spur you on more.

And if eventually you find your press profitable intellectually, emotionally, or even financially, I have a biggish project I'd like to toss up in the air as a possibility : the collected collaborations of Kenward & me. We own the copyrights on them all still, and I think it'd be a terrific book, if in the future the idea seems feasible. (Does it ring a bell?) At any rate—I'm sure we could work up something with Anne Waldman too, as the idea appealed to her as she recently zipped through town.

By-the-by, I'll be out in Naropa to give a talk (an "open" lecture) and a reading sometime in August. And am wondering how far away it is from you. . . . (?)

Thank you for the money, though, could you fill me in on what it's for, just to keep the records fairly straight. It will certainly come in handy ($$$) of course.

And as for the show—it sounds terrific to me—and will help in any way I can, of course.

I left the city in such a rush that I'll have to wait until Sept. to get Polaroids of works to you.

The Denver Art Museum is having a poet & painter show this fall, which I'll have some stuff in, which, if not too far away, maybe you can get to.[13] (?) Will fill you in on dates as soon as I know.

Terrific about your N.Y.C. visit with your sister and father, which maybe (?) will cancel out my need to send you photos, so—really—photos only give so much of a clue.

Stephen Sondheim had a heart attack, but survived, and is better now—thank God : (figuratively speaking).

Well—I guess you are ultra busy what with moving and all. But do try to find time to let me know what you think of our book. I think you're going to be mightily pleased with it. Depending upon how "fancy" you want to get, it might even be nice to have the plates tipped in—no? I mentioned it to "Three Lives Bookstore"—where I'll be giving the reading, come late September, and they said they'd like to order at least 25, especially, and if hopefully, it'll be "out" by then. (?) And, of course, I'll be happy to be your east coast distributor, unless you want to handle it yourself. For sure I know that "The Gotham," "The Phoenix," "The Oscar Wilde" & "The Museum of Modern Art" will order copies too. But, I guess it's silly to think about this until it comes out.

Well—running out of things to say.

Keep in touch.

(You know how nice it is to get mail up here in the wilds.)

Oh, before I forget, and looking ahead to the future, Allen Ginsberg and I were talking the other day about we ought to do something together—as we've been meaning to for years. Same thing too occurred, when Robert Creeley recently came through town. Both of which would guarantee money success, as well as artistic, which never hurts.

But—like I said—I hope you'll think not too far ahead. Better to do a thing before planning the next, I think.

And are you ever going to send me a tape of your song to me? I would love to have it.

Well—do take care. Take advantage of this change in your life. Know how fond I am of you.

All my love to you now,

Joe

P.S. And as I seem to be luckily in the position of having a lot of poets who would jump at the chance of working with me—(not to be conceited!)—if there is anyone in particular you're [sic] like to publish let me know, and I'll get the balls rolling. As I do believe your fondness for books is very genuine, if you're really serious about publishing, I think you'd be awfully good at it : and may well be your special "ninch" [sic] in life—don't you think? And—if you're any good at business—it might even turn into a money-making "business." And so I hope that you are, and that it will. (Or am I laying too heavy a trip on you?) You tell me.

Bill Elliott is up here now for two weeks, working with Kenward on the musical version of "City Junket."

You didn't mention if you like autographs or not (?) If so, say yes, as that is one thing I can supply you with "a many." Which would give me pleasure.

P.P.S. And please do give my love to your mother.

August 10, 1979, 8 Greene Street, New York City[14]

Dear Robert__

"Gee golly" and "holy shit!" Thanks tons for the deluge (? : is that a word?) of Chinese cut-outs and photo-chrome greeting cards. If you'll pardon my language, you are a dear.

Believe it or not, I am working on the drawings and little written works to go with them. And Monday I have designated as "post office" day : your fish!

In the meantime tho—thinking of something to send you right now—I am wondering if you like autographs. (I do.) And so—hoping you do too— am sending you two recent ones : Virgil Thomson (who wrote "The Four Saints" with Gertrude Stein, as I'm sure you know—come to think of it) and Ned Rorem. And also a birthday-homage book to Jonathan Williams I have a dumb little drawing in.[15]

Anne Waldman just flew into town, tho I've yet to see her.

Kenward's birthday party was absolutely great, if I do say so myself—as everyone else did.[16] The food was the best in the world—(cost me over a $1000 dollars!)—and the spotlighted platform for birthday homages got lots of use : songs, poems, etc. And little works by me were given out every 15 mins (door prizes!) announced with a bell, and hand delivered to each

winner by Wayne Padgett. (Who won one too, tho I saw him put his name
in the bowl more than once.) Any rate—so many people said it was the best
party they'd ever been to, I was delighted. I <u>did</u> want to do something real
nice for Kenward. And 50 <u>is</u> a major year, I would think.

Well—that's about it for news.

Look for package muy pronto with faith, if possible.

And thank you again for the beautiful cut-outs! (I especially liked the
colored one—the flowers—that are similar to that portfolio you gave me
once—remember?

Love, Joe

P.S. on second thought, will send just autographs now : book will come with
fish.

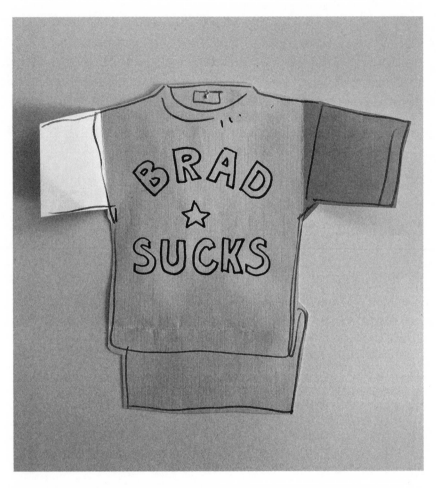

FIGURE 23.1 Image included in the August 13, 1976, letter, Brainard to Brad Gooch, courtesy of Brad Gooch.

DEAR BRAD

The poet, fiction writer, and biographer Brad Gooch met Brainard in New York City in the mid-1970s, an era that he, Giorno, and others describe as "the golden age of promiscuity."[1] Brainard, for all his anxieties about his relationship with Kenward Elmslie and the value (or lack thereof) of his own art, was clearly happy to be part of that golden age. You see it particularly in the second of the two letters included here. Brainard's outrageously pornographic imagination, a side of his personality that he pretty much kept hidden from his "straight" friends, is in full and frank display. It is a joy to find Brainard expressing his desire so freely. It is also great to see Brainard use the occasion of these letters to continue reflecting in his characteristically profound (but ever so light-footed) way about his own artistic practice: "My vision is monumental, but personal as hell."[2]

August 13, 1976, Calais, Vermont

Dear Brad__

Good to hear from you. (Twice!)

And sorry I missed out on answering them both individually.

(Which is not at all to say that I am now up to answering them both together.)

Have been feeling like shit. And today is not too much different.

However—if you can "do it," I can do it. (I think!)

First off—like very much new title. Also, like your "vision" of cover. And will probably in one way or another use it. Tho, often, in the process of doing something, different (un-predictable) new ideas pop up. And, for me,

"gift ideas" are usually the most exciting. What, especially in work-work, one tries to hold out for.[3]

Like what you say about dancing. A pardner [sic] is everything in terms of inspiration. (Faith in flexibility) Lucky is the more you can ride it.

About the boy who doesn't love you as much as you do him—does that mean you and J. J. [Mitchell] are no longer an "item"?

I wish I could have written down some of the many letters I have written in my head to you this past week. Tho some would have taken a lot more gall than I have to have actually sent. (Or perhaps the word is "confidence").

At any rate—much to my own surprise—upon receiving your first of most recent letters—I was trembling like a leaf all day. (Even rubbery knees) All of which was a pleasure in itself. I.e., I lay no heavy trip on you.

(My fantasy life knows no bounds, evidently.)

All of which, I would imagine, is an every-day occurrence for you : the creaming of jeans.

If all this embarrasses you, just chalk it up to flirting. Because I am.

Tho for some reason or another blacks (as a rule) have never turned me on all that much, I do think this enclosed is a big turn on, don't you.

And one can always use an extra pair of socks : (enclosed).

"What do I do all day?" you ask.

Right now I don't do much of nothing (I mean, anything) but this is far from my normal.

"Normal" is mostly work. Until around 4 or 5 P.M. At which time I usually read, or write letters, or go to openings (etc.), or start desperately to try and drum up a dinner date, some night action, etc.

These days in particular I walk around in large circles a lot, either around the house indoors, or around the house outdoors. After awhile you get into a very comfortable sort of trace [sic], and your mind can then wonder [sic] around freely everywhere. Star fantasies. Sex fantasies. Paintings and collages I do in my head. Witty letters. And inventing new and reliving old "spot" moments.

Also reading a bit. A new Black Sparrow collection of Jane Bowles' letters and notebook "fragments." And the re-re-re-reading of her "Two Serious Ladies." It never lets you down.

And too (primarily out of desperation) I decided to try my hand at some serious cooking. A cheese souffle. A quiche Lorraine. And (la-de-da) a Bavarian Cream a L'Orange, which, tho good, didn't quite live up to Julia Childs' description : total-ambrosia.

Am relatively certain that the above paragraph must contain at least 3 miss-spellings [sic] ((right?)) tho I don't suppose this can any longer come as any surprise to you : "sorry" tho, anyway.)

(One thing I really don't like about "age" is how easy it becomes to "use" one's defaults. Tho, indeed, it <u>does</u> make "sense." Alas, a rather over-rated word tho—yes?)

Well now—considering that I literally had to force myself to sit down and write this letter to you—(but only because I kept hoping for a more "up" mood)—I don't think I'm doing so badly.

(Right on.)

Except that. am running out of talk.

Well now—what do <u>you</u> do all day?

My depression, by the way, is only temporary (very much so, I mean) I know. It has a lot to do with Kenward : it takes <u>so</u> many years to get to know somebody that well that—it's a hard thing to give up. And then too—the comfort of someone knowing <u>you</u> so well : a form of security awfully hard to replace. I don't know if this really has anything to do with love or not, but I suspect so. Then too—I think I'm just at a funny age (34)—so "inbe-tween" [*sic*] somehow.

(And to top it off I still secretly think of myself as 18 or so.)

Which just isn't very practical to face reality with : tho from time to time one must.

But, actually, I have little patience with all this baby talk.

(I <u>do</u> make myself count my blessings from time to time.)

And, actually, all that I <u>really</u> want is a gorgeous face, a giant dick, and to be madly in love with someone who is madly in love with me.

(Can you believe it?)

The weather (you see, I <u>am</u> running out of "material") has been total shit: (no sun).

I hope you don't get a job so you can do some modeling for me still, this fall. I think I would be comfortable (comfortable <u>enough</u>) with you, and that's important. (Tho I wouldn't advise you to believe any of that "imper-sonal" stuff for a moment : nude as object, etc.) My vision is monumental, but personal as hell.

Another tall order.

Returning to the city Sept. 1st or so. But maybe I'll be lucky and hear from you again before then, yes?

<u>My love to you,</u>

Joe

P.S. Also enclosing an envelope of (to me) erotica.[4] Forgiving my one tracked [*sic*] mind (please) Hope you will like it.

(Help!: I seem to have started a whole new page : fuck it.)

June 18, 1979, Calais, Vermont

Dear Brad__

Am writing to you without anything to say, but just because it has been a strange and horny day, in which you prominently figure. As Kenward's out of town for a few days, I'm taking advantage of the situation to "Bach it up" : i.e., keep strange hours. And eat junk food—as I am doing right now— (dinner)—a "man pleaser" frozen chicken dinner, with mashed potatoes, peas and carrots, and an apple tart. All of which is delicious, except that I haven't got to the tart yet : but I have faith. At any rate—I've been doing drawings for "Gay Sunshine" all day, and just want to tell you what a help you've been : you down under that table all day, licking and sucking and eating me all over, below my waist. Just how I like you best in my fantasies : cleaning out my asshole, licking my feet, sucking my dick, and hungrily drinking gallons of piss. Your pretty face in my crotch all day. Outrageously "using" you, and abusing you. So—thanks a mint kid—you do it good. Only "news" is that I've given up sugar and coffee, and have taken up exercising and meditation. And have gained 15 pounds already! And am feeling good about myself, and about September. Have given little thought to doing your short story yet tho. But will. I enclose one of many pieces of paper I soaked with piss for you today. And for a major climax, I've got a big zucchini in the oven, which makes for a hot mushy fuck. Will be thinking of you. And I'm so fucky [*sic*] horny, you're really going to get it. I suppose this is a silly letter, and that I ought be be [*sic*] embarrassed, but I'm not. (For one thing, I admire people who dig humiliation—if I may assume that you do.) Well ... (well?) ... that's about it for tonight. Hope things are going well for you. Will write you a more diversified letter soon. And of course you know—I'd love to hear from you, sooner the better. Keep writing those short stories. And please don't think I'm trying to lay a heavy trip on you or anything. Just getting my rocks off. All most fondly, if meanly. Cause you turn me on that way.

 With love,
Joe

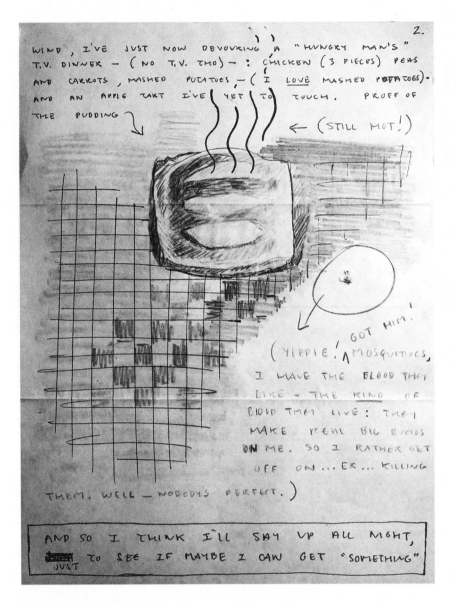

FIGURE 24.1 Page from the June 18–20, 1979, letter, Brainard to Keith McDermott, courtesy of Keith McDermott.

24

DEAR KEITH

B rainard met the actor and writer Keith McDermott through their mutual friend Edmund White at a party Brainard threw for Kenward Elmslie's fiftieth birthday. The two men were immediately attracted to each other, and shortly afterward, Brainard wrote McDermott a letter (postmarked May 21, 1979) that pops with erotic energy.[1]

The letters here show Brainard tripping over himself with delight at how lucky he felt to be connected to this handsome young man whom he suspected could fulfil his desire for all-consuming, obsessive love. This is not to say that Brainard cut off ties with Elmslie. Brainard continued living with him over the summers, with time in New York City devoted to nurturing Brainard's bond with McDermott. Over the years the situation changed; at times Brainard saw Elmslie and McDermott in New York City on alternate days and evenings, and both maintained an open relationship outside the triangle. Whatever the situation, though, McDermott was a major figure in Brainard's life. "I loved him," McDermott writes, "and, against all odds, he went bananas over me."[2]

May 21, 1979, Calais, Vermont

Dear Keith,

(Ah that felt good, writing your name down, for the first time. Thanks a mint, kid. And I <u>do</u> mean it.)

Showered and shaved, my favorite jeans on, late afternoon in Vermont, drinking a Campari and soda, smoking a cigarette, and writing a letter to YOU. Boy do I feel lucky!

Can't tell you how much your address—(a lot)—has been burning a hole in my pants, or . . . er . . . pocket, all this time. Which is actually only a little over a week. Nine days. Of feeling a whole lot different, and a whole lot better.

But let me tell you now—right now—that I'm not about to lay any heavy trip on you. Am just glad and grateful for what you have already given me. Which is a much longer story than I'll probably ever tell you. Except to say that I've had a "thing" for you way before I even knew what you looked like, or anything. Which is pretty weird, really, as I'm a pretty down to earth man.

And then seeing you on stage—such a bright clear light!—only rein-forced my feelings.[3]

And then seeing you at the party—well, it flipped me out so much I can't even recall the experience. Hard as I've tried to savor it, and have savored the few fragments I've been able to "find." Such as your eyes looking directly at me. Your light blue sweat shirt, sleeves pushed up to [the] elbow. And a vague sense of your arms : such clear skin, stretched over the pulsating veins of an animal, alive, I would just so much have liked to touch. And of telling you how pretty you are—how pretty I found you, and find you—and being rather embarrassed for having said it so crudely. And wondering if—as I'm sure everyone must say that to you—it might be boring for you to hear that. (?) Hard as it is for me to imagine that that could be true. And then some-how before I knew it, you were gone.

And then when having dinner with Ed [White] and Chris [Cox]—when Ed told me that you liked me—!!!—well, you have been beautifully on my mind ever since. Though I didn't dare inquire as to what "like" meant, as—for starters—just that in itself was (is) more than enough. Enough to allow me to bravely and sheepishly ask Ed for your address, so I could "send you a post card." Which, in fact, I am doing. (Enclosed) One that I especially like, and especially hope that you will too. It is based on a French myth—similar to our explanation of where our babies come from : the stork—that babies grow in vegetable gardens, most commonly out of heads of lettuce and/or cabbage.

And the only reason I have waited so long in writing to you—although I have been doing it in my head a lot—is that I haven't been feeling too good. Due to a new healthy "thing" I'm on. Due to Anne Waldman—a terrific poet, and one of my very best friends—who recently zipped through town in her usual, but glamorous, manner. Convincing me that I'd feel a lot more "steady" if I'd lay off the tons of sugar and coffee I have always consumed. And so I gave them up. And so for the past week I've been able to do little of anything but sleep and read. Am finally feeling a bit more alert tho. Tho I've yet to experience the promised "high" from having done so. That, plus medi-tating for one hour every morning : in hopes of acquiring a bit more patience. And in hopes too, of simply thinking things out a bit more. As I tend to try

to do everything, all at once. As opposed to being more selective, throwing all my focus and energy into that : a single thing at a time. As, at this point in my life, I do feel the need of that. (I'm a ripe 37, tho not all that ripe.)

At any rate—as I'm sure I told you—and aside from my fixation—I thought you were very good in the play. Would love to have seen you tho, in an earlier version of the play I saw years ago, in which your part was longer, and more integrated with the plot. As, in a recent letter from Don [Bachardy], he said he and Chris now feel was a mistake too: (to have isolated your presence so compactly.) But God—compared to most theatre I see—I thought it was terrific, and was surprised it didn't have at least a tiny run—weren't you?

As much as I'd love to go on and on, I don't really trust myself.

And think I maybe ought to wait until I hopefully hear from you— (wanna pen pal?)—before I. . . . whatever.

One thing first tho—I really have my heart set on this—I hope I can get you over to paint, when I come back come September. As I know you would inspire me—(yes, I believe in inspiration!)—and I really need that. To say nothing of being able to really look at you in the way only painting someone allows. So do think about this—if just for me—will you?

Well—I hope this letter doesn't have too much bullshit in it. Sometimes I don't know anymore. But, if so, it's just because I want to impress you—of course.

I've gained 5 pounds already!

Just want so much to get back to healthy and ambitious and capable of real fun. And you could help me a lot, if you feel like it, by just—in whatever way—responding. And—shit—I'll do <u>anything</u> for you. (Too.)

So—I think before I get mushy, I'll just end abruptly. And cross fingers. <u>THANK YOU!</u>
<div align="center"><u>AND LOTS OF LOVE,</u></div>

Joe

June 18–20 or 21, 1979, Calais, Vermont

Dear Keith__

A sunny Wednesday morning. Got up at six. Had breakfast. Dumpted [*sic*] dinner. Showered and shaved. Washed hair. Meditated. And feel real good. Plan to devote the day to finishing up a little book for a new California press : think I told you about it.[4] (?) No big deal. It's always a good feeling to actually finish something tho. To get it off and out of your life. And on to something else. So will stop and get started now. Just wanted to say "hello" to you. To see you through my day with. (More later.)

Damn it—fucked up! Jumped into too many things all at once and—
(butterfly-like)—I flittered [*sic*] away the day. Tho I've not given up yet. It's
one in the morning—I'm rather stoned—and ought to be real tired only am
too keyed up with "info." Throwing everything to the wind, I've just now
devouring [*sic*] a "Hungry Man's" T.V. dinner—(no T.V. tho)—: chicken
(3 pieces) peas and carrots, mashed potatoes—(I <u>love</u> mashed potatoes) and
an apple tart I've yet to touch. Proof of the pudding.

[See figure 24.1]

And so I think I'll stay up all night, just to see if maybe I can get "some-
thing" out of exhaustion. Wish me luck!

Well, I guess you can tell where <u>my</u> mind's at. [See figure 24.2] Early
dawn. Tired. Disappointed in myself work-wise. And just plain horny too.
<u>For you.</u>

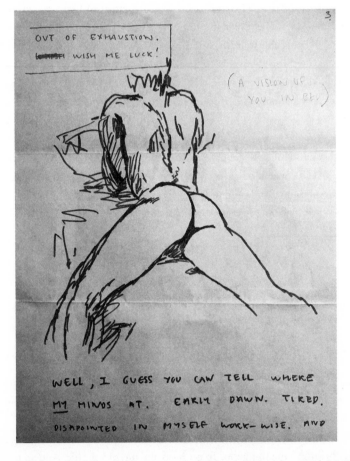

FIGURE 24.2 Page from the June 18–20 or 21, 1979, letter, Brainard to Keith McDermott,
courtesy of Keith McDermott.

Dear Keith,

I guess two or three days or so days [*sic*] have passed since I spasmodically
"did" the above. Which I feel—just in case—I ought to apologize for. But
I won't.

As to your just recent post card of "where are you?"—I'm right
here. With you a lot in my head, every single day. Well finally—finished
that fucking California book : rather like trying to pull teeth, towards
the end.

So—are you working like the devil on the Robert Wilson piece?[5] And
please tell me all about it. Please tell me all about it. [*sic*]

Hot muggy day. So I went out for a stroll in my bathing suit. With
ice cream bar on a stick. And almost as soon as I got outside, the sun
went behind the clouds, and a cool wind came sweeping up from the lake.
A dynamite trio, those : no clothes, ice cream, and a cool wind. It sure
felt good.

Just on the verge of racking my brain trying to think of something else to
say—it suddenly seems silly to do that. Nothing wrong with a short letter.
And I'm sure I'll write you a real long one as soon as I get another letter
from you to "respond" too. So if you haven't—will you?

But what I'm hoping is that our letters will cross in the mails. (To "cross
in the mails"—sounds pretty exciting, no?)

Well—Keith McDermott—I send you one hell of a lot of love, odd tho it
may be. But doesn't feel.

Love, Joe

Summer 1979, Calais, Vermont

Dear Keith,

Just back in from roaming around outside, thinking about everything and
nothing in particular, mostly, except when—from time to time—the "you"
of me popped up, to generously take over. Your persona as clear as a bell, as
fresh as all get out. Yet far too "many faceted" to be as plain as simple. Or,
rather, to be as "predictable" as simple. Tho—oddly enough—tho I can
"see" your face, I can't recall your individual actual features. Which remain
almost—(but let me underline "almost")—disturbingly elusive. Would you
send me a little picture of you? I'd love it. Tho please not a flattering one. (A
guy can only take so much, you know.) And I kid you only half.

And I almost stepped on a caterpillar, with no shoes on of course. Not
that it would have been any major event, even if I had of [sic]. Tho snakes
I find another story tho. I've stepped on lots of them, the feeling of having
something tubular, and surprisingly "chilly" imprinted into the soles of
a foot never ceases to give one a slight case of the willies. But, as there
are no poisonous snakes in Vermont, the sensation is—gratefully—more
emotional than rational. And probably—where [sic] it not for the shock—
rather sensual. If abstractly so. Tho—come to think of it—probably not
so abstractly so. And standing out still too—in my mind—is a field across
the way that is being taken over with "devil's paint brushes," a wild flower
not at all surprisingly like a tiny sun-burst, inwardly bleeding from a yellow
into an orange so rich your teeth want to grit.

But so much for recent history. Right now I'm in a big chair with two
pillows and two arms—great for throwing a leg over—in a black nylon
bathing suit, of the kind Olympic swimmers wear—(no reflection on my
swimming : that I do swim is about as far as I've ever gotten)—and a white
shirt, sleeves rolled up to elbows, and—bet your boots—not a button
buttoned.

So . . . you like hairy chests, huh? I'd love to find you down there some-
day. Or to be close enough that I could put you there, by taking just one
step forward. I can feel the fit would be good. And my dick seems to agree,
in little spasmodic jerks of "sudden interest" over the vision that looms of
something much more exciting to do than hang around in the crotch of a
black bathing suit all day, tho perhaps I am over "I.D."-ing with it. Tho I
don't suppose there's anything wrong with that, I'm suddenly more than
sure of. At any rate . . .

Boy!—(my hand falls flat against chest, and stays there)—you sure know
how to make a guy happy. Your letter was just really great to get. To open.
To read. To "visualize" you with. To get rubbery knees with. And to have.
Just wonder why I didn't smell it too, as long as I was at it. (Just did.) And
it seems to smell surprisingly like paper. Can't win them all, I guess. All the
while rubbing my thumb up and down the length of my cock, of the hand
holding my balls from underneath—cupped. But

(I wisely start a new page for a new day.)

So how'd you sleep? Me, like a log. Though some ways back ago.
Don't know where the day went. But here it is, after supper, and almost
time to hit the sack again. But I have so much more to say—I feel. But
tomorrow is Monday, and I want to get this off to you before too much
more time passes. As it does so fast, if you don't watch out. And so I

guess I'll have to save most of it until next time around. Like maybe
tomorrow.

Glad you're working.

So "you've got pretty feet too, huh? [*sic*—no end-quotation mark] They
are rare. I imagine yours as being especially so, combining the boldness
of feet with smallness in size. (Slurp) Me, I got big ones. A bit crunched
up from wearing cowboy boots for too many years. And a toenail that
never grew back in quite right, having got ripped up on a rock in the lake.
(Though—all in all—they aren't as bad as I make them sound.) Well—so
much for feet.

I guess I'm trying to be funny. And for obvious reasons I suppose. I think
I could get heavily involved with you in so many various directions. But
this way—holding back—I can save my choices—will be made <u>for</u> me—by
reacting to our encounters as and how and when they occur.

But still—I just want you to know that, well . . . the possibilities of you
simply take my breath away. Which I love, and too <u>do</u> find scary. Like when
the weight of your body evaporates, when you've got the kind of flu that
turns you into a jelly—hard to stand up—with butterflies in your stomach.
Generally speaking, on very thin ice.

But—fuck—I want to know so much of <u>anything</u> about you. Where'd
you grow up? Brothers and sisters? How old are you? When and with who
and how was it, the first time you made out? The various ways you feel,
just before going on. (?) And during a performance, and after. (?) Do you
smoke? And are you hopefully drawn to people more through other facets
than conventional good looks: (as <u>I'm</u> a sucker for, I do admit.)

I wish I was New York City so I could send you lots of flowers. But
instead I enclose 3 rather surrealistic postcards of giant fruit, a surviving
product of the mysterious year 1909. (Just think what a crazy future it has
encountered, and confronted!)

Hoping for both your sakes that you are constantly in touch with
Ed [White]—give him my love, if you think to. And maybe a kiss, right
on the lips, to boot. His bedroom "availability" to "anything"—if only
in the eyes—never ceases to turn me on, if somewhat meanwardly [*sic*].
As—among other things—I have a soft spot for those brave enough to
crave humiliation, in its most spiritual form. (And the just good and dirty
parts too.)

Warning me that a good time to sign off is now.

Make me feel good again as soon as you feel like it—O.K.? (Ran out of
paper with lines.) By writing back pronto.

As I'm just getting back into work again, my mind is already churning out a work to send you : if just so I can be on your walls.

Well kid . . . (humpy number and pretty baby)—as a favorite Charlie Rich song goes—"I got you all over me." And it feels real good.

A pat on the ass.

I kiss your eye.

Drive your ear bananas with my tongue.

And put my arm around your shoulder—my buddy—walking down the street with you, passing people to show how lucky and happy I am too. Or such is my fantasy. If maybe someday the cookie should so crumble, to certainly coin a phrase.

Be good, if not too good.

Always let me know just exactly how you feel, please. I would value that confidence. And it would help me to do like-wise.

<div align="center">Yours til the kitchen sinks,</div>

Joe

[Pen drawing of a kitchen sink with a dripping tap.]

August 20, 1979, Calais, Vermont

Dear Keith__

Fresh from a shower, with wet hair and bare feet, I'm sitting at my table, with one foot under me and the other thrown over the arm of my chair, trying to pretend it's not chilly outside, with the heat turned on and drinking ice tea. With my jeans on, and an opened white shirt—just to complete the picture. And inside my head I'm thinking only of you.

You: the sunshine in my life right now. And in more ways than one. It's been cold and autumn-like for over a week now. A bit depressing, as along with it comes the butterflies in my stomach—as though just around the corner is another first day of school. But you save me from feeling like shit with your wonderful letters. (Of delicious times to come.)

But you know—you sure know how to spoil a fellow good: three letters! All but in a role [*sic*]. Each devoured quite literally. With total pleasure, as I'm sure you can imagine, from the knowledge of their content.

You sure are sweet, to go and try to build up my confidence so. And at least momentarily so—it's worked!

And so for all this I thank you a lot. With an imaginary pat of a slap on the ass. And a big long kiss.

And if you'll pardon my quoting you out of context, I all but creamed my jeans over your saying "I'll put just about anything down my throat." (Though, in fact, you were referring to drugs.) So you can see where my mind's at.

(Perhaps I ought to warn you that the more confidence you give me the rougher I'm bound to get.)

And you've certainly come to the right place for long legs.

Using you as my motivation I finally went to a doctor—(I'm the exact opposite of a hypochondriac)—about my "funny" toe nail, which turns out to be a fungus I'm now taking stuff to kill. Though, alas, it'll take six months for the new nail to push to [sic] part out. And so one of these days I'll have you to thank for a perfect big toe nail.

Love my new wallet. Though it's all I can do not to use the rubber to jack off in, as the idea of it turns me on, and would feel mighty good to boot, I can well imagine.

(Help! Do all roads lead to sex?)

So this letter would seem.

Speaking of which, I was sitting at the dining room table yesterday afternoon reading about how Suzanne Pleshette and her husband (who isn't very cute at all) were vacationing on their yacht (not that looks are everything, of course) when a plane came swirling down from out of the sky right at them, etc. etc., when all of sudden I looked up and noticed two flies on the table—just inches away—fucking! I can't honestly say they seemed to be enjoying it all that much however. It was interesting to watch though. At least for awhile. And—just in case you're wondering how they "do it"—they do it rather like dogs, one humping the other from behind. So much for X-rated insect life in Vermont.

(And just in case you're wondering—though I seriously doubt it—what happened to Suzanne Pleshette and her husband—well, the plane narrowly missed the yacht. Crew members swam out to save the two pilots. Who turned out to be dope smugglers. And were eventually turned over to the police. End of story.) A vacation to remember, I suppose.

(And so if it isn't sex, it's drugs! Don't know what this world is coming to.)

At any rate—

Dear Sugar___

(As in ".... is sweet, and so are you.") I had no sooner followed "At any rate" with a dash, when a car drove up of friends from Boston. And so now—(a new day)—I won't be able to get this letter off to you til Monday. God damn it! But so the cookie crumbles. Just had lunch : a grilled cheese sandwich and a big glass of raw milk, straight from the udders of a cow. Which is awfully good. And always makes me feel a bit horny somehow. Which, today, I don't need. (Have been feeling that way all day.) Like ultra-aware of what I'm carrying around down there in between my legs. Which seems to have a life all its own today. And so it feels as big as I wish it was. (It's about as average as apple pie.) Not that I care. Wouldn't mind being a super stud for you though. (Not to accuse you of being a "size queen" of course.) Personally, I don't think anything is sexier than marble statues with tiny peckers.

At any rate—and definitely to change the subject—let me toot my horn for a moment, and quote a section of a review of that "Ploughshares" magazine I sent you that just came out in "The Boston Globe":

"One should also mention the room Schwartz has found for a few sporting performances like Joe Brainard's "Nothing to Write Home About" that like so much of his work becomes ineffable because they are so offhandedly specific."

(Well, I assume that's good.)

Listen—I've been spending the last two years drawing pretty faces and naked bodies, in preparation for some serious big paintings—and I'm hot and ready—and will you be subject to reap the fruit upon? I mean, after your play, and as a job. I just know you could be the extra boost of inspiration I need. So please say yes. I usually just pay models $7.50 an hour, but it's not hard work—(mostly you'd just be lounging around in bed in whatever comfortable position you fall into)—and if just for the pleasure of getting to stare right at you all over for hours, I'd gladly pay more. And if you think you'd feel funny getting paid for it, don't, as for me it's just a tax deduction. I've got my heart set on it. And I think we'd both find it fun. So do think it over. As I've really got to get down to brass tacks this year. (I've quit my gallery, and haven't had a N.Y.C. show in 3 years.)[6] So I'm over-due. And since what I want to do will be quite different from past work, I don't want to sign up with anybody (another gallery) until I have something definite to show.

But I'm getting a bit bored talking so much about myself. Yet I don't want to hound you with a lot of questions. Will just have to be a bit patient, I guess.

Boy do I have lots of fantasies of your [*sic*] first date too! One of which is not really a date, but a party that we are both going to. I guess I just like the idea of spotting you from across a crowded room. And flirting with you in public. (And picking you up, of course.) And so on and so forth. Actually, I don't think it'll be especially awkward at all. (Or at least no more so awkward than—alas—I often am.)

In the enclosed envelope you'll find a "puzzle" I made for you out of an old "pin-up" photo I just found of me in 1969 or so. It's probably a flattering picture—(well, certainly in terms of "now" it is)—but. . . . what the hell!

Have been working of late on a portfolio of six drawings—very sexy— called "On the Beach / In My Head / Down on Paper" for a little California magazine who's doing a special "Me" issue.[7] Plus a bit of writing too.

Still have a book plate design and two book covers to do—(I'm terrible at saying "no")—which I'm determined to get finished before I leave, as I want to arrive in the city free of all obligations.

I usually stay on until the end of September, but with you so much in my head, I think I'll plan to leave around the middle of the month. But will let you know for sure. And even that is taking more than a bit of will-power, I assure you.

Piano music is floating up loud and clear from the "Music Cabin" by the lake, where Kenward and Bill Elliott (an old grand passion of mine) are busy at work on a new musical. Funny—it just occurred to me—how I've kept other people out of our correspondence. (?) It's just you and me, baby—is how I feel, I guess.

So—you've been playing with your dick again, huh? (Well, better tuck it in for a rest, from time to time : we wouldn't want it to turn black and fall off, now would we?) But seriously, the very thought of you so much as touching yourself <u>anywhere</u> turns me on enormously. Just to think of you enjoying yourself, especially. (So don't let <u>me</u> stop you!) In fact—as my mind erases the distance between us—let me <u>join</u> you!

[A hand-drawn circle with the word "OH!" written in the middle of it centered on the page.]

<div align="center"><u>LOVE,</u></div>

JOE

P.S. And don't forget to let me know how you and the play are getting along.

P.P.S. Can't wait to miss the <u>real you</u>!

September 7, 1979, Calais, Vermont

My dear little Keith__

You don't mind if I think of you as little, do you? Because I do, and it turns me on.

First let me tell you how happy I am for you—(congratulations!)—about the "DA" part.[8] Of course it'll be good preparation for Broadway. And it's work. And that means money, experience, and (I assume) "fulfillment." To say nothing of plain old pleasure. So—know that I share in your happiness.

And—yes—I did realize (about the other play) that you meant Broadway.[9] But I must confess that, knowing how few plays run for long, and as you originally said you didn't think the play was very good, I rather assumed that it would probably not be of long duration. However, I now see that this was not very optimistic of me—(I'm sorry)—and have mended my ways : long may it live!

And/but what a funny bunny you are to take my kidding serious! (<u>Of course</u> I was kidding!) I assure you, you can't get too sexual for me : and raunchier the better. (Slurp!) That—(<u>you</u>)—turns me on enormously! So please don't let me intimidate you. But, rather, give me more! More! <u>More</u>!

(As for me, I'm forever messing around in my crotch, regardless of what else I'm doing. Reading, painting, or you name it.)

Why—just the other night—I fucked you good—(<u>real</u> good)—in the form of a zucchini. I heated it up in the oven. Cut out a hole in one end. And rammed it in!

So now don't you go getting embarrassed or uneasy about sharing with me anything—O.K.?

(Don't you know I am head over heels over you? <u>All</u> of you!)

It's a bright sunny hot day, and I'm out in it. Bright blue bathing suit on, for a change from black. I probably ought to be working, but I figure there won't be too many more days like today left, so I'm taking advantage of it. And besides, getting everything done before I leave doesn't seem quite so important to me anymore, since I haven't got <u>you</u> to look forward to so soon.

(I must confess that your letter threw me into the pits of depression for several days, but, as you can see, I have risen above it!)

(None of which is your fault, of course, it's just I was looking so forward to spending time with you, sending you flowers, taking you out places, getting down to work "on" you (painting) and just in general enjoying life in

a way I must confess I am not very good at doing. But which—with you—seems a possibility!)

I first thought of rushing back early, but then realized that, what with making a move and all, your head would be—rightly—elsewhere.

And—golly—I'd love to invite you to Vermont, but I can't. This isn't my house, you know. And although Kenward and I are hardly lovers anymore, he still thinks of me in that way somewhat, and know for a fact he wouldn't take to the idea much.

But. . . . I return to the city on the 20th of September. And anytime after that I am at your beck and call. You just let me know when you want me in Buffalo, and I'll be there. All over you, with pleasure.

But as for my philosophy of life—that's a tough one. Truth is, I don't think about it much. I think I'm more for gulping down instant reality, than gazing at the stars for answers. As I feel a bit like Gertrude Stein, who supposedly said upon her dead [sic] bed, when asked "what's the answer?", said "what's the question?"

But for starters let me tell you that I certainly don't believe in God. Or an after-life. Or, in fact, that anything ultimately matters very much.

And I believe in "right now" a lot more than I believe in "tomorrow."

And in living life from moment to moment as much as possible.

And that—certainly—the most rewarding times in life are in being "with" other human beings. (Contact, love, etc.)

But all this is right off the top of my head. Let me think about it a bit. And I'll get back to you, have no doubt.

Speaking of ludes—I got a big bag full just waiting for me in the city. So I'll send you some when I get back. Or will bring some up for you. (As I rather like them too.)

And—you know—anytime after the 20th you can call me collect anytime you want to. I don't know my phone number, but it's in the book.

And I'd love to treat you to a N.Y.C. visit (or so, or more) any time you get tired of Buffalo. You could come stay with me, that way it'd be like a real vacation. If but for a day and night.

One way I like to get off with you—in my head—is to cock tease you a bit. I'm standing up with my legs spread apart. And you're down on your knees in between them. And I've got my dick in my hand. And the control of your head with the other. And tho your mouth is dying for it all, first I just like to roam around your lips with the head of my cock. And then let you lick and suck it a bit more each time. Yanking it out of your mouth from time to time, so I can ram it back in, real slow, and all

the way. Letting you take over now, to suck it like you like to suck cock. And boy do I come for you! ("Hey, baby!") So turned on too, by looking down at you with your dick in your hand, getting ready to shot [sic] right up into my thighs, dripping down with your juices now. Dripping down far enough to lick up a mouthful, to give you a big wet kiss with. I like the idea of you drinking some of your come.

WELL NOW—

Listen baby—I'm going to sign off fast. I'm really happy for you. And we will be seeing each other before too long, one way or the other, I know. And can hardly wait. (And if you don't like my fantasy—never fear—I've got more, and hopefully yours : I'd like to know them, and I'd like to try them.)

There are a lot of things to come up with—of that I'm sure.

I seem to be real crazy about you, you know.

. . . that I love you

Joe

Mid-September 1979, Calais, Vermont

Dear Keith,

In your letter I have just received, and have read three times, you say:

"Joe, would you write me a letter as soon as you can?"

And so—dear Keith—here I am. At your command. Though hardly with bells on.

For of late—alas—I've lost a lot of faith (again!) in my infatuation for you.

As the idea of being madly in love with someone you hardly know strikes me as not very realistic.

And then I am not all that fond of myself anymore. And how can I expect to be good for you, if I'm not even good for myself?

And my fantasy that you might be able to make me feel better about myself is. . . . well, a heavy trip to lay upon you.

("To lay upon you": gee it sure does sound good though.)

And you know, I'm nervous and high strung. I don't know how to relax. I'm skinny. And I have weird posture : shaped like an "S" with a sway back. Am frustrated over work right now. And, sexually, I have never felt more ambiguous : (I have no "role" or "stance.") Much too wide-open, I fear, to know how to assert myself. And so on and so forth. (I.e., I'm no bargain.)

As to me you are, and deserve the same. "Confidence" is so important to a

relationship. And I just don't know if I can muster it up or not. And so I am not feeling very optimistic about "us." Though I feel sure that, if nothing else, we shall always be good friends. And that ain't nothing to knock.

But God how I hate to be such a "downer." And to throw so much upon your shoulders! It isn't fair. And I can't expect you to put up with it. But it is how I feel—the truth—and so I must tell you about it.

I've finished the "Gay Sunshine" porn drawings, and the book plate, and so now I have four more days to read and relax until. . . .

[Pen drawing of the Manhattan skyline with a small "x" marked on the right-hand side of the cityscape and the word "(me)" just underneath in parentheses.]

. . . I return to my modest, but very comfortable, Greene St. loft. Where—first of all—I plan to clean up and clean out, down to the bare necessities of life my large space : about 35' × 95'. (I like lots of empty space to walk around in, dance around in, make-out in, and to work in.) The best feature of which is the front wall, which is all glass, with no buildings to block the view, and as it faces west, I get great sun-sets every afternoon. I think you will enjoy the freedom the space allows, which I look forward to sharing with you.

Word is that the building is going co-op, and so I guess I'll buy it. Though I'm not crazy about the idea of owning property. Rather, I like the idea that any-time I want to I can throw some stuff in a suitcase and "disappear." But I guess it's about time I invested some money in something besides jewelry, of which I have a fantastic collection. (Ancient rings, gypsy gold, American Indian, and etc., etc.) Boxes and boxes of it. Though I rarely, if ever, wear any of it.

The Hotel Lafayette sounds and looks great.[10] I _love_ old hotels. (Do they have room service?)

I probably won't write again before I leave, but will call you as soon as I get back in hopes of catching you in. But, if not, will you call me? Though let me warn you that I'm much better in letters than over the telephone. To hear a person, but not see them too, always throws me for a loop. (I am not totally a man of this century, I fear.)

I have three standing invitations to visit the Hamptons, which I was hoping to take you with me, but since that is impossible, my enthusiasm has damp-ened. So, don't know if I'll be going out or not. Will play it by ear, as usual.

Just ordered and received this post card from a "serious" English dealer, to pass on to you.

Hopefully it will make up for any "down" note to this letter.

But you know, _anything_ can happen, and probably will.

And I still love you very much, regardless.

Do hope rehearsals go well. (?)

Look real forward to hearing your voice soon.

Til then—

Love, Joe

July 28, 1980, Calais, Vermont

Dear Keith__

As I'm sure you can imagine, I loved your long "Note Book" letter. Gee thanks so very much! You are a real swell guy.

(My tongue would like to say "thank you" too—in its own way—via your lovely pink ass hole. But that will have to wait of course. I just brought it up because I knew my dick would love it. And if "straight as a board" and "hard as a rock" is any indication, it does.)

Oh gee what I wouldn't give to.

But hell—this is no way to begin a letter. Except maybe a short sticky one.

So let me back-track a bit. Let me try to fill you in on a few everyday details of life in Vermont.

I do find it amazing how—with so little to regulate life up here—it regulates itself somehow. (?) Well, all I know is that I get up every morning around 6:30–7:00. And go to bed around 10:00–11:00 every night.

I sun when the sun is out.

I read some, if not a lot, every day.

And have gotten rather heavily into cooking too. Some of my more successful dishes to date are : a fancy Julia Child's version of potatoes a [*sic*] gratin, rhubarb pie, potato salad, and a cheese soufflé.

Other activities are writing, swimming, and exercising.

And then to top it all off, every day is peppered—(though sugared would be more like it)—with random thoughts of you. Sweet thoughts. Horny thoughts. And a few scary ones.

Although the thought of your being away for Sept. and Oct. makes my heart sink into my stomach,[11] I wish you luck with the Guthrie Theatre job.[12]

And when exactly in Sept. is your birthday?

If you are in town, and would like a birthday party or anything, just let me know. Nothing could make me happier than to make you happy, bring you pleasure, etc.

And oh now please don't be intimidated about talking sexy with me. Any time of the day or night is horny time where you're concerned. (And

dirtier the better.) Why—if I wasn't as inhibited as I am with you—you'd be shocked at my foul mouth, I bet.

(But—alas—I fear you think I'm "different" somehow. And that smutty talk from me would offend you more than turn you on.)

(???)

Not—for sure—that I am complaining. (Who needs it?) When at the moment simply a glimpse of your left elbow would be enough to cream my jeans—or so I feel.

Oh and thank you very much for the Quaalude. You know how much I (slurp!) love them.

One thing is beginning to bother me. I was not being quite honest with you when I said that "you" were the main reason I wanted (needed) to stay on longer in Vermont.

I am—frankly—not that strong where you are concerned.

I would rush back to the city muy pronto—(I had two years of Spanish in high school)—if it weren't for Kenward.

But you see, I can make his life a bit more pleasant and a whole lot easier by staying longer. And that I can do this for him is a pleasure to me, as I owe him tons, and still love him very much too, of course.

(Sex, by the way, does not even enter the picture. You were my last "physical contact" and—hopefully—you will be my next. And if I don't return until Sept. 1st, can you imagine how horny I'm going to be?)

Although my hand is forever in my crotch, of course : like at this very moment, for example. And it's hot as hell. And the veins are really throbbing aggressively. Especially when I—(right now)—squeeze it tight around the base. Makes me really feel "the power to fuck."

(Sometimes I re-create your ass hole with my hands, spit heavily into the cylinder-like formation, ram it in, and pump away—thinking of you every moment, of course!)

Another fantasy I have—a head fantasy—a more romantic fantasy—is about your nipples : it is that they are off limits to everyone but me—that you are "saving them"—though of course I don't really believe it for a second.

(Oh, Keith.)

Gee I sure do love you, my beautiful baby.

That's all I can say for now.

(Except thanks an awfully lot for just being you.)

Love, Joe

P.S. I am conceited enough to think that my staying on through August will upset you some, if not a lot. And—gee—I am sorry. (If so, will you forgive me?)

P.P.S. I'm in fifth heaven over finding three Iris Murdoch novels I've yet to read : "The Sacred and Profane Love Machine"*

P.P.P.S. Am so glad you are getting out of town some. Am so glad you are diary writing. <u>Am so glad our lives have crossed</u>!

P.P.P.P.S. If you look through the cellophane opening in a dark room at night, you will see the color of my new bathing suit! (I refer to the enclosed "card.")

P.P.P.P.P.S. Two questions:

Have you been apartment hunting?

&

Have you been seeing a head doctor?

[sign-off with pen drawing of five hearts covered in x's]

*(Am reading now) [Iris Murdoch's novels] "The Sea, The Sea," and "A Word Child." (!!!!!) I love her.

August 28, 1981, Calais, Vermont

Dear Keith,

Well now—sweetie—aren't you full of surprises!

You sound happy about your hotel room, and if you're happy, I'm happy.[13]

But if you're not happy about it—if you'd rather get an apartment—I could give you a thousand or so, to help. All you got to do is let me know. And the pleasure would be mine, of course.

However and indeed, I find the idea of you in a hotel room <u>extremely</u> sexy, I admit.

I have money up the ass right now, as a batch of collages just came back from the American Embassy in Paris (from an extended loan) and they instantly got snapped up via the Fischbach gallery.

Speaking of which (money) I just turned my back on a bundle. [Roy] Halston [Frowick] asked me to do some flower patterns to be silk-screened on evening gowns for his spring collection. I was mighty tempted to say yes, I can assure you. But . . .

But now is a time when the issues I've got to confront (art-wise) are very basic, and I can't afford any "clutter" from side-issues.

(Will you pat me on the back?)

Awfully sorry to hear you didn't do too well in the Times.[14] But nice as critical praise is to receive, I'm sure you know as well as I do that it doesn't "mean" anything. But what about the good reviews? What did <u>they</u> say? Would love to know. (Slurp!)

So you are skinny, and drinking and smoking a lot. I hope you'll let me fatten you up a bit, and soon! As for drinking, I consume a hardy share of Campari and wine, myself. And I started smoking again last week. But very low tar "Vantage"s, and I am limiting myself to three packs a week, with hopes of finding a happy medium I can stick to, and live with. I'll probably switch back to "True Blues" when I get back to the city. But I avoid them here, as they remind me too much of you. And I think about you all too much as it is.

I'm enclosing another $200 check, just in case hotel life is getting expensive. Or, if not, why don't you add this check to the other one, and buy yourself a record player? You enjoy music so much, you really ought to have one.

I also enclose a (to me) sexy clipping—(perhaps I've been in the country too long)—and some Edna St. Vincent Millay stamps.

Also, under separate cover, I am sending you a new shirt I got which shrunk, and a book I think you might like. It's about two boys, and though not sexual at all, I found it very sexy. (But then, as I said, perhaps I've been in the country too long.) And I don't know for sure if you'll like the shirt either. Your taste, you know, is not all that predictable. And I mean that as a compliment.

At any rate—

Just (just?) the mention of your nipples in your last letter created such a physical reaction in me I hardly know how to explain it. I got all rubbery and fevery [sic], like the first signs of the flu. And I totally lost my appetite for a day and a half. To say nothing of jerking off three times. I tie you up with white cord a lot these days, in my fantasies. And I fuck you a lot in the morning, before you are fully awake, though—indeed—you are wide awake by the time I shoot my hot juices into you.

Kenward has an all white cat named Lola, who has chosen this very moment—(walking all over this page)—for some affectionate attention. Living with a different animal from oneself is a real pleasure. I sure do hope you are in a position someday to have a dog. (Another erotic vision, somehow)

Well now—as I just wrote number six at the top of this page—it seems like "the old days" again, when our letters were longer, and fuller of expectations.

But oddly enough—and I want you to know this—I have very few expectations about us this year. I figure we'll probably be seeing a lot less of each other. I certainly plan to get out on my own more. And I am determined not to have any possessive "boyfriend" notions about you. Whatever happens happens. Which I think will suit you better.

I love you.

Joe

October 19, 1981, 8 Greene Street, New York City

Dear Keith,

Boy have I been a mess these past three days : totally depressed and appre-
hensive about everything. Bursting out in tears over nothing. Being quite
simply neurotic, I suppose you might call it. But today I received your
technicolored letter, and it picked me right up. Thank you!

To answer your two questions—yes, I did my stint in front on the mirror
today, pencil in hand. And the reason I mailed my first letter c/o Patrick
[Merla] was—simple as pie—I didn't know where you'd be.

Let me tell you what I had for breakfast this morning. A bowl of
Wheaties, with banana and cream. Two pieces of cinnamon toast. A large
glass of fresh orange juice. And a cup of coffee. Lunch was a sandwich
composed of olive loaf, chicken loaf, and ham. With lots of mayonnaise
and lettuce. On white bread. With potato chips and apple cider. Last night,
for dinner, I made mashed potatoes, which I then baked in the oven, with
cheese on top. To go with Kenward's meat loaf. Plus a salad.

(Are you z-z-z still with me?)

Speaking of food—I got so horny (in a raunchy way) the other night, I
jacked off with two bananas. One up my ass, and one down my throat. A
news item of some shock value, I hope, if but for a change.

Am reading a really great book : "Speak, Memory" (an autobiography
revisited) by Nabokov.

I may have gotten a bit carried away in my letter to Larry [Kert] and Ron
[Pullen] by suggesting that maybe we could spend Thanksgiving together at
our place. (?)

You were right not to take Kenward's final words as too final. Last night
he asked me if I'd like to go to Venice for Christmas. I said the last thing in
the world I could think about right now was Christmas.

Let me confess to being—yes—a bit apprehensive about our living
together a while longer, assuming you've yet to find a place by Nov. 1st.
Might it just be feeding my possessive instincts for you? Which I am forever
trying to keep under control. Then too, I fear you're getting bored with me,
and frustrated by a lack of freedom. But—hell—if there is one thing I really
believe in, it is living for the moment, and fuck the consequences.

And my gut reaction is "oh boy!" And besides—the fact that you need a
place to stay outweighs everything. So consider my arms wide open to you.
(As if you didn't know!)

If but to fatten up this letter a bit, I enclose two pink sheets of foreign
script, a photo of my feet, legs, and crotch, a sexy sepia post card, and one
sheet of "Watergate" stationery.

Yes—I certainly <u>do</u> remember your singing "Autumn Leaves" to me in
bed : every time I walk out the door!

How I get through each day knowing it be one less until I see you again,
but. . . .*

<u>Love</u>, Joe

*(Help!)

P.S. That was yesterday. Today is Sunday. Last night I got to feeling kinda
bossy, and you fell in by calling me "sir," and . . . (Jesus!) . . . that's how I came
with you last night in my head : real dirty and <u>good</u>.

P.P.S. If you find yourself going in that direction, and would like to do
something for me, how about dropping off my lizard boots (new heels) at the
shoe repair place next to my dry cleaners on Sixth Avenue? Am anxious to be
wearing them. More, as they make me feel . . . like you were saying the thick
black belt made you feel.

P.P.P.S. <u>I love you</u>!

March 1, 1983, 8 Greene Street, New York City

Dear Keith,

Oh yes—I'm a little bit drunk. And am allowing myself the luxury of writ-
ing to you one last time. Mainly just to say . . . well . . . "thank you." Really,
you were swell. And I'll never forget. . . .

Not a day goes by.

Even out in the Hamptons this weekend : the sea food restaurant, "The
Cozy Cabins," the beach (etc.) : ouch!

But gee I feel awfully lucky too : not many people get their "ultimate
fantasy" full-filled [*sic*]. Which is exactly what you were, and still are, to me.

And just want you to know how much—<u>so</u> much—I continue to miss
you so much.

But of course life goes on. My main desire being to get away, my current
plans are to visit my parents in mid-April. Then to Toronto for a caberet (cab-
era) [*sic*] stint. Then to Southampton for a month. And Vermont for four.

While in the meantime, I've ordered a new futon bed. And am re-paint-
ing my place white next week.

So I am putting all my eggs in one basket : change!

And I have no doubt that I shall become an active artist again : it is my only hope. And I am not a loser.

Rather had to spill the beans the other night—two weeks or so ago—when your mother called about how to get hold of you. Had to say I just didn't know.

Now—it's going to be a long time before I can be brave enough to see you again, but please understand this : that is if you ever need anything, I am here for you.

Do so hope you are enjoying work, and that all is well with you.[15] You only deserve the best, in my book.

Am afraid this letter is pretty sloppy and inarticulate, but it's a one-shot thing, and the best I can do at the moment.

Read between the lines, and you find it packed with nothing but love for you.

That's all.

(Sweet heart!)

Love, Joe

P.S. And so much pleasure is lost without you to share it with. One tiny example : these springbok photos in the new "National Geographic": that leap into the air! Takes my breath away. (Yours too : yes?)

P.P.S. Please continue to think of me fondly too. It is all I ask.

June 20, 1983, Calais, Vermont

Dear Keith,

Really and truly, how very very generous of you to forgive my erratic behavior so gracefully!

I am now more in awe of you than ever, which is saying a lot.

Just the possibility of maybe getting to hold you in my arms again has made me one very happy man : thank you!

(I look forward to missing your bump!)[16]

You know, you really are an amazing guy. I just don't know what to say. I mean. . . .

I am still in shock.

I really didn't expect.

I.

WHOOP—E—E- E- E!!!

Oh please let me make July an easier month for you with this check enclosed. It will make me so happy!

And please forgive this silly and spaced-out and totally inadequate letter. But you can see the state you have me in : I can hardly sit down much less collect my thoughts into words on paper.

I mean really, I just.

[a line of squiggles to represent Brainard's excited inarticulateness]

(HELP!)

Well now—obviously I'm going to have to settle down a bit before I can write you a real letter : (soon!)

In the meantime, I send you lots of love, raunchy thoughts, and sweet kisses.

I just totally adore you, sweetheart. And it feels so good. Thank you once again!

<u>Love</u>, Joe

July 15, 1983, Calais, Vermont

Dear Keith,

Just got your Sunday letter, and. . . .

Therapy!

(Just how well do I really know this person named Keith McDermott?)

And please, sweetheart, don't feel any pressure about writing to me. If it's a drag, don't. If it's a pleasure, do. It's as simple as that. And, really, I <u>do</u> understand.

Never have I felt more open and available to whatever happens between us. So don't feel any pressure about my affections for you either. I think it'd be fun to live together again. Or you'd make a great casual lover. Or as just a good friend, I would value you highly.*

Went to a flea market the other day in hopes of finding

*Not that I don't have preferences!

something worthy of you, but without much luck. What I did find though is a hand mirror for you to give your mother—(Christmas!)—as you did say she collected them didn't you?

Very excited about my New York City plan to keep irregular hours. Just to take fully [*sic*] advantage of my freedom—(no job)—and to get back into the pleasures of working at night.

It's a funny thing about sorrow. I cried five or ten minutes over Ted [Berrigan's] death, and then pretty much put it out of my mind. But now

the least little thing—(like "The Waltons" on T.V.!)—and the tears start
flowing. So I am quite a drip these days.

How <u>does</u> he do it? Got a three page (typed!) letter from Amos
[Abrams] not long ago. And it's not as though he had much to say. Just
about Greece, Karen [Hughes, née Magid] and Cliff [Hughes] getting mar-
ried in October, and that nobody in New York sucks cock anymore. (AIDS)
Well. . . . I certainly admire his abundant way with words.

So you said you wanted more pictures :

I enclose a sketch of two pansies, and.

Don't you love this mysterious postcard lady? One might assume she had
no arms, were it not for the written message on the back. A cape with no
arm holes? Is she pregnant? And what to make of the big tree painting? Just
a few of the things we'll never know.

Last night in my dreams we were little kids again. Say six or seven years
of age. And boy were you cute (!) in a navy blue sailor suit with short pants.
We were riding around in a giant Ferris wheel, when suddenly I looked over,
and your little dick was hanging out. Yellow juice was beginning to flow
from your pink piss hole, and you were crying. And I said "Oh sweetheart,
please don't cry. What's the matter?" And you said you <u>had</u> to pee—
couldn't wait—and were afraid of getting your pants wet. And I said not to
worry : I'll take care of it for you. So I laid my head over in your lap and—
(gulp, gulp, gulp)—came to your rescue. Just like the good buddy I am.
<u>Love</u>, Joe

P.S. Another phone call, another death! Edwin Denby, this time. Committed
suicide last night with sleeping pills.

August 23, 1983, Calais, Vermont

Dear Keith,

Thank you very much for your sleepy-sweet and breathless letter. It felt like the
first real "unconditional" love letter of the summer. And was very well received.

Boy am I standing tall these days. Three days ago I dove into the lake with
all my clothes on to save a six year old boy from drowning. How I swam back
to shore with one arm, I really don't know. But I did. And am awfully proud
of myself. (Another fantasy full-filled!) And the event has greatly restored
my faith in acting impulsively and instinctively, for which I am grateful.

Proud too—and much relieved—to have finished Proust. Amazing and mind-blowing though it is, it's also very tedious and trying. Followed up by "The Color Purple"—(upon your recommendation)—which of course I loved. And now I'm reading an E. M. Forster biography.

Although a single day can seem to go on forever, I am always surprised at how fast a month goes by. And so I am already feeling nervous and anxious and apprehensive about seeing you again. It's been such a long time (!) that you've become somewhat elusive to me. Which is very exciting (too) of course. But I literally tremble at the thought of "being" with you again. Just like the very first time!

And so if this letter seems a bit stiff, and brief, it is just because I am suddenly feeling shy.

I remember your birthday as being September 24th, but please let me know if I am wrong.[17]

In the meantime, I enclose a butterfly. A junior high school photo of me dressed up as Marilyn Monroe, at a "Come as your Favorite Person" party.[18] A check to ease your way through September. And.....
Lots of love, Joe

July 27, 1986, Calais, Vermont

Dear Keith,

Jesus! Just this morning realized it's the 27th of July! Which means that (1) I more than owe you a letter (2) that I'd better get some August money to you fast, and (2) that summer—my four month summer—is almost half over! I swear to God, it's the weirdest thing about aging, how time flies faster and faster each year. Do you find this true yet?

I really loved your letter about your English vacation.[19] Thank you. (How do you do it?) As you probably know, I once spent a year or so in Boston without meeting a single person! It must be those big blue eyes. Pretty face. And everything below the neck.

I'm sorry I haven't written to you sooner, but I feel as though I'm in constant contact with you, as I think about you, and dream about you, all the time.

Do you think we'll still be boyfriends this fall? And are you seeing any-body seriously? These are things I'd really like to know. (And won't affect my sending you money next month!)

Movies: I've seen two movies so far this summer : "Top Gun" (too noisy!) and "My Beautiful Launderette," [*sic*] which I loved again.

Books: am into big ones. Currently reading "Vanity Fair" (753 pages!) and plan to read "Ulysses" next (643 pages!) : probably the only two major works of fiction I've yet to read.

Work (grumble-grumble) isn't going too well, though I have done some drawings for a small literary magazine called "Exquisite Corpse," and a book cover for "Writing Down the Bones" sub-title : Freeing the Writer Within. (By Natalie Goldberg.)[20]

My only real news is that the University of California Museum is giving me a big retrospective, which opens in mid-February.[21] I mostly shudder at the thought of seeing so much old work, but I do look forward to a California vacation. Richard Thomas and family were here last weekend for a visit, and he said his wheels would be at my service, so between him and Jack [Larson] and Jim [Bridges], and Don, maybe I can finally make my way to (and around) L.A.

Here's the sky. The house. The guest cabin down by the lake. Lola in the living room. And me and Pat and Kenward, taken after dinner by Ron on July the 4th.

<div style="text-align:center">I miss you.</div>

<div style="text-align:center">And love you.</div>

Joe

P.S. How's Amos doing? And (I shudder to think) David Kalstone?[22]

25

DEAR MRS. RAY

T his single letter to Keith McDermott's mother, Betty Ray McDermott, is so polite, so thoughtful, and so very gentle in its suggestion that "love and affection" can and should be experienced both conventionally and queerly.

March 9, 1982, 8 Greene Street, New York City[1]

Dear Ray,

Although "Ray" seem [*sic*] a bit too familiar, "Mrs. McDermott" seems too formal, so. . . .

Am writing just to let you know how much I enjoyed your cake and lemon "sauce." Really, they were both very much enjoyed and appreciated. Thank you!

I hope you don't find my presence in Keith's life too embarrassing. Of course, I'm sure you'd rather he have a girlfriend—what mother wouldn't?—but on the other hand, I hope you agree with me that any form of love and affection can't be all bad.

At any rate—you can rest assured that Keith has a good and reliable friend in me.

As I hear you may be stopping over in New York on your way to England, perhaps I'll get to see you again soon?

Love, Joe

P.S. This letter is so tardy in arriving because I addressed the envelope wrong.

IT WAS ANYTHING BUT A BIRD,

UNTIL — TO AID YOUR LETTER — I

LOOKED IT UP IN MY DICTIONARY:

I.E. " *V.* crush; quiet. " , THO

— INDEED — I DIDN'T MEAN TO GET

SO "VISUAL" ABOUT IT. A RATHER

FLAT DEFINITION FOR SO FLUID A

WORD , I WOULD THINK , BUT IT'S

ONLY A VEST POCKET EDITION. AND,

BESIDES , I FEEL ABOUT IT ALREADY

THAT IT IS NOT A WORD I

WOULD WANT TO PIN - POINT TOO

PROSAICLY ANYWAY.

YOU OUGHT TO HAVE SEEN

KENWARD THIS MORNING — ALL DRESSED

FIGURE 26.1 Page from the June 1979 letter, Brainard to Ann Lauterbach, courtesy of Ann Lauterbach.

DEAR ANNI

"Of all the persons in the world I know or have known," the poet Ann Lauterbach writes, "Joe is the one I can least afford to lose; without him one will walk around with a constant sense of lack or a rip in the firmament which will not heal. Because only a very few persons ever come to represent or embody what we all, each of us, aspire to be, but are incapable of becoming."[1]

Brainard met Lauterbach in the late 1970s soon after she returned from London to her hometown of New York City. Their letters reveal a deep friendship spiced by Brainard's attraction to Lauterbach. "I absolutely have a total crush on you!" Brainard acknowledged in an early missive, adding provocatively, "To the point that I am beginning to wonder . . ." As we will see, the two remained friends until the very end, with Brainard sharing intimacies, flirting, advising Lauterbach on good books to read, and updating her on news both tragic (such as the death of Ted and Sandy Berrigan's daughter Kate) and everyday.[2]

Circa late April or May 1979

Dear Anni __

My silence has nothing to do with your not being on my mind, for sure. As I absolutely have a total crush on you! To the point that I am beginning to wonder. . . .

But as sincere as words on paper can be, and are, I don't totally trust their realism in actuality, and so I won't indulge in details.

And then too—as I simply like to flirt so much—it's hard to know for sure.

At any rate. . . .

I just can't thank you enough again for your part in the party, which, without, it could not have been.[3] And I did so much want to do something really nice for Kenward. And boy did we evidently do it! (I'm still getting cards of thanks and raves.)

Surely you must be feeling much better physically by now. Hope so mentally too.

Your book jacket is really intriguing, and your photo is enough to die.[4] (Now who did I pick that expression up from, I wonder?) Somehow it just doesn't sound like me. Oh well . . .

Only "news"—if you'll allow me to call it that—is that I've given up sugar and coffee, and have taken up meditating every morning. Resulting only in that I fall asleep a lot in the middle of books, so far. As I indeed have relied very heavily on them—sugar and coffee—for the better part of my life.

Gee . . . I would love to hear from you a lot. If the cookie should so crumble.

And don't think I've forgotten my desire to have you come over and pick out a work of mine you like. First thing upon return, I hope. A way of saying thanks, and more.

Bill Elliott is up here for two weeks working with Kenward on the musical version of "City Junket."

It's being cool today, we're going to build a big fire tonight, and have a wienie roast.

I hope you know that you'd be more than welcome to come up for a stay anytime the desire to do so struck/strikes you. All you need do is drop a line of when and where to pick you up, and we'll be there. And—just speaking for myself now—with bells on.

Well—(well?)—well, I hope you're . . . er . . . well, and all.

And that—if not in the flesh—we'll at least keep in touch via the United States post office. Before summer zips by into time to return to city life again.

Be well. Take care, if not too much. Good luck with your novel. And know that I love you and miss you.

Joe

P.S. "Forget-me-nots" enclosed. Just because I do love them, don't you?

Circa June 1979, Calais, Vermont

Dear Anni,

Boy that was good—hearing from you—and so it seems I am coming back
for more, tho only in hopes of.

Well now ... it doesn't sound so bad to me : you on the platform typing, lis-
tening to Brahms, (drinking a cup of coffee!) with a whole day ahead of you, all
quelled out by "a very beautiful young man"—not that you said it was : (so bad).

Yeh—I like that word "quell" too, tho I didn't know it was anything but
a bird, until—to aid your letter—I looked it up in my dictionary : i.e., "*V.*
crush; quiet," tho—indeed—I didn't <u>mean</u> to get so "visual" about it. A
rather flat definition for so fluid a word, I would think, but it's only a vest
pocket edition. And, besides, I feel about it already that it is not a word I
would want to pin-point too prosaicly [*sic*] anyway.

You ought to have seen Kenward this morning—all dressed up like a
Russian peasant in a snow storm—out in the garden planting cabbages—to
keep the <u>black flies</u> from biting him to death. Me, I just stay indoors until
they go away, which will be soon.

Speaking of which—(Russian)—I just finished Gogol's "Dead Souls,"
which is a whole lot funnier than I remember its being when—years ago in
Boston during my "Russian Period" I read it.

And what a jewel of a shocker "Ethan Frome" by Edith Wharton is : if
you haven't read this <u>please do</u>. (If not, let me know, and I'll send it to you.)

And Muriel Spark's new novel is heaven.

And delighted (slurp!) to hear you are reading [Asta Nielsen's] "The
Silent Muse," one of my all-time favorite novels.[5] Altho I hardly knew you at
the time, I carried along your image with me right thru it : i.e., <u>you</u> were her!

Just recently discovered a Henry James I hadn't read, and of course
instantly did : "The Reverberator": surprisingly light and playful, and good.
(Will send it to you too, upon request.)

Read Phillip Lopate's new novel too, and liked it, just short of a lot tho.[6]
(A bit analytical for my personal taste, I think.) I think—ideally—I prefer
figuring things out a bit on my own. But—(grumble, grumble)—so much
modern fiction seems to want to spell everything out in black and white.

Which reminds me of a particular line in I forget which Jane Austen
novel in which she <u>totally</u> drops a bomb by simply stating " ... she could
not help feeling a small pang of something which could only be described as
jealousy," and left it at that!

Well—and so how goes your novel? Would really like to know, unless
you don't like talking about it.

Bill Corbett was over the other night and was ranting and raving about
your book![7] (You see—books do get around on their own too.) Am glad
that it's out, and am anxious, of course, to read it. So will be sending away to
"Better Books, Inc." pronto.

I guess you've noticed that I ran out of paper with lines.

I also seem to be running out of anything to say. And ought to be getting
on to my project for today. Which is to finish up a little portfolio of "Draw-
ings and Some Words" for a new California press called "B.L.T.," as in that
which goes so well with a tall glass of iced tea in the good ol' summertime.

Well—(my hand falls flat on chest, and stays there)—I sure do think
you're pretty, loved your letter. And think of you often. And if you feel like a
pen-pal, you know where to find me.
 Love,
Joe

Circa 1981, 8 Greene Street, New York City

Dear Anni,

Oh you can say that again—about needing to be reassured—constantly!
Though just hearing from you did more for me than the photo. And so
thank you.

I've been a party-boy all week, and I'm beginning to feel the wear. An
Eileen Myles "Beat-Nik" book party in a dark loft with lots of kids and dogs
running around. A glamorous birthday party for Harry Mathews at his
mother's Beekman Place mansion. A "Z" Press book party at the Gotham,
with dinner and dancing at Kenward's place afterwards. And etc.

I go to Nautilus three mornings a week. I try to paint, but mostly draw.
(Self-portraits : really just a matter of convenience.) And—as always—read a lot.
"Night Wood" [sic] by somebody Barnes, is the best of the recent lot.
Started Vidal's new "Creation," but just lost interest in mid-stream, which is
odd, because I always enjoy him, if don't admire him, especially. Reading a
good, if somewhat depressing, journal by May Sarton now, called "Recovering."

Got another of those real short haircuts yesterday. And am turning
yellow from a medication I'm taking for amoebas : ugh.

And money have I none.

But otherwise I feel . . . er . . . O.K.

Had one good spurt of writing for several days a week or so ago. Five short chatty pieces, which have as much to do with language as with content, if not more so.

My sister is divorcing her cute blond male-nurse doctor, to marry her rich boss. (<u>Three</u> Brainard gold-digger! [*sic*]) Or, as Susan Sontag generously put it the other night, "There must be something about us that attracts money."

Am drinking a glass of fresh orange juice, with three generous scoops of protein powder. And running out of things to say.

"We" anxiously await your re-turn [*sic*]. But another letter from you would be real swell, in the meantime.

 Loved & missed,

Joe

September 1981, 8 Greene Street, New York City

Dear Anni,

It sure was good to hear from you. You write an awfully nice letter. And your tone of voice sounds real . . . well . . . almost calm. Pretty contented. If not more so. Which I was real glad to perceive.

Funny your birthday is the 28th of this month—so is Keith's. Who just so happens to be living with me for two weeks, while in between apartments. And how do I like it? Well, what I like best about it is having my sense of order ravished, if not raped. Kenward called yesterday, and Keith answered, and so he knows all about it, and—though he turned a bit icy, it seems that I am still to return to Vermont for October. Since I am totally incapable of making any definite decision between them, I leave it up to fate. I know this is no way to lead a life, but. . . .

I <u>do</u> love them both (and need them both) in quite different ways.

I quite often suspect that I'll end up with exactly what I deserve : neither of them.

Which I almost suspect is what I secretly want : God forbid!

Oh! If you are writing poems ("just?") I would count yourself lucky. Me, I'm rather happy over one little drawing (a self-portrait in underwear in mirror) in which I managed to totally involve myself for about one hour.

Not very interesting news is a new haircut, by a punk barber, that cost $48, and looks like a $3 clip. (<u>Very</u> short!) His concept was to make me look like a farmer whose wife just cut his hair. In fact, I look very much like a monkey.

Michael Lally is getting married to an actress named Penny Milford, perhaps on a boat.

A new Soho movie house is having a Fassbinder film festival, of which I have so far seen them all three.

I keep late hours because Keith is in a Shaw play entitled "Misalliance": very good.

I am applying for a Merrill grant again, with fingers crossed.

Went to Boston to give a reading in a gay bookstore and—if I do say so myself—was a big hit. (Even made out with a cute fan afterwards, which has always been my expectation at out-of-town readings, but has never happened before.)

Sweetheart—I would love to send you something for your birthday, but I just probably won't. Will think about you though. And do have a happy one.

I love you,

Joe

P.S. And thank you for the photo of Anne [Waldman] and me : I like it a lot, especially as it recalls to mind so vividly the exact moment you took it : (I.e., you are in the picture too!)

(x x x x x x x x x x)

Summer 1987, Calais, Vermont

Dear Anni,

Just a moment ago finished reading [Alice McDermott's] "That Night," which I loved. Such a sweet and sad little story, that could only have been written by a woman, and an American, which makes it very special, of course. Thank you!

And thanks, too, for the soon to be devoured Yourcenar (one smart cookie) book, and for the four tapes, which I haven't listened to enough to have a favorite(s) yet, but will, I'm sure.

Seems like yesterday, or years ago—I have no time slot for it—since we were gliding through our easy days together. Though perhaps you—struggling down in the cabin—may have a bumpier view. At any rate, I enjoyed being with you very much.

Steven Taylor (vegetarian) is here now, working with Kenward to extend "Palais Bimbo" into a full evening piece.[8] And so many vegetables for dinner.

(Two biscuits and a bowl of blueberries and cream for breakfast :
yum-yum.)

It's a real heavy gray damp Wednesday morning, good for trying to work,
and will, at least until mid-afternoon, when it's supposed to clear, though of
course there is no counting on nothing.

Terrible news: Kate Berrigan (Ted and Sandy's daughter) got run over by
a motorcycle on Houston Street, and died.

I enclose a couple pictures. A kiss for Brian [Wood]. And —————————▶

Lots of love to you,

Joe

JIMMY SCHUYLER : A PORTRAIT

LET ME BE A PAINTER, AND
CLOSE MY EYES. I SEE BROWN.
(TWEED.) AND BLUE. (SHIRT.)
AND — SURPRISE — YELLOW SOCKS.
THE BODY. SITS IN A CHAIR,
A KING ON A THRONE, FEET
GLUED TO FLOOR. THE FACE
IS HARD TO PICTURE. UNTIL
— (CLICK) — I HEAR A CHUCKLE.
AND THE VOICE OF DISTANT
THUNDER.

FIGURE 27.1 Prose poem included in the letter of July 22, 1991, Brainard to Nathan Kernan, courtesy of Nathan Kernan.

DEAR NATHAN

T he art critic, James Schuyler biographer, and poet Nathan Kernan was introduced to Joe Brainard by the pianist Alvin Novak following a Kenward Elmslie performance in SoHo. The two met again at a party at John Ashbery's in 1987. Their friendship was cemented after Carey Marvin, a former student of Brainard's at New York's School of Visual Arts, organized a dinner with them both.

The letter reproduced here is notable for Brainard's inclusion of a short impressionistic prose sketch entitled "Jimmy Schuyler: A Portrait," his funny responses to a questionnaire sent to Brainard by the poet Steve Abbott, and his usual book reports and updates on his social life in Vermont.[1] On a more solemn note, we also find Brainard describing a medical condition, which, in typical Brainard fashion, he avoids mentioning is linked to AIDS. Recalling when he finally learned about Brainard's diagnosis, Kernan explains, "It wasn't completely a surprise of course because he had these mysterious ailments for the last couple of years, you know, shingles at one point, then long lingering stomach trouble. In those days one began to get kind of uneasy about things like that in gay people, gay men, and so when he told me I was shocked and saddened, but not entirely surprised."[2]

July 22, 1991, Calais, Vermont

Dear Nathan,

It was wonderful to hear from you. (Three whole typed pages!) <u>Thank you</u>! But you leave me hanging : did you ever find the "Rigid-Dent"?[3] Of course I

envy you your time with Anne [Dunn] in France. Hope to hear all about it. And Italy too, of course.

I assume you've heard the exciting news about Carey [Marvin].[4] (!!!)

The other night in my dreams, falling down a long flight of red car-peted stairs, in a fancy hotel, a cute bellboy came to my rescue, helped me to my feet, and whispered in my ear "Remember Mary McCarthy." Which reminded me the next morning that I hadn't read "Memories of a Catholic Girlhood" in a long time, and so I am : awfully good.[5] My favorite books of the summer—so far—are "Jigsaw," an autobiographical novel by Sybille Bedford. And "Dogeaters" by Jessica Hagedorn. (Both out in Penguin paper.) "Dogeaters," in particular—(it's very funny : a bit Manuel Puig-ish)—would be good subway reading, as it's written in short conclusive chapters.

My only news—(not very pretty)—is that a cyst on my back got infected, and had to be cut open (ouch) so the "stuff" (yuk) could drain out. That's the bad part. The good part is codeine pills! Actually it wasn't that bad, and I only took two, but it makes me feel very secure to have them around, just in case, for the future. (I still pine for those three sleeping pills I gave Anni Lauterbach!)

∟ That was several days ago.

More like a week really, if not more. A fuzzy time for me—(actually all time in the country is a bit fuzzy, in its sameness)—but recently in particu-lar, as I've been mostly horizontal (bed) nursing my cyst, which didn't drain properly, and had to be more seriously cut into, etc. Quite painful really, though less so in a horizontal position. But much better today, on the mend I'm sure. Not very interesting, but it's the only news I have.

Bill Corbett is organizing a memorial reading for Jimmy [Schuyler] in Boston. Nov. 14th. I think I might go, spend the night, do the museums. Want to come with me? Probably not, as I think it's a Thursday. Speaking of which—Jimmy—I'm enclosing a little piece I wrote about him. Which reminds me—are you going to let me read something of yours one of these days? Would certainly like to, if and when.

Kenward left this morning for a week : a teaching and performance gig in Boulder. (Two tiny ducks are making giant "V"s on the lake, just outside my window.) Am looking forward to being totally alone, and pigging out on snack foods and T.V. frozen dinners! Though Pat and Ron Padgett are just down the hill—(will be eating some with them)—and Bill Corbett—(has a place nearby too)—and I are planning to spend a day together in Stowe,

to take a tour of the "Ben and Jerry's" ice cream factory, and a ride down the "Alpine Slide."

Oops—a whole new page, and I'm all talked out.

Miss you.

Oh—and thanks for the post cards!

<u>Love</u>, Joe

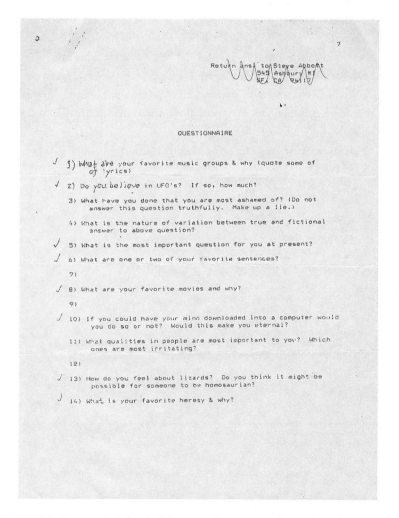

FIGURE 27.2 Survey included in the July 22, 1991, letter, Brainard to Nathan Kernan, courtesy of Nathan Kernan.

1. "The Smiths" (with Morrissey) because it's the only music group tape I listen to, because it's the only one I have. Duncan Hannah gave it to me. But I can't remember any of the lyrics. I don't really listen. I just use it as company. Like a cat on a sofa.

2. No.

5. Just how to get the most enjoyment out of life.

6. I like any sentence that ends with a preposition—a bit awkwardly—like an eleven year old boy. Also—(if a line of a poem can be a sentence)—I like (Elizabeth Bishop) "The art of losing isn't hard to master." I find this a great comfort.

8. "Some Like it Hot." Because it totally works : is totally consistent. Because it is never embarrassing. Very funny. And it's Marilyn Monroe at her best.

10. No, I would not. "Eternal" isn't a word I grapple with. (Doesn't interest me.)

13. I have no feelings what-so-ever about lizards. Though I imagine one could find them quite beautiful if one tried. Personally, I can't relate to a lizard at all, but I have met a few people who......

14. Heresy is such a severe word. I can't relate it to "favorite." I guess I don't understand the question.

28

DEAR ALICE

The two letters reproduced here from Brainard to the poet Alice Not-
ley—whom he met in 1969 when Notley and her husband at that
time, Ted Berrigan, were visiting New York City—were written in
the early 1990s when Notley and her then-current husband, the poet Douglas Oli-
ver, were editing and publishing *Scarlet* magazine. There were five issues of *Scar-
let* in total, published from 1990 to 1991. Brainard's contributions—minimalist
accounts of his dreams, which are as captivating and charming as anything Brain-
ard wrote—show how Brainard continued to work creatively even as AIDS fur-
ther weakened his body.

This is not to say that AIDS never made an appearance in his correspondence.
The great discovery in these letters are three heretofore unpublished dream
accounts, including one referring to Tim Dlugos (who died of complications due
to AIDS in December 1990) and one on seeing Frank O'Hara: "It was great to
see Frank O'Hara again, in my dreams last night. And looking so good, for some-
one in the advanced stages of AIDS." Was Brainard using Dlugos and O'Hara
as stand-ins for himself here? Or anticipating a meeting in a place we might call
heaven with his former lovers and friends, sooner rather than later?

September 24, 1991, 8 Greene Street, New York City[1]

Dear Alice,

Only three dreams made it down on paper this summer. As to if they are
of any interest, I leave that to you. Fall is very much here, and the city calls.

(October 1st) Just in time to hear Ron at the Church. Will you be there? See you, if not then, hopefully soon.

Love, Joe

P.S. "Love" to Doug. And a bit of money, just in case.

Last night in my dreams, I found myself falling down a grand staircase in a fancy hotel, when a cute bellboy came to my rescue, helped me to my feet, and whispered in my ear "Remember Mary McCarthy." Which reminded me, this morning, that I hadn't read "Memories of a Catholic Girlhood" in a long time, and so I am, and it's awfully good really.

Last night in my dreams Tom Carey, delivering a sermon in a large international airport terminal, announced that he had a message from Tim Dlugos— (everyone gathered in close with anticipation)—"Tim wants everyone to know that he's doing fine." A bit disappointing, though better than nothing I suppose.

It was great to see Frank O'Hara again, in my dreams last night. And looking so good, for someone in the advanced stages of AIDS. I asked him how he was feeling, and he said something non-committal, like "Oh pretty good." I was a bit surprised to realize that I didn't have any clothes on, except for a pair of black leather gloves. And I guess he didn't either (have any clothes on) because the next thing I knew my black leathered fingers were toying with his nipples. A totally mechanical gesture on my part, but hopefully a turn-on for him. Meanwhile he was asking me about my trip to Venice. Had I liked it? (Yes). And did I want to go back? (Not really). And he said "Not even for a particular painting, or a special sauce?"

March 29, 1993, 8 Greene Street, New York City[2]

Dear Alice,

I haven't forgotten you. You were in my dreams just last night. You and Anne Waldman and Madonna. All as one woman. (You kept changing into each other). Very confusing, but most enjoyable. Thank you for your Christmas card. It's tacked up on my wall so I see it daily—(green beetle, in case you've forgotten)—a constant reminder of you. Word is that you own

your apartment and that Doug—(hi!)—has a good job, so I'm not going
to worry about you. (Money). But if I'm wrong, and if you ever need tiding
over . . . I guess I'm going to make you ask!

No news here.

But all is well.

Love, Joe

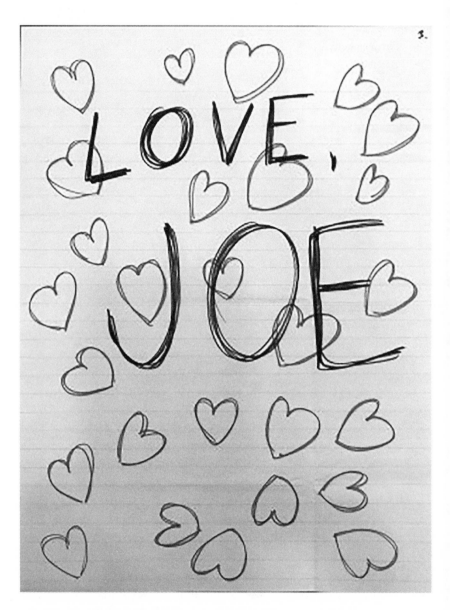

FIGURE 29.1 Valediction from the summer 1969 letter, Brainard to Bill Berkson.

DEAR BILL

T he letters selected here from Brainard to his friend the poet and art critic Bill Berkson begin in 1967 and end in 1993. Brainard discusses their poetry cartoon collaborations. He argues about Barnett Newman, insisting to Berkson that Newman "is, to me, like death" while agreeing with Berkson that Francis Bacon is "so melodramatic, and corny!" He requests copies of Judy Garland's albums and mourns her death. He reports on a "new piece" he is working on called *I Remember* ("So far it is 50 pages long it is GREAT!!!"). He makes a strong case for the pleasures of and right to gossip.

Brainard's insecurities and ambition are on full display as well. As early as 1970, Brainard concludes, "I think I have just about decided that I am no genius and that the world doesn't really 'need' anything I might do, so—so what's the hassle?" As we know from the range of letters collected here, Brainard developed a style in his life, art, and writing that was antithetical to the cliché of the "tortured artist." And yet, we know he agonized privately over his self-perceived failure as a painter even as he worked hard to shrug off anything remotely resembling taking himself too seriously.

As the correspondence moves forward in time, we also find hints that all is not well with Brainard's health. A 1990 letter records a fierce attack of AIDS-related shingles, even as (per usual) AIDS is not mentioned. A letter from early 1993 rather mournfully notes, "My birthday is March 11th, but as for what I'm up to—that's harder to say. Really, nothing much, and yet." Knowing what we know, the loaded silence inherent in those ellipses is almost unbearable even as we marvel at Brainard's sweetness, solicitousness, and generosity right up to the end.

Summer 1967, Southampton, Long Island[1]

Dear Bill__

I hope you had a wonderful trip. I'm working very hard at oil painting.
Doing some "damn good painting" but nothing of much interest. One thing
I know for sure now is that there is absolutely no such thing as realism. It
just isn't there. Another thing I know for sure is that I like oils. I like the pos-
sibilities. Another thing I am knowing is that I don't want to mess around
anymore with art, if possible. Larry Rivers made me realize it when he was
saying that he didn't understand how anybody could just paint flowers, etc.
It occurred to me how involved his painting is with art. And how, some-
how, it's kind of a big mess, all that stuff. I mean, when you get right to it,
minimal art isn't very minimal unless you're three years old. I mean, it's
"art." At any rate—this is all quite silly, really, as my biggest weakness is art. I
love it. So—I found a new postcard source here in Southampton. Some are
enclosed. Drawing for [Frank O'Hara's poem] "Blocks" is certainly going
to drive me crazy unless, somehow, I compromise. There are so many ways
of balance. Which is what I'm interested in : balance (poem—drawing).
Sometimes I think that perhaps I just ought to try to equal the poem's exu-
berance. At any rate—something will work out. So—I am having a wonder-
ful summer. Perhaps you will be out here soon? When you see D. D. [Ryan]
tell her "hello" from me (along with art I am also a sucker for extraordinary
women). So—see you soon I hope I hope—
Love, Joe

Summer 1969, Calais, Vermont[2]

Dear Bill

It was good to hear from you. I am doing some packing right now and there are
butterflies in my stomach. Like on the first day of school. Only they are good
butterflies. I mean, it's a good feeling. (Fall) (A new loft) (Painting) (Seeing
you) (Etc.) I will arrive in the city the 6th or 7th, depending on the sun.
 Here is what you need:
 "April the 27th is Kenward's birthday. May the 29th is my brother's
birthday. My older brother, Jim, who lives in St. Louis." I have been doing
nothing but writing all day every day on a piece I am writing called "I
Remember." So far it is 50 pages long it is GREAT!!!

I always thought that I had no (or practically none) memory but now
I am remembering everything loud and crystal clear. It's downright shock-
ing, and it's all on paper, and it's a "self-portrait" if ever there was one.

Now it is early morning and a bit foggy but I think it is going to clear up
soon and be a beautiful day.

I'm going to go outside now and remember more.

See you soon.

Love, Joe

June 22, 1969, Calais, Vermont³

Dear Bill,

Today is another cloudy, damp, and quiet day. The 3rd such day in a row. It is
eight o'clock in the morning. Breakfast is over. Did my exercises. And some
cleaning up. Of the house, and of me. It was really good to receive your letter.
I look forward to the 22nd or so. The news of Judy Garland's death just went
by me (didn't register) until this morning when I found myself singing "Have
Yourself a Merry Little Christmas." And now it is all I can do to keep myself
from bawling. Perhaps it is partly the weather. Not really. I've always loved
her. And it has always been one of my favorite songs. And it is her song, and
nobody else's. I am a sucker for people who seem to do what they do just for
you (me). And like Marilyn Monroe. And there is nothing romantic about it.
It is not even (I don't think) generosity. As you can see, I identify with them
both. Don't think this is conceit. I don't think it is (I'm getting in over my
head). Have been painting wildflowers some (oil) in a general (basic) sort of
way (thin) so I can work over them when I really feel like it : inspiration. In
other words—I've been drawing in oils on canvas. In reference to your letter—
I'm 27! I have always thought that vanity, selfishness, and self-centeredness
were terribly underrated. I do not mean to say that you are these things.
Maybe you are and maybe you aren't. I know that I am. Some people I know
would be a lot better off if they were a little more self-centered. Of course—
there is always that question of just how great is being "better off?" I agree
with you, actually, about being thin. I mean, it is healthy and good for you
and all that. And there are people, of course, who find thinness attractive :
sexy. But—to tell you the truth—I am interested in going to bed with lots
of people, and most people find normal builds more attractive. Also—I'm
just tired of being thin. I've been thin all my life. And "thin" is being a bit
kind (skinny). May I suggest, again, that you buy some of those cardboard

boxes (file-size) at a stationery store. Paint them white. Fill them up. And stack them up in a corner. They hold an awfully [*sic*] lot of belongings and, stacked in a column, take up very little space. And (visually) no clutter. When I first got here I did some fuck drawings which Kenward liked and is writing words for. We can still do a sex-manual cartoon, of course, but I just wanted to tell you that, if so, subject-wise, there will be some competition. If you can remember will you bring those Italian photo comics? I had a lot of fun the other day with my Polaroid and self-timer taking nude photos of myself. And some "dirty" ones. I wish I could write a pornographic story as convincingly. I've tried, but can't. It occurred to me the other day that perhaps, living in New York City in 1969, it takes longer for one to settle down, focus, and actually <u>accomplish</u> something. Especially if one is our age or younger. There are so many possibilities. (Unless, of course, one is not too smart, or unless one wants to compromise). And so many temptations and so many influences. It would be impossible (I would think) for either of us to be a "natural" at this point. But this, I am sure, is good. I'm going to stop writing now and draw-paint some more wildflowers (a totally unnatural thing to do in 1969). Love, Joe

P.S. If it is possible to buy a recording of "Have Yourself a Merry Little Christmas" by Judy would you bring it up? It is from (I am almost sure) "Meet Me In St. Louis." Yes, I'm sure it is.

August 1969, Calais, Vermont[4]

Dear Bill __

When I wrote you that last letter I knew that as soon as I mailed it I would receive a letter from you. I was right.

It was so good to hear from you, really.

Did I ever thank you really for the Judy Garland record? I have not played it yet and I am not going to play it until I move into my new place with my new record player. Thank you very much for it. It is my first record. Today is a nice day but not a great one. <u>Some</u> sun. I am not out in it. I worked this morning on a "Photo Album" cartoon with Kenward. It is just like a photo album only the photos talk. I don't know about "My Dream of Life." It seems good to me but if you want to continue it that is fine with me too. I hate to be so wishy-washy but I think you know by now that I don't use my brain very much. A fact I am <u>not</u> proud of. I think collaborating works with me because I respect poetry. (Which has nothing to do with

understanding it) For several days after you left I kept setting the table for
three. No, Anne [Waldman] has not told me about "it." I assume "it" means
she is having an affair. (?) I am curious. Don't tell me about it, tho, unless
you want to. Gossip is not really that bad is it? People don't take gossip seri-
ously. And the only people that gossip is interesting about is people you care
for. So—being gossiped about, in my book, is somewhat of a compliment.
I am sure you know of the affair I had last year. Frankly, I rather enjoyed the
fact that people were talking about it. Everyone likes (I assume) to be talked
about. Good _or_ bad. It's all the same really : just talk. Which has nothing
to do, really, with the people involved. I don't know why I am trying to sell
you on gossip. Yes, I will certainly see the de Koonings: I felt a little stab in
my heart when you said you liked the Newman. I admit he is good, but he
is everything I don't believe it [_sic_]. I wish I could explain how much I hate
him but I can't. It is not his work itself I detest, it is everything that he stands
for. If I ever turn into a real painter I will be a total reaction from him. In
the totally opposite direction. I cannot read a word he writes anymore as it
makes me so mad. Art is _not_ God. Art is _not_ that serious. And art is _not_ that
boring. And snotty. And stupid, etc. (See what I mean?). I don't really think
it is fair to judge a painter by what he says but_____

_____but really!
 He is to me a total pain in the ass. I am sorry I cannot explain exactly
why. All I know is that, to me, if art has an enemy, it is Barnett Newman.
He is like death to me.[5] Kenward is still working on The Orchid Stories. I
am still up in the air a bit and very anxious now for September to come so
I can move. It's going to take a lot of guts to do all that I plan (need) to do
this fall and I just hope I can do it. (Sorry to be mysterious) but—talking
about things is too easy for me. And not fair to you really. When I do, I will
talk. In fact, I am so anxious to move that I will probably come back to the
city a few weeks before Kenward does. Kenward wants to stay until Sept.
15th but I don't know if I can wait that long. By the way—did you mean to
give me the Judy Garland records? I _asked_ you for them and it was rather
inconsiderate of me to assume they were a gift. (The truth?) Let me know.
From your letter I would say you are somewhat up in the air too. Being up
in the air is not so bad really except that time flies so, when you are "up"
and "out of it" and in the long run it makes one feel cheated. That, at least,
is how _I_ feel. (So much water under the bridge that I am not swimming in.)
It is turning, actually, into a very beautiful day. The studio is finished being
painted. You should see the garden! The buzz saw stopped for many days

but today it is at it again. I don't think in my letter I wrote you yesterday
that I apologized for being so moody the last few days of your visit. It was
not wrong of me, as that is the way I felt. But—again—it was somewhat
of a waste. (Time) I have lost interest in gaining weight. It all seems a bit
hopeless. And come fall I would just lose it again. And besides—I am having
a period where I don't look good to myself, so, like I said, it all seems a bit
hopeless. To try and improve my looks. But I'm so lucky really. God there
are so many ugly people in the world. Nothing depresses me more than to
see an ugly person. I feel for them very much. Everything is very much the
same except the flowers. They continue to change. And the weather. It has
improved somewhat. (Not much rain) Perhaps I am enclosing an interview
for you to answer in words. I say "perhaps" because I have not written the
questions yet but I plan to do so now. So—if they work out I will enclose
them. I would feel free if I were you to skip any questions you don't feel like
answering. So—as always—I hope all is well with you. May I tell you some-
thing about yourself that I do not think you are aware of? Yes.

That is that you act snobbish (off-hand-ish) to people sometimes and
it really turns people off. I mean, in particular, people you don't know very
well. But even with people you know well (like me) every now and then you
utter a totally snobbish command that really throws one for a loop. (You
don't know you do this, do you?) Well, I don't think you do. At any rate—I
am telling you this because I feel I ought to. I hope I have explained what I
mean well enough so you will know what I mean. If not (and if you are inter-
ested) tell me and I will try to explain in more detail. Well—I'm going to try
and write some questions now. I just finished "My Life" by Isadora Duncan.
(Her autobiography) Altho I didn't really believe a word of it I think that
she thought she was telling the truth, and I suppose that is all one can ask for.
But I did enjoy reading it. (Tho I am not recommending it) Actually, it was
total-corn-ball, but like I said, she was so sincere about it all. Do write.
Love, Joe

P.S. Did I tell you that Mrs. Kent died? She was so old.

Summer 1969, Calais, Vermont[6]

Dear Bill____

How good it was/is (always) to hear from you. Today is not a good day:
rainy and dark. I have been unable to settle down and concentrate on

doing much of anything. First I tried drawing some dead weeds. I've been doing a lot of this lately: drawing dead weeds. But today I couldn't get into it. Then I tried re-doing some pages from a children's book Ron & I did several years ago.[7] The idea of which is to make money. But I couldn't seem to get into that either. Then I tried re-writing, polishing, & editing my 1st four entries in my new "Vermont Diary" I am keeping when I sun-bathe. It seemed outlandishly boring. This is nothing unusual for me, however, as I always find damp dark days hard to work in. So—now I am trying this. It was awfully good to hear from you. Pat just 5 minutes ago arrived with your letter she had picked up at the co-op on her way back from the hospital. Ron is O.K.[8] The old tube got clogged so they had to put in a new tube but now all is well. It is, now, just a matter of total horizontal rest until the hole grows back together. I am especially glad that you are writing so much. What you say about writing is almost always the way I feel about painting. It would be awfully nice to know for a change. But then, maybe it wouldn't be. There are so many things that I do that I could develop into something quite extraordinary, I am sure, but none of these things seem to interest me all that much. One thing about me, I don't ever think I'll get in a rut, but on the other hand, I may never actually accomplish anything either. Yes, I do think Jane Freilicher's paintings are selfish. Or that she is selfish. But I do not think that she does not trust her feelings. Rather, I think she does, and has given into them completely. This, of course, is a compromise. I think there are both good and bad things about giving in to your feelings. I just realized that I have said something I don't believe. That I didn't mean to say. I did not mean to say that giving in to your feelings is a compromise. I know what I meant to say but I don't know now how to say it. At any rate—I wish I were a little more selfish. I would say that I paint at least 50 percent for people. I don't think I would work as much as I do (or as well) if I didn't know that I had an audience to please. To try to please. Perhaps I meant that she gave into her limitations, which is not always an unwise thing to do. If you want to. At any rate, not much is new here. Pat is usually at the hospital. Kenward is usually in the studio (ex-garage) typing on I am not always sure what. And me, I am usually upstairs working at the round table or down and out in the yard sun bathing and writing anything that comes into my head down in my diary. Wayne is usually running around naked, or taking a nap, and hardly ever crying. He's a great little boy in the "good" department.

So—you must come up. Thanks again for writing. See you soon—
Love, Joe

August 22, 1970, Calais, Vermont[9]

Dear Bill___

"Happy Birthday." Being 31 doesn't seem any older somehow than being 30.
And that's good. Being 60 may be great but if you are like me you don't look
forward to being 40. One nice thing about being 40 is that we can be in
our 40'ties [*sic*] together. Now that's all I'm going to say about age. (As tho
growing old isn't the least of our problems)

 Today is an extraordinary day. Totally blue sky and a good strong cool wind.
And a hot sun. The grass seems extra green today. I came out here just a few
minutes ago, put on some oil, and thought I would write some more "I Remem-
ber" but instead I thought of you and decided to write to you. Harry [Mathews]
is here. And nice to be around. My reading is slipping. Just finished "Memories
of a Catholic Girlhood" by Mary McCarthy! (But I liked it) Kenward is at
the cabin. Whippoorwill is stretched out to the right of my feet. (O.K. except
for a pink old age bump on his stomach) Made love last night in my dreams
with Allen Ginsberg. He had small brown bumps on his neck. (Sorry to be so
sloppy)[10] But some days I just am sloppy. I didn't find him (Allen) especially sexy
at all., but he was so nice that _____

 One of my secret desires is to sleep with everyone I especially like. And I
don't mean sex. I just mean sleep. And body warmth. Just to hug all night.

 Dick Higgins was nice and terribly straight and I have absolutely no
desire to illustrate his book. Nor to ever see him again, for that matter. He
was very much like a person from another world. Altho we were able to
talk to each other we had nothing to say. One thing that turned me off at
the beginning of our visit was my showing him "Best & Co."[11] And him
saying "I have never liked Frank O'Hara's work." I can understand someone
not giving a shit about it but I cannot understand someone not liking it.
And I told him so. But it came out (of my mouth) in a too friendly way.
Which made me mad a bit. (To be so wishy-washy) Rather, to sound so
wishy-washy. I didn't feel that way at all. To me it was like someone saying
they don't like ice cream.

 (Impossible!)

 Or trees.

I am always amazed at (in) what a small world I live in. Over and over
and over again. The good of it. And the bad of it.

But he was really terribly nice. (And to me a total bore)

A car is coming. Came. And went. A bridge is out somewhere around
here so more cars come this way. On this road. Like four or five a day. Not so
bad really.

We have been drinking a lot and smoking a lot. (At night) And stagger-
ing to bed in a very nice way. (Flop)

Your birthday present will follow. It is not as personal as I wish it were.
Except in all the time it took to make it. There it is personal. I want to send
you a beautiful quilt I bought for you but I won't. Because it occurred to me
that right now it would just be another thing for you to "own." (Too big of
a possession) And also it occurred to me that you wouldn't <u>need</u> a quilt in
California. If I am wrong in my assumptions, let me know. (It <u>is</u> a beautiful
quilt) Light and with lots of green. (Which is why I thought of you : green)
Like purple makes me think of Anne.

Harry is typing. And the wind continues to blow. I guess I will try to
have a show at the Fishbach Gallery this year. (In the small room) <u>If</u> they
want me. I think they will, but you never can tell. I am not one to count my
chickens before they [remainder of page taken up with line squiggles]

Well, that's one way to write a long letter.

The nicest thing about writing you is how close I feel to you when I do so.

Well—I <u>do</u> hope you have a happy birthday. It seems to me that turning
31 should be much easier than turning 30 and I hope I am right.

<u>I love you,</u>

Joe

P.S. When Anne and Michael were here I found a rock that looks almost
exactly like a piece of chocolate pie! If it weren't so heavy I would give it to you.
Once again____

Love, Joe

Circa October 1971, 664 6th Avenue, New York City[12]

Dear Bill__

Writing a letter to Anne I just wrote "Bill" instead of "Will" two times.
Which has nothing to do with why I am writing you. I was going to write
you anyway.

Guess you hadn't got my last letter when you wrote. Didn't mean, really, for "head" to imply "Head Poems." Thought (hoped) it was such a "stock item" image that it wouldn't mean much of anything. Oh well—everything we do is going to mean so many different things to so many different people—it's a thing one can't afford to think about much.

I taught myself to embroider and am making some blue jean "tapestries" at night. (You, so far, in one). Only for "art," believe me, did I learn (totally boring). But I like the results.

Am enclosing a few new works for your magazine. Hope you like them.

The slight delay in "Bolinas Journal" arrival is due to the addition of two more visual pages which Kenward and Jimmy felt were needed. As for me— I don't know anymore.

I'm really glad you want to do it because if you didn't I would never have gotten it into shape. And would never have gotten done. It's a work that (for me) has to appear instantly or not at all.

So I thank you.

Does what you say mean that you and Susan [Burke] are not "together"? If so, I'm sorry. Especially so, if you are sorry.

A letter from Anne today says that Jim Carroll is in very good shape. That the methadone treatments, or whatever they are, seem to be working. And that Jim is writing a lot.

If this letter is "sloppy" it's partly because I'm outside in the hot sun (always zaps the mind a bit) and because writing on the arm of a lounge chair is slightly awkward.

Really glad (did I already tell you this) about your Canadian book.

Jimmy has a poem in the new *New Yorker*.[13]

[Lewis Warsh's] *Part of My History* not going easy.

Letter from Peter S. [Schjeldahl] with no news except news of an English book he wants me to do cover for ("Sure").

True about my doing so many other things taking away from my painting but I don't care anymore. And glad, finally, not to. No Alex Katz me. I admire his focus but I am beginning to admire my lack of focus too. To bring <u>everything</u> together in some way. I think maybe that's the direction I'm headed. Assuming I keep going. And assuming the pieces are accurate enough to somehow fit together some day (exciting enough) (beautiful enough) (wanted enough) (beautiful enough) (etc).

Talking too much off the top of my head. But I guess you know that.

Funny my trying to figure out my "worth" (as an artist) when, actually, I don't believe it that very much anymore. But then—I guess I <u>do</u> too.

"Some Came Running": yes I've seen it. Three or more times (Twice at the movie theatre and at least once on T.V.) and it's one of my favorite movies too. Tho I couldn't exactly tell you why. Except that it's somehow one of the purest movies I've ever seen. So pure as to almost not even be aware of itself as a movie (do you know what I mean?). I mean—no technical struggle. No art struggle. No need to please struggle. Etc. So secure and blind (Funny how "blind" can work with you if you're lucky). And Frank Sinatra always moves me in movies. And Shirley MacClaine [*sic*; MacLaine] will never be so lucky again. And Dean Martin so "Dean Martin" at just the right point.

I have a feeling I'm not being very "clear" today. On the point, so to speak. Well—

Michael [Brownstein] had a car accident (not his fault). He's O.K., but the car is a mess. In fact, a total wreck, according to Anne.

Also his grandmother died.

And he has the flu.

I hope you are "up." Sometimes hard from letters to tell.

Kenward just walked by, paused for a moment over my shoulder, and said "Oh, Michael had a car accident?"

I hope Joanne [Kyger] is happy with her house. (My crush lingers)

Feeling a bit freaked out a week or so ago. I wrote her a rather freaked out letter which I hope didn't freak her out (probably all in my head) where too much of everything is.

Isn't this funny, and beautiful:

"If life hands you a lemon—make lemonade."

(A recent "Friendly Way" quote)

Take care.
Miss you.
Love you,
Joe

December 7, 1971, 664 6th Avenue, New York City[14]

Dear Bill__

In a strange period of doing lots of writing, which means writing letters is almost impossible.

Pains in heart are beginning to scare me. Keep thinking each night they will go away before morning but they don't.

Just got my copies of "Selected Writings" so you'll be getting one soon.

Your collage package was quite a treat to open. I'll do my bit soon.

Enjoy Maxine [Groffsky's] visit?

Hard to believe Christmas is so soon.

I had a vision that when you visited New York you would fall in love with it again and move back. Guess it didn't work out that way.

Anne reads tonight at some library on 53rd Street.

Enclosing flyer I did for Sunday reading. And two group readings soon.

Working on a series of one line paragraph poems that sound "abstract" but aren't.[15] Example:

BOOK-WORM

Have always had my nose stuck in a book from little on.

MODERN TIMES

Every four minutes a car comes off the assembly line they say.

LAKE

A lake attracts a man and wife and members of a family.

Have written 51 so far and am especially proud of 9.

The only problem is how are people to know they should be read as written, word by word (?).

If not, they fall flatter than a pancake.

Well—it was very good to see you.

Don't you always feel as I do tho, that our being together is never as full as it should be, or as it will (someday) be?

Along with working hard and funny health all of a sudden a lot of people seem to have a crush on me (pretty boys who like my book) which started out fun and now it's getting a bit insane.

Never satisfied.

Lots of rain.

Write me a letter soon, O.K.?

Love you very much.

Joe

July 3, 1972, Calais, Vermont[16]

Dear Bill __

Good to hear from you.

Today is the first day of sun since I've been here so I'm out in it.

I haven't given up everything yet because Tom Hess asked me to do the cover for their 70th anniversary issue (December) and I didn't want to say no, so I didn't.[17]

So that's what I'm working on now.

So my new deadline is July 4th. July 4th I give up everything.

I would think that if you can "live" with Larry [Fagin] you can live with anybody (that's not an insult to Larry). It might even be a compliment.

I sure don't look forward to cold turkey (from pills & cigarettes). Will you write me lots to cheer me up?

And then again I do look forward to it too.

Not much is new except that I have the crabs again (which I just gave to Kenward) who is out writing (typing) a mile a minute in the gray studio. Out by the garden. Lettuce very soon!

Clouds are beginning to cover up the sun in such a way that I suspect is permanent. But, no, here it comes again.

I'm enclosing a few more short works but I'm afraid that this is it until fall. Unless I break my no writing rule, which I won't.

How come [John and Margot] Doss are leaving Bolinas (and why does the memory of them scare me a bit)?

You and I are impossible when it comes to talking about looks. At any rate, I'm glad you like the way I look, and I'm glad I love the way you look (he-he).

You forget that, secretly, all I want is to be popular.

And not too secretively.

I always forget how hot the sun is!

How is Joanne these days?

In the back of my mind, off and on is a vision of trying to get a grant to go to some strange country to do a book on it (drawings, opinions, descriptions, etc). I suspect it to be one of those ideas that will someday come to a head.

I think, really, I am tired of trying to be a "painter."

I miss you.

Love, Joe

January 7, 1973, 664 6th Avenue, New York City[18]

Dear Bill__

Hard to explain why I haven't been writing—because I don't know. Just too "fuzzy" and "jumpy" (etc.) I guess. But—I think of you often,

AND VERY FONDLY.

Hepatitis! (Holy shit!) Well, I know how you feel. And I'm sorry. Do hope it's not a bad case. (?)

When I had hepatitis I kept a "hepatitis journal" which is so boring I have never been able to reread it to see if it really is that boring. But I'm sure it is.

Also I embroidered a pair of jeans. And did a lot of reading.

You got any hepatitis plans?

Thank you very much for the Mexican package of paper stuff. A real treat to run through. And re-run through. Etc. And to use. (Already I have used a butterfly and a sun for a series of post cards I'm doing for the Museum of Modern Art for Christmas of next year.)

I'm sorry I haven't gotten anything to you yet, but I just wasn't able to get it up this year.

But—one of these days.

In fact, now that you have hepatitis, I plan to swamp you with mail. (Because I remember how important it became : mail)

Other things I have been working on are:

A series (13, so far) of "Imaginary Still Lifes." I close my eyes and then describe the still life that slowly, or sometimes fastly [sic], appears in my head. It's fun.

A series of "Portraits" of friends: a mass of single words that go towards (to me) describing whoever it is I'm thinking about. Example:

Jimmy Schuyler

Trees. Baby Blue.

Plaid. Pajamas. Leather. Wrist

watch. Pocket knife. Books.

Silver. Autumn. Coffee.

Scissors. Yellow. Lima beans.

Belt.

I have one on you but I'm not happy with it yet.

Also, I'm writing a longish piece on Anne for some magazine that's doing an "Anne Waldman Special Issue."

Christmas was quiet. And so was New Year's Eve.

How about yours?

However, tonight, 12th night, Kenward is giving a big 12th night party.

Fantastic Chinese acrobats were here.

Also the Moscow Circus.

Reading a lot of Evelyn Waugh.

Oh, and my biggest project of all has been <u>More I Remember More</u>, which is almost finished now. This will be the last one I'm sure.

Lots of readings, most of which I don't go to. In a room listening to words seems not to be where I feel like being at night much these days.

Joe LeSueur went to Europe for the first time, and is now back.

Anne has back troubles.

Kenward has New York City troubles.

A lot of people has [*sic*] money and book problems.

Which perhaps, come to think of it, all boils down to "not much is new."

Spent Thanksgiving with D. D. and John & the boys at Nantucket. (My god!) Which is not to say that it wasn't enjoyable tho.

A guy who was staying at the house said something very funny. He said that if D. D. was reincarnated she would return as a sponge. (Funny because she had a sponge in her hand the entire weekend) And I thought my mother was a fiend!

(Well, it all has to come out one way or another, I guess)

Well (I'm written out) _____

My love to Joanne. And Peter.

Bob [Creeley] and Bobbie [Louise Hawkins].

Lynn.

And <u>YOU</u>!

Love, Joe

P.S. Yes, I have "Recent Visitors" originals.[19] Should I give them to Anne, or what?

[simple red-ink drawing of a heart]

December 1973, 8 Greene Street, New York City[20]

Dear Bill,

You should be back by now. I do hope that your trip was a good one. I feel that I should apologize for our not being as close of friends this year as I think we both wanted to be. It's a funny year what with me working so hard on my show and you out of town so much. And it's very hard for me to stay up very late. At any rate—what I really want to apologize about is our collaboration. It was stupid of me to think that I could work on it until

after my show (wishful thinking).[21] For the past year and a half I have just been working around in every direction, drawing a lot, etc., and so now I am stuck with "doing a show." Actually, I'm sorta enjoying it: doing a show. It really peters me out tho. I can't believe that it is almost Christmas. Right now I am working on a big (big for me) garden. Actually, I would rather be, I think, just a good and "interesting" artist rather than a Picasso but from time to time it's hard to resist at least trying. And you? I mean, what have you been doing, writing? I bet you have a great suntan. Kenward has been sick : flu. Scott Burton is in the hospital with hepatitis. Ron will <u>not</u> have to have his operation unless his lung collapses again. Clarice [Rivers] moves into the Oppenheim apt. this Friday. Kenward's kitchen is being all redone. Anne and Lewis might want to do my Vermont diary if I can ever believe it long enough to rewrite it (believe the diary). It will be good to see you soon. I hope I haven't confused you about our not being as good of friends as we should be. Actually, I don't mean that at all. All friendships, I guess, are a little bit of a compromise. I'm going to try to alter this. Be seeing you soon—

Love, Joe

October 1977, 8 Greene Street, New York City[22]

Dear Bill__

Terrific hearing from you!

Starting out this year trying to be very social and—so far—I am doing pretty good at it (i.e., having fun).

Otherwise, mostly I read. Big romantic novels too. Right now: "Daniel Deronda." By George Eliot. Wonderfully full of people and situations.

Am finally more or less "out" of collages. But not quite into painting yet. So—have been doing some writing too.

Last night was a very glamorous Jasper Johns opening at the Whitney : etchings for his book with Samuel Beckett. Met Joan Collins (worrying over a tiny frog inherited by surprise in a new plant just bought). John Ashbery and Ruth Kligman were all over the floor. And so many beautiful and interesting (and "available") girls, I began to wish I was straight.

<u>Love</u> our de Kooning cartoon. And, yes, of course I'll sign 20. But not without grumbling a bit over only getting 5 copies. It's not much fun to have something "out" if you can't share them (show off to, too) with friends. So—if you can con a few more out of the guy, will you?

And before I forget—if it's not too late, would you date at the end my
Frank [O'Hara] piece? I feel very strongly that what I said then is not what
I would say now. And I feel very strongly too about making clear about
my writing that it relates most accurately only to the particular occasion
of having "done" it exactly when I did it. I shudder at being responsible for
what I say.

Showing in Paris right now (was a big hit there last year). Tho a flop
in Australia (to say nothing of Kansas City and Philadelphia and Rhode
Island: zero again). I suspect my wide range only baffles. Tho, as I said, Paris
seems able to lump it.

A show this spring in Santa Fe may find me there and, if so, Bolinas and
you I would find hard to resist.

What I would say—since you ask—about teaching a writing class would
be "work shop," related life-style, and motivation. The "whys" and the
"hows" of walking as thin of a line as possible. Setting oneself up for the
unexpected. Riding the waves. Etc. All rather romantic, I suppose.

A production of Kenward's "Washington Square" opens this Thursday.[23]

Michael Brownstein has gotten himself involved in a dance piece where
he interviews a dancer who replies in motion rather than words.

Maxine has become a very successful agent.

My little brother John has moved to N.Y. to get into advertising (art-
wise) which he seems to be doing quite well already.

End of "news," I'm afraid.

As you know—it's a big city only when you don't live here.

Guess I've covered all the ground I've got at my finger tip at the moment.

Except to let you know that I miss you, and think of you often too.

My love to Lynn

My love to you,

Joe

P.S. enclosing some recently published French post cards I hope you'll like.

Late spring, early summer 1989, 8 Greene Street, New York City[24]

Dear Bill,

A beautiful (sunny and crisp) Thursday afternoon, just back from the
dentist (intricate bridge). And tonight? Absolutely nothing for a change.
Which means a deli sandwich, T.V., and reading. Currently Mary Wesley,

another of those English ladies I find myself drawn to. Somewhat reminiscent of Elizabeth Bowen and Elizabeth Taylor, with a bit of Colette thrown in. Most endearing to me is that she didn't start writing until her early seventies!

Real good to hear from you as always. Though of course I'm sorry to hear about the Denver guy. But delighted about the possibility of a Black Sparrow book. But—please!—do go for a big one! In the meantime, I'll go ahead with the drawings and—fuck it—if no one else wants to do it I'll do it.

Kenward just got back from Boston where he was the General in "The General Returns, Etc." Directed by Arnold Weinstein, with (all-star cast) Larry Rivers, Kenneth Koch, and John Ashbery. Part of a Frank O'Hara festival of sorts, I gather. Which "went very well" until later that night, in his hotel room, Kenward lost two teeth, biting into a refrigerated chocolate bar. (Went over last night for dinner: soup, scrambled eggs, and ice cream). And tomorrow he leaves for Vermont. (There is a dentist there). Me: not until June 1st. Not so far away. What with so much to do, and so many people to see. (I'm real social because I like to keep in touch with everybody: 30 years in N.Y.C. makes for a lot of friends).

I know what you mean about Francis Bacon. I think he's probably a great painter : at least he certainly has a way with paint. But still—I find myself embarrassed. He's so melodramatic, and corny!

Have some hopes of seeing Anne this Wednesday night, zipping through N.Y. towards home, after an Eastern European reading tour with Allen and others (she loved Bali, and Reed [Bye] is getting fed up with her never being at home). Do you keep in touch?

Well—I'm written out—til next time:
Love, Joe

January 22, 1990, 8 Greene Street, New York City[25]

Dear Bill,

Oh well—it shouldn't be hard work. And/but I certainly know what you mean about not having much to write about. My dream life is much more interesting and—alas—satisfying than my waking hours. Last night—for example—I made out with the governor of New York, Mario Cuomo. Hardly my type, but it was fun, and he was terribly nice. I asked him if it's true that Ed Koch is gay and he said "Oh sure. You'd be surprised how many (politicians) are." Then sometime later I had a nice chat with Rosanne Barr,

who is surprisingly down to earth, and easy to talk to. I liked her a lot. All in all a very enjoyable and star-studded evening.

Today is Sunday, with rain and snow which equals slush. Did you know that Kenward is going to be reading in San Francisco in early March? Forgot where. And Jimmy is fine—very happy in fact—though I haven't seen him much lately—(it happens when people get new boyfriends): his name is Artie.

I got a nice assortment of flowers to draw today. Which I hope to approach with "what's in it for me?", as opposed to "How can I make a drawing out of this?" (Pleasure and discovery verses executing a vision). We'll see.

Right now I can't quite see a future slot to visit Bolinas in. But I can imagine just doing it on the spur of the moment. Though a lot of things don't get done in just this way. (I sometimes feel that my life is a composite of all the decisions I didn't make. Which—however—hasn't turned out so bad at all!)

Love, Joe

April 16, 1990, 8 Greene Street, New York City[26]

Dear Bill,

Please forgive my silence. Both verbally and pictorially (probably with only one "l" each?). But it's been one hell of a 1990 so far (physically). Most recently, a devastating attack of shingles. All over my face, onto my scalp, and inside one ear! Three and a half weeks later, I'm fine now. Though my face is still pitted and discolored.

As for the book, I think I'm probably going to need a new location (Vermont) and a deadline, and—as I go to Vermont June 1st—how does July 1st sound? I.e, can you live with this? Such old friends can always say "no," so please don't hesitate to exercise the privilege, if.

A pleasure to come across two references to you in one day (!) in the current "Interview" and "People" (via Alex [Katz] and your mother).

Recently zipped through (they move at quite a clip) four reissued novels by Dawn Powell: about N.Y.C. in the 40s and 50s, funny and atmospheric. And am currently reading (and recommend highly to Lynn) "Lost in Translation" by Eva Hoffman (autobiography, Penguin paperback).

A rainy Easter Sunday, with three dental appointments this week.

And that's about it for news!

Love, Joe

Spring 1993, 8 Greene Street, New York City

Dear Bill,

Real nice to hear from you, again so soon, and as always. And thank you for the perfectly correlated copy of "Bolinas Journal."

I was thinking of you just last night, having dinner at Pat and Ron's—(fried chicken, mashed potatoes, gravy, spinach, and biscuits: yum-yum)—off your plates—(remember?)—with the blue bleeding "rainbow" borders. Passed on, from your famous move west.

My birthday is March 11th, but as for what I'm up to—that's harder to say. Really, nothing much, and yet.......

Of course there's breakfast, lunch, and dinner. Some physical activity (gym). And then I read a lot. And dinner with friends. And so time flies, and very pleasurably so. I really seem to enjoy comfort a lot. And peace of mind. Not too many decisions to make. And—best of all—a good night's sleep.

Did you know—could you care less?—that there's a store in New York called "Big Sky"? (Western gear). I pass it often, and think of you.

Spring is here, and Kenward is in Vermont; soon Seattle. Alice Notley arrives any day now. As does the Frank O'Hara biography.[27] Word of mouth is bad, but I'm sure I'll love it anyway. Just to know more about his early days, and to be reminded.

Well I guess that's about it.

Love, Joe

P.S. All best to Lynn!

August 20 1993, Calais, Vermont[28]

Dear Bill,

Thank you for your letter of June 5th! I'm awfully sorry for being so late in getting back to you, but things have been very hairy. First Kenward developed diabetes, which was pretty scary, though under control now. We eat five small meals and take two walks a day. No sugar or alcohol, of course. And he has to prick his finger twice a day. And of course he's on a diet. And has lost 30 pounds! Then I came down with some mysterious stomach thing—(cramps, bloating, pain)—and the doctors still can't figure out what it is. However, I had a sonogram yesterday, so maybe I'll know something by

tomorrow. This has been going on for almost two months, and I am getting very bored and grumpy! The only thing that offers <u>some</u> relief is lying flat on my back, so—picture me reading a lot.

And now it's your birthday and I didn't have anything to send you except—

<div align="center">

<u>LOTS OF LOVE</u>,

Joe

</div>

P.S. "<u>Happy birthday!</u>"

P.P.S. And <u>I've</u> lost ten pounds!

P.P.P.S. Sorry for such a boring note: all I'm up to right now. But hopefully more soon. In the meantime_____

<u>All best</u> to you and Lynn!

Summer 1993, Calais, Vermont[29]

Dear Bill,

Let's see. It's Monday morning, just after breakfast—(orange juice, cinnamon roll, banana)—and today promises to be a perfect summer day: blue sky, sunny and warm: a rarity this odd (and cool) summer. So picture me this afternoon out in the middle of the lake—white swimming trunks—floating around on a bright red air mattress, blissed out of my mind. Though, of course, anything could happen between then and now.

And—really—that's about it for news. I read and sleep and eat (miss you). And time flies.

Black beans are soaking in a big bowl of water on the kitchen counter, for supper tonight. With basmati rice. And left-over ham. And orange jello (made from scratch). With maybe heavy cream and blueberries on top. A sprig of mint.

And so now you know everything!

"<u>Happy birthday!</u>"

<div align="center">&</div>

<u>lots of love</u>,

Joe

P.S. <u>All best</u> to Lynn!

NOTES

INTRODUCTION

1. Joe Brainard to Anne Waldman, 1971, box 4, folder 1, Anne Waldman Papers, Special Collections Research Center, University of Michigan Library.
2. Patti Smith, *Just Kids* (London: Bloomsbury, 2010); James Schuyler, *Just the Thing: Selected Letters of James Schuyler, 1951–1991*, ed. William Corbett (New York: Turtle Point, 2005); Richard Hell, *I Dreamed I Was a Very Clean Tramp—An Autobiography* (New York: HarperCollins, 2014); Bill Berkson and Bernadette Mayer, *What's Your Idea of a Good Time? Letters & Interviews, 1977–1985* (Berkeley, CA: Tuumba, 2006); Andy Warhol, *The Andy Warhol Diaries*, ed. Pat Hackett (New York: Twelve, 2014).
3. Rudy Kikel to Joe Brainard, October 14, 1980, box 4, folder 23, Joe Brainard Archive, Special Collections & Archives, University of California, San Diego.
4. W. C. Bamberger, *Locust Gleanings: Essays, Reviews, and Other Interregna on Books, Language, and Literature, 1984–2009* (Cabin John, MD: Wildside, 2010), 42.
5. For example, Brainard often (but not always) inserted spaces just before and after colons. Instead of "correcting" this practice by aligning the colons directly against the preceding letters, I have preserved Brainard's spacing. These spaces reflect Joe's rhythm, resisting the typical abruptness associated with colons and allowing readers to envision a more relaxed, musical pause within his sentences.
6. Keith McDermott, "Homage to Joe," in *Loss Within Loss: Artists in the Age of AIDS*, ed. Edmund White (Madison: University of Wisconsin Press, 2001), 256.
7. As Brian Glavey put it, Brainard's handwriting is "drawings. Writing is, in other words, already a form of draughtmanship for Brainard." Brian Glavey, "The Friendly Way," in *Joe Brainard's Art*, ed. Yasmine Shamma (Edinburgh: Edinburgh University Press, 2019), 143.
8. Marjorie Perloff, "Afterword," in Shamma, ed., *Joe Brainard's Art*, 250.
9. Joe Brainard to Sue Schempf, December 22, 1961, courtesy of E. G. Schempf.
10. Donald Allen, ed., *The New American Poetry: 1945–1960* (New York: Grove, 1960).
11. Frank O'Hara and Larry Rivers, *A City Winter and Other Poems* (New York: Tibor de Nagy, 1951); John Ashbery, *Turandot: And Other Poems* (New York: Tibor de Nagy, 1953); Nell Blaine and Kenneth Koch, *Prints Nell Blaine / Poems Kenneth Koch* (New York: Tibor de Nagy, 1953); and Barbara Guest, *The Location of Things* (New York: Tibor de Nagy, 1960).

12. See Catherine Gander, "'Twenty-Six Things at Once': Pragmatic Perspectives on Frank O'Hara and Norman Bluhm's Poem-Paintings," in *Mixed Messages: American Correspondences in Visual and Verbal Practice*, ed. Catherine Gander and Sarah Garland (Manchester, UK: Manchester University Press, 2016), 85–107, for a reading of O'Hara and Bluhm's collaborations. Also see Mark Silverberg, ed., *New York School Collaborations: The Color of Vowels* (New York: Palgrave Macmillan, 2013); and Jenni Quilter, *New York School Painters & Poets: Neon in Daylight* (New York: Rizzoli, 2014), for analyses of collaborative practice in the New York Schools of poetry and visual art.

13. Drawing on his inheritance, Elmslie supported Brainard financially throughout his life. His private foundations donated funds anonymously to indigent writers and poetry-related projects and organizations. Several addressees in *Love, Joe* benefited directly from Elmslie's largesse.

14. For more on the importance of niceness as a kind of affective mode seeding Brainard's work, see Richard Deming, "Everyday Devotions: The Art of Joe Brainard," *Yale University Art Gallery Bulletin* (2008): 75–87; and Brian Glavey, "Friending Joe Brainard," *Criticism* 60, no. 3 (2018): 315–40. Andy Fitch's *Pop Poetics* argues how niceness "does not fit this poet, so much as it defines him," and urges readers to move beyond treating the activity of reading and seeing Brainard's work as a proxy for rubbing shoulders with "Saint Joe" (as Brainard's friend Edmund White memorably put it). Andy Fitch, *Pop Poetics: Reframing Joe Brainard* (Champaign: Dalkey Archive Press, 2012), xx.

15. John Perreault, "Poets and Painters," *Village Voice* (April 20, 1967), 12.

16. Gavin Butt, "Joe Brainard's Queer Seriousness; or, How to Make Fun of the Avant-Garde," in *Neo-Avant-Garde*, ed. David Hopkins (Amsterdam: Rodopi, 2006), 277–300, is a good companion piece to Fitch's monograph and Deming's and Glavey's essays, as he invites us to "consider how [Brainard's] work might be taken as providing an *alternative* approach to serious meanings, ones which we might construe in terms of an unstraight seriousness, a 'queer' kind of earnestness" (284).

17. Joe Brainard to Bill Berkson, undated pre-November 1975, box 1, folder 36, Bill Berkson Papers, Archives and Special Collections, Thomas J. Dodd Research Center, University of Connecticut.

18. Barnett Newman, *Barnett Newman: Selected Writings and Interviews* (Berkeley: University of California Press, 1992), 140.

19. Lewis Warsh, *Angel Hair Sleeps with a Boy in My Head: The Angel Hair Anthology*, ed. Anne Waldman and Lewis Warsh (New York: Granary), xxiv–xxv.

20. Warsh interview with Peter Bushyeager, *The Poetry Project Newsletter* 187 (Dec.–Jan. 2001–2002), 13.

21. Quoted in Deming, "Everyday Devotions," 83.

22. Joe Brainard, "Andy Warhol: Andy Do It," in *The Collected Writings of Joe Brainard*, ed. Ron Padgett (New York: Library of America, 2013), 178–79.

23. Andrew Epstein and Andy Fitch, "I Wonder: In Dialogue, On Dialogue," in Shamma, ed., *Joe Brainard's Art*, 175.

24. Fitch, *Pop Poetics*, xx.

25. Frank O'Hara, "Personism," in *The Collected Poems of Frank O'Hara*, ed. Donald Allen (Berkeley: University of California Press, 1995), 499.

26. John Yau, "Joe Brainard *The Nancys*," *Brooklyn Rail*, May 1, 2008, https://www.mutualart.com/Article/Joe-Brainard-The-Nancys/D9CB70355729E9AC.

27. Joe Brainard to Ron Padgett, October 21, 1965, New York City, courtesy of Ron Padgett.

28. Joe Brainard to Fairfield Porter, Summer 1974, Calais, Vermont, courtesy of Ron Padgett.

29. Padgett writes, "Over the years, [Brainard] took an increasingly dim view of his work, seeing it as lightweight, facile, and lacking in the qualities of the high art of the oil painters he so admired, such as de Kooning, Manet, Goya, Katz." Ron Padgett, *Joe: A Memoir of Joe Brainard* (Minneapolis, MN: Coffee House, 2004), 253.

30. John Yau, *Joe Brainard: The Art of the Personal* (New York: Rizzoli, 2022).

31. Joe Brainard to James Schuyler, undated, box 2, folder 6, Joe Brainard Archive, Special Collections & Archives, University of California, San Diego.

32. Joe Brainard to Larry Fagin, box 1, folder 48, Larry Fagin Papers, Archives and Special Collections, University of Connecticut Library.

33. Alice Notley to Joe Brainard, 1993, box 5, folder 17, Joe Brainard Archive, Special Collections & Archives, University of California, San Diego.

1. DEAR DICK

1. These letters are courtesy of Ron Padgett.

2. "Newsprint" refers to the poor-quality paper Brainard was writing on.

3. According to Ron Padgett, "Mr. Stevens was a businessman who had an office in downtown Tulsa, an oil man, if memory serves. (I accompanied Joe on his visit to that office.) Joe did the painting for him, of an oil well. (Ron Padgett, e-mail to the editor, November 17, 2021).

2. DEAR JOAN

1. These letters are courtesy of Joan Brix Banks.

2. "T.U." is the University of Tulsa.

3. Brainard did end up going to Mexico, accompanying Tulsa-based painter Nylajo Harvey and her family.

4. The "fairy godmothers" were Anne Kepler, Leslie Segner, and Joan Brix.

5. "I remember Anne Kepler. She played the flute. I remember her straight shoulders. I remember her large eyes. Her slightly roman nose. And her full lips. I remember an oil painting I did of her playing the flute. Several years ago she died in a fire giving a flute concert at a children's home in Brooklyn. All the children were saved. There was something about her like white marble." Joe Brainard, "I Remember," in The Collected Writings of Joe Brainard, ed. Ron Padgett (New York: Library of America, 2013), 26. Kepler actually died in Yonkers, New York, where she was teaching flute to children at the Yonkers Jewish Community Center. While Brainard writes that "all the children were saved," in fact nine children succumbed. This terrible event made the cover of the following day's New York Times (see "9 Children and 3 Adults Killed in Fire at Yonkers Jewish Community Center," New York Times, December 21, 1965, 1, 30).

6. "I remember how much I used to stutter" ("I Remember," 6); "I remember one day in gym class when my name was called out I just couldn't say 'here.' I stuttered so badly that sometimes words just wouldn't come out of my mouth at all. I had to run around the field many times" ("I Remember," 14).

7. I have not been able to identify who "Tom" is.

3. DEAR SUE

1. These letters are courtesy of E. G. Schempf.

2. Brainard was referring to work belonging to the gallery, not his own work.

3. I have not been able to determine who J. B. Thompson is.

4. Title of one of Joe Brainard's paintings from this period.

5. The "Art of Assemblage" exhibition at the Museum of Modern Art, New York City, was on view from October 4 through November 12, 1961.

6. Brainard was eventually called up by the Selective Service Board but was excused from service after acknowledging his homosexuality.

7. The postmarked envelope for and first page of this letter are lost, but Brainard's references to his "7-Up" paintings date it to 1962.

8. Schempf had arranged a show for Brainard at her frame shop in Tulsa. When she saw his collages "that had words typed and scribbled on American flags, she was so offended that she cancelled the exhibition." See Ron Padgett, "Joe Brainard in 1961–1963," accessed March 16, 2024, http://www .joebrainard.org/Joe%201961-63.pdf/.

9. The first page of this letter is missing.

10. Brainard's reference to an "Old Swedish Film Series" at the Museum of Modern Art dates this letter to late 1962, as MOMA showed a three-month retrospective entitled "Swedish Films, 1909-1957" that began on October 10, 1962.

11. Phillip Lopate served on the editorial board of Columbia University's literary magazine *The Columbia Review* when both he and Padgett were students there, though Padgett was no longer serving in the capacity. In 1963, following the Dean's Office demand to the editors that they remove poems by Berrigan and David Bearden for purportedly obscene content, Padgett and other members of the editorial board quit in protest. From the ashes of *The Columbia Review* emerged Ted Berrigan's own *C: A Journal of Poetry*.

4. DEAR PAT

1. These letters are courtesy of Pat Padgett.

2. "I remember the great girl-love of my life. We were both the same age but she was too old and I was too young. Her name was Marilyn Mounts. She had a small and somehow very vulnerable neck. It was a long thin neck, but soft. It looked like it would break very easily." Joe Brainard, "I Remember," in *The Collected Writings of Joe Brainard*, ed. Ron Padgett (New York: Library of America, 2013), 41.

3. Monroe died on August 4, 1962.

4. "A Prize in Every Box" was the motto for the popular Cracker Jack caramel-coated popcorn and peanut snack.

5. The "Kelly Girls" was the popular name for women working through the temporary employment agency Russell Kelly Office Services.

6. Brainard moved to Boston on January 9, 1963. This is the first letter he wrote Pat Padgett from Boston after leaving New York City.

7. David Goodis, *Shoot the Piano Player* (New York: Grove, 1956); Julian Huxley, *Evolution in Action* (New York: New American Library, 1960); Grace Metalious, *The Tight White Collar* (London: Muller, 1961); and Edith Hamilton, *The Roman Way to Western Civilisation* (New York: New American Library, 1957).

8. Havelock Ellis, *On Life and Sex* (New York: New American Library, 1957).

9. Bickford's was a popular cafeteria chain.

10. By "all his novels," Brainard is referring to Fyodor Dostoevsky's works.

11. Constance, or "Connie," Chatterley, the main character in Lawrence's novel *Lady Chatterley's Lover* (1928).

12. The Bartletts were a well-to-do, politically connected family in Tulsa with whom Brainard was acquainted.

13. While there is a text entitled "January the 13th" in *The Collected Writings of Joe Brainard* (485), it bears no relation to the text "January 13th, 1963" that Brainard sent to Pat Mitchell. However,

"January 13th, 1963" contains some phrases and lines that made their way into "A True Story," which is published in Padgett, ed., *The Collected Writings of Joe Brainard*, 162–69.

14. John Ashbery, *Some Trees* (New Haven, CT: Yale University Press, 1956).

15. The first Filene's Department Store, founded in Boston and opened in 1912.

16. Brainard submitted these works to the Boston Fine Arts Festival, an annual arts festival that in 1963 was judged by Edward Hopper, Robert Motherwell, Henry Varnum Poor, Theodor Roszak, and William Zorach.

17. "Jo Anne" was a woman Brainard worked alongside at Magna Film Company, Boston.

18. This was a 7 × 4¾″ collage entitled *Homage to Marilyn Monroe*.

19. Brainard reproduced the brand name "Kellogg's" in black ink and superimposed it on a number of his artworks.

20. "I remember Royla Cochran. She lived in an attic and made long skinny people out of wax. She was married to a poet with only one arm until he died. He died, she said, from a pain in the arm that wasn't there." Brainard, "I Remember," 41.

21. Following the valediction, Brainard copied down his poem "I Like," reproduced in Padgett, ed., *The Collected Writings of Joe Brainard*, 172–74.

22. "4B" and "4C" refer to a series of works Brainard was getting framed.

23. *Untitled (Big Marilyn Monroe)*, 1963, assemblage, 28 × 14 × 1″, is reproduced in John Yau, *Joe Brainard: The Art of the Personal* (New York: Rizzoli Electa, 2022), 70.

24. Published by Lorenz Gude and edited by Ted Berrigan, *C: A Journal of Poetry* ran from May 1963 (vol. 1, no. 1) through May 1966 (vol. 1, no. 1–vol. 2, no. 14).

25. The section of the letter just above the line was written in blue pen while this section was written in red. Brainard often used lines and different-colored pens to graphically mark new times or days working on the same letter.

26. *Untitled (Big Marilyn Monroe)*, 1963.

27. "Boom" and related works are reproduced in Ron Padgett's essay, "Boom: Joe Brainard 1961– 1963," in *Joe Brainard's Art*, ed. Yasmine Shamma (Edinburgh: Edinburgh University Press, 2019), 69–79.

28. Bernadean Mitchell, Pat and Tessie Mitchell's sister, was known as "Bernie."

5. DEAR TED

1. Ron Padgett, *Ted: A Personal Memoir of Ted Berrigan* (Great Barrington, MA: The Figures, 1993), 12.

2. *C Comics* (New York: Boke, no. 1, 1964; no. 2, 1965).

3. Ted Berrigan, Ron Padgett, and Joe Brainard, *Bean Spasms* (New York: Kulchur, 1967); Ted Berrigan and Joe Brainard, *Living with Chris* (New York: Boke, 1968).

4. Joe Brainard to Ted Berrigan, n.d., box 1, folder 14, Joe Brainard Archive, Special Collections and Archives, University of California, San Diego.

5. Brainard to Berrigan, n.d., box 26, MA Am, 2729, Ted Berrigan Correspondence, Houghton Library, Harvard University.

6. Brainard to Berrigan, n.d., box 2, folder 5, Ted Berrigan and Alice Notley Collection, Stuart A. Rose Manuscript, Archives, and Rare Book Library, Emory University, Atlanta, Georgia.

7. "Building a House" and "Some Feathers" are poems by Dick Gallup that were included in *C* 1, no. 3 (1963): 29–30 and 7, respectively.

8. These two lines are excerpted from Dick Gallup's poem "Building a House."

9. "And O, I am afraid" is the ninth line in Ted Berrigan's "Sonnet 52," published in *C* 1, no. 2 (1963): 24.

10. The line "Tell me now, again, who I am" is the final line in Berrigan's "Sonnet 34," published in *C* 1, no. 3 (1963): 9.

11. These are the opening lines in Berrigan's "Sonnet 37," published in *C* 1, no. 3 (1963): 10.

12. This is the sixth line in Berrigan's "Sonnet 44," published in *C* 1, no. 3 (1963): 11.

13. These are lines two through six in Berrigan's "Sonnet 37," published in *C* 1, no. 3 (1963): 10.

14. Warhol produced the front and back covers for volume 1, number 4 of *C: A Journal of Poetry* (September 1963). It created quite a scandal in New York's art and poetry world because the back cover was composed of an image of the poet and Velvet Underground dancer Gerard Malanga kissing the poet and dance critic Edwin Denby. For more detailed information on the issue and the hubbub it caused, see Reva Wolf, *Andy Warhol, Poetry, and Gossip in the 1960s* (Chicago: University of Chicago Press, 1997).

15. It is unclear what Brainard is referring to here, as no works of his were published in *C* 1, no. 4 (1963) or in any other issues of *C* that might be described as an "art article" and features the phrase "dear Japanese babies."

16. All the works from *Grand no. 1* through *Grand no. 5* that Brainard references here were three-dimensional, around two or three inches deep. In an email to the editor of this book, Ron Padgett explains, "Framers call the structure 'shadow boxes.' Brainard's later constructions (such as his *Prell*) tended to be more fully developed in all dimensions and didn't fit inside glassed frames. One could say that the Grands ('grand' perhaps because they suggested a large scale) were precursors to his constructions, which he started making when he moved into Tony Towle's apartment in late 1963." Ron Padgett, email to the editor, February 6, 2023.

17. This short note, postmarked just four days after Frank O'Hara died from injuries sustained in an accident on Fire Island, was found by Nick Sturm in the Ron Padgett Papers, box 6, Correspondence 1964–1968 "Mainly Ron's letters to Ted [Berrigan], from Tulsa, VT & NY," Beinecke Library, Yale University, New Haven, Connecticut. On the back of the envelope, Berrigan wrote, "Dear Ron—I wouldn't sell this one: so here's a present for you. Note the date. Love, Teddy."

6. DEAR SANDY

1. These letters are courtesy of Sandy Berrigan.

2. There is not much in the way of correspondence between Brainard and Sandy Berrigan between 1963 and the later 1960s. While no postmark is available for this letter, Brainard's reference to Sandy and Ted Berrigan's breakup and the closing of a solo show of his means this must have been written in mid-1969, particularly as the show Brainard refers to is in all probability one held at the Landau-Alan Gallery (March 22–April 17, 1969).

3. Brainard wrote this over the course of a couple of days. His reference to a Jim Brodey reading at the Poetry Project dates the letter to October 25. Brodey read on October 29, 1969.

4. Ted Berrigan died on July 4, 1983.

7. DEAR JIMMY

1. See Nathan Kernan, "Joe Brainard: The Madonna of the Future," in *Joe Brainard's Art*, ed. Yasmine Shamma (Edinburgh: Edinburgh University Press, 2019), 41–68, for an analysis of how Schuyler and Brainard influenced each other's approaches to art, writing, and life.

2. Joe Brainard to James Schuyler, n.d., James Schuyler Papers, box 2, folder 4, Special Collections & Archives, University of California, San Diego. Brainard was staying at the painter Robert Dash's loft apartment on Mercer Street in New York City at the time.

3. Brainard is referring to Ted Berrigan's *C: A Journal of Poetry* 1, no. 8 (April 1964).

4. Ron Padgett, *In Advance of the Broken Arm* (New York: C Press, 1964).

5. Though John Ashbery and James Schuyler's collaborative novel *A Nest of Ninnies* was published in its entirety in 1969 (New York: E. P. Dutton), excerpts from the novel were published in *Locus Solus* no. 2 (Summer 1961), so it is possible Brainard was referring to these excerpts or to a manuscript of the novel that Schuyler may have given him.

6. Jack Kerouac, *Big Sur* (New York: Bantam, 1963).

7. *C: A Journal of Poetry* 1, no. 9 (1964).

8. Ted Berrigan, *The Sonnets* (New York: "C" Press, 1964).

9. I have been unable to identify "Emilio's" surname.

10. The Gallery Moos, Toronto.

11. An undergraduate women's college established in 1900 and closed in 1976. It had two locations, one on the Upper East Side of Manhattan and another in upstate New York. Under the directorship of Elayne Varian (1964–75), the Finch College Museum of Art hosted important shows of contemporary art, including the series "Art in Process."

12. Brainard to Schuyler, n.d., James Schuyler Papers, box 2, folder 5. Brainard wrote this letter while staying at Fairfield and Anne Porter's home in Southampton with Kenward Elmslie, while Schuyler was probably in Maine with the Porters.

13. Based on Brainard's description, it is likely that he is referring to the painter Leon Kroll.

14. "Bernard" is probably the painter Bernard Perlin, who was friends with Schuyler at the time.

15. Porter's works were included in the 1968 Venice Biennale. Schuyler was close friends with Anne and Fairfield Porter, and it is widely understood that Schuyler and Fairfield also were lovers.

16. "Leonid" is possibly the painter Leonid Berman.

17. Peter Schjeldahl, "Poets and Painters as Painters and Poets," *New York Times*, August 11, 1968.

18. Brainard to Schuyler, n.d., James Schuyler Papers, box 2, folder 5.

19. Brainard to Schuyler, n.d., James Schuyler Papers, box 2, folder 5.

20. The poet John Giorno, a friend of Brainard's, was in an on-again, off-again relationship with the painter Jasper Johns.

21. The poet John Wieners was committed to Central Islip State Hospital in Long Island in July 1969. He suffered from schizophrenia throughout his adult life.

22. "Dial-A-Poem" was a telephone call-in service developed by the poet John Giorno. Basing the project initially in the Architectural League of New York townhouse at 64th Street and Madison Avenue, Giorno set up twelve telephone lines, each of which broadcast a different prerecorded poem. Callers would simply dial the given number and listen to the poem.

23. This might be a reference to the 1971 film *A New Leaf*, directed by Elaine May.

24. Brainard to Schuyler, n.d., James Schuyler Papers, box 2, folder 5.

25. Brainard to Schuyler, n.d., James Schuyler Papers, box 2, folder 6.

26. Brainard to Schuyler, n.d., James Schuyler Papers, box 2, folder 6.

27. Elmslie and Brainard had mailed Schuyler marijuana.

28. Brainard is referring here to amphetamine, or "speed" pills.

29. Brainard to Schuyler, n.d., James Schuyler Papers, box 2, folder 6.

30. Joe Brainard, *The Banana Book* (New York: Siamese Banana, 1972).

31. Brainard to Schuyler, n.d., James Schuyler Papers, box 2, folder 6.

32. To this day, phoebe birds make a nest under the front porch ceiling of Elmslie's home in Calais, Vermont.

33. A tremendous bolt of lightning had torn a trench in Elmslie's front yard.

34. Brainard to Schuyler, n.d., James Schuyler Papers, box 2, folder 7.

35. A version of this sentence is included in Brainard's *Bolinas Journal* (Bolinas, CA: Big Sky Books, 1971).

36. Brainard is referring to his book *Selected Writings, 1962–1971* (New York: Kulchur Foundation, 1971).

8. DEAR PAT AND RON

1. All the letters addressed to Pat and Ron Padgett are courtesy of the Padgetts, though they are also archived in Ron Padgett Papers, Beinecke Rare Book and Manuscript Library, Yale University.

2. As there is no such review in *Kulchur* or, indeed, in any other journal of the period, it appears that Brainard's review never got published.

3. The book by the poet Lawrence McGaugh that Brainard mentions is probably *A Fifth Sunday* (Berkeley, CA: Oyez), 1965.

4. This is possibly a reference to *Signal*, a London-based arts and literature magazine published between 1964 and 1966.

5. "Ernie Padgett" refers to Ron Padgett, who produced a piece under that name for the collaborative book *Bean Spasms*. Ernie Bushmiller created the nationally syndicated *Nancy* cartoon strip. Brainard and Padgett collaborated on creating détournements of Bushmiller's cartoon, thus the composite name "Ernie Padgett." From 1963 through 1978, Brainard adapted the Nancy character into a series of witty and sometimes pornographic images. Many of these images have been collected in Joe Brainard, *The Nancy Book* (Los Angeles: Siglio, 2008).

6. Leo Castelli's gallery, founded in 1957 in his apartment at 4 East 77th Street on the Upper East Side of Manhattan, was one of the first to show works by painters including Jasper Johns and Robert Rauschenberg. By the early to mid-1960s, Castelli's gallery had become known for its visionary promotion of pop, minimalist, and conceptual artists such as Andy Warhol, Richard Serra, Donald Judd, and Roy Lichtenstein. In 1965—the year Brainard wrote this letter to Ron and Pat Padgett—Castelli's gallery had solo and group shows featuring artists including John Chamberlain, Frank Stella, and Larry Poons. Brainard's drawings were included in the "Benefit for the Foundation for the Contemporary Performing Arts" show at the Castelli gallery. It ran from December 14, 1965, through January 4, 1966.

7. As there is no book entitled *Letters and Tomatoes*, Brainard is probably referring *The Groucho Letters: Letters from and to Groucho Marx* (New York: Simon & Schuster, 1967).

8. Brainard showed his work at the Alan Gallery through 1969.

9. The gallery mentioned was the Park Place Gallery, which in 1965 was located at 542 West Broadway. Paula Cooper served as the director, and as Brainard notes, the gallery featured weekly poetry readings.

10. James Schuyler, *May 24th or So* (New York: Tibor de Nagy, 1966).

11. *Tzarad*, edited by the poet Lee Harwood, was a magazine that ran for three issues (1965, 1966, 1969) and featured several poets aligned with the New York School of poetry. Brainard's poems were published in *Tzarad* no. 2 (October 1966).

12. Toffenetti, marketed as "the busiest restaurant on the busiest corner," was a vast thousand-seat restaurant in Times Square that was founded in 1940 and closed in 1968.

13. Berrigan reviewed shows by the painters Robert De Niro, Julian Stanczak, and Mario Yrisarry. The review was published in *Art News* 64 (October 1965).

14. *Kulchur* magazine nos. 1–20 (1960–65) and the associated Kulchur Press, funded, edited, and managed by the uptown doyenne Lita Hornick, was an important outlet for Brainard, Berrigan, Padgett,

and other writers and artists affiliated with the New York School. *Kulchur* also published reviews, essays, and creative work by poets aligned with Black Mountain College (Paul Blackburn, Charles Olson), the Beats (Allen Ginsberg, Diane di Prima, Gregory Corso, William Burroughs), the nascent Black Arts movement (Amiri Baraka, then known as LeRoi Jones), and the Objectivists (Louis Zukofsky).

15. There were twenty issues of *Kulchur* in total, though the "Rose Book Drawings" Brainard is referring to did get published as a collaborative visual-verbal work with Ron Padgett under the title "Go Lovely Rose," *Kulchur* 20 (Winter 1965/66): 37–42.

16. The Grolier Poetry Book Shop in Cambridge, Massachusetts, an independent book shop specializing in poetry.

17. *Lines* nos. 1–6 (September 1964–November 1965) was a printed offset poetry magazine published and edited by Aram Saroyan. *Fuck You: a magazine of the arts* nos. 1–4 (February 1962–August 1962); no. 5, vol. 1 through no. 5, vol. 9 (December–June 1965), was published and edited by Ed Sanders, founder of the proto-punk band The Fugs.

18. Boke Press (New York) published works including Kenward Elmslie and Joe Brainard, *The Baby Book* (1965); Ron Padgett and Brainard, *100,000 Fleeing Hilda* (1967); and Elmslie and Brainard, *The 1967 Game Calendar* (1967).

19. *On a Clear Day You Can See Forever*, music by Burton Lane and book and lyrics by Alan Jay Lerner. The Broadway production that Brainard attended opened at the Mark Hellinger Theatre on October 17, 1965.

20. The "lady" was the art patron and oil fortune heiress Marie-Christophe de Menil. The reading took place on November 12, 1965 at her home, a converted firehouse on the Upper East Side.

21. Brainard showed "Japanese City" at the Alan Gallery in 1966. James Schuyler reported that "Joe Brainard had his first one-man exhibition in 1965 at the Alan (now the Landau-Alan) Gallery. [In 1966, Felix Landau bought the gallery from Charles Alan and renamed it the Landau-Alan Gallery. Alan left in 1969, and Landau changed the name to the Felix Landau Gallery. The gallery closed in 1970.] Brainard showed assemblages, some of them like shrines or altars. In 1966 he showed one large construction, *The Japanese City*. James Schuyler, *Selected Art Writings* (New York: David R. Godine, 1998). Somewhat more floridly, Thomas Hess wrote at the time, "Joe Brainard's *Japanese City* rejoices in similar polyphiloprogenitive energies. The gimcrack parts (artificial flowers that would make an undertaker weep, beads that Sadie Thomson would consider outré) as they are repeated and multiplied, take on a severe Gothic radiance." Thomas B. Hess, *Art News Annual XXXII: The Grand Eccentrics: Five Centuries of Artists Outside the Main Currents of Art History* (New York: Macmillan, 1966).

22. While di Prima never did publish *The Champ*, the book was eventually published by Black Sparrow Press. See Kenward Elmslie and Joe Brainard, *The Champ* (Los Angeles: Black Sparrow, 1968).

23. Like the review of the Man Ray show mentioned earlier, *Kulchur* did not publish the review. Lichtenstein's show took place at the Castelli Gallery, November 20–December 16, 1965; Alex Katz had a show of paintings at Fischbach Gallery, November 23–December 26, 1965; Robert Mangold's "Walls and Areas" was his first solo show, taking place at the Fischbach Gallery, October 12–30, 1965; and Freilicher's exhibition was at Tibor de Nagy Gallery in November 1965.

24. The book Brainard is referring to is Edwin Denby, *Dancers, Buildings and People in the Streets* (New York: Horizon, 1965). *Dancers* included an introduction by Frank O'Hara.

25. The "deaf-mute friend" was George Wilson, a deaf and speech-impaired man whom Taylor met at a bar in the mid-1950s. Shortly after their first meeting, the two men moved in together, first as lovers and eventually as friends. They lived with each other until Wilson's death in 2004. For more information about their relationship, see Paul Taylor, *Private Domain* (New York: Knopf, 1987).

26. The "Tinguely opening" at the Jewish Museum that Brainard refers to was a preview of the exhibition "Two Kinetic Sculptors: Nicolas Schoffer and Jean Tinguely." Both the Royal Danish Ballet

performance at the New York State Theater and the Jewish Museum preview took place on November 22, 1965.

27. Jack Beeson and Kenward Elmslie, *The Sweet Bye and Bye: An Opera* (New York: Boosey & Hawkes, 1966); Jack Beeson and Kenward Elmslie, *Lizzie Borden: A Family Portrait in Three Acts* (New York: Boosey & Hawkes, 1966).

28. Ron Padgett and Joe Brainard, "The Physical Sciences," *Mother: A Journal of New Literature* no. 6 (Thanksgiving 1965): 63–71. *Mother* was a poetry and arts journal that Peter Schjeldahl cofounded in 1964. There were eight issues in total, published from 1964 to 1967.

29. Joe Brainard, "Untitled Drawing," *Mother* no. 6 (1965): 3. The "drawing by Ted that I did" is signed by Ted Berrigan, though it is credited to Brainard in the table of contents.

30. Padgett recalls having two of his poems published in the UK-based journal *Granta*, though I have been unable to locate bibliographic information for the issue Brainard is referring to.

31. Based on the 1888 play of the same name by August Strindberg, *Miss Julie* is an opera composed by Ned Rorem, with a libretto by Kenward Elmslie. Commissioned by the New York City Opera, *Miss Julie* was first presented in 1965 as a two-hour-long two-act opera. It received almost universally scathing reviews. Elmslie and Rorem later cut about thirty minutes from the work, and in 1979, it was presented as a single act for a production by the New York Lyric Opera. A further revised one-act version of Rorem's opera produced in 1994 met with a more generous reception. See James R. Oestreich, "Opera Review; 'Miss Julie,' to Rorem's Music," *New York Times*, December 9, 1994, sec. Arts, https://www.nytimes.com/1994/12/09/arts/opera-review-miss-julie-to-rorem-s-music.html.

32. Brainard is referring to a cover of *C: A Journal of Poetry* that Berrigan ended up using because he could not afford to have it printed correctly.

33. From January 1 through January 13, the transit workers unions in New York City called a strike that effectively shut down all public transportation in the city.

34. This is the Alan Gallery show noted earlier.

35. See "Brunswick Stew" in Joe Brainard, *The Collected Writings of Joe Brainard*, ed. Ron Padgett (New York: Library of America, 2013), 198.

36. Ted Berrigan, "The Portrait and Its Double," *ArtNews* 64, no. 9 (January 1966): 30–33, 63–64.

37. Joe Brainard, "Joe Brainard's Ladies: Six Faces," *Mother* no. 7 (May 1, 1966): 47–53. As the title reveals, Schjeldahl published just six of the eight "faceless women." In his introduction prefacing the images, Schjeldahl wrote, "Joe Brainard's ladies have nothing to say to us intelligent members of a doddering audience. They are all paint and talent and impenetrable mystique" (47).

38. Ruth Landshoff Yorck died of a heart attack in the lobby of New York's Broadway Theatre during a performance of Peter Brook's production of Peter Weiss's play *Marat/Sade*. She died in Ellen Stewart's arms—Stewart was the founder and director of La Mama Experimental Theater Club on East 4th Street, New York City. See Barbara Lee Horn, *Ellen Stewart and La Mama: A Bio-Bibliography* (Westport, CT: Greenwood, 1993), 219, for more details on Landshoff Yorck's dramatic death.

39. *The Connection* (1959) is a play by Jack Gelber first performed at the Living Theater, New York City. It was directed by Judith Malina and designed by Julian Beck. In 1961, Shirley Clarke directed a film version of *The Connection* using the screenplay that Gelber had adapted from the original play.

40. "Cherry," a visual-verbal cartoon collaboration between Padgett and Brainard, never appeared as a stand-alone booklet, though it did appear in several of Padgett's books, including *Tulsa Kid* (Calais, VT: Z Press, 1979) and in a German translation of Padgett's work, *Grosse Feuerbälle; Gedichte, Prosa, Bilder*, trans. Rolf Eckart John and others (Hamburg: Rowohlt, 1973).

41. "*Pretty Papers* was a very limited edition book—three copies?—I produced by gluing, well, pretty pieces of paper I was finding in Paris. I glued them into nice little notebooks I bought at, if memory serves, the Bon Marché department store, which at the time had an affordable stationery department." Ron Padgett, email to the editor, May 8, 2023.

42. There is no evidence that Fischbach ever published any of these books.

43. Padgett and Berrigan's collaborative poem "NOH" was published in *Long Hair* 1, no. 1 (London: Lovebooks, 1965): 34. The one and only issue of the magazine was edited by Barry Miles. "NOH" was also published in 1965 as a broadsheet through Aram Saroyan's Lines Press imprint.

44. Brainard's brother John Brainard writes, "Of all the 'things' as images and images as things that Joe was passionate about, from pansies, to NANCY, to Madonnas and Catholic shrines, to white briefs, to sailors' tattoos, to buttons and beads and all manner of ephemera, I would venture that none held greater grasp or pride of place than cigarettes" (27). John Brainard, "Smoking Joe," in *Joe Brainard's Art*, Yasmin Shamma, ed. (Edinburgh: Edinburgh University Press, 2019), 27–31.

45. John Ashbery, *Rivers and Mountains* (New York: Holt, Rinehart and Winston, 1966).

46. This sentence was included in "Saturday, Dec. the 11th, 1965," a journal entry designed for publication. Readers can find the piece in full in Brainard, *The Collected Writings of Joe Brainard*, 204–5.

47. This letter was written over the course of a week.

48. "The First Bunny" was a one-page collaborative cartoon by Kenneth Koch (text) and Joe Brainard (images) included in *C Comics* no. 1 (1964): n.p. Koch and John Ashbery appeared in Richard Moore's "USA: Poetry" series on WNET (Channel 13), broadcast on August 21, 1966. See https://licensing.wnet.org/programs/usa-poetry/ for a list of all the poets who appeared on the series.

49. Since the late 1950s, Katz has produced numerous cutout sculptures of his family and poet and artist friends. Initially painted on canvas and mounted on wood or painted directly on wood, he now typically paints on aluminum sheets. The cutouts are known for their bold, flat forms and vibrant colors.

50. "*New Paintings: Michael Goldberg*" took place at the Martha Jackson Gallery, New York. I have not been able to find any information about Goodnough's opening.

51. The Fugs were a proto-punk rock ' n' roll band founded by the poets Ed Sanders and Tuli Kupferberg.

52. Ned Rorem, *Poems of Love and the Rain: Song Cycle (1962–63); Second Piano Sonata (1949)* (New York: Composers Recordings, 1965).

53. Aram Saroyan, *Works* (New York: Lines, 1966).

54. Anne Hoene, "Baker, Brainard, Squire, Brice, Gill," *Arts Magazine* 40, no. 5 (March 1966): 58.

55. The "Cornelia St. place" was the Phoenix Book Shop, owned by the bibliographer, bookseller, and collector Robert A. Wilson.

56. Brainard may be referring to downtown institutions such as the Charles Theater and the Filmmakers Co-Operative, which in the 1960s regularly showed and/or distributed films by Shirley Clarke, Jonas Mekas, Andy Warhol, Jack Smith, and other New American Cinema luminaries.

57. The Fugs held a long-term residency at the Bridge Theater, 4 St. Mark's Place.

58. Brainard is probably referring to *The East Village Other*, a counterculture paper founded in the fall of 1965 by writers including Ishmael Reed and Allen Katzman.

59. Police at the time were enforcing "quality of life"–style policies, including shutting down cafes for holding unauthorized poetry readings and jazz clubs for contravening cabaret license laws.

60. *FRICE: A One Shot Magazine* 1, no. 1 (April 1966). FRICE was part of a series of magazines that the poet Tom Clark edited, and many of the covers were drawn by Brainard.

61. Brainard is referring to *Prell*, an assemblage composed of a dozen bottles of green Prell brand shampoo.

62. Kenward Elmslie owned two whippet dogs, Whippoorwill and Rossignol. Whippoorwill, a white whippet, proved a lasting subject for Brainard. At the time of this letter, Rossignol—the "her" Brainard refers to—was pregnant. See Brainard's letters to Fairfield Porter, where he describes in great deal the composition of some of his Whippoorwill paintings.

63. *Vice: A One Shot Magazine* 1, no. 1 (1966).

64. Brainard is referring to Warhol's "Exploding Plastic Inevitable," a series of multimedia events held at the Dom on St. Mark's Place that featured the Velvet Underground live on stage as films and stroboscopic light-shows were projected on them, poet Gerard Malanga and Warhol "superstar" Mary Woronov performed an S&M–themed dance, and more.

65. It's proved difficult to find precise information about the NYU reading. However, given that Ashbery gave a reading in Buffalo, New York, on November 18 from the same books Brainard lists, we can say (if cautiously) that Ashbery probably read at NYU on November 7, 1966 (if by "last Sunday" Brainard means the Sunday just passed, and not October 31, 1966).

66. By this Brainard means copies of *The Village Voice*, an alternative newsweekly founded in 1955 by Dan Wolf, Ed Fancher, John Wilcock, and Norman Mailer.

67. Thomas Hess, *Art News Annual*.

68. Brainard is referring to a chapter from Ted Berrigan's novel *Clear the Range*, included in *Angel Hair* no. 2 (Fall 1966).

69. The poem Brainard is embarrassed by is entitled "Dear little potted plant," *Tzarad* no. 2 (October 1966): 5.

70. It seems unlikely that Berrigan visited Kerouac in December 1966, as Berrigan and Aram Saroyan's now widely cited interview with Kerouac took place in Kerouac's home in the spring of 1967 and was published as "Jack Kerouac, The Art of Fiction," *Paris Review* no. 41 (Summer 1968). See https://www.theparisreview.org/interviews/4260/the-art-of-fiction-no-41-jack-kerouac.

71. Poetry reading with John Ashbery and Barbara Guest, December 1, 1966, Academy of American Poets, New York City.

72. Henri de Toulouse-Lautrec and Maurice Joyant, *The Art of Cuisine* (New York: Crescent, 1966).

73. Alice B. Toklas, *The Alice B. Toklas Cook Book* (New York: Harper, 1954).

74. "Earl" was Earl Wilson, a newspaper columnist and radio personality whose column, "It Happened Last Night," reported on the comings and goings of the beautiful, rich, and famous of New York City. His "Earl's Pearl's" were one-line gags that were included in the column from time to time.

75. *The Grass Harp*, libretto by Kenward Elmslie, music by Claibe Richardson, directed by Adrian Hall, with performances by Barbara Baxley, Carol Brice, Elaine Stritch, and others; December 16, 1966–January 14, 1967, Trinity Square Repertory Theater, Providence, Rhode Island. Based on Truman Capote's novel *The Grass Harp*. Elmslie and Richardson's musical received poor reviews from newspapers including the *Record-American*, the *Herald*, and the *Boston Globe*. In 1971, the show was revived on Broadway, but it again received mixed reviews and closed after just seven performances. Since then it has become a cult classic.

9. DEAR KENWARD

1. Joe Brainard, "I Remember," in *The Collected Writings of Joe Brainard*, ed. Ron Padgett (New York: Library of America, 2013), 26.

2. Joe Brainard to Kenward Elmslie, n.d., box 4, folder 2, Kenward Elmslie Papers, Special Collections & Archives, University of California, San Diego.

3. Brainard was having an affair with Joe LeSueur at the time. LeSueur was a roommate and occasional lover of the poet Frank O'Hara. For more on LeSueur's relationship with O'Hara and Brainard, see Joe LeSueur, *Digressions on Some Poems by Frank O'Hara* (New York: Farrar, Straus and Giroux, 2004).

4. This letter is courtesy of Ron Padgett. Brainard had a show with Yvonne Jacquette at the Fischbach Gallery from May 1 to 22, 1971, which makes it possible to date this letter accordingly.

5. I've been unable to determine who "Alan" is.

6. Brainard to Elmslie, box 4, folder 2, Kenward Elmslie Papers.

7. Schuyler suffered from bouts of severe mental illness throughout his adult life.

8. Mathews attended a production of *The Sweet Bye and Bye* (director Russell Patterson, music Jack Beeson, libretto Kenward Elmslie, performed by the Kansas City Lyric Theater) that was taking place in Kansas City. According to the *Paris Review* editor Maxine Groffsky, "Harry was in New

York and planning to fly out with Joe to Kansas City, Missouri on Sept 18th to see performances of Kenward's opera. On the 18th, Harry wrote from the Bellerive Hotel in Kansas City, 'Batting this out frantically an hour before pre-opera drinks and black-tie dinner.' I was in Paris working on a movie." Maxine Groffsky, email to the editor, March 7, 2023.

9. This letter is courtesy of Ron Padgett.

10. At the time this letter was written, Brainard was in the process of moving to what would be his final home at 8 Greene Street, New York City. "The Russians" is probably a reference to people who planned to rent his apartment on 6th Avenue but then changed their minds.

11. This letter is courtesy of Ron Padgett.

12. Elmslie was having a relationship with the Scottish-born musician and poet Steven Hall, who collaborated with Elmslie on a number of texts during this period.

13. This letter is courtesy of Ron Padgett.

14. This letter is courtesy of Ron Padgett.

15. This letter is courtesy of Ron Padgett.

16. Probably the composer Bill Elliott and a friend or companion named Willie.

17. The Toyota belonged to Elmslie.

18. Henry James, *What Maisie Knew* (1897).

19. This letter is courtesy of Ron Padgett.

20. *Lola* was a musical based on the life of the nineteenth-century Spanish courtesan Lola Montez. Elmslie wrote the lyrics and Claibe Richardson, who had worked with Elmslie on their 1971 production *The Grass Harp*, composed the music. The show was produced by the York Theatre Company and ran for twenty performances in March 1982.

21. This letter is courtesy of Ron Padgett.

22. This letter is courtesy of Ron Padgett.

23. Tenants in the building Brainard was living in were in the process of buying it from the original owner. "Going co-op," as the practice is known, means that tenants become tenants-in-common, which gives them all occupancy and co-ownership rights to their properties.

24. This letter is courtesy of Ron Padgett.

25. Brainard had just returned from a week's holiday in Key West with the writer Edmund White and his partner, Christopher Cox. See Edmund White, *City Boy* (London: Bloomsbury, 2014), for White's recollections of Brainard and Cox.

26. Joe Brainard, *Nothing to Write Home About* (Los Angeles: Little Caesar, 1981). Dennis Cooper edited *Little Caesar* magazine in 1976 and started Little Caesar Press in 1978.

27. Brainard to Elmslie, n.d. box 4, folder 3, Kenward Elmslie Papers.

28. This letter is courtesy of Ron Padgett.

29. Brainard is referring to a teaching position he held at the School of Visual Arts in New York City.

30. Elmslie traveled to Nepal and Indonesia in the early 1980s, so Brainard is probably referring to one of those journeys.

31. Brainard to Elmslie, box 4, folder 2, Kenward Elmslie Papers.

10. DEAR MAXINE

1. These letters are courtesy of Maxine Groffsky. She no longer has the postmarked envelopes they were mailed in and has dated them to the best of her recollection and based on internal evidence.

2. Brainard is referring to Ned Rorem and Kenward Elmslie's opera *Miss Julie*.

3. The "good news" refers to the publication of Elmslie and Brainard's "The Power Plant Sestina" in *Paris Review* no. 38 (Summer 1966).

4. Alex Katz, *Joe Brainard*, 1966, oil on aluminum, 46½″ × 13½″.
5. Brainard's description here of "the woman" suggests it was a blow-up doll, though Groffsky recalls, "XMas 1965, I was in Athens with Harry [Mathews]. Unlikely place to pick up that present for Joe, whatever it was" (email to the editor, March 12, 2023).
6. Much to Auden's outrage, Ed Sanders published (without permission) Auden's "Platonic Blow" in *Fuck You: a magazine of the arts* 5, no. 8 (March 1965). The poem described the protagonist cruising a young man and receiving oral sex. Sanders got hold of the manuscript from a source working in the Morgan Library, New York City, where the manuscript had been kept under lock and key. For a description of Auden's reaction to the publication, see Humphrey Carpenter's *W. H. Auden: A Biography* (Boston: Houghton Mifflin, 1981).
7. Brainard designed a promotional *Paris Review* T-shirt featuring an image of Nancy wearing a *Paris Review* T-shirt. You can see images of it at https://store.theparisreview.org/products/joe-brainard-x-nancy-t-shirt-first-edition.
8. Bill Berkson, ed., *In Memory of My Feelings* (New York: Museum of Modern Art, 1967), a commemorative book containing thirty of O'Hara's poems accompanied by images produced by artists he was associated with. O'Hara died on July 25, 1966, from injuries he sustained after he was struck by a dune buggy on Fire Island, New York.
9. Brainard is referring to the interview that was published as "Jack Kerouac, The Art of Fiction" in *Paris Review*.
10. Olson died on January 10, 1970.
11. John Ashbery, *The Double Dream of Spring* (New York: Dutton, 1970).
12. As noted elsewhere in this book, the Felix Landau Gallery (founded by Charles Alan as the Alan Gallery) closed for good in 1970.

11. DEAR FAIRFIELD

1. Ted Leigh, ed., *Material Witness: The Selected Letters of Fairfield Porter* (Ann Arbor: University of Michigan Press, 2005), 316. Leigh dates this letter to August 1973, but I am hesitant to cite that date as fact, given that Leigh ascribes incorrect dates to some of Porter's letters to Brainard. *Material Witness* contains a number of other unrelated errors—for example, Leigh attributes authorship of *One Hundred Years of Solitude* (which both Brainard and Porter were reading) to Jorge Louis Borges rather than to its actual author, Gabriel García Márquez.
2. All the letters from Brainard to Porter are courtesy of Ron Padgett.
3. *The Grass Harp*, libretto by Kenward Elmslie, music by Claibe Richardson, dir. Adrian Hall.
4. Fairfield Porter, *The Mirror* (1966), 72″ × 60″, oil on canvas.
5. James Schuyler, *Art News* (April 1967): 57. Brainard produced the cover for this issue.
6. The book Brainard refers to is *Bean Spasms* (New York: Kulchur, 1967).
7. Stand oil is a thickened version of linseed oil used as a painting and glazing medium.
8. Brainard was teaching art at the Cooper Union, Cooper Square, New York City.
9. Alex Katz, *One Flight Up*, cutouts, oil on metal, 5'7¾″ × 15' × 3'11″.
10. South Dakota Senator George McGovern, who in 1972 was running for the presidency of the United States, lost to Richard Nixon.
11. For an example of Brainard's "grass ('etc.') works," see his *Blades of Grass* (1972), 9½″ × 7″, watercolor and collage.
12. For examples of Porter's "large heads," see paintings including *Katie* (1972), 16″ × 12″, oil on Masonite; and *Self-Portrait* (1972), 14¼″ × 10 7/8″ oil on Masonite.
13. Gabriel García Márquez, *One Hundred Years of Solitude* (London: Penguin, 1973).

14. "You say you 'think more highly of arrogance' than I do," Porter replied. "I believe this says that your under-
 standing of arrogance is a kind of admirable sureness. Of course sureness is admirable. What I dislike is a
 sureness that imagines it knows better than anyone else." Quoted in Leigh, ed., *Material Witness*, 251–52.

15. "Ellen Oppenheim" is in fact the realist painter Ellen Adler, who continued to use her maiden name
 professionally. Adler married the clarinetist David Oppenheim in 1957.

16. The toothbrush painting exercise resulted in one of Brainard's most celebrated paintings, *Untitled
 (Toothbrushes)*, (1973–74), oil on canvas, 9″ × 12″.

17. It's difficult to figure out what Brainard meant to write instead of "finger," which appears very clearly
 in the original letter but makes no sense in the context of this sentence. Perhaps he meant to write
 "figure," but as I can't be sure, I'm keeping "finger" as is.

18. Brainard was responding to a comment Porter made in an earlier letter: "Your spelling is so fantastic
 that sometimes I am not sure I know what you are saying. For instance you said, 'What I admire
 about Evonne's paintings' and I read that as 'everyone's' paintings, but then I decided that perhaps
 you mean Yvonne Burckhardt." Quoted in Leigh, ed., *Material Witness*, 252. Ted Leigh dates Porter's
 letter to 1968, which cannot be correct given that internal evidence in Brainard's letter, including
 his description of painting Whippoorwill, almost certainly dates the letter to 1974. Porter's letter
 itself contains internal evidence—including a reference to Carlos Castaneda's *Journey to Ixtlan*, first
 published in 1972—that shows Porter could not have written the letter in 1968.

19. Brainard is most likely referring to his show of oil paintings at the Fischbach Gallery, which took
 place in April 1974, not January.

20. Joe Brainard, *New Work* (Los Angeles: Black Sparrow, 1973).

21. Porter wrote to Brainard that de Kooning told him "the way to make a slatted chair back stand out
 from the wall behind was to paint the spaces between the slats as though they were things them-
 selves." Quoted in Leigh, ed., *Material Witness*, 252.

22. Brainard is referring to the fact that he has reached page ten of this letter.

12. DEAR ANDY

1. Brainard lived in the painter Robert Dash's studio on Elizabeth Street for two months in the summer
 of 1964.

2. Joe Brainard, Note (from Joe Brainard to Andy Warhol, not posted), n.d., The Andy Warhol
 Museum, Pittsburgh; Founding Collection, Contribution The Andy Warhol Foundation for the
 Visual Arts, Inc. T1785.

3. Note that the final lines of Brainard's verbal portrait "Andy Warhol: Andy Do It" ends with "and
 Warhol knows what he is doing. Andy Warhol 'does it.' I like painters who 'do it.' Andy do it." Ron
 Padgett, ed., *The Collected Writings of Joe Brainard* (New York: Library of America, 2013), 178–79.

4. Joe Brainard, Envelope and two-page letter (from Joe Brainard to Andy Warhol, posted June 11,
 1968, New York, NY), 1968, The Andy Warhol Museum, Pittsburgh; Founding Collection, Con-
 tribution The Andy Warhol Foundation for the Visual Arts, Inc. TC4.57.1–TC4.57.2b. On June 3,
 1968, Valerie Solanas entered Warhol's studio on Union Square and shot him, almost killing him.
 This letter was addressed to Warhol as he recovered at Columbus Hospital, New York City.

5. Joe Brainard, Envelope with letter (from Joe Brainard to Andy Warhol, postmarked [illegible], 1969,
 New York, NY), 1969, The Andy Warhol Museum, Pittsburgh; Founding Collection, Contribution
 The Andy Warhol Foundation for the Visual Arts, Inc. TC83.81.1–TC83.81.2.

6. Joe Brainard, Envelope with letter (from Joe Brainard to Andy Warhol, postmarked March 7, 1972,
 New York, NY), 1972, The Andy Warhol Museum, Pittsburgh; Founding Collection, Contribution
 The Andy Warhol Foundation for the Visual Arts, Inc. TC53.30.1–TC53.30.2.

7. Joe Brainard, Envelope with letter and clipping (from Joe Brainard to Andy Warhol, postmarked April 15, 1971, New York, NY), 1971, The Andy Warhol Museum, Pittsburgh; Founding Collection, Contribution The Andy Warhol Foundation for the Visual Arts, Inc. TC75.79.1–TC75.79.4.

8. "This cow" refers to a cutout picture of an infrared image of a cow that Brainard included in his letter to Warhol. The image was taken from the July 30, 1956, issue of *Life* magazine, included in an article entitled "Speaking of Pictures."

13. DEAR ADA AND ALEX AND VINCENT

1. All the letters from Brainard to the Katzes included here are in series 12: Correspondence, Alex Katz Archive, Colby College Museum of Art, Waterville, Maine.

2. Elmslie rented Fairfield and Anne Porter's house in Southampton, Long Island, for part of the summer of 1967. Brainard also visited the Katzes at their home in Lincolnville, Maine, with the remainder of the summer spent at Elmslie's home in Calais.

3. References in this letter to an issue of the *Paris Review*, teaching at Cooper Union, and what is probably the 1967 Arab-Israeli Six-Day War date it to around June 1967.

4. *Paris Review* no. 40 (Winter-Spring 1967).

5. Guillaume Apollinaire, *The Poet Assassinated*, trans. Ron Padgett, illust. Jim Dine (New York: Holt, Rinehart and Winson, 1968).

6. There is no evidence that Hudson ever purchased a home in Vermont, so this may have been just a rumor.

7. Don Carpenter, *Hard Rain Falling* (New York: Harcourt, Brace, 1966).

8. The "prose piece" Brainard was working on was "Little-Known Facts About People," which includes the line, "Did you know that the Katz Tumor is named after Ada Katz who discovered it?" Ron Padgett, ed., *The Collected Writings of Joe Brainard*, (New York: Library of America, 2013), 230. For more on this piece, including how parts of it were adapted into a poster-size cartoon, see Brian Glavey, "Friending Joe Brainard," *Criticism* 60, no. 3 (2018): 315–40.

9. Given that Wayne Padgett was born in 1966, I am dating this letter summer 1967 in light of Brainard's description of the baby's development.

10. The townhouse was located at 104 Greenwich Avenue.

11. Katz created the cover for Kenneth Koch, *The Pleasures of Peace and Other Poems* (New York: Knopf, 1969).

12. Kenward Elmslie, *The Orchid Stories* (New York: Doubleday, 1973).

13. This is possibly a reference to Claibe Richardson and Kenward Elmslie's revival of their musical *The Grass Harp*, but it's unclear, as the revival took place in 1971.

14. The postmarked envelope for this letter was retained.

15. Katz produced a number of images of the family dog, Sunny, including the large *Sunny #4* (1971), oil on canvas, 96 ¼" × 72".

16. Joe Brainard, *I Remember* (New York: Angel Hair Books), 1970.

17. Richardson and Elmslie's musical, *The Grass Harp*, opened at the University of Michigan in October 1971.

18. The postmarked envelope for this letter was retained.

19. As noted earlier, Brainard is referring to his show of fifteen hundred small works that took place at the Fischbach Gallery (December 1975–January 1976). Although it was a major critical success, Brainard never again showed any of his new works in a commercial gallery.

20. Katz's cutouts show took place at the Robert Miller Gallery, 724 Fifth Avenue, February 21–March 17, 1979.

14. DEAR ANNE

1. Joe Brainard to Anne Waldman, n.d., box 3, folder 1, Anne Waldman Papers, Special Collections Research Center, University of Michigan Library. Unfortunately, only the first three pages of this letter were found in Waldman's archive, though, as you will see, what is saved is a wonderful reflection of Brainard's euphoria as he was writing initial drafts of *I Remember*.
2. Brainard to Waldman, n.d., box 3, folder 1, Anne Waldman Papers.
3. Brainard might be referring to the sculptor Scott Burton.
4. Michael Brownstein, *Three American Tantrums* (New York: Angel Hair, 1970).
5. Brainard to Waldman, n.d., box 3, folder 1, Anne Waldman Papers.
6. Brainard is referring to the cover he designed for Anne Waldman, *Giant Night* (New York: Corinth, 1970).
7. "Jughead" Jones, a character in the *Archie* comics series who always wore a felt crown-shaped hat and a sweatshirt with a large "S" on it.
8. See "Little Known Facts About People," in Ron Padgett, ed., *The Collected Writings of Joe Brainard* (New York: Library of America, 2012), 228–31.
9. *The World* was the poetry magazine published and printed initially as a mimeograph journal at the Poetry Project at St. Mark's Church. Miles Champion writes, "The first issue of *The World* was edited by Sloman and appeared in January 1967. . . . *The World* would go on to enjoy an extraordinarily long lifespan for a little magazine, with its last issue, #58, appearing in fall 2002, almost thirty-six years after the first" "Insane Podium: A Short History, The Poetry Project, 1966–2012," *The Poetry Project* (blog), accessed April 20, 2024, https://www.2009-2019.poetryproject.org/about/history/. Anne Waldman (with occasional guest editors) went on to edit twenty-nine mimeographed issues of *The World*.
10. Brainard to Waldman, n.d., *The Angel Hair Archives*, MSS.004, box 2, folder 1, Fales Library and Special Collections, New York University.
11. The book was eventually published as Joe Brainard, *I Remember More* (New York: Angel Hair, 1972). *I Remember* was published in three instalments before it was edited and published by Full Court Press in 1975 as the single volume, *I Remember*.
12. Brainard was preparing to leave for Bolinas, California.
13. See Joe Brainard, "Death," in Padgett, ed., *The Collected Writings of Joe Brainard*, 263–64.
14. Brainard to Waldman, n.d., *The Angel Hair Archives*, MSS.004, box 2, folder 1.
15. Brainard is referring to Elmslie's dog Whippoorwill.
16. Lewis Warsh, *Part of My History* (Toronto: Coach House Press, 1972).
17. *The Grass Harp*, libretto by Kenward Elmslie, music by Claibe Richardson, dir. Adrian Hall.
18. Brainard to Waldman, n.d., box 4, folder 1, Anne Waldman Papers.
19. Brainard is referring to Anne Waldman, *Life Notes* (Indianapolis: Bobbs-Merrill, 1973).
20. Brainard to Waldman, n.d., box 4, folder 1, Anne Waldman Papers.
21. Joe Brainard, *More I Remember More* (New York: Angel Hair, 1973).
22. Brainard to Waldman, n.d., box 4, folder 1, Anne Waldman Papers.
23. The writer and musician Lee Crabtree committed suicide on February 6, 1973.
24. Brainard is referring to Bill and Beverly Corbett, not Corman.
25. "Famer Martin" was Earl Martin, a neighbor of Elmslie's in Vermont. He wasn't actually a famer, but Ralph Weeks, the caretaker of Elmslie's property, referred to him as "Farmer Martin."
26. Joe Brainard, *New Work* (Los Angeles: Black Sparrow, 1973).
27. Brainard to Waldman, n.d., box 4, folder 2, Anne Waldman Papers.
28. Waldman appeared in *People* magazine, vol. 4, no. 7 (August 18, 1975): 22–23.
29. Brainard to Waldman, n.d., box 4, folder 2, Anne Waldman Papers.
30. Elmslie had just ended a relationship with the Scottish-born musician and writer Steven Hall. See the "Dear Kenward" section for more context about their affair.

31. In 1976, Brainard had a solo show at FIAC (Foire Internationale d'Art Contemporain) in Paris.

32. It is not clear who "Steven" is, but given Waldman's place in Naropa, it might be Steven Hall, who occasionally taught there.

33. Brainard to Waldman, n.d., box 4, folder 2, Anne Waldman Papers.

34. Brainard to Waldman, n.d., box 4, folder 2, Anne Waldman Papers.

35. *City Junket* received several staged readings and performances in New York City, Chicago, Houston, and Port Townsend, beginning in 1972 (when Larry Fagin's *Adventures in Poetry* issued the first publication of the text). In 1980, there was a run of fully staged performances that took place at Ada Katz's Eye and Ear Theater. A 1987 reissue of *City Junket* included several pages of Elliott's musical sketches. See Kenward Elmslie, *City Junket: A Play* (Flint, MI: Bamberger, 1987).

36. Brainard to Waldman, n.d., box 4, folder 2, Anne Waldman Papers.

37. The maquette the poster was based on is entitled *Stay Ahead of the Game* (1975), cut and pasted printed paper, ink markers, graphite, and gouache on paper, 32½" × 54⅛".

38. Brainard to Waldman, n.d., box 4, folder 2, Anne Waldman Papers.

39. Brainard to Waldman, n.d., box 4, folder 4, Anne Waldman Papers.

40. Anne Waldman, *Helping the Dreamer: New and Selected Poems* (St. Paul, MN: Coffee House, 1989).

41. Katy Keene is a comic book character created by Bill Woggon that appeared in several comic book series published by Archie Comics.

42. Brainard to Waldman, n.d., box 4, folder 4, Anne Waldman Papers.

15. DEAR JOHN [ASHBERY]

1. Rona Cran, "Men with a Pair of Scissors": Joe Brainard and John Ashbery's Eclecticism," in *Joe Brainard's Art*, ed. Yasmine Shamma (Edinburgh: Edinburgh University Press, 2019), 104.

2. John Ashbery and Joe Brainard, *The Vermont Notebook* (Los Angeles: Black Sparrow, 1975); John Ashbery, *Self-Portrait in a Convex Mirror* (New York: Viking, 1975).

3. Quoted in Brian Glavey, "Friending Joe Brainard," *Criticism* 60, no. 3 (2018): 318.

4. Joe Brainard to John Ashbery, box 79, John Ashbery Papers, circa 1927–2018 (MS Am 3189), Houghton Library, Harvard University.

5. James Schuyler, "As American as Franz Kline," *ARTnews* 67 (October 1968): 30–33.

6. Al Held's show took place at the André Emmerich Gallery, New York, October 5–24, 1968.

7. *The Grass Harp*, libretto by Kenward Elmslie, music by Claibe Richardson, directed by Adrian Hall.

8. This was Brainard's third solo exhibition at the Landau-Alan Gallery (March 22–April 17, 1969).

9. Brainard to Ashbery, box 79, John Ashbery Papers, circa 1927–2018 (MS Am 3189).

10. *Gothic Blimp Works*, a tabloid-style underground comics journal that published eight issues in 1969. It featured works by R. Crumb, Spain Rodriguez, Trina Robbins, Art Spiegelman, and many other figures now recognized as groundbreaking graphic artists.

11. *C Comics* no. 3 was never completed.

12. Brainard to Ashbery, box 79, John Ashbery Papers, circa 1927–2018 (MS Am 3189). This letter is a collage Brainard made from letters sent in by readers to magazines such as *Women's Household*.

13. Brainard to Ashbery, box 79, John Ashbery Papers, circa 1927–2018 (MS Am 3189).

14. Ashbery's play *The Heroes* is included in John Ashbery, *Three Plays* (Manchester, UK: Carcanet, 1988).

15. Brainard to Ashbery, box 79, John Ashbery Papers, circa 1927–2018 (MS Am 3189).

16. John Ashbery, *A Wave* (New York: Viking, 1984).

16. DEAR JOHN [GIORNO]

1. John Giorno to Joe Brainard (July 39, 1969), box 4, folder 1, Joe Brainard Archive, Special Collections & Archives, University of California, San Diego.
2. John Giorno, "Thanx 4 Nothing on My 70th Birthday in 2006," *Magazine Palais* no. 22 (October 15, 2015): 33.
3. The letters from Brainard to Giorno are courtesy of the Giorno Poetry Systems and the Giorno Poetry Systems Archive, 222 Bowery, New York, New York. Identification numbers for the letters are as follows: July 10, 1969—CO.615; August 8, 1969—CO.616; July 18, 1969—CO.619; and July 23, 1969—CO.618.
4. A Garrison belt is a heavy-duty leather belt traditionally used by police and tradespeople.
5. In a July 12, 1969, letter to Brainard, Giorno wrote, "Would like to do a pornographic comic about 2 boys sucking and fucking etc. Would you draw them?"
6. This is a play on Edward Field, a poet included alongside John Ashbery, Barbara Guest, Kenneth Koch, and James Schuyler as one of the "New York Poets" in Donald Allen's 1960 anthology *The New American Poetry, 1945–1960* (New York: Grove, 1960).

17. DEAR LEWIS

1. Joe Brainard to Lewis Warsh, *The Angel Hair Archives*, MSS.004, box 2, folder 1, Fales Library and Special Collections, New York University. Brainard began this letter on November 1 and wrote it over the course of several days.
2. Kenward Elmslie, *Album* (New York: Kulchur, 1969).
3. See Joe Brainard, "A Special Diary," in *The Collected Writings of Joe Brainard*, ed. Ron Padgett (New York: Library of America, 2013).
4. Ron Padgett, *Great Balls of Fire: Poems* (Minneapolis: Coffee House, 1990).
5. Michael Brownstein, *Highway to the Sky* (New York: Columbia University Press, 1969).
6. Brainard to Warsh, *The Angel Hair Archives*, MSS.004, box 2, folder 1.
7. It is unclear which poem Brainard is referring to.
8. John Ashbery, *Some Trees* (New York: Corinth, 1970).
9. Padgett, *Great Balls of Fire*.
10. Following Giorno's arrest for drug possession, the Poetry Project at St. Mark's Church held benefit events on November 21 and 22, 1969, for the "John Giorno Defense Fund." Participants included Taylor Mead, Yvonne Rainer, Angus MacLise & Joyous Lake, Larry Rivers, and other writers, artists, and musicians.
11. Brainard to Warsh, *The Angel Hair Archives*, MSS.004, box 2, folder 1.
12. John Bernard Myers, ed., *The Poets of the New York School* (Philadelphia: University of Pennsylvania, 1969).
13. It is not clear what Brainard is referring to here. Warsh and Waldman published Larry Fagin, *Landscape* (New York: Angel Hair, 1972), so perhaps Brainard was trying to get Black Sparrow to publish it in late 1969. The artist George Schneeman, not Brainard, drew the cover for Fagin's *Landscape*.
14. Waldman and the poet Michael Brownstein became a couple soon after Waldman and Warsh broke up.
15. "Henry" is possibly Ted Berrigan's friend from Iowa City, Henry Pritchett.
16. Brainard to Warsh, *The Angel Hair Archives*, MSS.004, box 2, folder 1.
17. Dick Higgins, *A Book about Love & War & Death* (Barton, VT: Something Else Press, 1972).

18. "Short Story" is reproduced in Padgett, ed., *The Collected Writings of Joe Brainard.* Until I read this letter, I always thought, as have other critics who have commented on this "short story," that Brainard was the original writer of the two sentences.

19. Robert Creeley, *In London* (New York: Angel Hair, 1970).

20. Brainard to Warsh, *The Angel Hair Archives*, MSS.004, box 2, folder 1.

21. Lewis Warsh, *Part of My History.* (Toronto: Coach House, 1972).

22. Brainard to Warsh, *The Angel Hair Archives*, MSS.004, box 2, folder 1.

23. Lewis Warsh, *Dreaming as One* (New York: Corinth, 1971).

24. In his *Bolinas Journal* Brainard describes several of his Bolinas-based friends and acquaintances in candid and at times embarrassing and critical terms.

25. Joe Brainard, *The Cigarette Book* (New York: Siamese Banana, 1972).

26. *The Grass Harp*, libretto by Kenward Elmslie, music by Claibe Richardson, directed by Adrian Hall.

27. In 1971, Schuyler was hospitalized following a severe nervous breakdown.

18. DEAR LARRY

1. All the letters from Brainard to Fagin included here are located in box 1, folder 48, Larry Fagin Papers, Archives and Special Collections, University of Connecticut Library.

2. Larry Fagin, *Brain Damage* (Paris: Sand Project, 1970).

3. "I remember trying to visualize what my insides looked like." *The Collected Writings of Joe Brainard*, ed. Ron Padgett (New York: Library of America, 2013), 46.

4. While no date is available for this letter, it is clear that it was written in 1970, as Brainard discusses his cover for Fagin's *Brain Damage* (published in July 1970) and refers to John Giorno's Dial-a-Poem exhibition, which also took place in July 1970. Note that this letter contains two salutations, so it was probably written over the course of two or more days.

5. Fagin's parents were living in London at the time.

6. Brainard drew several possible covers for Fagin's *Brain Damage*, including the one reproduced in figure 18.1. Fagin ended up choosing a simple smiley face that Brainard created (which he refers to as "the funny face" in the letter) for the cover.

19. DEAR BERNADETTE

1. Joe Brainard letter to Bernadette Mayer, n.d., box 1, folder 25, United Artists Records, Special Collections & Archives, University of California, San Diego.

2. Brainard to Mayer, n.d., box 1, folder 25, United Artists Records.

3. Brainard is probably referring to the cover he created for Bernadette Mayer, *The Golden Book of Words* (Lenox, MA: Angel Hair, 1978).

4. Brainard to Mayer, n.d., box 1, folder 25, United Artists Records.

5. Brainard to Mayer, n.d., box 1, folder 25, United Artists Records.

6. Bernadette Mayer, *Sonnets* (New York: Tender Buttons, 1989).

7. Box 5, folder 3, Bernadette Mayer Papers 1985–2017, Special Collections & Archives, University of California, San Diego.

8. Bernadette Mayer, *The Formal Field of Kissing: Translations, Imitations and Epigrams* (New York: Catchword, 1990).

9. Brainard to Mayer, n.d., box 1, folder 25, United Artists Records.

10. Brainard is referring to work that was eventually published as Alice Notley, *The Descent of Alette* (New York: Penguin, 1996).

20. DEAR JOANNE

1. As Brainard reported in *Bolinas Journal*, "I asked Joanne if she'd spend the night with me last night, as [*sic*] so we did. Mainly I just wanted us to be close. Which was the kind of night it was. I'm not sure how much sex was on my mind, except that it <u>was</u>. But we didn't. Being queer isn't an easy habit to break." Joe Brainard, *Bolinas Journal* (Bolinas, CA: Big Sky, 1971), n.p.

2. All the letters from Brainard to Kyger included here are located in box 4, folder 16, Joanne Kyger Papers, Special Collections & Archives, University of California, San Diego.

3. Anne Waldman was spending time on Allen Ginsberg's farm in Cherry Valley in upstate New York.

4. Joe Brainard, *New Work* (Los Angeles: Black Sparrow, 1972).

5. Brainard, *New Work.*

6. ZZZ was the third in a series of six magazines published by Kenward Elmslie's Z Press (the first entitled *Z*; the second, *ZZ*; and so on). Kyger's work was included in *ZZZ* (Calais, VT: Z Press, 1974). The "new book" Brainard refers to was most likely *All This Every Day* (Bolinas, CA: Big Sky, 1975).

7. In a letter to Anne Waldman, Brainard wrote that he was "having a very successful thing with Juan Antonio, a dancer with the Louis Falco Company . . . with the best sex ('loose' and adventurous) I've ever had!" Quoted in Ron Padgett, *Joe: A Memoir of Joe Brainard* (Minneapolis: Coffee House, 2004), 212.

8. The "Drawings for Books" show took place at the Carlton Gallery, New York City, January 7–February 1, 1975, and featured works by Brainard, Red Grooms, Fairfield Porter, and others. "The Condition of the Tie Today" opened on January 10, 1975 and took place at the Lajeski Gallery at 8101 Madison Avenue, New York City. Participants and attendees included Yoko Ono, David Bowie, and Larry Rivers.

9. Brainard is referring to The Palm Casino Review, a drag show that took place at the Bowery Lane Theater, New York City.

10. This is probably a piece that ended up being titled "Religion," included in Ron Padgett, ed., *The Collected Writings of Joe Brainard.* (New York: Library of America, 2013).

21. DEAR MICHAEL

1. Michael Lally, email to the editor, January 11, 2022. All the letters from Brainard to Lally are courtesy of Michael Lally, though they can also be accessed in the Michael Lally Papers, Fales Library and Special Collections, New York University.

2. Brainard redacted three of his efforts to spell "friction" correctly, finally settling on "fricion."

3. Included in this letter was a clipping of a photograph of Bruce Jenner (now Caitlin Jenner) running with a javelin.

4. A photograph of Bruce Jenner was used on the front of Wheaties breakfast cereal boxes.

5. Brainard is referring to a photograph of Lally taken by Edie Baskin that graced the cover of Dennis Cooper's magazine *Little Caesar*, no. 11 (December 1980).

22. DEAR ROBERT

1. Ron Padgett, *Joe: A Memoir of Joe Brainard* (Minneapolis: Coffee House, 2004), 270.
2. Joe Brainard letter to Robert Butts, box 5, folder 9, Joe Brainard Archive, Special Collections & Archives, University of California, San Diego.
3. Brainard to Butts, box 5, folder 9, Joe Brainard Archive.
4. The work Brainard describes here was for the 1975 Fischbach showing of his miniatures.
5. Brainard to Butts, box 5, folder 12, Joe Brainard Archive.
6. The show Brainard refers to took place at the Root Art Center, Hamilton College, Clinton, New York, in 1978.
7. Brainard to Butts, box 5, folder 12, Joe Brainard Archive.
8. The "beautiful lyric" was a song lyric Butts wrote and sent to Brainard in an earlier letter.
9. Brainard to Butts, box 5, folder 12, Joe Brainard Archive.
10. Richard Whelan, "Imagination Is the Mother of Reality," *Christopher Street* 3, no. 8 (March 1979): 10–14.
11. Brainard to Butts, box 5, folder 12, Joe Brainard Archive.
12. The published title for the book Brainard is referring to is *24 Pictures & Some Words* (Los Angeles: Press of the Pegacycle Lady, 1980).
13. "Poets & Painters," Denver Art Museum, November 21, 1979–January 13, 1980.
14. Brainard to Butts, box 5, folder 15, Joe Brainard Archive.
15. Jonathan Greene, ed., *A 50th Birthday Celebration for Jonathan Williams* (Frankfort, KY: Gnomon, 1979).
16. It was Elmslie's fiftieth birthday party.

23. DEAR BRAD

1. The title of Gooch's second novel is *The Golden Age of Promiscuity* (New York: Knopf, 1996).
2. The letters from Brainard to Gooch collected here are courtesy of Brad Gooch.
3. Brainard is referring to working on the cover for Brad Gooch, *The Daily News* (Calais, VT: Z Press, 1977). Of the cover, Gooch recalls, "Yes it's *The Daily News* cover. My idea was stars. Joe's reimagination was a cum splatter. But could be read as either." Brad Gooch, email to the editor, April 11, 2023.
4. The "erotica" Brainard included was not erotica understood conventionally but, rather, a series of objects and images rich with double-entendres, including a postcard of the Old Faithful geyser erupting, a "Wet-Nap Moist Towelette" package, a small piece of paper with a hole in its center, and so on.

24. DEAR KEITH

1. All the letters from Brainard to McDermott are courtesy of Keith McDermott. In McDermott's essay "Homage to Joe," *Loss Within Loss: Artists in the Age of AIDS*, Edmund White, ed. (Madison: University of Wisconsin Press, 2001), 256–69, McDermott quotes from several letters included in full here and provides readers with a wonderful recollection of his relationship with Brainard.
2. McDermott, "Homage to Joe," 269.
3. Brainard is referring to seeing McDermott appear in Christopher Isherwood and Don Bachardy's *A Meeting by the River* at the Palace Theater, Broadway, New York City, on March 28, 1979.

4. Brainard is referring to Joe Brainard, *24 Pictures and Some Words* (Los Angeles: Press of the Pegacy-cle Lady, 1980).
5. McDermott was rehearsing for Robert Wilson's theater piece *Edison*. It was performed in a number of places in 1979, including from June 19 through 24 at the Lion Theater, 422 West 42d Street, New York City.
6. At some point in late 1977, Brainard decided he would no longer show his works at the Fischbach Gallery.
7. These works were published in Dennis Cooper's magazine *Little Caesar* no. 10: 20–24. The issue also included an interview with Brainard by Tim Dlugos, along with several of Brainard's "Mini Essays."
8. Brainard is referring to the news that McDermott was going to perform in Hugh Leonard's play *Da*, Buffalo Playhouse, New York, 1980.
9. The "other play" was *Harold and Maude*, which was performed at the Martin Beck Theatre, 302 West 45th Street, New York, in February 1980. McDermott played the part of Harold.
10. A hotel in Buffalo, New York.
11. McDermott canceled his planned first date with Brainard to perform in the play *Da* in Buffalo.
12. McDermott was preparing for an audition at the Guthrie Theatre in Minneapolis.
13. McDermott had moved into the Arlington Hotel on West 25th Street, New York City, because it was near The Roundabout Theater, where he was performing in George Bernard Shaw's *Misalliance*.
14. Brainard is referring to Frank Rich's review of a production of *Misalliance* published in the *New York Times*, July 17, 1981, sec. C, 3.
15. Along with the actor Orson Bean, McDermott was performing in a production of David Mamet's *Life in the Theater*, Schoedinger Theater, Columbus, Ohio, March 1983.
16. Brainard is referring to a sebaceous cyst on McDermott's back.
17. McDermott's birthday is September 28.
18. "I remember when I went to a 'Come as your favorite person' party as Marilyn Monroe." In Ron Padgett, ed., *The Collected Writings of Joe Brainard* (New York: Library of America, 2013).
19. McDermott was visiting his grandmother in England.
20. Natalie Goldberg, *Writing Down the Bones: Freeing the Writer Within* (Boston: Shambhala, 1986).
21. In February and March 1987, the Mandeville Special Collections Library at the University of California, San Diego, held a large exhibition of Brainard's works drawn from the Robert Butts collection.
22. Both men were suffering from AIDS-related medical issues.

25. DEAR MRS. RAY

1. This letter is courtesy of Keith McDermott.

26. DEAR ANNI

1. Quoted in Laurie Roark, "Dear Anni, Love Joe," ArcGIS StoryMaps, March 22, 2022, https://story-maps.arcgis.com/stories/52e7c6b501aa44ac963a5cc163d2fd46.
2. All the letters included here from Brainard to Lauterbach are located in Mss. 736, box 1, Ann Lauterbach Papers, Beinecke Rare Book and Manuscript Library, Yale University.
3. Brainard and Lauterbach organized a fiftieth birthday party for Elmslie in New York City.
4. Ann Lauterbach, *Many Times, But Then* (Austin: University of Texas Press, 1979).

5. Nielsen's *The Silent Muse* is actually a memoir, not a novel.
6. Phillip Lopate, *Confessions of Summer* (Garden City, NY: Doubleday, 1979).
7. Lauterbach, *Many Times, But Then*.
8. Kenward Elmslie and Steven Taylor, *Palais Bimbo Lounge Show* (New York: Painted Smiles Records, 1985).

27. DEAR NATHAN

1. The letter from Brainard to Kernan is courtesy of Nathan Kernan.
2. *Nathan Kernan Remembers Joe Brainard: "I Love His Ingenuousness,"* 2022, video, 7:09, Library of America, https://www.youtube.com/watch?v=UeQfH_sqifQ.
3. The artist Anne Dunn had requested that Kernan, who was planning to visit her in Europe, bring some Rigident denture adhesive for a friend.
4. The "exciting news" may be a reference to Marvin's pregnancy.
5. Brainard sent a slightly edited version of this dream account to Alice Notley and Doug Oliver for inclusion in their magazine *Scarlet*. See the "Dear Alice" chapter.

28. DEAR ALICE

1. Joe Brainard to Alice Notley, box 19, folder 6, Alice Notley Papers, Special Collections & Archives, University of California, San Diego. Notley recalls, "I remember this letter; it is wonderful. I think it came too late for any of the issues. We were actually working on *The Scarlet Cabinet* by then instead of magazine issues—we thought of it as issues 5 and 6. If I remember correctly. Then we left for Paris and later edited *Gare du Nord*, but Joe was dead by then and I guess I just forgot about these dreams." Email to the editor, October 22, 2021.
2. Brainard to Notley, box 19, folder 6, Alice Notley Papers.

29. DEAR BILL

1. Joe Brainard to Bill Berkson, box 1, 36 (undated pre-November 1975), Bill Berkson Papers, Archives and Special Collections, Thomas J. Dodd Research Center, University of Connecticut.
2. Brainard to Berkson, box 1, 36 (undated pre-November 1975), Bill Berkson Papers.
3. Brainard to Berkson, box 1, 36 (undated pre-November 1975), Bill Berkson Papers.
4. Brainard to Berkson, box 1, 36 (undated pre-November 1975), Bill Berkson Papers.
5. Berkson responded to Brainard's comments about gossip and Barnett Newman soon afterward.

> Gossip is bad, Joe, when it's not good. Gossip about people's love affairs is hopeless, because you never find out what's important about them, which is what people feel, and, then again, what people feel is not important, to you. I don't know who you fucked last year, and I don't care; I don't think you do either.
>
> I am glad Barney Newman means that much to you. He does to me too. I really like his work, it moves me, and I am not a fool for it. There's room for both of you in my heart. You are both very courageous. (Berkson to Brainard, August 18, 1969, Joe Brainard Letters, MSS 0703, box 1, folder 9, Special Collections & Archives, University of California, San Diego.

6. Brainard to Berkson, box 1, 36 (undated pre-November 1975), Bill Berkson Papers.
7. This is probably a reference to a children's book called *Jenny Jump* that Brainard and Padgett were working on in 1966 but never completed.
8. Padgett was suffering from lung complications at the time.
9. Joe Brainard, letter to Bill Berkson, Box 1, 36 (undated pre Nov. 1975), Bill Berkson Papers, Archives and Special Collections, Thomas J. Dodd Research Center.
10. Brainard is referring to words and letters that he has redacted in the previous sentence.
11. Bill Berkson, ed., *Best & Company* (New York: Bill Berkson, 1969).
12. Brainard to Berkson, box 1, 36 (undated pre-November 1975), Bill Berkson Papers.
13. James Schuyler, "Evening Wind," *New Yorker* (October 9, 1971): 127.
14. Brainard to Berkson, box 1, 36 (undated pre-November 1975), Bill Berkson Papers.
15. Brainard included versions of these one-liners in a work entitled "30 One-Liners." See Joe Brainard, *The Collected Writings of Joe Brainard*, ed. Ron Padgett (New York: Library of America, 2013), 414–16.
16. Brainard to Berkson, box 1, 36 (undated pre-November 1975), Bill Berkson Papers.
17. Brainard is referring to a cover he was working on for *Art News* magazine.
18. Brainard to Berkson, box 1, 36 (undated pre-November 1975), Bill Berkson Papers.
19. Bill Berkson, *Recent Visitors* (New York: Boke, 1971).
20. Joe Brainard, letter to Bill Berkson, Box 1, 36 (undated pre Nov. 1975), Bill Berkson Papers.
21. Brainard is referring to his show of oil paintings at the Fischbach Gallery, April 6–25, 1974.
22. Brainard to Berkson, box 1 (1989–90), Bill Berkson Papers.
23. Elmslie wrote the libretto for the composer Thomas Pasatieri's adaptation of Henry James's novel *Washington Square*. Performed by the New York Lyric Opera, it opened on October 13, 1977, at the New York University Theater.
24. Brainard to Berkson, box 1 (1989–90), Bill Berkson Papers.
25. Brainard to Berkson, box 1 (1989–90), Bill Berkson Papers.
26. Brainard to Berkson, box 1 (1992–93), Bill Berkson Papers.
27. Brad Gooch, *City Poet: The Life and Times of Frank O'Hara* (New York: HarperPerennial, 1994).
28. Brainard to Berkson, box 1 (1992–93), Bill Berkson Papers.
29. Brainard to Berkson, box 1 (1992–93), Bill Berkson Papers. While this letter lacks a postmark, I am dating it summer 1993, as this was the last letter included in the folder containing letters from 1992 and 1993. According to Melissa Watterworth, the archivist responsible for the Berkson papers, Berkson filed his correspondence according to the date received.

GLOSSARY

The following names include all the people Brainard addressed or mentioned directly in his letters who were active in his social circle, as well as those who were merely associated with it. Not included here are the names of authors, artists, and filmmakers whose works he mentions but who were not connected to him personally.

Abbott, Steve (1943–1992): Poet, editor, novelist, and critic based in San Francisco and an acquaintance of Brainard.

Abrams, William Amos (1943–1986): Actor and friend of Brainard's lover Keith McDermott and member of a supper club Brainard, McDermott, and friends started called "The Negroni Club."

Adler, Ellen (1927–2019): American realist painter, contemporary of Larry Rivers and Jane Freilicher, wife of the classical clarinetist David Oppenheimer.

Alan, Charles (1908–1975): Founder, in 1952, of the Alan Gallery, located at 766 Madison Avenue, New York. Alan was the first to show Brainard's work in a commercial New York City gallery.

Allen, Donald (1912–2004): Editor of the anthology *The New American Poetry* (1960), Allen met and befriended Brainard when Brainard visited Bolinas, California, in 1971. The two corresponded for some time afterward.

Antonio, Juan (1945–1990): Dancer, choreographer, and associate director of the Louis Falco Dance Company. Antonio choreographed a piece based on Brainard's *I Remember* and had a brief affair with him.

Ashbery, John (1927–2017): Poet who, along with Barbara Guest, Kenneth Koch, James Schuyler, and Frank O'Hara, was a central figure in the New York School of poets. Ashbery befriended, corresponded, and collaborated with Brainard for decades.

Bachardy, Don (1934–): Portrait artist and lover of the novelist and playwright Christopher Isherwood. Brainard posed for Bachardy and was on friendly terms with him and Isherwood for many years.

Baldwin, Gordon (1939–2020): Artist and curator who met Brainard when Brainard visited Bolinas, California, in 1971.

Bartholic, Bob (1925–2009): Tulsa-based artist and friend of Brainard who founded the Bartholic Gallery and, later, with his wife, Barbara Bartholic (née Simon), the Barking Dog art gallery.

Berkson, Bill (1939–2016): Poet, editor, and close friend and long-time correspondent of Brainard, Berkson was a central figure in the second-generation New York School of poets (along with Ron Padgett, Ted Berrigan, Bernadette Mayer, Anne Waldman, and others).

Berrigan, David Anthony (1963–): Son of Brainard's close friends and correspondents Ted and Sandy Berrigan.

Berrigan, Kate (1965–1987): Daughter of Brainard's close friends and correspondents Ted and Sandy Berrigan, Kate Berrigan was killed after being hit by a motorcycle on Houston Street in lower Manhattan.

Berrigan, Sandy (1942–): First wife of the poet Ted Berrigan and long-time friend and correspondent of Brainard.

Berrigan, Ted (1934–1983): A central figure in the second-generation New York School of poets and long-time collaborator and correspondent of Brainard. The two first met in Tulsa, Oklahoma, when Brainard was in high school, and remained friends throughout the rest of Berrigan's life.

Blaine, Nell (1922–1996): Painter who collaborated with Brainard's friend the poet Kenneth Koch and was affiliated with the New York School painters and poets.

Boyle, Kay (1902–1992): Novelist, poet, short story writer, and creative writing teacher at Wagner College who briefly taught Brainard's lifelong friend Ron Padgett and was on friendly terms with first- and second-generation New York School poets.

Brackman, Robert (1898–1980): Artist and teacher at the Art Students League, New York City, who, in the early 1960s, taught Brainard painting.

Brainard, John (1954–): Joe Brainard's younger brother, now an artist living in Paris.

Bridges, James (1936–1993): Director, screenwriter, actor, producer, and longtime partner of Jack Larson who was friendly with Brainard when Brainard visited Bridges and Larson in Los Angeles.

Brix, Joan (1942–): Friend, correspondent, and fellow Central High School (Tulsa) classmate of Brainard.

Brown, Pat (1942–): Friend and fellow Central High School (Tulsa) classmate.

Brownstein, Michael (1943–): Poet, novelist, environmental activist; former partner of Brainard's close friend, the poet Anne Waldman; and friend of Brainard.

Burckhardt, Rudy (1914–1999): Swiss American photographer and filmmaker, longtime friend of the dance critic and poet Edwin Denby, friend of many first- and second-generation New York School painters and poets, and longtime friend and collaborator of Brainard.

Burke, Susan (1950–): Former girlfriend of Brainard's close friend Bill Berkson.

Burton, Scott (1939–1989): Sculptor and performance artist and partner of the painter John Button who was immersed in the worlds of New York City's intersecting avant-garde dance, New York School poetry, and arts communities.

Button, John (1929–1982): Painter, close friend of the poets Frank O'Hara and James Schuyler. See Scott Burton.

Butts, Robert (dates unknown): Collector of Brainard's artworks, correspondence, and related materials, Butts was a correspondent of Brainard about whom very little else is known.

Bye, Reed (1948–): Poet, singer-songwriter, former husband of Brainard's close friend Anne Waldman, and father to his and Anne Waldman's son, Ambrose Bye.

Carey, Tom (1951–): Poet, writer, former Franciscan monk, and vicar who, in the 1970s and 1980s, was literary assistant to and friends with Brainard's friends James Schuyler and John Ashbery.

Carillo, Macario "Tosh" (1941–1983): Photographer, actor, prop designer, and a member of the Warhol entourage at the Factory, featured in Warhol films including *Camp* (1965), *Vinyl* (1965), and *Horse* (1965).

Carroll, Jim (1949–2007): Poet, diarist, singer-songwriter, author of the 1978 autobiography *The Basketball Diaries*, and a central figure in the second-generation New York School of poets.

Clark, Tom (1941–2018): Poet and, in the 1960s and early 1970s, poetry editor of *The Paris Review*. Brainard produced covers for Clark's own books of poetry and Clark's small-circulation mimeographed magazines.

Clough, Harold (1897–1993): Calais, Vermont, handyman who was friendly with Kenward Elmslie and Brainard.

Cochran, Royla (1937–2019): Art student at Tulsa University and friend of Brainard with whom he had his first sexual experience.

Cohen, Arthur (1928–1986): Editor, art critic, theologian, novelist, and publisher, Cohen was close to several of the New York School poets and published Ron Padgett, David Shapiro, and John Ashbery.

Corbett, Bill (1942–2018): Poet, essayist, publisher, and friend of Brainard who edited, among many works, the collected letters of James Schuyler.

Corbett, Beverly (1942–): Wife of Bill Corbett, a retired therapist now living in Brooklyn.

Cox, Christopher (1949–1990): Author, actor, and editor at Ballantine Books and partner in the 1970s to writer Edmund White. Brainard was on friendly terms with both men.

Crabtree, Lee (1943–1973): Composer and musician who performed with the Fugs and the Holy Modal Rounders and was also close to several of Brainard's poet friends, including Anne Waldman and Peter Schjeldahl.

Creeley (née Hawkins), Bobbie Louise (1930–2018): Friend, poet, short story writer, and former wife of poet Robert Creeley.

Creeley, Robert (1926–2005): Poet and fiction writer, a central figure in the New American Poetry, former husband of Bobbie Louise Hawkins, and friend and occasional collaborator of Brainard.

Crosby, Caresse (1892–1970): Patron and friend of writers and artists in Paris and New York from the 1930s through the 1960s. Inventor of the modern brassiere and founder with then-husband Harry Crosby of Black Sun Press.

Cunningham, Merce (1919–2009): Choreographer and dancer, partner of the composer and poet John Cage.

Dash, Robert (1934–2013): Writer, artist, and gardener based in the Hamptons and New York City who was friends with New York School painters and poets and whose loft Brainard lived in for a short period in 1964.

Denby, Edwin (1903–1983): Poet, dance critic, and librettist whose work was hugely important to the second-generation New York School poets.

Dennis, Donna (1942–): Sculptor, painter, printmaker, and former girlfriend of Brainard's close friend Ted Berrigan.

De Saint Phalle, Niki (1930–2002): French American painter and sculptor, Harry Mathews's first wife, and a close friend of Brainard's friend Clarice Rivers.

Diamond, Martha (1944–2023): Painter, partner for a short period of Ted Berrigan, and friends with New York School poets including Bill Berkson and Peter Schjeldahl.

DiCarlo, Lawrence (1949–): Gallery director and, later, CEO of the Fischbach Gallery in New York City. In the early 1970s, the gallery represented Brainard and fellow artists Jane Freilicher, John Button, and Nell Blaine.

Dine, Jim (1935–): Contemporary artist, friend and collaborator of Ron Padgett.

Di Prima, Diane (1934–2020): Poet, editor of important little magazines including *The Floating Bear*, publisher, friend of Beat and New York School poets, and political activist.

Dlugos, Tim (1950–1990): Poet, contemporary of third-generation New York School poets such as Eileen Myles and David Trinidad, and friend of Brainard.

Doss, John (1923–): Medical doctor and poet, husband of Margot Doss, who met Brainard when Brainard visited Bolinas, California, in the summer of 1971.

Doss, Margot (1920–2003): Journalist and columnist for the *San Francisco Chronicle*, wife of John Doss, who met Brainard when Brainard lived for a short time in Bolinas, California, in the summer of 1971.

Droll, Donald (1927–1985): Curator, art dealer, patron, and former director of the Fischbach Gallery (see DiCarlo, Lawrence).

Dunn, Anne (1929–): English painter associated with the second-generation School of London painters including Lucian Freud, David Hockney, and Francis Bacon; friend of Brainard.

Gooch, Brad (1952–): Poet, fiction writer, author of biographies including *City Poet: The Life and Times of Frank O'Hara* (1993), and friend and correspondent of Brainard.

Elliott, Bill (1944–1985): Composer, musical director of off-Broadway productions and theaters including La Mama, friend of Brainard, and collaborator with Brainard's longtime partner and lover, Kenward Elmslie.

Elmslie, Cynthia (1914–1996): Sister of Kenward Elmslie.

Elmslie, Kenward (1929–2022): Librettist, poet, performance artist, and longtime partner and lover of Brainard.

England, Paul (1918–1988): Tulsa artist who lived part-time in New York City and was a friend of Brainard and members of his circle.

Escobar, Marisol (1930–2016): Venezuelan American artist who, in the 1960s, was affiliated with Pop artists including Andy Warhol and Roy Lichtenstein.

Fagin, Larry (1937–2017): Poet, publisher, and editor affiliated with the second-generation New York School poets, and correspondent and close friend of Brainard.

Fischbach, Marilyn (1931–2003): Founder and former sole owner of the Fischbach Gallery in New York City where Brainard showed his work.

Fizdale, Arthur (1920–1995): Pianist best known for his partnership with the pianist Arthur Gold, friend and acquaintance of a number of first-generation New York School poets, and acquaintance of Brainard.

Freeman, Jonathan (1950–): Actor, singer, and friend of Brainard's lover Keith McDermott.

Freilicher, Jane (1924–2014): Painter affiliated with New York School artists including Alex Katz, Larry Rivers, Grace Hartigan, and Fairfield Porter; muse to the poets Frank O'Hara and John Ashbery; and friend of Brainard.

Gallup, Dick (1941–2021): Poet, correspondent and friend of Brainard; editor with Brainard, Ron Padgett, and others of the high school literary journal, *The White Dove Review*; and part of the nucleus of young Tulsa poets who moved to New York City in the early 1960s.

Georges, Paul (1923–2002): Artist and friend with artists in Brainard's circle such as Larry Rivers and Jane Freilicher.

Gold, Arthur (1917–1990): See Fizdale, Arthur.

Greenwald, Ted (1942–2016): Poet affiliated with the second-generation New York School and Language School poets.

Groffsky, Maxine (1936–): Former editor of the literary journal the *Paris Review*, literary agent, and close friend and correspondent of Brainard.

Golde, Morris (1920–2001): Businessman; literary, dance, and arts patron, and friend of people in Brainard's circle including Ned Rorem, John Ashbery, Kenward Elmslie, J. J. Mitchell, and Frank O'Hara.

Gude, Lorenz (1942–): Publisher of *C: A Journal of Poetry*, edited by Ted Berrigan. Gude met Ron Padgett when they were freshmen at Columbia University, and he soon became close to Brainard, Dick Gallup, and other related figures.

Guest, Barbara (1920–2006): American poet, novelist, and biographer, an original member of the first generation New York School of poets, and friend and collaborator of Brainard.

Gulley, Phil (circa 1941–?): Acquaintance and fellow Central High School (Tulsa) classmate, friend of Dick Gallup.

Hall, Steven (dates unknown): Musician and poet who, in the 1970s, had a relationship with Brainard's longtime lover and companion, Kenward Elmslie.

Halston (Roy Halston Frowick) (1932–1990): Internationally renowned fashion designer and friend of Brainard's close friend D. D. Ryan.

Hannah, Duncan (1952–2022): Visual artist, memoirist, actor in 1970s underground movies, friend of Brainard and related artists and poets, and a regular presence at CBGB and other punk clubs.

Harvey, Nylajo (1926–2022): Tulsa-based visual artist and friend of Brainard during his high school years.

Harwood, Lee (1939–2015): English poet whose second book, *The Man with the Blue Eyes* (1966), was published by Lewis Warsh's and Anne Waldman's Angel Hair Press.

Hazan, Elizabeth (1965–): Visual artist whom Brainard first met when she was a small child, daughter of Brainard's friends Joe Hazan and Jane Freilicher.

Hazan, Joe (1916–2012): Artist and husband of Brainard's friend the painter Jane Freilicher.

Held, Al (1928–2005): Artist affiliated with the Abstract Expressionist painters and other figures on the margins of Brainard's various social circles.

Higgins, Dick (1938–1998): Poet, artist, publisher, and printmaker who was central to the international experimental arts community Fluxus.

Hornick, Lita (1927–2000): Patron of poets and artists, memoirist, and publisher of *Kulchur* magazine and press. Hornick published Brainard's *Selected Writings, 1962–1971*.

Hughes, Clifford (1946–2016): Husband of Karen Hughes, friend of Brainard and McDermott, and member of the "Negroni Club" (see Abrams, Amos).

Hughes (née Magid), Karen (1949–2003): Actress, friend of Brainard and McDermott, and member of the "Negroni Club" (see Abrams, Amos).

Hurley, Irma (1929–2009): Actor who met and befriended Frank O'Hara in the 1950s when they were both in Ann Arbor, Michigan. Hurley later moved to New York City and befriended other poets and artists in Brainard's and O'Hara's circles. Hurley was the poet Tony Towle's wife from 1965 to 1979.

Isherwood, Christopher (1904–1986): Playwright, screenwriter, novelist, friend of Brainard, and partner of Don Bachardy.

Jenkins, Paul (1923–2012): American abstract expressionist artist affiliated with the New York School of painters.

Jordan, Bob (circa 1927–?): James Schuyler's boyfriend in the late 1960s and early 1970s.

Kalstone, David (1933–1986): Literary critic, author, professor of literature at Rutgers University, and friend of Brainard's friends such as Edmund White and Chris Cox.

Katz, Ada (1928–): Co-founder of The Eye and Ear Theater in New York City; biologist at the Memorial Sloan Kettering Cancer Center; wife of the painter Alex Katz, mother of the poet Vincent Katz, and friend and correspondent of Brainard.

Katz, Alex (1927–): Painter, sculptor, printmaker, husband of Ada Katz, father of Vincent Katz, and friend and correspondent of Brainard.

Katz, Bill (1942–): Architect, designer, publisher, and friend of Brainard. Katz designed the installations of the Brainard traveling retrospective at the Berkeley Art Museum and PS 1 in New York (2001).

Katz, Vincent (1960–): Poet, son of Ada and Alex Katz, and friend and correspondent of Brainard.

Kennedy, Betty (1927–2011): Tulsa artist, contributor to and editor of *The White Dove Review*, the high school literary journal for which Brainard served as arts editor. Kennedy and her husband, the artist John Kennedy, hosted Brainard, Padgett, and their friends at numerous salon-style parties at their home.

Kennedy, John (1924–1983): See Kennedy, Betty.

Kent, Louise Andrews (1886–1969): Calais, Vermont–based friend of Kenward Elmslie and acquaintance of Brainard. Kent wrote children's books and was known for her cookbooks, written under the name "Mrs. Appleyard."

Kepler, Anne (1941–1965): Flautist and high school friend of Brainard who died tragically in a fire in the Bronx. Kepler is memorialized in Ted Berrigan's poems "People Who Died" and "Tambourine Life."

Kernan, Nathan (1950–): Poet, editor, James Schuyler biographer, and friend and correspondent of Brainard in the late 1980s and early 1990s.

Kert, Larry (1930–1991): Actor, singer, and dancer best known for his starring roles in Broadway musicals including *West Side Story*, and friend of Brainard's lover Keith McDermott.

Kikel, Rudy (1943–2017): Poet, editor, and friend and correspondent of Brainard.

Kligman, Ruth (1930–2010): Artist, friend of first- and second-generation New York School poets including Kenward Elmslie, James Schuyler, and Brainard; and lover of Jackson Pollock and Willem de Kooning.

Koch, Kenneth (1925–2002): Poet, professor, creative writing pedagogue, a central figure in the first generation New York School of poets, and friend and collaborator of Brainard and his circle.

Krauss, Ruth (1901–1993): Poet and well-known children's book writer and contributor to Ted Berrigan's *C: A Journal of Poetry*.

Kyger, Joanne (1934–2017): Poet based in Bolinas, California; first wife of Gary Snyder; and friend and correspondent of Brainard.

Lally, Michael (1942–): Poet affiliated with the second- and third-generation New York School poets, TV and film actor, and friend, lover, and correspondent of Brainard.

Lally, Miles (1969–): Son of the poet Michael Lally.

Larson, Jack (1928–2015): Actor, screenwriter, and producer famous for his portrayal of Jimmy Olsen in the TV series *The Adventures of Superman* (1952–1958). See Bridges, James.

Lauterbach, Ann (1942–): Poet, art critic, essayist, close to poets in Brainard's circle including John Ashbery and Kenward Elmslie, and close friend and correspondent of Brainard.

LeSueur, Joe (1924–2001): TV scriptwriter, memoirist, novelist, former roommate and lover of Frank O'Hara, and close friend and lover of Brainard.

Lopate, Phillip (1943–): Essayist, fiction writer, poet, film critic, professor, and friend of Ron Padgett. In the early 1960s, Lopate, then an undergraduate at Columbia University, served as one of the editors of the *Columbia Review*.

Machiz, Herbert (1923–1976): Theater director of the off-Broadway Artists Theater, partner of John Bernard Myers, and friend of first- and second-generation New York School poets, composers, and artists.

MacWhinnie, John (1945–): Artist, set designer, and member of the Hamptons artistic circle that included Brainard's friends the artists Larry Rivers and Fairfield Porter.

Malanga, Gerard (1943–): Poet, photographer, and former dancer with the Velvet Underground. In the 1960s, Malanga published Brainard's work in the *Wagner Literary Review* when he was student editor of the college journal.

Mangold, Robert (1937–): American artist affiliated with the minimalist movement who, in the 1960s, showed in many of the same galleries (including the Fischbach) that Brainard and his fellow artists showed in.

Marberger, Aladar (1947–1988): Art dealer and director of the Fischbach Gallery who showed Brainard's work in the mid-1960s.

Marsh, Michael (circa 1941–2019): Friend and fellow Central High School (Tulsa) classmate who served as art coeditor with Brainard on the *White Dove Review*.

Martory, Pierre (1920–1980): French poet, lover of the poet John Ashbery when Ashbery was living in Paris in the 1960s.

Marvin, Carey (1954–): Painter and former student and friend of Brainard who introduced Nathan Kernan to Brainard.

Mathews, Harry (1930–2017): Novelist, poet, essayist, translator, and founding editor with John Ashbery, Kenneth Koch, and James Schuyler of *Locus Solus* literary magazine. A friend of Brainard's, Mathews was romantically involved with Brainard's close friend Maxine Groffsky.

Mayer, Bernadette (1945–2022): Poet, director of the Poetry Project at St. Mark's Church, New York, and friend and correspondent of Brainard.

McDermott, Keith (1953–): Actor, writer, theater director, Brainard's lover in the late 1970s and 1980s, and friend and correspondent of Brainard for the remainder of Brainard's life.

McDermott, Ray (1924–): Mother of Keith McDermott.

McGaugh, Lawrence (1940–2006): California-based poet whose work was published in anthologies including *The Poetry of Black America*, ed. Arnold Adoff (New York: Harper & Row, 1973).

McShine, Kynaston (1935–2018): Curator at the Museum of Modern Art in New York City from 1959 to 2008 and friends of numerous artists and poets affiliated with the New York Schools of poetry and painting.

Merla, Patrick (1945–): Literary agent, essayist, fiction writer, editor of gay-centered magazines including the *New York Native* and *Christopher Street*, and friend of Keith McDermott.

Milford, Penelope (1948–): Stage and screen actress and second wife of Brainard's friend the poet and actor Michael Lally.

Mitchell, Bernadean (1945–2003): Sister of Pat Padgett (née Mitchell) and Tessie Mitchell.

Mitchell, J. J. (John Joseph) (1940–1986): Writer, friend, and occasional collaborator with the painter Joan Mitchell; lover of Brad Gooch and of Frank O'Hara; and friends with other poets of the first- and second-generation New York School.

Mitchell, Joan (1925–1992): Abstract-expressionist painter and a central figure in the New York Schools of painters and poets.

Mitchell, Tessie (1947–): Sister of Pat Padgett (née Mitchell) and Bernadean Mitchell.

Mounts, Marilyn (circa 1942–?): Classmate of Brainard at Central High School in Tulsa in whom Brainard had some romantic interest, cited in Brainard's *I Remember*.

Mundy, Sephronus (1939–1990): Rochester-based friend of John Ashbery in the later 1960s who often drove Ashbery to his hometown Sodus, near Rochester, when Ashbery wanted to visit his mother.

Myers, John Bernard (1920–1987): Director of the Tibor de Nagy gallery, editor and publisher, and friend and promoter of the New York Schools of painters and poets.

Myles, Eileen (1949–): Poet, novelist, short story writer, art critic, performance artist, and essayist, a contemporary of Tim Dlugos, Dennis Cooper, and other related writers.

Nevin, John (1922–2003): Artist originally from Tulsa who was living in Mexico when Brainard visited him there in the early 1960s.

Notley, Alice (1945–): Poet, former wife of the poets Ted Berrigan and Douglas Oliver, and close friend and correspondent of Brainard.

O'Hara, Frank (1926–1966): Poet, curator at the Museum of Modern Art, critic, and central figure in the first generation New York School poets.

O'Hare, Lynn (1939–): Painter, photographer, and wife of Brainard's close friend the poet Bill Berkson from 1975 to 1996.

Oliver, Doug (1937–2000): British poet, editor, novelist, and husband of Alice Notley.

Owen, Lauren (1941–): Friend of Ron Padgett, Dick Gallup, and Ted Berrigan when they were all living in Tulsa, and an acquaintance of Brainard. Owen moved to New York City in the late 1960s.

Owen, Maureen (1943–): Poet, editor, biographer, wife of Lauren Owen, and part of the New York School and Beat poetry circles with which Brainard was affiliated.

Padgett (née Mitchell), Pat (1937–) Wife of Ron Padgett and one of Brainard's closest friends and correspondents.

Padgett, Ron (1942–): Poet, memoirist, husband of Pat Padgett, and one of Brainard's oldest and closest friends and correspondents.

Perkins, Anthony (1932–1992): A minor acquaintance of Brainard, Perkins was an actor best known for his role as Norman Bates in Alfred Hitchcock's *Psycho* (1960).

Plimpton, George (1927–2003): Founding editor of the *Paris Review*, a highly regarded literary magazine that showcased the works of emerging writers including Brainard and many of his friends and acquaintances, alongside interviews with established authors.

Porter, Anne (1911–2011): Poet, wife of Fairfield Porter, and friend and correspondent of Brainard.

Porter, Elizabeth (1956–): Daughter of Anne and Fairfield Porter.

Porter, Fairfield (1907–1975): Painter, art critic, central figure in the New York Schools of painting and poetry, and friend and correspondent of Brainard.

Porter, Katherine (1950–): Daughter of Anne and Fairfield Porter.

Pullen, Ron (1955–2023): Actor and longtime lover and companion of Larry Kert.

Ratcliff, Carter (1941–): Art critic, poet, and contemporary and friend of several second-generation New York School poets.

Rengers, Ella (1924–1998): Friend and patron of Brainard whom he had met in 1960 while a student at The Dayton Art Institute.

Rich, David (1927–2017): Husband of Faye Rich and Tulsa-based patron of Brainard.

Rich, Faye (1927–): Tulsa-based patron of Brainard, wife of David Rich.

Richardson, Claibe (1929–2003): Composer and close friend and collaborator of Brainard's lover and long-time companion, Kenward Elmslie.

Rivers, Clarice (1936–): Wife of the painter Larry Rivers, close friend of Brainard, and a central figure in the Hamptons summer social scene of which Brainard and his circle were a part.

Rivers, Larry (1923–2002): Artist, jazz saxophonist, and writer; a central figure in the second generation of New York School of painters including Jane Feilicher, Nell Blaine, Joan Mitchell, Mike Goldberg, Alex Katz, and Fairfield Porter; and husband of Clarice Rivers.

Robbins, Margaret (circa 1943–?): Cousin of Sandy Berrigan, an aspiring dancer from Long Island who, in the early 1960s, lived in the East Village, New York City.

Roper, Jane (circa 1944–45–?): Acquaintance of Brainard from Tulsa who attended university in Boston or Cambridge while Brainard lived there in 1963.

Rorem, Ned (1923–2022): Composer of contemporary classical music, writer, friend of Brainard, friend and collaborator with Brainard's lover and longtime companion, Kenward Elmslie.

Rosenberg, David (1943–): Poet, educator, biblical translator, editor, acquaintance of Brainard, and friends with Brainard's close friends Lewis Warsh, Bernadette Mayer, and others.

Ryan, D. D. (1928–2007): Editor at *Harper's Bazaar*, fashion icon, associate of the fashion designer Halston, and friend of Brainard and other writers and artists in his circle.

Saroyan, Aram (1943–): Poet and publisher of the poetry magazine *Lines* and son of the novelist and playwright William Saroyan. Brainard became friendly with Saroyan and produced covers for some of his publications.

Schempf, Sue (1918–2009): Tulsa-based artist and frame shop owner and early patron of Brainard who, in the early 1960s, sent Brainard much-needed cash.

Schiff, Harris (1944–): Poet affiliated with the second generation of New York School writers, was particularly close to Brainard's friend Ted Berrigan.

Schjeldahl, Peter (1942–2022): A poet and poetry editor in the 1960s and 1970s, Schjeldahl later became a renowned art critic for publications including the *New Yorker* and *The New York Times*.

Schuyler, James (1923–1991): A central figure in the first-generation of New York School poets and close friend and correspondent of Brainard.

Segner, Leslie (circa 1941–?): Acquaintance of Brainard and fellow Central High School (Tulsa) student.

Simon, Barbara (1939–2010): Tulsa-based friend, UFO investigator, a central figure in Tulsa's bohemian community, and wife of Bob Bartholic.

Sola, Mrs. (dates and first name unknown): Mrs. Sola owned an antique store/junk shop on First Avenue that Brainard watched for her on occasion in exchange for items in the store.

Solomon, Holly (1934–2002): Founder in 1969 of the 98 Greene Street Loft performance space and, in 1975, of the Holly Solomon Gallery, art collector, gallerist for artists in Brainard's circle.

Sontag, Susan (1933–2004): Internationally renowned essayist, novelist, and acquaintance of Brainard.

Southgate, Patsy (1928–1998): Writer, translator, scene-maker in literary Paris during the 1950s and the Hamptons in the later 1950s and 1960s, wife of Peter Matthiessen and Mike Goldberg, and friend and contemporary of Larry Rivers, Willem de Kooning, Frank O'Hara, and other writers and artists in Brainard's circle.

Spender, Steven (1909–1995): English poet, playwright, novelist, professor, and author of the groundbreaking novel *World Within a World* (1951), notable at the time for its frank depiction of homosexuality.

Stanton, Johanna (1944–): Wife of Johnny Stanton.

Stanton, Johnny (1943–): Novelist, editor, publisher of Brainard's *Cigarette Book* (1972) and *Banana Book* (1972), and friend and collaborator with Brainard.

Steiner, Michael (1945–): Painter, sculptor, printmaker, and loft mate of Brainard for a short period in 1964.

Taylor, Paul (1930–2018): Internationally renowned choreographer and dancer and founder in 1954 of the Paul Taylor Dance Company.

Thomas, Richard (1951–): Actor and poet best known for his role as John-Boy in the TV series *The Waltons*. Thomas was an acquaintance and fan of John Ashbery and Kenward Elmslie.

Thomson, Virgil (1896–1989): Composer, contemporary of Aaron Copeland, Henry Barber, and other composers affiliated with the so-called American sound. Thomson lived in New York's Chelsea Hotel (Ned Rorem worked there with Thomson, as his copyist) and was a neighbor to Brainard's close friend the poet James Schuyler, who moved there in 1979.

Thorpe, Opal (1908–2006): One of Brainard's art instructors at Central High School, Tulsa, Oklahoma.

Tinguely, Jean (1925–1991): Swiss-born sculptor best known for his kinetic "Métamatics" sculptures, husband from 1971 to 1991 of Brainard's acquaintance the artist Niki de Saint-Phalle.

Towle, Tony (1939–): Poet affiliated with the first- and second-generation of New York School poets and friend and roommate of Brainard.

Veitch, Tom (1941–2022): Poet, novelist, and comic book writer who started out in the underground comics scene and later wrote for the *Star Wars* comic book franchise. He was affiliated with the second generation of New York School poets and publishers and a friend of Brainard.

Waldman, Anne (1945–): Poet, assistant director and director of the Poetry Project at St. Mark's Church, New York City, from 1966 through 1978 and cofounding director with Allen Ginsberg of the Jack Kerouac School of Disembodied Poetics. Waldman is a central figure in the second-generation New York School poetry scene and was a close friend, collaborator, and correspondent of Brainard.

Warhol, Andy (1928–1987): Internationally renowned Pop artist who, in the 1960s, was friendly with and filmed "Screen Tests" of several first- and second-generation New York School poets including Brainard, John Ashbery, Ron Padgett, Ted Berrigan, and Gerard Malanga. He was a friend and admirer of Brainard.

Warsh, Lewis (1944–2020): Poet who, with Anne Waldman, published the first installment of Brainard's *I Remember* (1970): through their Angel Hair press imprint; and a friend and correspondent of Brainard.

Warshall, Peter (1943–2013): Bioanthropologist and environmentalist living in Bolinas, California; editor of and writer for *The Whole Earth Catalogue*; partner in the early 1970s of Brainard's friend the poet Joanne Kyger.

Weeks, Ralph (1917–1982): Carpenter and handyman for Kenward Elmslie's home in Calais, Vermont.

Weinstein, Arnold (1927–2005): Poet, playwright, librettist, a central figure in the first- and second-generation New York School art and poetry scenes, and close friends with many of the writers and artists in Brainard's circle.

Weir, William Corsane (1909–1991): Husband of Kenward Elmslie's sister, Cynthia Elmslie.

Whalen, Philip (1923–2002): Poet affiliated with the San Francisco Renaissance and Beat Generation writers, Zen monk, and friend of Brainard and other poets in Brainard's circle.

White, Edmund (1940–): Novelist, memoirist, professor, biographer, essayist, and friend of Brainard and other writers and artists in Brainard's circle.

Wieners, John (1934–2002): Poet affiliated with the Black Mountain School and friend of Frank O'Hara and other poets in Brainard's circle.

Winkfield, Trevor (1944–): Painter, writer, and collaborator with a number of Brainard's friends such as John Ashbery and Harry Mathews.

Williams, Jonathan (1929–2008): Poet, publisher, essayist, photographer, and founder and publisher of Jargon Press.

Wilson, Jane (1924–2015): Painter; contemporary of Jackson Pollock, Helen Frankenthaler, Willem de Kooning, and others associated with Brainard's circle; wife of the art critic, art historian, photographer, and composer John Gruen.

Wood, Brian (1948–): Visual artist who was the partner for a time of Brainard's close friend the poet Ann Lauterbach.

Worthington, Rain (1949–): Composer, wife of Brainard correspondent and friend Michael Lally.

Yorck, Ruth Landshoff (1904–1966) German American actor and writer and close friend of Kenward Elmslie. Yorck played the part of Ruth in Friedrich Wilhelm Murnau's silent film *Nosferatu—A Symphony of Horror* (1922) and was a cabaret performer alongside Marlene Dietrich and others in Weimar-era Berlin.

INDEX